"A THOROUGHLY ENTERTAINING ORAL BIOGRAPHY OF A TINSELTOWN INSTITUTION."

—*The San Francisco Examiner*

"Here is the quintessential Hollywood Roshomon. . . . David Rensin has impossibly and heroically channeled Studs Terkel and Harold Robbins all at once. This is a pinball machine clanging secret truths that move and career as brashly as the movers who blurt their guts onto every shockingly entertaining page. And the best part is that we learn that people who are now very, very rich were forced to do very, very humiliating things to achieve such. What a refreshing equalizer for all of us."

—BILL ZEHME
Author of *The Way You Wear Your Hat:
Frank Sinatra and the Lost Art of Livin'*

"David Rensin's book offers a fascinating look at some of the most powerful people and institutions in Hollywood. It's packed with entertaining anecdotes . . . cautionary tales, and survival tips for those who dare to try their luck in one of the world's most unpredictable businesses."

—KIM MASTERS
Author of *Keys to the Kingdom*

"Rensin captures the ambition, manipulative plotting, and hustler mentality . . . in this series of raunchy, realistic interviews . . . making [the] book an uncompromisingly truthful tell-all of what it takes to make it in the movie biz. . . . The stories are amusing, intriguing, and sometimes horrifying, but Rensin, to his credit, never dilutes sordid details."

—*Publishers Weekly*

"An oral history of a crucial Tinseltown institution, related by some folks who make Machiavelli look like a pussycat . . . Edgy, frenetic, and entertaining reports from the room that launched a thousand deals."

—*Kirkus Reviews*

THE
MAILROOM

HOLLYWOOD HISTORY
FROM THE BOTTOM UP

DAVID RENSIN

BALLANTINE BOOKS • NEW YORK

A Ballantine Book
Published by The Random House Publishing Group

Copyright © 2003 by David Rensin

All rights reserved under International and Pan-American Copyright Conventions.
Published in the United States by The Random House Publishing Group, a division of
Random House, Inc., New York, and simultaneously in Canada by Random House
of Canada Limited, Toronto.

Ballantine and colophon are registered trademarks of Random House, Inc.

www.ballantinebooks.com

Library of Congress Control Number is available upon request from the publisher.

ISBN 0-345-44235-0

Cover design by Gene Mydlowski
Cover illustration by Phil Heffernan

Book design by Joseph Rutt

Manufactured in the United States of America

First Hardcover Edition: February 2003
First Trade Paperback Edition: February 2004

10 9 8 7 6 5 4 3 2

For Suzie, for Emmett, for always

For Bernie

You don't get what you deserve in life;
you get what you negotiate.
—*Dr. Chester Karras*

No kid ever said to his dad,
"You know what I want to be when I grow up?
An agent!"
—*Mike Rosenfeld Sr., cofounder of CAA*

Contents

AMBITION

TIES THAT BIND

PRESSURE, PRESSURE, PRESSURE

Introduction

EVERYONE HAS TO START SOMEWHERE

To everything there is a season, and a time to
every purpose under heaven.
—*Ecclesiastes 3:1*

Anyone can become anything; it's the American dream. To become anything in Hollywood, to succeed in show business by *really trying,* the most enduring path to behind-the-scenes power and position runs through a talent agency mailroom.

There are other routes, of course, but none quite so romantic or romanticized, and none so deeply embedded in our can-do mythology that when someone says, "I started in the mailroom," we instantly know what they mean.

There is a universality to starting at the bottom.

An old William Morris Agency ad once promised, "The little mailroom employees of today are the big power brokers of tomorrow." Generations of movers and shakers kept that bargain: media moguls David Geffen and Barry Diller; supermanager-producer Bernie Brillstein; William Morris Agency (WMA) chairman Norman Brokaw and chairman emeritus Lou Weiss; producer-director Irwin Winkler; Jerry Seinfeld's managers, George Shapiro and Howard West; Universal Studios chairman Ron Meyer; former "most powerful man in Hollywood" Michael Ovitz; motivational speaker–cookie king Wally Amos; *Cosmopolitan* doyenne Helen Gurley Brown; author/playwright Larry Kramer (*The Normal Heart*); bestselling medium to the dearly departed James van Praagh; and many more.

Most graduates of this classic Hollywood apprenticeship take their places as part of the star-making machinery, but not all. Some leave to become lawyers, writers, publicists, editors, waitresses, security guards. There's a Deadhead, a few drug casualties, a cop, a missionary, a Christmas ornament kingpin, a psychiatrist, and a California state congressman.

Everyone has to start somewhere.

The mailrooms themselves are not remarkable and have changed little over the years. Mimeographs and teletypewriters gave way to copiers and fax machines. A wall of wooden mail slots is now a wall of steel-and-glass post office boxes. But the workers still stand on the same linoleum floors, enclosed by the same industrial paint jobs, in similarly cramped quarters. Too many bodies, elbows akimbo. The smells of frayed nerves and intestinal gas. Cabinets are stuffed with office supplies. Celebrity head shots cover the walls. Stacks of scripts and videotapes teeter precariously. There's always a half-eaten turkey sandwich in the trash bin and coffee cups littering the counter.

United Talent Agency's (UTA) mailroom in Los Angeles is more modern: a carpeted labyrinth on the technological cutting edge where banks of VCRs copy tapes and huge duplicating machines spew out movie and television scripts from disks, collate them, and even insert the binding brads. At Endeavor the mailroom is decorated with decoupaged news clippings about the company's revolutionary beginning, when four agents left International Creative Management (ICM) in the middle of the night with their files and Rolodexes. There's also a congratulatory letter from Michael Ovitz, and on the far wall is the ultimate inspirational totem: a plaque with the names of Endeavor trainees who made it out and became agents.

But mostly mailrooms are mailrooms, wherever you find them. It's the dreams they inspire that are different. At IBM the new recruit imagines maybe someday making division vice president, even running the company. Hollywood is the company in a company town. The dreams are bigger.

RUN, RUN, RUN

You come in early. Wear a suit and tie, or slacks and a pressed blue shirt. Maybe a Rolex, more likely a Schmolex. Sharp haircut. Always comfortable shoes—or else. Walk the halls. Fill in-boxes, empty out-boxes. Deliver packages around town. Learn names and faces. Run, run, run. Copy scripts and videotapes. Work the switchboard. Get up at 5 A.M. to buy groceries for the morning staff meeting. Close the office near midnight. Work sixteen-hour days like a dog in between. Make fruit plates. Clean dirty dishes. Scrounge for leftovers. Lift office furniture. Wash an agent's car. Read and summarize—"cover"—scripts. Walk a client's dogs. Haze your coworkers. Jockey for position. Eliminate the competition. Take a senior agent's urine sample to the doctor. Fight exhaustion and depression. Try to make the rent on poverty-level wages. Ask yourself over and over how you got a college degree and managed to end up here.

But if you play your cards right, don't tick off the bosses, make yourself invaluable, kiss some ass, get the big picture and the fine print, seize every opportunity, have brains and drive, are canny and cool, and don't quit in disgust, one day you'll be plucked from the crucible and become an agent's assistant.

Now what you once did for everyone you'll do for only one. Only more so.

Answer the phone. Listen in and take notes. Learn the business. Tell your boyfriend you "talked" to Tom Cruise today. Roll the calls. Keep the log. Baby-sit a client's kids. Get the car gassed. Get the tux pressed. Make reservations. Book travel. Rebook it. Book it again, damn it! Hand-deliver Christmas gifts. Send flowers. Run someone else's life. Please the boss's wife. Give the credit. Take the blame. Yell at those idiots in the mailroom. Get it done yesterday. Find a mentor. Ask a million questions. Dream of your promotion but leave nothing to chance. Plot your escape. And, of course, find some poor sucker in the mailroom to deliver the urine sample.

From the ego-killing shit work to the ego-thrilling sense that the sky's the limit, the minute you start in the agency training program, you're traveling in another dimension, between light and shadow, on a journey worthy of a *Twilight Zone* episode. There's the signpost up ahead. Your next stop: the mailroom.

The industry's greatest launching pad.

"It started because they said, 'We need somebody to do this shit,' " says Jack Rapke, William Morris mailroom class of 1975, who excelled as a literary agent at CAA before partnering with director Robert Zemeckis to produce movies such as *Cast Away.* "The system wasn't designed to be a psychological crucible. But that was the benefit of it. It was, 'Hey, you want to learn the business? You learn it from the absolute bottom up.' "

You have to. According to the *New York Times,* "The trade itself cannot be taught in a seminar, being smoke and mirrors, three-card monte and the ability to recognize talent. But in mingling with the real agents and navigating the city's nightlife after work, the baby moguls can absorb certain lessons in the craft, including making connections, feigning importance (never place a call your secretary can place) and mastering the art of becoming someone's best friend."

Bernie Brillstein said it best: "There is no school for show business." At least, no other school.

The hours are long, the pay is abysmal—now about $400 a week, up from $12 in 1937—and you put up with several years or more of virtual indentured servitude just for the shot at becoming someone licensed to get jobs and negotiate deals for other people.

Yet it all works because the bowels of the ambition factories are a microcosm of the show business life; like a hologram, every part contains the whole. "Each agency is a miniature Hollywood, and each mailroom a miniature agency," wrote Johanna Schneller in her 1992 *GQ* article "Is This the Next Mike Ovitz?" (To give you an idea of how fast things move, the article asked its title question only seven years after Ovitz began to be *Ovitz.* Hollywood, like marriage, has an inevitable itch.) "The skills one learns, if one learns them well, are primitive versions of the skills that get clients, which in turn yield the beach house in Malibu, the ski chalet in Aspen, the Mercedes, the reverence, the Power."

To get them, the successful trainee is expected to absorb osmotically and use consistently these lessons during an eyes-wide-open, full-body immersion in a world based on information, relationships, glad-handing, backstabbing, manipulation, hyperbole, and the willingness to do whatever it takes to sell, sell, sell. "What's needed," says Jeremy Zimmer, a William Morris mailboy in 1979, who for a time ran the

training program at UTA, where he is a partner and a legend, "is a person who says, 'Hey, I can take care of it,' and then takes care of it."

In other words, it takes a person who is willing to make every sacrifice in the world to reach the promised land. It's a high-pressure crapshoot that weeds out the weaklings. But if you want in on the action, there is no place better to roll the dice. "Working at a talent agency is like working for the CIA," explains Rob Carlson, William Morris's affably whip-smart young head of Literary and Directors. "You get to know what's going on at the networks, at the studios, you have access to all this talent, on-screen and off. At Sony or Disney or NBC they only know what they know about themselves. At an agency you know everything about everybody—even in the mailroom."

These days you have to fight to get in at the bottom. While it never hurts to be able to fill in "David Geffen" on the "Who do you know?" line of the employment application, it's almost as tough to find a place in a talent agency training program as it is for an agent to get a client a steady acting gig, maybe tougher. Candidates are routinely interviewed by anywhere from three to ten people. There's a basic skills test. According to *Entertainment Weekly*, only one in ten applicants makes it into the William Morris program, the granddaddy of them all. A *New York Times* story placed the ratio even higher, at thirty to one, and compared it with the chances of getting into Harvard Law School (nine to one), Columbia University Graduate School of Journalism (four to one), and Stanford Business School (four to one). No wonder David Geffen once called his alma mailroom, the Morris office, "the Harvard School of Show Business—only better: no grades, no exams, a small stipend, and great placement opportunities."

And once you're in, of course, it's all about getting the hell out—as quickly as possible.

In the old days you could start in the mailroom right after high school, or work summers while still in school and if they liked you, go full-time after graduation. Now summers are reserved for showbiz kids between college semesters who, if they want to make it permanent, need to reapply, degree in hand, like everybody else. Don't bother lying about the sheepskin, either; they check. Just ask David Geffen, who famously fibbed about his. The irony? He didn't have to; degrees weren't

officially required in 1964—unless you said you had one. Panicked when another dissembling trainee got canned, Geffen came into the mailroom early, intercepted the letter from UCLA, forged a confirmation, and got to stay at William Morris.

Today, for anyone who meets the educational requirements, the agency training programs are equal-opportunity power boot camps for the self-starter.

"It's the American dream," says Joel Peresman (WMA, 1979), now a vice president of Madison Square Garden, "because getting in gave you access to so many opportunities."

"What I love," says Patrick Whitesell (InterTalent, 1990), now a top talent agent and partner at Endeavor, "is that the mailroom is the great chance for the outsider in a town that often runs on nepotism."

Peresman's father was in the garment business. Whitesell is a lawyer's son from Iowa Falls, Iowa, who first tried mortgage banking. Bob Crestani (WMA, 1976) is a steelworker's kid from Portage, Indiana, who rose to run the company's television operations before casting his fate to the new technology boom. Donna Chavous (CAA, 1984) is the Los Angeles–born daughter of a cop and a nurse—and was the first African American in CAA's mailroom. Gary Lucchesi's (WMA, 1977) dad drove a bread truck in San Francisco. David Geffen's mother created custom-made bras. Mark O'Connor (CAA, 1994) loved television so much that when he was in the eighth grade, he wrote the late Brandon Tartikoff at NBC with scheduling advice. Ben Press (ICM, 1991), scion of the J. Press clothing empire, thought his experience selling political candidates would translate nicely to selling actors. Gary Randall (WMA, 1975) sold insurance. Brandt Joel (UTA, 1991) was in the Gulf War. Sandy Gallin's (GAC, 1962) fantasy was "to live in Hollywood, be rich, have a big house, and have stars know me, like me, and recognize me on the street."

Others were better-connected; someone they knew knew someone. Lou Weiss, a Morris employee since 1937, is George Burns's nephew. Brian Medavoy (ICM, 1986) is industry legend Mike Medavoy's son; Jodi Guber (ICM, 1993) is producer and former Columbia Pictures head Peter Guber's daughter. Countless sons (and now daughters) whose fathers started in the mailroom followed in their footsteps.

But whether you have a show business bloodline or just have show business in your blood, once you're in the door, whatever got you in

doesn't matter anymore. "It was just, 'You're in. Now start swimming. See where it takes you,' " says Peresman.

That's why, despite the list of spectacular successes, perhaps only 3 percent of those who start at the bottom of the pyramid even make it to midlevel. "Cream rises," says Marty Bowen (UTA, 1991), "but even bright kids don't make it. There's an enormous amount of contradiction at an agency. You're asking the same people who are incredibly aggressive to work as a team, to sublimate their instincts and pay their dues. That's really hard. Everybody who goes in the mailroom wants to be the first and the best and the fastest and the most powerful—and then they're told to answer the phones, be someone's 'person,' and live vicariously through someone else for three years. That conflict was the most difficult thing I've ever had to deal with."

THEN AND NOW

The talent agency mailroom tradition began in 1912 when fourteen-year-old Abe Lastfogel, a Russian immigrant's kid from the tenements of New York City's Lower East Side, was hired as an office boy at the William Morris Agency. Described by Frank Rose in *The Agency*, his must-read history of the Morris office, as "a scrappy kid, compact and solidly built . . . a hustler who knew right from wrong," Lastfogel soon became Morris's personal secretary and then, according to Rose, more than that: "He was his chief lieutenant, most trusted aide, almost a son."

By 1930, suffering from heart disease, Morris turned over the business jointly to his son, William Morris Jr., and Lastfogel. Bill Morris became largely a figurehead president. Lastfogel became general manager and had hands-on responsibility for running the agency.

In May 1952 when Bill Morris retired, Lastfogel was alone at the top. Though it had long been the reality, now his ascension was indisputable. He had risen from the mailroom to run it all, and the mailroom was reinforced as an embarkation point for the promised land.

Others who wanted to make something of themselves followed his route, not only to William Morris, but to talent shops such as MCA, CMA, IFA, Ashley-Famous, Triad, Leading Artists, Bauer-Benedek, InterTalent, and today's majors: UTA, CAA, ICM, Endeavor. Through

mergers and acquisitions, and agents changing jobs or starting their own businesses, every agency was pollinated with the training program tradition.

"The personality of the agency is created out of the mailrooms, and that's also where the history of the town is passed on," says Ron Mardigian (WMA, 1958). "The people starting out are at a most impressionable age, and there they are, sucking up all this stuff, real or myth. And it comes from the very top, from guys who were very strong and very specific, straight to the training program, where their philosophies were put into effect. At William Morris I had the feeling that the traditions of the company came straight down a tube, right into an in-basket in the mailroom, and that they contained all the instructions for how I was going to comport my professional life. Nobody said it out loud. At the most Abe Lastfogel would pop in and say, 'Does anybody have any gum?' It was just tradition. Somehow, what the guy before you did, you did. If you could change it to improve it a little bit, okay, but there were certain rules of behavior—ethics, honesty—and lines you didn't cross. It was very much like lessons from your parents."

As the mailroom generations changed, streetwise hustlers became college grads and postgrads. The perks and seductions also evolved. The new attraction was less the thrill of it all and more the thrill of *having* it all. This started in the eighties, when the Michael Ovitz–led CAA juggernaut earned him the title "the most powerful man in Hollywood" and raised the stature of agents from putzes to power brokers who had not only cash and clout, but finally, and most importantly, respect. According to the *New York Times,* "Once thought of as a pen of rough-around-the-edges Brooklyn teenagers who would do anything (ethical or not) to become a talent agent, the mail room now attracts lawyers and M.B.A.'s. There is a formal, structured training program with seminars, luncheons, manuals and grammar tests, a change that reflects the new button-down image of the profession as a whole."

RITE OF PASSAGE

I wanted to know what it was like to start at the bottom, in a talent agency mailroom, dreaming of the top. Having reported on show busi-

ness for many years, I knew the mythology: the training program is a secret society, a breeding ground, an incubator for baby moguls. The mythology is a great recruiting poster. I wanted the reality.

To find it, I started with a few names. Each name led to more names, like a chain letter, and the list grew exponentially. For two years, and in two-hundred-plus interviews, I asked people who had started as long ago as 1937 and as recently as 1999 to share their experiences, insights, and hindsights. Who were you before Hollywood beckoned? Why show business? Why the mailroom route? Who put you on the path? What was it like to push a mail cart? What was your plan to get noticed, your scheme to get ahead? What opened your eyes? What caused a meltdown? When did you stop being naive? What was the most fun? Most dehumanizing? What almost got you fired? What challenged your values; what confirmed them? Did your boss come from the mailroom? What was passed on? How did it change you? What story would you tell at a mailroom class reunion? How do mailrooms create show business culture? Does it mean anything more than just a job?

The result is more than oral history; it is oral anthropology. It is a portrait of ambition, of accident, of serendipity, of dreams lived and dreams broken. The mailrooms and training programs, in all their incarnations through the years, are at the core; but in the end they are simply a process, way stations, long hallways with many doors. It's a journey. A rite of passage. It's about Hollywood and not about Hollywood at all.

"I WAS BORN TO BE AN AGENT"

Some things I discovered:

No one wanted to be thought of as Sammy Glick, anti-icon of Budd Schulberg's classic show business novel, *What Makes Sammy Run?* because Glick is to opportunism what Brutus is to betrayal. Understandable. Glick was relentlessly grasping and deceitful. (Schulberg now laments that Glick has become a role model for these cutthroat times.) But even if they knew, no one who mentioned his name ever pointed out that the Glick character was a *newspaper copyboy turned Hollywood mogul*. Most people think he was an agent. (He wouldn't have made a good one because he cared more about himself than anyone else.)

Only a few of those I interviewed really *wanted* to be agents at the outset. The rest needed a job. They loved the glamour. They were pushed into it. It was a stepping-stone. They'd try it, and if they liked it, who knew?

A few confessed to once having had absolutely no idea what an agent did, what an agent was. "Do you mean travel agent?"

Others knew but reflexively imagined agents to be disreputable, unprincipled men chewing big cigars who talked out of the side of their mouth. These men were not movers and shakers but schleppers. Chislers. Flesh peddlers.

The idea of aspiring to *that* was offensive.

They did it anyway. For the stardust, for the money, to please their parents, to piss them off, or to follow an irresistible muse even though Daddy had paid for an Ivy League education and thought they were throwing it all away.

Some were actors/musicians/writers/film-school grads who, in the end, could never be the talent. The next best thing: help the talent be the talent and learn to enjoy the reflected glory.

Many kept an open mind and relished the adventure.

To be sure, they all swore the same oath before a gauntlet of interviewers—"I was born to be an agent"—but then, that's what they had to say. It doesn't mean the uncertain ones fooled anyone. In Personnel the bullshit detectors log much overtime.

So what did the trick? Enthusiasm, passion, relentlessness. Smarts. A good reference. An interesting personality quirk. A belief in their own bullshit—which, in the kindest sense and with all due respect, is just what it takes to be an agent, or anything else in show business. Unless there were obvious disqualifications (in the early days being black or a woman; sometimes not being Jewish), somebody was finally willing to take a chance that the fresh-faced kid across the interview desk would either find a quick and comfortable fit, learn to love the life, or discover something about him- or herself and stick around.

If not, the kid would at least have worked hard for slave wages until he or she couldn't take it anymore and moved on. Or got fired.

Here's what everyone who made it—and some who went on to other successful pursuits—had in common: *an addiction to opportunity and a voracious thirst to become.* They are the bedrock of the whole enterprise.

Making it, especially in Hollywood, is all about a commitment to

perpetual forward motion. Aspiration. Upwardness. It's all about traction and trajectory. You "start" in the mailroom. You "sweep" the office for envelopes. Deliver packages on "the runs." Get a desk—but you don't have the desk, you're just *on* it—and waiting to *pounce* on a bigger one. It's about striving, reaching, grabbing, moving, shaking—not sitting with your back to the wall, waiting for the party to come to you. The life is lived call to call, crisis to crisis, lunch to lunch, deal to deal, ulcer to ulcer, score to score. To survive and prosper, you have to go with the flow, even if you have to create the flow yourself.

MYSTERY DRIVE

The Mailroom is also in motion.

When I invited mailroom graduates to be a part of this book, they didn't ask me what it was about—that much was obvious—but how I hoped to cover the vast territory that lay ahead. After all, no one had tried to gather so many mailroom stories in one place before, and there were many I'd have to leave out. I said that reading the book would be like jumping from lily pad to lily pad to get a pretty damn good sense of the pond. Also, like starting at the bottom yourself, with hundreds of characters as your proxies. But privately another metaphor felt just as apt. Doing the book was a mystery drive along an endless highway; there was no map, only horizon and hitchhikers, none alike. I picked up one to get started, and listened to a story. I picked up another because the first one knew him. I picked up a third because he dressed funny; a fourth because she had an interesting smile and a provocative way of crooking her thumb. Soon I had to trade in my car for an SUV, then a mobile home, then a semi, and finally a fleet of tour buses full of people all talking at once.

Eventually my passengers coalesced into smaller groups—the "classes" you will read about—and I began to make sense of the noise. This is what they had to say.

Tell you the truth, I'm not nuts about our particular mailroom system; I think it needs to be a bit harsher. I would crank up the boot-camp element and I would let people know that it's really serious. Now, when somebody in the mailroom really goofs up, I just want to shave their head. Most of the time I don't even want to give them a second chance, because it's usually just laziness. In my day that's the one thing I never was. You always have to say, "Yessir, how high?"

In the end, to be the best at it, you have to be humble. I mean, you're an agent, not a principal. If somebody in the mailroom is already giving you attitude, that shows at the very least that they're not going to go the extra mile, which is what every good agent must always do. It shows that if they ever actually got real power, they're going to be arrogant as hell. I'd just as soon put a bullet in the head of that real early.

—Creative Artists agent, 2000

KIDS AT WORK

KIDS AT WORK

William Morris Agency, New York, 1937–1951

**LOU WEISS, 1937 • SOL LEON, 1938 • LARRY AUERBACH, 1944 •
HILLY ELKINS, 1950 • LEONARD HIRSHAN, 1951**

*My sense of what I had to do was simple:
get out of the mailroom as fast as I could.*
—*Hilly Elkins*

LOU WEISS: My recollection of all this is unfortunately perfect.

I was interested in the entertainment business because my uncle was George Burns. My mother was one of his seven sisters, and whenever he was in town, we'd all go to see him perform. I loved being backstage near talented people.

My mother wanted me to go to college. I'd rather have hung out with the guys and played ball, or gone to a poolroom, or chased the girls, but school is what she wanted. When she died young, in July 1937, I immediately dropped out of school and went to work. Another uncle, Willie Burns—George's manager and writer—called Abe Lastfogel, the boss at the William Morris Agency, and asked him to give me a job of any sort. Nat Lefkowitz and Morris Stoller interviewed me, and in August 1937, when I was nineteen, I got a job as an office boy at twelve dollars a week.

SOL LEON: I grew up in Brooklyn. My father was in the women's coats and suits business. He was able to put me through the first year of college at NYU-Heights, but when the Depression hit he said, "Sorry. I can't afford to send you back."

I got a job and went to Brooklyn Law at night. I sat next to Nat Lefkowitz in class for four years; it was alphabetical. Morris Stoller was also there. Lefkowitz and Stoller worked at William Morris; Nat

practically ran the place under Bill Morris Jr. When I became disenchanted with the law, I asked him to find a place for me.

I started October 1, 1938; I was twenty-five. Nat made me head of the mailroom, while Stoller trained me in business affairs. I had nothing directly to do with handling mail. My job was to tear off the Teletypes and distribute them. Get theater tickets. Get train tickets for Mr. Lastfogel; he didn't fly to California then. Anything that had to be delivered or sorted, I'd delegate. I just told the kids what to do.

WEISS: Before Sol Leon came to oversee the mailroom, "Uncle Henry"—Bill Morris Sr.'s wife's cousin—supervised the office boys. He was an elderly guy who didn't hesitate to crack the whip and make sure we weren't off playing cards someplace. I wish now that I had behaved myself better. I wasted a lot of time. I'd rather have gone dancing than deliver a script, listen to great bands and vocalists in Harlem than sort mail. I hung out at the Savoy Ballroom and watched Billy Eckstine and Sarah Vaughan and Ella Fitzgerald and Ellington. I was also hooked on comics and comedy writers. I loved to go to Lindy's and hang around, try to get myself recognized.

LEON: I wanted to fire Lou Weiss, but I couldn't because he was George Burns's nephew.

WEISS: Maybe because I always dressed better than Sol Leon [*laughs*]. He'd get very upset.

LARRY AUERBACH: My father was in the dairy restaurant business in Brooklyn. After the stock market crashed, he opened a smaller place but he didn't own the building, and when the city built a new highway, they tore it down, leaving him to sell off his tables and chairs. He was dejected and sad, and the pain of watching him spend more than a year looking for another situation is still vivid.

I had a work ethic early. When school let out for the summer, I'd always find a job. At twelve I helped my grandparents at their cleaning store, making deliveries. At thirteen I worked for a friend of the family, stacking cans neatly in the Epicurean Department of Gimbel's. The next summer a friend to whom my uncle sold stationery asked me, "Would you like to work in a theatrical agency?"

I had no idea what that was, so he told me a little bit about it, and I said, "Yeah, it sounds better than delivering suits."

I got the job at William Morris in June 1944. It was just for the summer, running things around town, mimeographing. I didn't care. It was

New York, the big city, exciting and glamorous. I was just shy of fifteen, a little younger than most people in the mailroom. A few years later I was also the youngest ever made an agent at William Morris—to my knowledge. Norman Brokaw claims he was, but what's the difference now?

HILLY ELKINS: I went to the theater often and from the first was attracted to the idea of putting together what I saw on the stage. When I was fifteen I auditioned for a radio program at WNYC and got in. I ran the sound board, produced, directed, wrote, acted.

At Brooklyn College my drama coach was Gordon Davidson's dad. Gordon—who has for years been artistic director of the Center Theatre Group/Mark Taper Forum of Los Angeles—and I were friends and opened a tent theater in Belle Harbor. I had a combination job: producer, star, and janitor. It didn't lose too much money, but we ran it into the ground.

I thought maybe learning the agency business would be a good way of getting a rounded entertainment education. People were in either the theater, nightclubs, or motion pictures. But now it was the beginning of television. Milton Berle and the *Colgate Comedy Hour*. The only players were William Morris and what was then MCA. I thought it was an interesting opportunity.

I came in cold. Sid Feinberg interviewed me. I was eighteen; I already had my college degree and was starting law school. I gave it up for a job in the mailroom.

LEONARD HIRSHAN: I could say I loved movies and went all the time when I was ten years old, and knew about directors and scripts, and loved the actors, and said to my father that one day I would grow up and be an agent—but that's not true. No one tells their parents they want to grow up to be an agent. Until I applied for a job at William Morris, I hadn't the slightest idea of what the agency business was, or any desire to be in show business. The fates pushed me there.

I got out of the navy in December 1947 and applied to NYU. I'm a very compulsive person, so I went to school *all year long* and graduated in about half the normal time, in August 1950, on a Friday. Having been accepted at NYU law school, I started the next Monday, but after a few months I burned out. I decided to take a leave of absence after the first semester, get a job for a while, and then go back.

I asked my uncle, who had booked shows at the Temple Emmanuel,

what kind of temporary situations I could find. He lived in the same building as Nat Kalcheim, an important agent at the Morris office, who told him to have me call Sid Feinberg.

RULE #1

WEISS: We called the boss Mr. Lastfogel, never Abe. Years later I was sitting with him and Elvis's manager, Colonel Parker, at Hillcrest Country Club in Los Angeles, and Colonel Parker said, "Abe, why don't you let Lou call you Abe?"

Mr. Lastfogel said, "He can call me Abe."

I said, "I don't call my father Sam. I'm not going to call you Abe."

It was automatic with all of us.

HIRSHAN: There was a Nedicks stand in the lobby of our building, 1270 Sixth Avenue, where they sold hot dogs and orange drinks. Whenever I walked by, I'd want something to eat and drink, but I wouldn't do it because I didn't want anyone from the office to think that's where I got my food—until the day I saw Mr. Lastfogel standing there with a hot dog and drink. That's when I realized the democracy of William Morris and dropped all my airs.

WEISS: Mrs. Lastfogel—Frances Arms—was a comic and a performer, and it was rare that she'd ever come up to the office. But one day she did and said, "Get Lou Weiss out of the stockroom." I couldn't imagine what she wanted. To my surprise she said, "Lou, let me see the new dance steps." We put on a record and I danced with the boss's wife. I couldn't say no. Even after I became an agent, whenever she and the boss were in town, she'd say, "Lou, hang around."

KIDS AT WORK

WEISS: First I was a delivery person. If an actor had to sign a contract, you got on a bus, went to the actor's house. I once waited for Mae West to sign a piece of paper. *That* was exciting.

HIRSHAN: I was told to deliver a script to Judy Garland at the Palace

Theater. It was a matinee day. I brought it over between shows. I went down to the dumpy-looking dressing rooms, looked in one, and saw a little girl in a ratty bathrobe sitting on the floor watching television. I said, "Excuse me, young lady. Do you know where I can find Judy Garland?" She turned around and said, "I am Judy Garland." It was so embarrassing.

AUERBACH: I delivered to Marilyn Monroe. She had just started, but I knew who she was. Her guy at William Morris was Johnny Hyde, a terrific agent, and there was some romance going on between them. I also took something to Gloria De Haven. She opened the door in her underwear. I was too young to know if I was getting an invitation to come inside, and if I was, I didn't know what to do about it. The only thing I remember is that her underwear was pink. Later I decided that I had really blown it!

WEISS: Belle Baker was not quite Sophie Tucker, but she was an important client who'd made a name for herself in vaudeville. She had an apartment on Central Park West. I had to get her to sign a contract. Her little dog yapped the whole time I stood in the vestibule. When I went out, the dog bit me. I stood there, my leg bleeding, afraid to go back in. At the office I told Morris Stoller what had happened.

He sent me to a doctor, who said the board of health *had* to get the dog. But Belle Baker had left town. They found her working in Atlantic City. They grabbed the dog and checked it out for hydrophobia. Thank God it was clean.

AUERBACH: By 1944, Sid Feinberg, a lovely man, oversaw the trainees. He was deathly afraid of Nat Lefkowitz, his boss. There was a cutout window between their offices, and when Nat would open it and say, "Sid!" he'd jump. Sid had the tough job of telling us when we did things wrong, and what to do. One day he told me the company wanted to paint the office walls but didn't have the money. Would I be interested in putting together a group of kids and whitewashing the walls? You bet. Then one guy stood on William Morris Jr.'s desk to reach the ceiling and broke the glass top. Of course we denied it was us.

HIRSHAN: According to tradition, on my first day I was taken in to meet William Morris Jr. He looked up at me from behind his desk and said, "Ah. Another capitalist." I thought, I'm making $38.50 a week. What is he talking about? But he was right. I didn't understand. He was saying that in the agency business if you become successful, you make a

good living. My game plan was if I didn't get out of the mailroom in a year, I would go back to law school. If I got promoted, loved what I was doing, but didn't make agent in two years, I'd also leave. But I was willing to give it a chance because almost immediately show business had seduced me.

DRESS THE PART

ELKINS: One joke around the mailroom was the way I dressed—considering the salary. I did that on purpose. Everybody had to wear suits, but there are suits and there are suits. I went over the edge. I was very chic.

One of my first delivery runs was to the Berle show. Milton, at that time, was Mr. Television. He ran the rehearsals a little bit like Auschwitz, but he got the goddamn shows on. I came in with a package, and he said, "Who are you?"

"Hilly Elkins."

He looked at my clothes. He said, "And what do you do?"

"I'm one of your agents," I said. I don't think he believed me, but he said nothing.

READ EVERYTHING!

AUERBACH: A college education wasn't yet required to get into the mailroom then. All you needed were street smarts and the ability to deal with a situation on your feet. There was no book to read, no school to go to that would tell you how.

The mailroom was my school. I made it my business to read every piece of paper I could get my hands on. Booking sheets. Internal memos. Meeting minutes. I memorized important telephone numbers. I sopped up information. They didn't tell you to do that or not do that, *but only a schmuck wouldn't read stuff before he delivered it*. It was very glamorous to learn about the money the performers received. Some got paid so much, the salaries read like telephone numbers, and it's still that

way, only now the numbers include area codes. I thought these people must have been like God to get that kind of money.

ELKINS: An early assignment was to take Abe Lastfogel's New York bankbooks in for interest to be recorded. I went to ten banks, each with the maximum of $100,000, and I had them stamped. I figured if his New York money alone was a million bucks, it's got to be a good business.

A MATTER OF DEGREE

WEISS: Everybody wants to be in show business. Today a thousand college graduates show up every June to go into our training program, when there's room for just a few. We eventually drew the line at college degrees to thin out the number of applicants. At least we wouldn't be getting the high school dropouts; we'd get people who were educated and ready to face the next step in life.

AUERBACH: They'll kick me in the ass for saying this, but the truth is that the reason a college degree became important was not to have to accept every minority applicant. That's where it started. At some point you could no longer say no to minorities, because you would face legal problems, so they required a degree.

WEISS: The day it was decided that you had to be a college graduate bothers me. Abe Lastfogel didn't go to college. Normie Brokaw didn't go to college. I didn't go to college. Being street smart is not dependent on having a higher education. David Geffen is well known for having gotten into the program by saying he had a college degree when he didn't. He didn't reveal that until much later, but had I known then that he didn't have a degree—after I got to know him to some extent—I wouldn't have let him go for anything. *Anything*.

THE WAGES OF WAR

WEISS: I went into the service in early 1941. It was not a European pleasure trip. I didn't think about a show business career, only surviving.

I was in Italy with an infantry division. Bob Dole was in my outfit. I was discharged in September of 1945. While I was gone, the Morris office put aside 10 percent of my weekly salary each week so I'd have a few dollars when I got out. I made next to nothing, so it was 10 percent of nothing—but it was better than nothing.

I got my job back, but after four and a half years William Morris had changed and so had I. I was married and a different man from the one who had gone to war. War makes you grow up fast. Now I had a great interest in facing rather than avoiding responsibilities. I wanted only to be in the business. I loved the company in a way I can't describe.

LEARNING THE TRADE

ELKINS: The learning opportunity was there for anyone who wanted to take advantage of it. I was unquestionably an ambitious guy. My one-liner is that I was the only guy in the office who *wasn't* there to get laid. Not totally true: A lot of other people weren't there for that reason, and I *did* want to get laid. But it was my love of theater that propelled me and made me want to make it work for myself.

LEON: If you showed some promise, you were assigned to a desk and you worked for an agent. You listened in on all the phone calls and got to learn a little bit about the business.

WEISS: I was asked to handle publicity and do less office-boy stuff. That didn't mean sending items to Walter Winchell. When an actor was booked, I got their picture and a bio and made sure at least a week in advance they were mailed to the venue. It was a lot of work because we booked acts all over the country.

After publicity I became an assistant to Sam Bramson, who booked clubs. Sam already had a secretary. My job was to find a chair to sit in, hang around, and learn. His job started late in the afternoon, with clients like Joe E. Lewis, Harry Richmond, Sophie Tucker, and a lot of lesser stars. They played the Copacabana, the Latin Quarter, and whatever the other clubs were. I can see how Sam might have thought I was a monumental pain in the ass, but he was a saint. He tolerated my bothering him and his secretary with endless questions. I also went with him on the rounds after work, and in those days there were three shows

a night, the last being at 2 A.M. Sam always ended the night at Lindy's, and I'd go with him. All the Runyonesque guys were there. I got to know all the racket guys, the gamblers and the shylocks. The bosses were tough guys, but they loved the business.

I'd get home at four o'clock in the morning. I diapered the baby and went to sleep. What kind of life my wife had, I don't know. For me it was cockeyed, but I loved every second of it.

• • •

I also worked very closely with an agent named George Wood. Having George as a friend could come in handy. I once booked a club in the Village, and the owner confirmed the deal with me. A couple days later he changed his mind. I said, "I've already written it up. You can't do that. The deal's made, and a deal's a deal."

"Are you telling me what to do?" He was a tough guy.

"No, but you can't do that. I confirmed it."

"You calling me a liar?" He was really edgy. "I'm going to come up there and throw you out the window."

I went into Wood's office after he hung up. I said, "George, this guy's mad as hell and he's full of shit. He confirmed an act and he's changing a deal. He wants to come up here and hit me."

Wood told his secretary, "Get this guy on the phone." I sat there, ready to get out of town for a month, but he said, "Listen, you blank-blank-blank son of a bitch, you threaten Lou Weiss over here, I'll break your fucking neck and your fucking legs," and so forth and so on, and then slammed down the phone.

Maybe a half hour later I got a call from the club owner. "What are you so upset about, Lou?" He knew that Wood had relationships with people that the club owner didn't want to cross.

AGENTING THE AGENT

AUERBACH: I used to bump into Lou Weiss, who is eleven years older than me, on the train to the city from Brooklyn. Because of his uncle, Lou had the golden spoon, a charmed life. He came in at strange hours. He was in the nightclub business. We got to know each other a little bit, and I realized that's who I wanted to work for. We weren't best

buddies, but I could communicate with him. He was a comer; he traveled in better circles than me. I thought he might be able to teach me something.

Weiss had a secretary named Shirley and was happy with her. She was a nice person, but I only wanted what I wanted. I told him I could do better, and plotted to get the job. I said I'd put in more hours, that I wanted to learn. Whatever bullshit I said, he bought it and I got her desk. I also got a raise. It was the summer of 1947. I was nineteen.

ELKINS: My sense of what I had to do was simple: Get out of the mailroom as fast as I could. In fact, at the risk of being self-serving, I think I made the fastest transition from office boy to secretary: seven weeks.

One agent, Lester Hamill, was very good at what he did—he handled King Features Syndicate—but he was ungrammatical and monosyllabic, in both his verbal intercourse and his dictation. I knew that if I could get his desk, I could get *off* that desk because I'd stand out by improving his correspondence. He picked me by virtue of my making sure, to the extent that I could, that I was the only mailroom person he saw on a regular basis. I also did a little homework, and I learned about his operation so that when we came across each other, I could talk about his current deals. He noticed I was not only aware of what he did, but I *understood* it.

• • •

I worked for Hamill only four or five weeks. The guy who really interested me was Marty Jurow, head of the Theatrical and Motion Picture Department. I adored Marty. When you worked as a secretary, you pulled Saturday duty once a month. I pulled Jurow. He called me into the office and started to dictate a memo on the D'Oyly Carte Opera Company; it was lousy with percentages, and I knew it would go on for about nine pages. I did my best to write quickly, but I knew I couldn't do it. About halfway through the first page I put down my pen. He said, "What are you doing?"

"Mr. Jurow," I said, "there's a problem."

"What's the problem?"

"Well, I don't know enough dictation to take this memo."

"You're kidding."

"No, sir."

He said, "What am I to do with you?"

I said, "Well, sir, you have two choices. You can fire me or promote

me." He promoted me. That Monday I became his assistant. Three months later I was an agent. When I eventually left to go into the service, Lenny Hirshan, my secretary, got my job.

HIRSHAN: I was always aggressive, ambitious; I'd volunteer to work seven days a week. I loved it.

In 1952 I worked for George Morris, who handled theater. It was a year or so after our merger with the Berg-Allenberg Agency. We had accumulated a lot of agents and clients, but there was a recession that year and a lot of people were let go—including Morris. I went to see Nat Lefkowitz and said, "Where do *I* go now?"

He said, "We have no room for you. You're let go, too."

I said, "But I'm making forty bucks a week."

He shrugged. "If you find a desk, you can stay."

I did, with Hilly Elkins. Working for Hilly wasn't bad. But he was more a Sammy Glick than I was, so I didn't imitate him. My personality is more the lone wolf. I just did my job. I also kept watching my personal clock because I was prepared to go back to law school at any time. After about four months on Hilly's desk he left and I replaced him. I left, too, to start my own business, but that took another fifty years.

WMA: THE NEXT GENERATIONS

WEISS: Being an agent sounds great: you get an act, you book them, you get 10 percent. An easy job. But you don't just become an agent. You have to start at the bottom and learn by osmosis. Minimally, it's knowing the names: of theaters, of clubs, of club owners, of clients. You absorb information. Then you have to form relationships.

It takes years for what you absorb to take hold. There's no way today you're going to jump from the mailroom and become a David Geffen. Even he didn't. He worked for me. Every day he said, "Lou, why don't we go into the music business?"

I said, "David, your job is to do your job for me." In those days I had to make sure our TV shows were covered properly. We used to read every episode of every show we had on the air. He was great at it, but he'd always say, "Lou, why aren't we in the music business?"

He was right, and eventually he was ready.

Over the years I've watched the office boys, and I could always see which ones were the bright ones, how the cream rose to the top. Geffen was easy to notice. Barry Diller—the man was a hit the second you met him. Irwin Winkler. Scott Shukat. Bernie Brillstein. Bob Shapiro, Howard West, and George Shapiro.

How could I tell? Energy. Street smarts. They got it.

A WAY OF LIFE

AUERBACH: The business part of me grew up awful fast; I'm not sure I grew as well as a person in the early days. I shortchanged myself. My life became the business, and the business became my life. Most of my time was spent trying to stay abreast of things. Most of my meals were with show business people. Most of my evenings were spent catching shows. I didn't spend enough time with my kids—and they've let me know that. We lived on Long Island, and by the time I got home, they were sleeping.

WEISS: I'm lucky. I always knew I had a massive support system around me. Young people today don't quite understand what a support system is. And if they do, they don't appreciate it. I've seen more people leave this company through the years and quickly fall on their ass because they tried to function without a support system. An act has to be lousy someplace before it gets good. A person needs a place to learn.

I never thought I'd not spend my whole career at William Morris. I've been offered every job in the business, believe me, but I always knew this was my job for life. August 2002 marked my sixty-fifth year with the Morris office. Originally I was going to retire when I was seventy, and I asked my uncle George, "What do you think?"

He said, "Well, Louie"—he always called me Louie, and he's the only one who did—"what do you want to do?"

I said, "I thought I'd travel and play golf and tennis."

My uncle, besides being a huge talent, was a very, very wise man. He said, "That's only good if you have something else to do."

• • •

LOU WEISS is based in New York and is chairman emeritus of the William Morris Agency. He has been with the company longer than any other living employee.

SOL LEON is an executive vice president in the TV Department at William Morris. He lives in Los Angeles and still comes into the office every day.

LARRY AUERBACH left William Morris when he was an executive vice president and board member. He is currently the associate dean of the School of Cinema-Television at the University of Southern California.

HILLY ELKINS heads Elkins Entertainment, a management/production company based in Beverly Hills. He represents actors (James Coburn), directors, and writers. Elkins has also produced forty-five shows on Broadway, including *Golden Boy,* with Sammy Davis Jr., and *Oh! Calcutta!* as well as films such as *A New Leaf* and *Alice's Restaurant.*

LEONARD HIRSHAN left the William Morris Agency in October 2001 after fifty years. He now heads his own company, Leonard Hirshan Management.

A CHARMED LIFE, OR A THIRTY-SIX SHORT MAKES IT BIG

William Morris Agency, Los Angeles, 1943

NORMAN BROKAW

Norman Brokaw followed in Abe Lastfogel's footsteps, rising from office boy to chairman of William Morris. Today Brokaw gives anyone he hasn't met before a star-studded tour of his career, right down to the row of pictures on his office credenza. It's not braggadocio; he just feels that to know his life is to know him, and to know that his life has been devoted to William Morris is to know him best of all.

If you want to be in this business, there's no greater place to learn than in a mailroom.

I got my job on Saturday, July 7, 1943. My mother and I were at her brother's house—her brother being Johnny Hyde, one of the all-time top William Morris agents. He handled Lana Turner and Betty Hutton and Marilyn Monroe. He was a partner with Abe Lastfogel, who ran the company, and had himself started as William Morris Sr.'s mailboy and assistant.

Three things took place on that day. First, Johnny Hyde had just closed a deal for two moguls, Leo Spitz and Bill Goetz, and formed Universal-International Pictures. Later he told my mother, "There's a young lady named Esther Kovner who's going to be a big, big star, and I just made an important deal for her. She'll be here shortly."

I was inside having a sandwich, and when I came out, I saw this attractive young lady jump into the swimming pool. Her name was Esther Williams. She had just married Dr. Kovner.

Then Johnny asked if I'd like to go to work as a mailboy at William Morris.

I was fifteen years old. Only Mr. Lastfogel started younger. The company didn't call it a training program at the time, but Mr. Lastfogel loved William Morris, and William Morris loved him. Out of that relationship our New York office was built. Lots of young men started that

way and grew up in our company. Lou Weiss, Sol Leon, et cetera. If I had to relive my life again, I would still want to start at the William Morris Agency, in the mailroom, and learn show business from the bottom up.

My grandmother, grandfather, uncle, aunt, and mother were the first Russian dance troupe to arrive in America, in 1898. Coincidentally, that was the same year the William Morris Agency was founded. My mother appeared on the bill with George M. Cohan; she retired early and raised a family of six sons. I was the youngest.

One of my brothers went to New York Military Academy at Cornwall-on-Hudson. In August 1941 he was sent to the Philippines. Four months later the Japanese struck Pearl Harbor, continued to the Philippines, and bombed Albay Gulf. My brother, a reserve officer with General MacArthur, was in the area. Later we found out that he was executed at the age of thirty-two during the infamous Bataan Death March.

My father had died about a week before my brother went overseas; he had a coronary. When my mother got a letter from the War Department telling her my brother was missing in action, it gave her a heart attack. Later one brother joined the army, one the navy, and one the marines to avenge our brother's death, and we moved to California, where my brothers were being trained. My mother came to California right from the hospital so she could be with her children. I later entered the army.

My first day at William Morris, I took the streetcar from Gramercy Place, got off at Cañon Drive three or four blocks away, and walked to the office. I carried my lunch in a brown bag, probably a chicken salad or tuna fish sandwich my mother had made.

My wardrobe was one pair of slacks, a bow tie, a regular tie, and a sport jacket I'd bought at Jerry Rothschild's, a top haberdashery. It cost forty dollars. I took home twenty-one dollars and forty cents a week and paid off my jacket at two dollars a week.

It wasn't my first job—before William Morris I'd worked at the Pennsylvania Drug Company in New York, delivering prescriptions for a nickel a delivery; I was lucky if I made fifteen bucks a week—but I guess I'd always been interested in show business. Back East when I was

nine and ten, I would take milk bottles to the grocery store, collect the money, then take a streetcar to the Riverside Theater on Sunday afternoons to see the talent shows. Sometimes on the weekend I'd go to the Loews State Theater on Broadway and see Ella Fitzgerald and the Chick Webb Orchestra. I'd see Mickey Rooney or Judy Garland at the Strand. I'd go to the Music Hall. When I started at William Morris, my interest showed. I'd even come into the office on Saturday. I was the only mailboy, but I was told that if I worked out well, they'd like me to be the first trainee in the Los Angeles office.

My uncle Johnny's two sons also worked in the office, but I didn't want people to think I'd gotten the job just because I was his nephew. I wanted to get ahead on my own. As it happened, Abe Lastfogel became my mentor, so I didn't have to be wholly identified with my uncle.

An agent named Ben Holzman was also like a father to me. He handled Al Jolson and Eddie Cantor and the Marx Brothers. Every Monday night he'd take me to the Orpheum Theatre.

At the end of my first day they gave me the keys to a 1941 Ford two-seater coupe to take the mail to the post office. We were at 202 North Cañon, and the post office was a few blocks away. I said, "I'd like to go, but I'm only fifteen and I don't have a driver's license." Then I started to worry. Can I still work here? They promised to work out something, and Doris Appel, a girl who worked in the mailroom, got the job of driving me to the post office at night. When I had to deliver something to a studio, I took the streetcar into Hollywood, then walked to Columbia and RKO and Paramount to pick up checks. I got to know everyone in town, as well as what our clients earned. Knowing that information was a stepping-stone to my being promoted: when I served coffee to a group of agents having a picture meeting, one said so-and-so got three thousand a picture, and the other said, "No, it's thirty-five something." I said, "Sir, it's thirty-eight fifty," and I was right.

When I was older, I got to drive Lana Turner to meet L. B. Mayer. Both the guard and the receptionist said, "Oh, hi, Mr. Brokaw. Hi, Miss Turner." Being greeted by name, particularly in front of Lana Turner, was very impressive.

I also used to pick up Marilyn Monroe, on Harper Avenue and Fountain, and take her early in the morning to her acting coach at Twentieth Century Fox. She was going around with Johnny Hyde then.

I took her out often on job interviews. I remember selling her for fifty-five dollars a day for a movie. Paramount used to have an audition room where people would perform; they could see you, but you could not see them. I took Marilyn there and I asked the man in charge, "Would you be interested in her?"

He wasn't. He said, "She's just another blonde."

When she scored big, I ran into him one day. His head was down. "I missed it," he said. "You were right."

About a year and a half after I arrived, I officially became a trainee, which meant being groomed to be an agent. A few years later I got out of the mailroom and worked as the secretary to three men: Moe Sackin; Murray File, who handled Mae West; and Joe Schoenfeld, who was later the editor of *Variety*. Eventually I worked only for Joe. By twenty I was a junior agent. I had dinner with Mr. Lastfogel on Monday and Friday nights, religiously, and sometimes during the week as well. One day he said to me, "We're going to start working with something called television. I'd like you to start our TV Department."

I've made this business and this company my life. It's exciting: running and building careers, making success happen. I like seeing results. I knew that by putting in the time and making sure my clients did well, I would make great progress. I wound up representing people like Loretta Young and Barbara Stanwyck, Susan Hayward, Marilyn Monroe, Kim Novak, Natalie Wood, Bill Cosby, Clint Eastwood, and President Ford. I just tried to do a good job every day. It wasn't to impress anyone; I just worked hard so I could have a job.

There's a picture in my office today of Red Skelton, Joe Louis, Harpo Marx, George Burns, Frank Sinatra, Calvin Jackson, and me. I was very young. You don't just stand with people like that unless they ask, which they did, because I made it a point to develop relationships early on. The picture was taken at a benefit by a paparazzo at the hotel; I still don't know his name. I made copies for Burns and Harpo and Sinatra. They said they were glad to get it.

Some people always look for ways to promote themselves and say, "I'm the greatest." I never say that. Other people have said that I'm in the same category as Lew Wasserman, Myron Selznick, Abe Lastfogel, Jules Stein, and Charles Feldman—but I would never say that about

me. I'm not self-aggrandizing. I'm just a guy who learned the agency business from the bottom up, became William Morris's first vice president, became their cochairman of the board, became president and CEO, became chairman and CEO. When I turned seventy, I gave up being CEO because I thought it was time to give that to someone else.

Along the way I was offered a studio to run; a network contacted me about being president. I always said no. I wanted to stay at William Morris because I respect and love the company. I appreciate what they did for me. We're the oldest company in the business, and the sky was always the limit. Even now, nearly sixty years later, I still put in seventeen hours a day. I'll stop by the office on Saturdays and Sundays, try to catch up on calls, read my mail, make deals.

Once an agent, always an agent.

THE THRILL OF IT ALL

TRAFFIC

Music Corporation of America, Los Angeles, 1942–1958

HELEN GURLEY BROWN, 1942 • JAY KANTER, 1947 • ROBERT SHERMAN, 1952 • FRED SPECKTOR, 1956 • RICK RAY, 1957 • MIKE FENTON, 1958

Let's face it, we were the world's best-educated,
best-dressed, lowest-paid messenger service.
—Rick Ray

HELEN GURLEY BROWN: I started working the instant I got out of high school. I got six dollars a week for answering fan mail at radio station KHJ in Los Angeles, and with that money I attended Woodbury Business College and learned how to take shorthand and type so I could make eighteen dollars a week. All my job moves were about earning a little more money to take care of my injured sister and a mother who didn't work. My next employer was MCA, where I worked as a secretary for Larry Barnett in the Band Department for twenty-five dollars a week.

MCA was quite seductive in terms of decor. Their building at 9300 Burton Way had chandeliers and winding staircases and antique English furniture. It was glorious. Of course, if you were a secretary, you were treated like hired help and used the back entrance. The mailroom then was manned by girls who never became agents, but it wouldn't have entered my furry brain at the time to think about doing something better with myself. We're talking 1942, and the most a woman could hope to be was a secretary to somebody wonderful or maybe work as a clerk in a department store. To expect more would have been like hoping to change your sex or be president of the United States— not a possibility. You didn't even think about it.

JAY KANTER: The main building, across from the Beverly Hills City Hall, was a beautiful colonial mansion commissioned by Jules Stein,

who owned the agency, and designed by Paul Williams. It opened in 1938 when Lew Wasserman came out from Chicago, and it housed the agency until 1962, when Wasserman, under a Justice Department edict, chose to run Universal Studios over agenting.

I enlisted in the navy when I was seventeen, to be a pilot; after the war I was put on inactive duty and studied business at USC. I lived in a little apartment on Palm Drive in Beverly Hills. Coming home at night from dates, I was curious about guys I'd see in the windows of a building on the corner of Wilshire and Palm, on the phones at 11 P.M. I found out the place was MCA, a theatrical agency, and went to the receptionist and asked for a job. She said, "We don't hire anybody here. This is just the Band and Act Department."

At the main building I was introduced to Virginia Briggs, from Personnel, who said that the only thing available was a messenger job in the mailroom, which was called Traffic.

ROBERT SHERMAN: I went to the College of the Pacific, in Stockton, California. They had a great football team, and I teased myself into believing I could play, but was never eligible: too much *cerveza* and chicks. You get away from home and you go nuts, you know. After three years I quit to surf in Hawaii. I was twenty.

Eventually I got a call from my father—an agent with his own company—saying, "Come on home. You've got an interview at MCA." I didn't know what MCA was, even though I lived three blocks from the building. But I did know that surfing was not a career, beer wasn't a career, and getting laid wasn't a career. Maybe being an agent was; I'd get to wear a suit and then maybe get laid.

I interviewed with Taft Schreiber, third man in the company after Jules Stein and Lew Wasserman, and one of the coldest fish I'd ever met. Schreiber knew my father, and he said, "Just remember: Your father is in some respects an ally, but in some respects he's a competitor. What you hear here you're not supposed to take home. Remember: Blood is thicker than the *Hollywood Reporter*." Schreiber referred me to Earl Zook in Traffic. He did all the hiring.

FRED SPECKTOR: I grew up in Beverly Hills, on Bedford Drive. My father owned various stores at different times: dry goods, furniture, liquor. He was a hardworking guy, and we were solidly middle-class. My closest entertainment connection was a friend whose father was head of the Legal Department at Paramount Studios, which was really

no connection at all. After college and the army a girlfriend asked me what I planned to do. I said, "I don't know." She said, "Why don't you go to work for MCA? A couple guys you went to school with work there." I called a fraternity brother, and he set up an appointment for me with Earl Zook.

RICK RAY: I considered graduate school after UCLA, but I didn't think I could be a lawyer because I didn't have a good memory, or a doctor because I'd throw up on my first patient, or an engineer because I can't add. Teaching sounded gratifying, but while I never lusted after being very rich, I wanted even less to be very poor. That left me unable to identify a specific talent that might drive me in a particular direction. My ambition was amorphous. I had no idea what the hell I was going to do.

One day, walking through Beverly Hills, I ran into a very dear friend from UCLA who I hadn't seen for close to a year: Fred Specktor. We went to lunch, and it was the most serendipitous moment of my life. Had I rounded the corner thirty seconds earlier, I would never have wound up in the entertainment business.

In retrospect, going to MCA was the single most important decision I've ever made, and I'm fascinated that I made it. It fits into my personal philosophy: people who succeed are capable of recognizing an opportunity when it occurs and can quickly evaluate whether the opportunity is good, bad, or indifferent. I wouldn't have put it that way then. I only knew it felt right and seemed like an exciting way to earn a living.

I met with Earl Zook. He was a wonderful man. But there was a problem. Even though I passed the test with him, MCA evidently had difficulties with some of his earlier selections. Some people he hired had gone through the usual nine months plus of penal servitude in the mailroom, but when it was time for them to be absorbed as junior agents, nobody wanted them. So I had to be not only accepted by Earl Zook but interviewed and accepted by every single department head at MCA. I met eight different guys—among them Jay Kanter and George Chasen—all of whom were quite brilliant, all of whom were angry that they had to waste time with me. They wanted to see me like they wanted cancer.

The first agent, I forget who, asked, "Why do you want to be an agent?" I'm sure I answered, "It's an exciting, challenging business."

He said, "A salesman can say that. Why do you want to be an agent?"

Time to give a real answer. "Because it seems to me that to be a good agent, you have to be creative like your clients. In doing so, you can help them and help yourself."

He sat back and said, "That's absolutely right." The tone of the meeting changed immediately. Every subsequent guy asked me the same question. I gave them all the same answer.

To check out all my options, I also went to the William Morris Agency. I was interviewed by Morris Stoller, may he rot in hell. He also asked me the same question. I gave him the same answer. And he said, "That's bullshit. We're not here to be creative. We're here to sell clients. Just sell them and get the money."

However, William Morris offered me a job, which I was thrilled to turn down, and I accepted MCA's offer instead.

MIKE FENTON: My father was a multimillionaire before he was twenty-six; he had a seat on the New York Stock Exchange. My older sister grew up with a chauffeur and a nanny and a maid, all in a huge house. Then the crash came and he lost everything. I grew up in a one-bedroom apartment on Elm Drive in Beverly Hills. My father leased a gas station from Standard Oil of California in downtown Los Angeles, and then another at a different location, and began to recover.

I went to USC film school to study cinematography and directing but afterward couldn't get work in the industry. I went to law school for one year but didn't like it. I went into the army for six months and didn't like that either. My sister had worked at MCA, so she said, "Why don't you apply to William Morris and MCA and become an agent?"

I said, "What's an agent?"

She said, "Don't ask such stupid questions. Just go to work in the industry."

THE UNIFORM

SPECKTOR: We had to wear suits. There were two acceptable colors, blue and black. Also a white shirt and a blue or a black knit tie.

KANTER: On Saturdays we could be a lot less formal and wear a sport coat.

BROWN: My standard dress was secretarial clothes. Nothing provocative, ever. I had a nice little figure because I padded my bra, but nobody knew about things like that. Most of the women wore sweaters and skirts; there were not too many suits. One day all the girls decided to wear red. But by the end of the day none of the men had said a word. We might as well not have bothered, we were so invisible.

FENTON: Guys would get axed for what seemed to me the silliest of reasons. A kid in the mailroom named Jack was sent home one day by Arthur Park. It was 110 degrees out, and the kid came to work in a tan-colored suit. He never came back.

THE MONEY

KANTER: The salary was one hundred dollars a month, paid on the first and fifteenth. I delivered mail and went to the studios on Wednesdays and Thursdays to pick up checks for our clients: the writers, directors, producers, actors. The envelopes were unsealed, and I was astounded at what I saw: checks for Fred Astaire, Gene Kelly. And the money was out of sight: a thousand a week, fifteen hundred.

SHERMAN: One client had over $300,000 sitting in a checking account at the Bank of America. After deductions I cleared $26.40 a week.

TRAFFIC

RAY: My first day a guy who looked like a hood walked out the back door, followed by a spindly old man badly dressed in a floppy suit. Several days later I found out that the "hood" was a major executive and that the old man had an office on the second floor that seemed as big as my entire condominium today. In fact, every time I walked down the hall, I tripped over fourteen world-famous people. It was all pretty awesome for a hick from West Los Angeles.

SPECKTOR: In most ways the MCA mailroom seemed benign and slow, just like the rotary phones we used then. It was a small operation.

A couple Teletype machines. Nobody hazed you. There was no game. You just did what you were told or you got fired.

There were six guys in Traffic. You started as number six and worked your way up, and ran the mailroom. The two newest employees were outside guys and made deliveries in their cars. I would go to the market and get the special hundred-proof vodka that Joan Crawford liked, and put the milk in the icebox for the agents who had ulcers. We did everything from drop off scripts to old-time movie stars like John Payne, Montogmery Clift, Clark Gable, and Cary Grant, to deliver spaghetti to Pier Angeli's mother or take soup to June Allyson when she was sick. She lived all the way over in Mandeville Canyon. I also loved driving the owner's, Jules Stein's, incredible Mercedes 300 Gullwing to be fixed.

SHERMAN: We were always asked to do strange extracurricular things.

One afternoon Mario Lanza's agent asked if we wanted to make fifty bucks on the weekend. Lanza's furniture was about to be attached by the Internal Revenue Service. He couldn't hire professionals, so somebody had to do it. We hid the stuff at an actor's house in the San Fernando Valley. Another time an agent's secretary told me, "We're going for a ride." Fine. Also, "You're sworn to secrecy." Fine. This was during the heyday of the House Un-American Activities Committee, when the trick was to avoid being called to testify, because if you were called, they pressured you to name names or go to jail.

We drove to the house of one of the world's most beloved screen entertainers—and I mean beloved. The secretary had a key and we went inside. Turned out this beloved star had a stash of books on Communists three feet long in his basement. I crawled around in my dark suit like a marine slithering under barbed wire, fished out his books, and gave them to the secretary.

I don't know what ever happened to the stash, but at least the guy never got called to testify.

THE MAN IN CHARGE

RAY: It was clear from the get-go that at MCA there was plenty of room for all of us to be successful; I didn't have to kill the guy next door to get ahead. At the William Morris Agency, if you weren't one of Abe and

Frances's "kids," then you weren't going anywhere. It was not the same kind of social bullshit. Wasserman was one of the genuinely smartest men I've ever known.

I'd been working for MCA for approximately two weeks when someone pointed him out to me in the hallway. A couple of days later he and I passed each other in the hall, and he said, "Good morning, Rick, how's everything in the mailroom?"

I said, "Thank you, sir, it's just wonderful," or whatever baloney I could muster before I turned the corner and almost had a coronary. No wonder he's the president, I thought. It was really impressive that he should know the lowest cog in his building, with the possible exception of the janitor. I was the number-six man in Traffic, for God's sake.

KANTER: For the first few months I was very busy because I was the only one in the mailroom. Then one of Lew Wasserman's many secretaries left, and I was offered the job.

I had to meet Mr. Wasserman first, and that made me nervous. But it wasn't much of a job interview after all. One reason I'd been offered the job was because Mr. Wasserman liked to come in early and leave late, and he felt it was an imposition to ask a woman to work until eight-thirty at night.

SPECKTOR: I worked in Traffic about eight months, then went to work for George Chasen. George was always nice to me, but I don't think he took any personal interest. This is just what he did for a living, and if I wanted to get into the select club of MCA agents, good luck.

Then I was Lew Wasserman's second assistant. He was intense. It was all about work. No sense of humor, seldom a smile on his face—at least at the office. The agents were scared to death of him. He never said much, but he was the most powerful man you could imagine.

Lew's office probably wasn't as big as I still think it was. His desk was at the far end, and he'd come in every morning carrying his coffee cup. In the afternoon I'd sometimes drive him to lunch at the Polo Lounge. He had a great 1951 Bentley, dark green.

Wasserman liked to listen to baseball games. We were driving to some studio and heard Ted Williams hit a home run. It was his last year of baseball. I said, "Oh, isn't that fantastic for an old man!"

Wasserman said, "Watch what you say, kid. You know how old I am?"

"Yes, sir," I said. "You're forty-four. What I meant was an old man in baseball."

"Well, you know, you're right," he said. "He is an old man in his business. And I'm an old man in my business. This business is all about guys like you."

I thought, I'm twenty-two years old, making a dollar an hour driving this car. What kind of business could it be that's about me?

RAY: I had been in Traffic about two months and was still number six when I got summoned to Mike Levee Jr.'s office. He was head of the Television Division and had a gorgeous room on the second floor. Levee was as sophisticated, handsome, suave, debonair, and well dressed as Cary Grant. Every time he walked down the hall, women fainted. He was also smart, and he became my mentor.

Levee said, "How would you like me to pull you out of Traffic, jump you over the other five guys, and make you a literary agent?" What he saw in me I do not know. I had only my two months' experience and a giant crush on Grace Kelly, who used to come in at night and go down to the theater and watch movies. Her only problem getting down the hall was slipping on my tongue.

I had decided I wanted to be an actor's agent—so I could represent Grace Kelly, of course—and told Mike. Back to Traffic I went. Three months later I was the number-one man. I ran Traffic superbly. I don't want to pat myself on the back, but I was really good at it. One day Lew Wasserman's office informed me that I was being made his personal assistant.

For three months I drove Mr. Wasserman around in his Bentley and sat by his desk. I learned almost instantaneously that if I had anything to say to him, I'd better know exactly what I was talking about and make it brief; otherwise he'd tear my throat out. Casual conversation was not Mr. Wasserman's style.

Eventually I got called to Mike Levee Jr.'s office again. "How would you like me to take you out of Mr. Wasserman's office and make you a literary agent?"

"Are you kidding?" I said. "I'd kill for the opportunity."

"You've learned something in the last nine months, haven't you," he said.

"You bet I have," I replied.

THE DIFFERENCE THEN BETWEEN BOYS AND GIRLS

BROWN: I was at MCA twice. The second time I stayed two years. I worked for Mickey Rockford, who was head of the Radio Department. I was earnest and I showed up on time, but I wasn't desperately efficient. Still, they moved me up from the secretarial pool to outside Rockford's door, in the hallway. Lew Wasserman's secretary, Janice Halpern, also worked near him, but that was about it. It was a big deal for Jules Stein, the owner, to allow women upstairs. Secretaries and bosses did not fraternize. There was never a lunch date with your boss. The girls hardly talked to the agents.

If an agent wasn't supposed to have lunch with or talk to one of the girls, he certainly wasn't supposed to take her to bed, but nonetheless I began having an affair with an agent named Herman Citron. I didn't feel too bad about it. Citron was very eligible: thirty-seven years old, very attractive, very sexy, and not married. I was nuts about him and I expected to marry him. I used to meet him after work. He'd park his car on Burton Way. When it was dark, I'd slip into the car and get down on the floor so nobody could see me waiting. Eventually I left Herman. He wouldn't marry me because he was Orthodox Jewish.

Sometimes I also went out with Mr. Rockford, my boss. No sex, but it was a date with a lot of smooching. Eventually I got fired because I think he was a little irritated that I was having an affair with Herman but wouldn't go all the way with him.

THE REAL TEDDY Z AND OTHER BALLSY MOVES

SPECKTOR: Jay Kanter was a hotshot agent who represented Marlon Brando. But Jay was so young that it became an industry legend. Years later there was a sitcom called *The Famous Teddy Z,* about a mailroom guy to whom a big star took a liking and insisted he represent him, so they had to make the kid an agent. People think the story was based on Jay.

KANTER: Here's what really happened: I had *just* become an agent, the youngest, lowest man on the totem pole. As such, I got all the worst jobs, like covering a little studio on Cahuenga called the Motion Picture Center. It was home to a lot of independent producers, like Stanley Kramer, and I serviced his company on behalf of MCA. At the same time I'd developed a very good relationship with some of our theater agents in New York: Maynard Morris and Edith van Cleve. Edith represented Marlon, and I used to correspond with her quite often. One day she told me that Marlon had finished doing *Streetcar* and was living in Paris. However, his father wanted him to go back to work. It would have been easy; all the studios wanted him, but they wanted him to sign a seven-year contract and he wouldn't.

Stanley Kramer was producing a movie written by Carl Foreman and directed by Fred Zinnemann called *The Men*. Stanley wanted Brando. I said, "Well, he won't sign a long-term contract."

Stanley said, "I don't want a contract; I just want him for this movie." He gave me a twenty-page treatment of Carl's story, and I sent it to Edith, who sent it to Brando. Based on that, Marlon agreed to do the movie and came to Hollywood. His plan was to stay with his aunt in San Marino. I picked him up at the train station. We got on very well.

Later I took him to meet Stanley and Carl and Fred, and our friendship grew. A couple of times I said, "Marlon, why don't you come in and meet some of the other people in the office?" He'd say, "What for?"

"Everybody wants to meet you." He was about as hot a young actor as you can get.

Finally he let me bring him to the MCA building. Afterward he told me, "Look, I don't want to be talking to a lot of different people. I'll just do all my business through you, okay?"

I said, "Great!"

As it happens in this business, if you're handling the talent, suddenly all the business starts to come to you. Calls would come in about Marlon, and Lew Wasserman would say, "I can't get him on the phone. You have to talk to Jay Kanter."

They'd say, "Who is Jay Kanter?"

I handled Marlon until MCA went out of the business—and we're still good friends.

FENTON: I'd been number one in Traffic for three months. One day

Earl Zook said, "The time has come. You're going into the Motion Picture Department to work with Herman Citron."

I was fortunate to end up with him. A friend in the mailroom, Fred Roos—we were classmates at UCLA, and I had brought Fred to MCA; he later became a big producer—worked for Herb Brenner and lasted about nine weeks before getting fired.

I introduced myself to Citron, and we chatted. He handled Alfred Hitchcock, Shirley MacLaine, Jerry Lewis, Lilli Palmer, Cliff Robertson. He said to show up at nine o'clock on Monday morning, prepared to become an agent.

For the next three years I was with him almost every waking moment.

The first day Herman said, "See if you have any phone calls to return, then meet me in the parking lot in ten minutes. We're going to Paramount for lunch." At twelve noon we got in his black Cadillac and drove off.

Herman had his own parking place at Paramount. We walked to Jack Karp's office in the executive building. Karp, a lawyer, ran the studio. He wasn't an artistic producer type, but he was very smart. Karp's secretary buzzed us in.

That office was gigantic. Citron took me up to the desk and said, "Jack, I want you to meet my colleague Mike Fenton." I never forgot that. I wasn't his assistant. I wasn't his trainee. I wasn't his slave. I was his colleague. He spoke of me that way to everyone. I loved Herman like a second father.

SHERMAN: I was out of Traffic and a junior agent before I was twenty-one. But I had to be accompanied by a senior agent all the time because they couldn't get me a subagent franchise until I was of legal age. I guess they thought I was good.

I worked in the Story Department under Ned Brown, a great agent but a prick of pricks. Three months later Mickey Rockford called me and said, "This guy Ned Brown is going to find a way to kill you. How would you like to be in the Television Department?" By then, I would have gone into any department.

But what I mostly thought about was waves and surfing and having fun. Probably because he could tell I wasn't happy, my dad said, "Come work for me." I quit and joined his company for a while. I didn't enjoy it. When two of my buddies went to Europe, I sold my car and went along.

I came back when I turned twenty-five. I'd grown a bit smarter and realized I'd screwed up at MCA. I tried to get back in, but they wouldn't take me. Their policy was if you leave, you leave.

RAY: I wound up as second in command to Laurie Helton, the head of the Television Literary Division. I'd been there about a year when Laurie went on a vacation and simply didn't come back. She was a lovely woman, but I think that psychologically she had a lot of trouble with being an agent. Agents have to be able to go to a lot of places where they know they're not wanted. You have to have enough assertive elements in your personality to be able to walk through those doors. Laurie had difficulty dealing with the job. Mike Levee Jr. gave her a month to get her act together and get back, but she didn't do it. I patiently waited for my new boss to arrive. One day Mike informed me that my new boss was me. Suddenly I was head of the Television Literary Department. I brought in somebody else to be my associate, and I stayed with MCA until it went out of business in 1962.

<p style="text-align:center">• • •</p>

HELEN GURLEY BROWN became editor in chief of *Cosmopolitan* magazine, as well as the widely published author of *Sex and the Single Girl* and other bestselling books.

JAY KANTER is currently a film producer based in Beverly Hills.

ROBERT SHERMAN is retired and living in Colorado, where he skis, rides his horse, "listens to his contemporaries bitch," and has started writing screenplays. To get there, he worked in public relations, was an agent, produced movies, and held high-level studio production jobs at Twentieth Century Fox, MGM, and Orion.

FRED SPECKTOR has been an agent at CAA for twenty-five years.

RICK RAY was a founding and senior partner of the Adams, Ray and Rosenberg Agency and its president on a rotating basis. He gave it all up to become a gentleman of leisure. Today he flies his plane, rides his horse, plays tennis, and pursues a "lifestyle worth living."

MIKE FENTON has been a major casting director for movies and television since 1963. Today his company, Fenton-Cowitt Casting, is among the foremost in the business.

THE THRILL OF IT ALL

William Morris Agency, New York, 1955–1958

BERNIE BRILLSTEIN, 1955 • IRWIN WINKLER, 1956 • GEORGE SHAPIRO, 1956 • HOWARD WEST, 1956 • MARTY LITKE, 1956 • MIKE ROSENFELD SR., 1957 • HARRY UFLAND, 1958

The dream then was to become an agent and to find talent. Now it's the bottom line and owning stock.
— Marty Litke

The mailroom is like a blind date. You don't know what you're getting yourself into, but if you like it, you want to do it more.
— Bernie Brillstein

IRWIN WINKLER: I guess I could have gotten another job. Actually, I *had* another job, which I didn't like, working as a trainee in a big textile company. I was going to be a salesman in Cleveland. Then I read *The Carpetbaggers,* by Harold Robbins. The glamour of the show business lifestyle he described seemed somehow . . . more interesting.

I went to MCA and talked to someone in the Publicity Department. He asked me a whole bunch of questions that I couldn't answer because I knew nothing about agents. The meeting took ten minutes, and most of the time the guy was on the phone with Burt Lancaster. But through talking to him I found out about this other agency, William Morris, so I went there for an interview a couple days later, with Sid Feinberg, who was in charge of Personnel. He asked almost the same questions, but this time I was smart enough to give better answers.

Feinberg gave me a job in the mailroom, but just for the summer. I took it even though it was a big risk for me. Maybe it doesn't seem that way because I hated the textile job, but it meant giving up a formal training program that paid almost seventy dollars a week, for something temporary at forty dollars a week. I just didn't want to move to Cleveland enough that I was willing to gamble.

GEORGE SHAPIRO: In the early 1950s my brother, Don, worked as a lifeguard at Tamiment, a resort in the Pocono Mountains. When I was eighteen, Don suggested I work there, too. I brought my best friend,

Howard West, with me. We'd known each other since we were both eight years old and Howard was the new kid in third grade at PS 80 in the Bronx. The school has a rich background: Garry Marshall and Penny Marshall went there, the comedian Robert Klein, Ralph Lauren—who then was Ralphie Lifschitz—and his brother, Lennie, and even Calvin Klein.

At Tamiment, Howard and I got our first big exposure to show business. The resort put on shows, and part of a lifeguard's job was to work as a stagehand. It was my first hyphenated job: lifeguard-stagehand. The management brought up writers, singers, choreographers, dancers, and composers. Neil Simon and Danny Simon, Herb Ross, Dick Shawn, Carol Burnett, Woody Allen. Max Liebman, who produced Sid Caesar's *Your Show of Shows,* was the artistic director; certainly Caesar's *Your Show of Shows* had its genesis there.

HOWARD WEST: As part of the "social staff," George and I slept adjacent to the talent quarters. That alone helped seduce me into the business. I don't know why I was impressed by celebrity. I guess it's where you grow up and what you're exposed to. I was lower middle class from the streets of New York, always looking for an edge.

SHAPIRO: After the army, my brother, who had become a salesman in El Paso, said I could work with him. He offered me two hundred dollars' draw a week against commission. I tried to imagine working with him, but I had seen *Death of a Salesman* and I didn't want to be Willy Loman in El Paso. I also applied to the management training program at Household Finance. That job paid eighty-five to start. A third possibility was the William Morris Agency. Carl Reiner, who was married to my aunt Estelle, suggested it. I liked that idea, and Carl made the call.

WEST: In the 1950s the college grad of my generation got a starting salary, depending on the company, of between $100 and $125 a week. But there were two industries that said, "We're glamour industries. You want in? You work for less." One was advertising, the other was entertainment. You got from $38 to $45 a week and needed a lot of intestinal fortitude to swallow hard and believe you'd potentially love it enough to live on that money, because when you're in your twenties, how the hell do you know what you're going to love or not love?

BERNIE BRILLSTEIN: In every job you've got to start someplace, even show business. You're young. You think, I think I know talent, but I've

never done it. No one is going to hire me. I'm not good enough. But I want in. You could become a network page, go to a record company, work at a studio. But the place where all those roads intersect is the agency.

Most of the mailroom guys I worked with came from Brooklyn or the Bronx. My roots were Manhattan. I grew up going to the Stage Deli and the Stork Club. My father, who sold millinery in the garment district and was president of his temple, took me to Madison Square Garden, Murray's Sturgeon Palace, Barney Greengrass, the Polo Grounds. I went with him to Fifty-second Street, where his friends from Harlem, the connected guys, owned the jazz clubs in which you could hear music like nowhere else in the city.

My uncle Jack Pearl was a successful comedian who'd been with the Ziegfeld Follies and went by the name of the Baron Munchausen. He showed me Fifth Avenue, Bergdorf Goodman, the Stork Club (where you could see Ethel Merman and Walter Winchell), the Harwyn—and Toots Shor's. There I saw presidents, movie stars, ballplayers. Jackie Gleason. Joe DiMaggio. Mickey Mantle. Rodgers and Hammerstein. Jack Benny. George Burns. My favorite spot was the Copacabana. I was comfortable around celebrities.

My friend Billy Rubin told me he thought I'd make a great agent and set me up with Lou Weiss, a cigar-smoking TV packager who handled NBC for William Morris. Weiss sent me to Sid Feinberg, a civil-servant type. His first question was "Can you type?"

I told him I'd learned in the army.

"Do you know anyone in show business?"

"Yes, my uncle." He probably thought my uncle had set up the interview. He hadn't.

Feinberg said, "You're terrific. There's only one problem. You're too old."

"For what? I'm only twenty-four."

"That's too old to put up with the crap in the mailroom."

Maybe he was testing me. I didn't want to take no for an answer. I told him how much I loved and understood show business. "I can put up with anything," I insisted. What I *didn't* say was that I didn't plan on staying in the mailroom long enough for my age or the crap to matter.

He said he'd call me.

I went home that night not knowing what to do next. To my surprise I had a message from Sid Feinberg. "You got the job." I'd start on Monday, June 6, 1955. I still have my first paycheck. I made $38 a week—or $32.81 after taxes.

Good thing I wasn't in it for the money. I got into show business for the thrill of it all, not the thrill of having it all.

MIKE ROSENFELD SR.: I was born in 1934 in Philadelphia and grew up in a pretty much all-Jewish neighborhood called Strawberry Mansion. My dad was a state senator for eight years. When my parents could finally afford it, we moved out to the Main Line. I went to Penn State as a music major and put on two shows a year.

Eventually I graduated, got married, and moved to a dump on Eighty-seventh and Amsterdam in Manhattan. I knew I had talent, but I began to wonder if I had *enough* talent. By then my dad had passed away and I didn't have him to talk to about it. I figured I should probably get a job. Two close friends had a friend, Sid Kalcheim, whose father and uncle, Harry and Nat Kalcheim, were at William Morris.

Nat Lefkowitz interviewed me. He said, "You're married, your wife's pregnant, you're a college graduate. Are you sure you want to do this?" Good question. I didn't really want to be an agent. I thought it was pretty much a piece-of-shit job: forty dollars a week to deliver mail and schlepp stuff around town in the snow. But I have no regrets. I do things for a reason and I don't look back. That's how—twenty years later—Ovitz, Meyer, Perkins, Haber, and I started CAA.

MARTY LITKE: I graduated from Brooklyn College with a B.A. in speech and theater and English, but I wasn't clear about what to do next. So I pushed my draft up to get it over with but forgot that I'd had rheumatic fever. The doctors told me to go home. My uncle was a critic for the *New York Times*. He said, "You've always been interested in the business"—I used to discuss his reviews with him—"so why don't you go work in an agency?" He said I should apply to the biggest one, William Morris.

HARRY UFLAND: I played baseball in the army and at one time thought I'd go pro for the Yankees. But when I left the service in 1958, I applied to CBS and to William Morris because I had this big fantasy about being a producer. I had already worked in the Paramount mailroom for a couple of summers, because my aunt, who worked for the Shuberts, had

arranged an introduction. CBS and William Morris both asked me to start in their training programs. I chose the Morris office because after being in the army, I liked that you didn't have to get in until ten o'clock.

BIG CITY, BIGGER DREAMS

BRILLSTEIN: A few years earlier the Morris office had moved to 1740 Broadway, in the Mutual of New York Building. It took up one square block between Fifty-fifth and Fifty-sixth. The Park Sheraton Hotel was behind it; Jackie Gleason had a triplex apartment there. Sometimes the William Morris guys met after work in the hotel bar, which was right next to the barbershop where, in 1957, Albert Anastasia of Murder, Inc. was killed in a mob hit.

Everything that mattered was in the neighborhood. ABC was on Sixty-sixth Street. NBC was at Fiftieth and Sixth Avenue. CBS was at 485 Madison. Radio City Music Hall was at Fifty-first and Sixth. Both the *Ed Sullivan Show* and the *Jackie Gleason Show* were broadcast from the Ed Sullivan Theater (then called CBS Fifty-third Street, now home to David Letterman's show) on Fifty-third and Seventh. Steve Allen's Sunday program came from the Colonial Theater, at Sixty-sixth and Broadway, which is now Lincoln Center.

The Stork Club was at Fifty-second, off Fifth. Toots Shor's was at Fifty-first, between Sixth and Fifth. Food: The Stage Deli was on Seventh Avenue, between Fifty-fourth and Fifty-third; the Carnegie Deli was between Fifty-fifth and Fifty-fourth, but the Stage was more popular. Danny's Hideaway was on Forty-sixth, between Lexington and Park Avenues. Los Angeles Scala was at Fifty-fourth and Seventh. We'd eat there Fridays because we got paid—that is, if we had any money left over after the lazy Friday-afternoon floating craps games at work.

In other words, the show business life was all encompassing. There was something for everybody.

SHAPIRO: I walked into 1740 Broadway on my first day, wearing a suit and tie, and looked around the lobby. There were two sets of elevators, and nearby on the wall was the building directory. I stared up at the names of all the agents and visualized my own there. They were

listed alphabetically. One agent was named Sol Shapiro. I thought, Soon my name is gonna be just above Sol Shapiro's. That was a big thing for a kid from the Bronx. Every day I'd walk in, look up at the names, and imagine.

QWERTYUIOP

BRILLSTEIN: My first day I wore a suit—my only suit—a tie, and a white shirt. Sid Feinberg told me, "Your object is to get out of the mailroom and become an agent's secretary. Not all of you will succeed. It's up to you." At first I was a bit nervous, but after a couple of days it was just like being in basic training: I knew everyone, we were all pals, and I couldn't remember being any other place.

LITKE: Feinberg explained that if we wanted to work for an agent, we'd have to take typing and shorthand lessons.

BRILLSTEIN: Every morning from 6 to 8 A.M. I went to Sadie Brown's Collegiate Secretarial Institute. But all Sadie wanted to do was fix me up with the rich Jewish girls and yentas who went there. Even worse, William Morris wouldn't pay for it, so I had to foot the bill.

SHAPIRO: Lucky for me, when I was in high school, my mother had said, "Typing always comes in handy." So I had a little step up. But I didn't have shorthand. Bernie Brillstein recommended I go to Sadie Brown's. Fortunately the GI Bill of Rights gave me an allotment of one hundred dollars a month while going to school, and Sadie Brown's was fifty dollars a month, so I had fifty dollars left over in addition to my thirty-eight-dollar-a-week salary, which enabled me to eat.

BRILLSTEIN: There were other ways to get by. Sometimes managers would send their clients' record albums to the Morris office. We'd clip them and take them to the record store, where the exchange rate was eight promotional copies for one new record. But we did that for records, not money. That would have been stealing [*laughs*].

HUMILITY TRAINING

BRILLSTEIN: A young black guy, Lloyd Alene, ran the mailroom and had a little office inside, surrounded by smoked glass. Along the wall were mailboxes and shelves. Our mail carts were like little metal shopping carts with file folders labeled for every agent and executive. Each floor had its own cart. Our routine was simple. Each employee had a mailbox; when the mail came, we put it in the right slot. Three times a day we'd deliver whatever was in the slots and collect outgoing mail, pushing our carts down the hallways. At first I tagged along with a couple of more-experienced guys. Because I had a college degree, I remember thinking, Oh, how thrilling.

SHAPIRO: Some found it humiliating. I didn't. It seemed like honest work. However, I did learn humility by filling the paper towels in the men's room. Or mixing chemicals for the Photostat machine and worrying that my hands would get damaged. I also had to fill Nat Lefkowitz's fountain pen. Lefkowitz, an accountant, ran the New York office. Every morning I'd go in with a bottle, put down a towel, and very carefully fill his pen to the brim.

LITKE: My first day I learned to water the plants and change the toilet paper.

WEST: I thought it would be glamorous, but it was the furthest thing from it. I was a schlepper. It was a lot of garbage work.

SORRY, WRONG NUMBER

SHAPIRO: One day a trainee named Tony Fantozzi and I were sorting mail, when Lloyd Alene said, "Tony. There's a phone call for you. It's Mr. Lastfogel's secretary." Neither of us could believe it: Abe Lastfogel, the chairman and owner of the William Morris Agency, calling Tony Fantozzi—a kid who'd just started in the mailroom?

Fantozzi listened for a moment and then said, "Of course I'm free to have lunch with Mr. Lastfogel on Thursday."

After he hung up, he turned to me and said, "Abe Lastfogel wants to have lunch. What a great place to work! The head of the company calling a guy in the mailroom? I mean, this is *great*."

Twenty minutes later he got another call. It was Lastfogel's secretary saying, "I'm sorry. We thought we were calling Tony *Franciosa*."

DELIVERY, PLEASE!

SHAPIRO: Almost immediately I went on a delivery run. Pearl Bailey was my last drop-off. At her office I handed her an envelope, and she said, "Thank you, honey. I'm just about to see a cut of my movie. Come on and watch it with me, let me know what you think." I couldn't say no and didn't want to. Later I left thinking, This is my first day, and already, what a thrill. This job is gonna be really good! Then I realized that I'd be back so late, I'd probably get fired. Fortunately, when I explained to Lloyd Alene, there was nothing he could say.

WINKLER: When I delivered an envelope to Zsa Zsa Gabor at the Waldorf-Astoria, she came to the door in a negligee. Immediately I had all these fantasies of her inviting me into her bedroom, where I would have this wild sexual encounter with the beautiful Miss Gabor. Instead she said, "Zank you," and closed the door in my face.

BRILLSTEIN: On my first trip outside the office I delivered a $25,000 check to Red Buttons at 50 Sutton Place South. I knew what was in the envelope because, like any ambitious guy with a head on his shoulders, I opened all the interesting-looking letters and packages before handing them over. Everyone did it, because information is king. In the office I'd go into the men's room, run the water as hot as possible, and wait for the steam to do the rest. I'd read and then carefully reseal. I'd find client lists, contracts, personal correspondence, checks. I never worried about being caught, because usually another guy from the mailroom was at the next sink doing the same thing.

Buttons's check was part of the hundred thousand a year he got from CBS to be exclusive. Go back to 1955: $25,000 was like, what—three or four hundred grand now? If I could have made $25,000 a year somewhere, I would have signed on for life.

When Buttons answered the door, he took the envelope and looked inside. He didn't notice, or didn't care, that it had been tampered with. Then he handed me a quarter tip. That works out to 1/100,000 of the check I'd delivered. I didn't take the money. I said, "I'm not allowed to."

But I did take away a valuable lesson about the parsimony of comedians. And to be honest, had it been a dollar, I probably would have grabbed it.

UFLAND: I took something to Mrs. Lastfogel at her apartment in the Essex House hotel. She was a pistol and had a mouth like a truck driver. When she tried to tip me a dollar, I said, "I'm sorry, I can't take that."

"I know how much money you make," she said. "Take the fucking tip."

ROSENFELD: For most deliveries we walked. Sometimes we took the bus or the subways. But cabs? You could take a cab only if the load you had weighed more than you did.

WEST: Sometimes it seemed like it did. We often lugged large metal film cans containing kinescopes. They weighed maybe ten, fifteen pounds each, and we had to deliver them, no matter what the weather, to networks, clients, and producers. If it was more than forty blocks, they'd give us two dollars for cab fare. In those days I think a tuna sandwich was sixty-five cents and coffee was a dime. If I could take three buses with two-cent transfers, I could pick up two days' worth of lunch and pocket the spread. No one ever asked for a receipt. I ate that way for two years.

BRILLSTEIN: I used to clip money from my father for cab fare so I could come back quicker to the office. Schlepping around New York in the summer was no holiday for a heavyset guy, and I knew that making deliveries would get me absolutely nowhere at William Morris. In order to learn the business, I had to be *in the building*. A trip usually involved a bus and lots of waiting. I'd be out of the loop for two hours. I might as well have worked in the garment center pushing dress racks along the sidewalk. To make friends, overhear something, be invited anywhere, or be in the right place at the right time to kiss a little ass, you had to be in the center of the action.

HEROES AND VILLAINS

SHAPIRO: I had to pick up some guests for a TV variety hour called *The Martha Raye Show*. That night she had on some of the New York Giants and Brooklyn Dodgers. I took a limo to Ebbets Field to pick up Peewee

Reese and Duke Snider. My heart was pounding. Reese was my lifetime hero, and I worshiped him because we were both little, both infielders. I admired what he'd done to support Jackie Robinson. I even had that famous picture of him with his arm around Robinson.

I purposely got to Ebbets Field early, in the third inning. I met pitcher Don Drysdale. It was his first season; he was just seventeen years old. I met Jackie Robinson and Roy Campanella. It was like a dream. I don't know if they realized I was from the mailroom; maybe they thought I was an agent. I didn't bring it up.

After the game, in the limo—a big Cadillac town car—I sat in between Peewee Reese and Duke Snider. At one point they told the driver, "Pull over for some beer."

I said, "But you're my heroes! I didn't think you ever drank beer. I thought you did everything perfect."

"Ahhh, kid," they said as we stopped at the curb, "we shit around . . ."

WINKLER: Sid Feinberg had an emergency. He gave me an envelope and asked me to take it to the singer Billy Eckstine in Harlem. There were papers inside that needed to be signed *right away*. Feinberg said it was such a rush that I should take a taxi. He gave me a few bucks for cab fare.

When you make forty dollars a week, you don't jump into taxis so quick. I walked to the subway on 59th Street. The uptown express was just pulling in when I got to the platform. Next stop, 125th Street. I got off and walked a couple blocks to Billy Eckstine's apartment. He signed the contract. I got back to the subway just as the downtown train pulled in. Next stop, 59th Street. I walked into Mr. Feinberg's office, gave him the contract, and said, "Here." Instead of saying thanks, he just stared at me and then told me he couldn't believe I'd made it so quickly, even in a taxi.

"Not only do I think you kept the taxi fare"—which I had—"but I think you forged Eckstine's signature," he said. I tried to defend myself, but he cut me off. "I've seen some scams before, but this one . . ." He could hardly speak. Feinberg was about to fire me, but some instinct— perhaps just to show me that he was no fool—made him call Billy Eckstine first. Of course Eckstine confirmed that I had been at his apartment and that he had indeed signed the contract.

Feinberg felt so guilty, he gave me a full-time mailroom job.

SERVICE WITH A SMILE, BABY

BRILLSTEIN: William Morris had a great reputation for servicing. That means when a client appears at a nightclub or on a television show, someone from the agency goes to let the client know he's there to help. Generally the talent couldn't care less if anyone is around, but at William Morris covering the client was the same as covering our own ass. No one could complain that we *weren't* there. The unenviable task was doled out to poor schmucks who wanted to score points and get out of the mailroom. Thus, more chances to perfect the greeting: "Hi! I'm Bernie Brillstein from William Morris."

I thought servicing was bullshit, an old premise that served no function except to remind you of the good time you thought you'd have that didn't turn out that way. Like a hangover. But I was ambitious, so I did it. I figured out quickly that the talent always has stuff to do. Maybe he needs a little rest time. Maybe he wants to get laid. Maybe he wants to study the script. Or maybe he's just not in the mood for you to show up. It's a hassle for him to entertain some fresh-faced mailboy he hardly knows. "Oh, Bernie Brillstein's here. Shit, I've got to spend an hour and a half with him."

But sometimes it works out. One day in January 1956 Harry Kalcheim said, "Saturday night Elvis Presley is doing *Stage Show*. Would you go and take care of him?"

Stage Show, featuring Tommy and Jimmy Dorsey, was a short-lived TV variety show produced by Jackie Gleason as a lead-in for *The Honeymooners*. I'd met Elvis earlier when he came in for his signing picture, but I still didn't know much about him. This was before the Ed Sullivan appearance, so he was still well below the pop-culture radar. In fact, *Stage Show* was his first TV appearance: Saturday, January 28, 1956.

I got to the rehearsal at the CBS Fifty-third Street Theater and found Elvis talking to a reporter from *Pageant* magazine. After a while I introduced myself.

"Hello, Elvis. Bernie Brillstein from William Morris."

"Hello, sir," he said. Sir? I was only a few years older, but the legend is true—Elvis was very polite, and he seemed to genuinely welcome my presence.

It was cold backstage, and as we talked I could see Elvis shivering.

After a few minutes I excused myself and ran across the street to a haberdashery and bought him a sweater. I gave it to Elvis and he loved it. A photographer from *Pageant* magazine took a few pictures of him holding my gift. I still have that photo on my office wall.

FLOATING

SHAPIRO: When we were asked to cover temporarily for an agent's secretary, we called it "floating." You could end up in any department, and it gave you the opportunity to find out where you thought you'd best fit in later on.

BRILLSTEIN: You also got a shot at displaying a second of smarts or personality so someone might notice you.

SHAPIRO: Once, I temped for Marty Jurow, who handled Edward G. Robinson. His secretary, Florence Gaines, was on a call when Robinson phoned. She put him on hold, turned to me, and said, "Edward G. Robinson is on three. Pick him up; he wants to leave a message."

There was no mistaking the voice. "This is Edward G. Robinson. I have to dictate some things to you regarding my settlement with my wife. We're getting divorced. I want you to take all this down. Give it to Mr. Jurow."

Robinson started talking about money, about paintings, about the artists, then stocks and bonds. I wrote frantically, but my shorthand was no good. Florence left for lunch, and when she came back, I was still on the phone. When we finally hung up, I had twenty pages of dictation and the absolute certainty that I should have taken speed writing instead. I typed up my notes and gave them all to Florence. It wasn't perfect, but I only cared that it was done, and never thought about it again until eight months later when I was in the Television Department at a meeting. Someone mentioned that Edward G. Robinson's divorce settlement had gotten all fucked up. There were all kinds of inaccuracies. I slowly put my hand in front of my face and began to sweat. I knew it was my fault, and I was sure someone would remember. But no one seemed to notice, and I got away with it.

ASS KISSING 101

BRILLSTEIN: You don't earn anyone's respect by staying in the mailroom. You're just another office boy who jumps when someone says, "Go get me lunch." Unfortunately, getting out is not as easy as taking a test, getting an A, and being promoted. You need to attract the attention of a higher-up who can help. That's why people who *want* the jobs *get* the jobs. They're never content to sit and wait to be noticed. Any schmuck can do that, and lots of schmucks have.

I did a few things to set myself apart from the crowd.

I kissed ass. But not the big executives. I didn't want to reach too far too soon.

I showed up early for work. Our office didn't open until 9:00 A.M., but I got in every day at 8:00 because I knew that Nat Kalcheim walked in at 8:15 or 8:20. I made it my business to stroll through the halls so he'd see me.

I befriended the agents' secretaries. They'd once been in the mailroom, so they knew the procedure. They were trying to move up the ladder themselves, to junior agent, so the idea was to get someone to recommend you to take their place.

I did favors for agents—within the law. Along the way you somehow learn how it all works. If you're smart and you absorb it, you can look around and say, "Aha. These guys ain't so fucking smart." Then you're ahead of the game.

SHAPIRO: No one in the mailroom impressed me, and everyone who'd gotten out and found a desk to work on did. I'd ask, "How long did it take you? What did you do? How long have you been at that desk? What do they tell you? What was your raise?"

WEST: I looked at the assistants and agents ahead of me. I saw how they dressed. I saw them out at night. I thought, I've gotta get there, too; that's for me. To do that you have to learn very quickly about the competition: your peer group. How smart they are and what they know. Who's aggressive? Who's passive? What assistant desks are opening? Who should you buddy up to? It took guile. Intestinal fortitude. Brilliance. Inquisitiveness. A work ethic. The idea was to become a sponge for information, however acquired. The smart ones look for the edge. Otherwise, who would want to hire you? If you're not looking for

that edge, you won't make a very good agent, because agents *better* be looking for the edge on behalf of their clients. So you learned to go where you weren't supposed to go, to read things you weren't necessarily supposed to read. We weren't encouraged to break the rules; you had to figure that out for yourself.

MOMENTS OF DOUBT AND PAIN

LITKE: Lots of guys fell out of my mailroom group. Either they weren't ready for the business or they couldn't be patient for a year or two. At one point I told my parents I was never going to make it at William Morris. "I see these guys who are supposed to be pushing the mail wagons, schmoozing with the agents, not doing their work. Meanwhile, I do *my* work, but I can't stop feeling like they're going to get ahead faster than me." My parents, being good parents, said I'd be judged by my abilities. They were right.

WINKLER: Some people remember a lighter and more inspirational time, but I felt misused and exploited in the mailroom. I knew I was just a messenger boy with a college degree. At first it didn't bother me because William Morris masked the job in this mystique that if you did well, you'd get promoted and be an agent someday. You were motivated by that hope. But only a handful of "trainees" ever got out and developed into talent agents, not to mention producers or writers or directors or managers. Meanwhile, the executives took advantage of those hopes and got young people to work a five-and-a-half-day week for very low wages.

Of course, I never shared these feelings with anyone. I didn't want to get fired.

MOVING UP

SHAPIRO: When an agent asked you to be his assistant, most guys took the first offer. My offer was to work in the Nightclub Department. I

wanted Legit Theater instead and decided to wait. Some thought my refusing was a bad move, but I believed in setting my own path.

It took nine months until I was asked to work for Lee Karsian in the Legit Department. He was married to the actress Pat Carroll, who'd been a performer at Tamiment. I worked for him maybe three months, and then he got fired.

After Karsian I floated until I got another desk, working for Elliott Kozak, a television agent. Then Kozak got fired. When I tried for another desk, most agents looked at me funny, as if I were bad luck.

In the early sixties I moved to the Los Angeles office. All of TV was moving to the coast, and I badly wanted to be there, too. Bernie Brillstein had told me, "Look, you're smarter than most people, especially out in California. You should do well." (Later he was my inspiration for going into management. He was the role model for my career path. So thanks, Bernie.) But no one would actually send me, so I asked an agent friend, Elliot Wax, who'd already made the move, to help me start a rumor that I was being transferred. Pretty soon everyone was saying, "Shapiro's coming. Shapiro's coming."

ROSENFELD: I also looked toward California. I asked Charlie Baker if I could do anything out there to help him. I also offered to pay for my own move. It took him a while, but he came up with a plan for me to be an assistant to Lenny Hirshan and Julie Sharr. Lenny was in the movie business and Julie did variety television, but they also did West Coast theater. Years later when Abe Lastfogel found out that I'd been transferred but the company didn't pay for it, he didn't believe it.

BRILLSTEIN: I got out of the mailroom by finding a weak link in the company, someone whose personality and job performance created an opportunity. I could have tried to be an agent's secretary, but what for? When you're on a toll bridge, you try and pick the line that moves the quickest. Some people wait for the best job. Some people wait for a middle job. I didn't care. I wanted *anything*. I thought, Just get me outta here, because no one's gonna know I have any talent *until* I get out of here. In my heart I was always an agent and just working to make it official.

Jerry Collins was head of publicity. His assistant quit and he offered me the job. All my friends said, "It's grunt work. Don't take the job." But I knew three things: One, the publicity office was opposite Nat

Kalcheim's office, and proximity is priceless. Two, in publicity you worked with *everyone* in the company. Three, I'd be *out of the mailroom!*

WINKLER: After the mailroom I was put in charge of the audition room. It was the lowest job around. No one was anxious to have it because it didn't lead to anything specific.

Even so, something good happened for me. A guy named Lou Bass ran the audition room in the Los Angeles office. One day he sent me a note about a woman he'd met socially who had just moved to New York. It read, "She's a very nice lady. Why don't you call her and ask her out?" I did, and that's how I met my wife. Lou later married Marie "The Body" McDonald. It didn't last very long. Then he quit the Morris office. I think he became a cop.

When I finally became an agent, Wally Amos was my secretary. He used to come into my office with chocolate chip cookies that his grandmother had made. He'd point to the cookies and say, "This is going to be my fortune." I said, "Wally, you're not going to make a fortune making chocolate chip cookies. Get back to the typewriter."

Oh, well.

LITKE: After eight months I went to work for an agent in the Play Department. I lasted about a month. Luckily there was an opening with Joe Wolfson in the TV Guest Appearance Department, which was big because there were twelve variety hours in prime time.

When Betty Hutton replaced Carol Burnett in a Broadway musical for two weeks, Joe took me to meet Hutton. She was my first star. Most of the executives at William Morris were five foot four or less and wore a thirty-six short suit. I'm a thirty-six short. Joe said, "Betty, I want you to meet this young man. He's gonna be very big in the business."

"Well," she said, "he's fucking-A the right height."

IT PAYS TO GET IN EARLY

WEST: I resented being a college grad who made only thirty-eight dollars a week, so after six months I left the company. No one cared. I didn't mean anything. We were all Schmendricks in the mailroom. But a couple months later I was back. You want glamour? You pay the price. You

learn how to live on tuna sandwiches and coffee. I went to Harry Kalcheim instead of Sid Feinberg. I said, "Listen, I screwed up," and sold myself back in with whatever story I could create. I had to. If I couldn't sell myself, how could I sell a client?

I got a part-time desk, floating. Then I got tired of the low pay/sacrifice bullshit *again* and left again. I went to IBM, which was boring, and sold card-punch equipment.

• • •

In 1964 I moved to the West Coast. George Shapiro was already in town. I met with Morris Stoller. He was an accountant, an attorney, and, to me, God. Stoller was the most well rounded person at the company. If I wanted to discuss music, art, the Korean War, self-hypnotism, problems in the London office, why so-and-so is a putz—whatever—he could. Sam Weisbord, on the other hand, talked about seventeen-year-old girls, stocks, and his dinner with Mr. Lastfogel. Morris let me start over again, as everybody's assistant in the Variety Television Department. They gave me a barely livable salary, but I quickly got the lay of the land. I learned how to shoot by people who had been there for ten or fifteen years. My life was all about outworking, outthinking, seven days a week—and I made agent.

A few years later I noticed someone else with the same drive. I'd come in early to work the phones and saw this young man who assisted Fred Apollo wandering around the halls. I started talking to him not only because we were both in before everyone else, but because that quality suggested he was bright and had a great work ethic. After a while I grew to like him enough that I managed to arrange for Michael Ovitz to leave Apollo and come to work as my assistant.

THE THRILL OF IT ALL

LITKE: I spent my nights going to Greenwich Village. I went to the Gaslight Club and saw a young black comedian who turned out to be Bill Cosby. We signed him. I saw this ugly girl singing her heart out until two or three in the morning. She was Barbra Streisand. It was about finding the Smothers Brothers in the clubs and Linda Lavin in an

off-Broadway show. It was about discovering people you could make into stars. They don't do that anymore. If you're casting a TV series today, you go to a college, find twenty-seven attractive kids, pick out five, throw them on the screen, and whatever happens, happens. They "people" the shows. It doesn't have to do with talent.

UFLAND: In my day we were great characters and we worked with great characters, and that's completely gone. So many agents then had a real love of this business. They were not afraid to be themselves. Today you've got people who don't know how to be themselves. They're from a mold.

BRILLSTEIN: In the mailroom you read the mail of the biggest stars in the world. You touched the letter. Or you went to a nightclub opening because the boss invited you; never mind he just needed to fill a table for a William Morris act, you were *there* and you felt part of the family. You saw acts that your friends hadn't seen. You got records your friends didn't even know about. You met people on delivery runs your friends couldn't hope to. Then some big agent asked you to go to a TV show, sit in the audience, laugh, and lead applause—and get paid five bucks to do it. What could be better?

• • •

BERNIE BRILLSTEIN is the founding partner of Brillstein-Grey Entertainment, the industry's preeminent management/production company. He will always love show business with his eyes wide open.

IRWIN WINKLER is a widely respected producer whose films include *They Shoot Horses, Don't They?; Raging Bull; The Right Stuff; GoodFellas; Music Box; New York, New York; Up the Sandbox; The Mechanic; Rocky* (and sequels); *Round Midnight; The Shipping News;* and more. His movies have been nominated for Best Picture four times—a record; he won the Oscar for *Rocky*. Winkler also directed *The Net, Guilty by Suspicion, At First Sight, Life as a House,* and *Night and the City*.

GEORGE SHAPIRO and **HOWARD WEST** are big-time managers (of Jerry Seinfeld, among others), TV and movie producers, and partners in Shapiro/West and Associates of Beverly Hills. According to Mr. West, he's been carrying Mr. Shapiro forever, and vice versa. Between one's brain and the other's body, they are one perfect person.

MARTY LITKE became vice president in charge of talent, East Coast, at William Morris before leaving in 1974 to pursue management and pro-

duction. Now in semiretirement, he teaches theater at Rowan University in Glassboro, New Jersey.

MIKE ROSENFELD SR. is one of five former William Morris agents who, in 1975, cofounded Creative Artists Agency. He retired in 1982 and relocated to northern California, where he is now a flight instructor who believes it is better to be lucky than smart.

HARRY UFLAND is a film producer whose work includes *Snow Falling on Cedars, The Last Temptation of Christ, Moving Violations,* and *Not Without My Daughter.*

THE MENTOR

SANFORD LIEBERSON, 1957 • RON MARDIGIAN, 1958 • JOE WIZAN, 1958 • RON DEBLASIO, 1958 • ROWLAND PERKINS, 1959 • BOB SHAPIRO, 1959

Phil Weltman truly cared. It was his humanity.
—Rowland Perkins

SANFORD LIEBERSON: My parents were both poor immigrants from Russia. My father died when I was eleven. My mother worked for Prudential Insurance, in the cafeteria. Show business seemed as far away from my life as China.

After the navy and L.A. City College I worked part-time in the parking lot of the El Dorado Restaurant. One lunchtime a convertible rolled in with a beautiful blonde in the passenger seat. I realized I'd gone to high school with the driver. I thought, Christ, that's fantastic. I asked him what he did, and he said he'd become an agent. I didn't know about agents, but I immediately asked, "What can you do for me?"

BOB SHAPIRO: After college I just wanted to get a job, so I applied at MCA and William Morris. My father, Danny Shapiro, a comedy writer for Bob Hope and *The Jackie Gleason Show*, was represented by Morris. Big agents like Phil Weltman and Sammy Weisbord had been at my bar mitzvah.

I met at MCA with Earl Zook, then Lou Goldberg at the Morris office. I waited a couple of weeks for a call. Goldberg offered me a job on a Tuesday, and I took it. Zook called Wednesday. When I told him I'd taken the Morris job, he harrumphed.

I cleared $37.50 a week after taxes. Not great, even for 1959, but I was very excited. I had always loved *The Man in the Gray Flannel Suit*, so I made sure I looked a little like that when I went in. At the Morris

office the dress code was less stringent than at MCA, where a friend of mine had been sent home because he wore a Brooks Brothers seersucker suit in the summer.

RON DEBLASIO: I knew I wanted something different from the life mine could easily have become. I'm Italian, from Providence, Rhode Island, son of a pharmacist. I thought going to California would be a way to escape all the predictable stuff. I told my family that after high school I was moving, with or without them. They decided to come, and in 1953 we moved to Pasadena. It was about as white bread as possible.

After college and the service I looked for work at a number of industrial outfits. They all said, "Okay, fine, you got the job. Come in on Tuesday, meet our regional boss." But I'd always make some excuse and not go. I kept wondering: I'm ambitious, why don't I want these jobs?

I took three days of tests—interests, aptitude, IQ—to find out. Afterward the adviser said, "You should be dealing with people. You could work insurance, advertising . . . but have you ever heard of MCA?"

I knew a guy from high school who worked in their mailroom. But his clique and my clique had been at odds. I took him out to lunch at Frescati's. It was a big deal for me to humbly ask my rival if he could get me an interview. He confronted me with my sins of the past, but to my surprise he said he'd make a call.

At lunch I also happened to run into another guy, who, by chance, worked at the William Morris office. "What are you doing with *that* guy?" he asked. "William Morris is much better than MCA."

"Just trying to get a job," I said.

"Fuck that. You still living in Pasadena? What's your number? I'll call you."

It was an early lesson: Politics were involved in even the social aspects of show business.

RON MARDIGIAN: I went to Stanford in anticipation of going into medicine. Then the theater and the movies turned my head. I never performed, but I loved the production, the creation, the history. I transferred to UCLA, graduated in 1958, and went looking for a job. I was twenty-four, married, had one child. I lived in Glendale, in an apartment. Unfortunately, that was a depressed year for the entertainment industry. They just weren't hiring. But a friend who worked for Paul Henning, who created *The Beverly Hillbillies,* said, "You look like

an agent." Whatever that meant. Maybe it was the dark suit I wore to interviews. He said, "Let me introduce you to someone."

ROWLAND PERKINS: I went to Beverly Hills High and was always interested in the entertainment business. I thought I wanted to be a producer, movies primarily. After college and the navy reserve I figured I'd give myself two years to get established. If not, I'd practice law.

My girlfriend's best friend was going with William Bowers, a successful writer who'd won an Oscar. We became good friends, and I told him my plan. He said, "Look, you can always be a producer, but I think you'd be a good agent. And more important, it's the best way to learn about the business." I ended up with an appointment at MCA.

That evening I had a dinner with a friend and his aunt, Loretta Young. I told her what I was doing, and she said, "Did you talk to *my* agent at William Morris?"

"No."

"Well, you're *gonna* talk to him." She picked up the phone right then and called Norman Brokaw at his house.

Both William Morris and MCA offered me jobs. I decided I'd be better off at the Morris office because I'd more easily fit into that culture. MCA was much more competitive by design. They pitted people against one another to see who'd survive. William Morris was supposedly more familial, and I wouldn't have to spend all my time watching my back.

JOE WIZAN: I am the only son in a Jewish family. My dad had a couple of retail furniture stores in East Los Angeles. He wanted me to take over the business. I hated it; I got such migraine headaches that I thought I had a brain tumor.

I graduated from UCLA in 1956 and went into the National Guard. There I met a young guy named Vic Friedman, who was in the mailroom at the William Morris Agency. Vic got me an interview. I never expected to be hired, because I didn't know anybody, but it looked good until they asked me if I was married. When I said yes, they said they couldn't hire me because they paid only forty-five dollars a week.

"Money is insignificant," I said. "I have my own." I wasn't bullshitting. I had accumulated a vast sum playing poker in college. I mean a *vast* sum, especially for 1952. I didn't have to work.

I bought a light gray sharkskin suit, a nice white shirt, and a black tie for my first day. Then I walked up the steps to 151 El Camino and be-

came a different person: amazingly focused and very straight. No one there knew my poker-playing background. No one knew I loved practical jokes. This was work. This was it.

CULTURAL AND OTHER IMPERATIVES

MARDIGIAN: William Morris was very Jewish. I'm not, so I had to learn all the Yiddish stuff and become sort of baptized in that world. I'm joking about that, of course . . . but it was not unimportant to get the culture.

DEBLASIO: One guy said, "Aren't you a little intimidated? You're a gentile." I said, "Why? I've been around Jewish people, I understand them, they understand me." There was no intimidation of that sort whatsoever.

MARDIGIAN: The office was primarily men and primarily short. The story was that there was a rack of suits—thirty-six short—in the basement, and if you fit, you were in. Another joke going around at the time illustrates what I mean: In 1951, a few years before I started, Walter Wanger, a legendary producer who was married to the actress Joan Bennett, thought she was having an affair with Jennings Lang, her agent at MCA. Wanger saw Lang one Sunday in a parking lot in Beverly Hills, pulled out a gun, and shot him. He got Lang right in the nuts. The story was that Lang was left with only one ball, and I think that's probably true. The joke made afterward was that had Wanger thought his wife was having an affair with Mr. Lastfogel, who ran the Morris office, Wanger would have shot him right between the eyes.

SAMMY GLICK BUT NOT SAMMY GLICK

LIEBERSON: We were all crammed into one room on the first floor, but we managed to get along, which was extraordinary because in those situations it can be very competitive and unpleasant.

PERKINS: I didn't come in until the end of the year, and some of the guys were six and seven months ahead of me. Ed Levy in Personnel told

me that with rare exceptions people got promoted in chronological or-
der. "It takes time," he said. "You've got to be patient." Plus no one had
been promoted for a while, so the prospect of rapid advancement
looked bleak. One guy in the last ten had made it to a desk. Then liter-
ally within two weeks five guys got fed up and quit, and William Mor-
ris was running around trying to find people. Some of the departures
were, uh . . . calculated; other guys in the mailroom wanted these peo-
ple out of the way, so they encouraged dissatisfaction: "You're right. It's
taking too long. Why don't you quit?"

DEBLASIO: The mailroom was always about who would last. The idea
was not to get discouraged and act stupid when some guy said, "This is
bullshit. What are we doing this for?" I got the game early. Kill or be
killed. If a guy said, "Gee, I have aspirations to be a comic," even if he
didn't have any talent, I'd say, "Yeah, you're really good. Keep at it."

MARDIGIAN: To get ahead you often had to be pushy and get in some-
body's face and promote yourself. The squeaky wheel got the grease,
sometimes without even being competent. I wasn't a goody-goody; I'd
screw someone over to get a job if I had to, if I felt I was more qualified,
but I never encouraged someone to quit so I could move a notch.

DEBLASIO: After I'd been in the mailroom awhile, I made an agree-
ment with the switchboard that any calls that came in with no place to
go—like someone looking for William Morris—would come to me.
One day the switchboard buzzed and said, "Ron, here's a doozy."
Turned out to be a guy who said he was a professor of economics at
Harvard and he was in town with this political candidate and he needed
help because he was afraid the candidate had blown his throat. He said,
"You maybe have heard of him. He's John Fitzgerald Kennedy." I
couldn't believe it. I said I'd do whatever he needed, and rushed to meet
him at the Shrine Auditorium. Backstage a guy stuck out his hand and
said, "Hi. I'm Frank." Sinatra. Sammy was also there. They were in
their Vegas clothes. I was in my Brooks Brothers. I was so in heaven.

PERKINS: It's not necessary to be a Sammy Glick to succeed. In fact,
you're probably better off if you're not. More Sammy Glicks bite the
dust when they're found out. Of those who survived, many quit being
agents early; they got so far and then looked for good opportunities
elsewhere. They didn't really want to be agents; they just liked the busi-
ness. More to the point, they liked the money.

DRIVING MRS. LASTFOGEL

MARDIGIAN: The mailroom was Frances Lastfogel's private collection of boys to take her around to the dressmaker, to the shops in Beverly Hills, to Hillcrest Country Club. We used agents' cars or idle dispatch vehicles. I'd drop her off, and Mrs. Lastfogel would say, "Here's a dollar, go have lunch. Pick me up when you get back."

Mrs. Lastfogel loved *lavosh*—Armenian cracker bread—and when she found out I was Armenian, that became the basis of our relationship. She knew an Armenian bakery, so she'd always ask me to get her some bread. I liked to believe that our dumb connection was a help to me with her husband: "Hey, that Armenian kid, Abe; keep your eye on him."

SHAPIRO: Even though she wasn't particularly forthcoming in terms of the specifics that I wanted to know about the company and people, we got along very well. When I dropped her off at the side entrance of the Beverly Wilshire Hotel, she always leaned over and put a dollar bill in my jacket as a little tip.

Years later, when I ran William Morris's London office, I'd come back to Los Angeles two or three times a year, and Mr. Lastfogel and Sammy Weisbord would always take me to Hillcrest for dinner. They didn't like to bring wives, except that they both really liked my wife, so sometimes they'd invite her and Mrs. Lastfogel.

The first time this happened, I told my wife that she had to get to Hillcrest on her own because I had a meeting at Warner Brothers. I stopped at the office on the way back to dinner and found a message: Would I mind picking up Mrs. Lastfogel?

So the head of the London office drove to the side entrance of the Beverly Hills Hotel, and Mrs. Lastfogel got in the car. She said, "Hello," and we drove to Hillcrest. When she got out, she said, "Thank you," then leaned over and put a dollar in my coat pocket.

The valet asked if he should park the car, but I couldn't move. I sat there for a few minutes trying to figure out if this was a joke or she thought I was still in the mailroom. I *was* young; I had gone to London when I was only twenty-nine. When I finally went in, Mrs. Lastfogel just winked at me and smiled.

ELEANOR AND ABE

LIEBERSON: Eleanor Flaherty worked for Mr. Lastfogel for about thirty years. She was a wonderful woman but also an alcoholic. It had gotten to the point where the afternoons were, for her, a dead loss. She really couldn't handle it anymore. So she asked for me to sit in when she left at about four o'clock.

DEBLASIO: Eleanor Flaherty's relationship with Mr. Lastfogel was pretty much like that of his clients Spencer Tracy and Katharine Hepburn on-screen—and though I have no evidence, maybe off. All I know is that they were very, very tight and there was some visible tension about it. Frances Lastfogel wouldn't come to the office when Eleanor was working, which may be why Eleanor left early.

One day she walked into the photocopy room wearing a big smile and said, "You're DeBlasio. You're Catholic-Italian, aren't you?"

I said, "Yes."

She said, "Okay," and left. I stood there scratching my head.

The next time she came in, she said, "So, what are you doing here?"

"I'm just doing this temporarily." I explained that I'd been promoted to an assistant's desk, but there had been nowhere to go in the department, so I was just floating until something came along.

She said, "Do you take shorthand?"

"I take it as good as anybody does," I said—which was both a lie and the truth.

"Well, sometimes I want to blow out of here early and Mr. Lastfogel still needs things done. Maybe you can sit at my desk after I leave."

I told her I'd love to.

LIEBERSON: I'm not sure why she picked me. Maybe because I chatted with her when I delivered the mail. Maybe it was luck. I certainly had no plan. You don't plan to work for Mr. Lastfogel.

My being chosen right out of the mailroom caused a huge reaction within the company. The first day everyone who came by said, "Where's Eleanor? What are you doing here, kid?" I think the last male secretary Mr. Lastfogel had was Sam Weisbord, twenty-five years before. The mailroom guys were also amazed; they couldn't figure out what I'd done.

"You have to remember two things," Eleanor said before she left me

alone. "One, listen in on the phone conversations so that if anything has to be done, you know it." The first conversation I listened to was with Spencer Tracy. "And two, make sure you chill the glass he has his six o'clock whiskey in."

The whiskey was a ritual when the agents would come by to check in at the end of the day. It was a chance for them to promote themselves and for him to find out what was going on. From my secretarial desk I could see into Mr. Lastfogel's office and hear the conversations. I could tell who he liked and didn't, who got his eye. People with enthusiasm and ideas got his attention. You didn't have to look a certain way, but you had to have a little flair. Lenny Hirshan was an incredibly ambitious agent who would work eighteen hours a day. Stan Kamen was one of Mr. Lastfogel's favorites. And Norman Brokaw. They were all committed to William Morris, to being there for Mr. Lastfogel, to being part of the family.

DEBLASIO: My visibility grew on Mr. Lastfogel's desk, which was a good thing because no one had really noticed me before. Now everyone could see how I dressed, how I answered the telephone. And I got to know the agents: who was nervous, who was insecure, who bucked the line. Mr. Lastfogel didn't say much to me, but he appreciated the fact that I knew whose drinks belonged to whom, like Sinatra.

One day Sinatra rolled in a little late for a meeting. I poured him a Jack Daniel's. Mr. Lastfogel was down the hall. As Sinatra waited an agent from a nearby office stopped by and said, "Hey, Frank." Then, perhaps because he couldn't resist trying to buddy up to the great Sinatra by proving he was in the know, he said, "Didn't you know? *She's* here. At the Beverly Wilshire."

Sinatra immediately understood. Ava Gardner, the love of his life, was in town. And she hadn't called him. He put down his drink and said to me, "Tell Abe I'll see him later." Then he threw the "Wee Small Hours of the Morning" trench coat over his shoulder, grabbed his hat, stuffed one hand into his pocket, and walked down the hall, a dejected guy.

• • •

Little by little Eleanor left earlier and earlier. Sometimes she'd take a day off and I'd sit there morning to night. When Eleanor died, they held the mass at Saint Vibiana's in Los Angeles. Only a few of the high-rankers from the Morris office came down; I think no one wanted to appear as

if he was choosing Eleanor over Frances. But Frances was there. She felt her husband's pain and wasn't afraid to show it. She and Mr. Lastfogel sat together in the front row, weeping.

ALL IN A DAY'S WORK

PERKINS: Some agents would call a mailboy to pick up their laundry. That was the worst job. It wasn't what I was there for. I could spend the same time picking up a letter from a lawyer. At least that was part of business.

DEBLASIO: When we delivered, we used a company car or one belonging to a lesser agent who had his car expense taken care of by the agency. This was before they had their little fleet. You knew which cars were good and which weren't, and you always tried to stick one of the other guys with the Volkswagen that always fucked up someplace, or the Chevy that overheated, or the car that had bad air-conditioning. You also wanted the best delivery run so you didn't end up searching for some little house on Woodrow Wilson Drive at four o'clock in the afternoon. And you always tried to get back in front of the dispatcher faster than anybody. The dispatcher's office was right next to the personnel director's, so if you worked quickly, there was the chance someone who mattered would hear the dispatcher saying, "Gee, Ron, you're already done!"

LIEBERSON: I once had to deliver a script to Elaine May up in Laurel Canyon. I knocked at the door and there was no answer. I walked around the side. She was sitting by the pool, reading a script, wearing full body makeup from head to toe—so she looked tan.

MARDIGIAN: I once met James Michener. He was in Los Angeles meeting with his agent to talk about his new assignment. He asked me if I'd like a drink. I took water. He asked me what I was reading, and I said, "Thomas Wolfe." He said, "Really? What do you think?" I said, "Well, the sentences are very long."

PERKINS: Sometimes you'd hear things in the building that you couldn't believe. Once, I walked into an agent's office to get something, and there was another agent with him. They were talking about the actress Debra Paget. The first guy said, "Oh, boy, what a dumb cunt."

The other guy said, "Well, she's nice enough, but Jesus . . ." Then the phone rang and the secretary said, "It's Debra Paget." The first agent answered and said, "Hi, honey, we were just talking about you." I thought, Okay, *now* I get what this is all about.

THE MENTOR

PERKINS: Phil Weltman was a big TV agent, rough-hewn, maybe five ten, who also oversaw the trainees. He had a bit of big-screen top sergeant in him. He was demanding, but not unreasonably so; the things he wanted from you were things you *should* do. When I was young, he'd make me give him reports of what I did almost every hour. There was a method to it: he wanted you to stay conscious. Call him a tough guy, but he truly cared.

WIZAN: I don't know why he cared so much. Maybe because he didn't have family of his own until he married late in life—but Phil Weltman was the world's greatest mentor.

SHAPIRO: He cared about the trainees because he wanted to build the agency. He wanted bench depth, to use a baseball analogy. He thought the Morris office was the best, and he wanted it to stay the best. He would literally, I believe, have killed for the agency. It was his life. Weltman was a hard taskmaster. He had his rules. Something Jeff Katzenberg said years later was also true of Weltman: "If you're not prepared to come in on Saturday, don't bother to come in on Sunday." Weltman worked twenty-four hours a day, seven days a week. If he worked, you worked. There were no hours. Sometimes I would curse him for it and want to quit, but he instilled a great work ethic in me.

DEBLASIO: Weltman came from New York, but he understood what the West Coast was all about. A lot of agents who came out from the East Coast didn't quite get it. Everybody says we're looser in Los Angeles than in New York, but that's wrong. New York is a little more rough-and-tumble: "Hey, gimme that fuckin' pack of cigarettes there, buddy. You heard what I said." Los Angeles is actually tighter. It's a company town. You never know who's listening. The artists live here. This is their home. You're always seen.

In New York you walk down the street, the guy next to you works in

a market, somebody else works in the garment district, somebody else works in securities. Here, you go down Rodeo Drive today and yell, "So-and-so just lost his deal at Fox," and half the people in those stores will come out and say, "When?" They know what you're talking about.

SHAPIRO: Everybody wanted to be on Phil Weltman's desk, and so did I, but I didn't try to engineer it. Frankly, I would have been happy to be on Attila the Hun's desk, just to get out of the mailroom. The day they told me I'd be working for Phil, I was thrilled. And this much was clear: I hadn't gotten it because he'd been at my bar mitzvah and knew my family. I never forgot that the day I started in the mailroom, he had said, "Forget your father. This is you. You want this? *You* have to perform."

• • •

Weltman was the CBS guy. He went to the network every day and walked up and down those halls. He knew every show, every director, every actor. He prided himself on booking the most and knowing the most. If you covered a studio and you *didn't* know what was going on, you'd be reprimanded. You *had* to know.

I went with him to CBS lots of times. I wasn't assigned to do it, but whenever I had a chance to see him in action, I took it. He was dynamic. Selling today is different. Now most agents don't leave their desks; it's all done on the telephone. These days you can talk to people for two years and not even know who they are, let alone recognize them. When I became an agent, Weltman would never let me get away with that. If we were out at night together and we ran into some producer who didn't say, "Hi, Bob," he would take me aside and say, "How do you not know this guy? He's producing a show."

Weltman would put you right on the carpet. You could hate that or you could say, "You know what? It's teaching me to be thorough. I may not choose to do my business that way someday, but I'll know." To him it was teaching someone right from wrong.

WIZAN: When there was a message to call Phil Weltman, I would shake. To this day, forty years later, I remember the knot in my stomach: What did I do wrong? How did I fuck up? Usually it was nothing—but you never knew that. He was fair, but when he ripped you, he really ripped you.

PERKINS: I remember Weltman yelling at George Shapiro. It was al-

most like a cartoon. Weltman said, "I ought to fire you for doing this." Shapiro said something like "You can't fire me, I quit!"—and he stalked out of the office, slamming the door. Then he stopped dead in his tracks, realizing this momentous thing he'd just done. He turned around, knocked meekly on Weltman's door, and said, "I was just kidding." Then they laughed and talked. Somebody lesser would have kept walking. Somebody lesser would have let him.

WIZAN: After the mailroom I worked on Gene Houston's desk in Literary, but I wanted to be in TV. One morning there was a message: "See Phil Weltman." I stated to shake—as usual. Howard Rubin was Weltman's assistant, and Bob Shapiro was his secretary. Weltman had fired Howard the night before. I thought Shapiro was going to move up, and I hoped maybe I'd take his place.

I was wrong. Weltman said, "You're going to be my assistant."

I said, "What about Bob?"

He said, "Bob's not ready yet."

SHAPIRO: That was a defining moment for me. I felt strongly that I deserved the promotion; so did others in the company. I couldn't conceive that the job wouldn't be mine. When I didn't get it, I could easily have said, "I'm outta here." I would have had no problem getting another job. But I asked myself if I wanted to let my ego get the best of me, or if I wanted to keep my investment and continue. I had to fight my every instinct not to quit. I stayed because above all else I loved and respected Weltman. I also liked Joe Wizan; he was a friend. I was happy for him—just devastated for myself.

Here's how Weltman handled it: He took me to lunch and told me to be patient. He said I had great potential and I should continue to work hard, absorb everything, and my time would soon come. He urged me not to get discouraged. Actually, if you knew him, you could say it was more of an *order* that I not get discouraged. I swallowed my pride and stayed. And Weltman was true to his word. After about six months I was promoted to junior agent and went to work as Norman Brokaw's assistant. I had a terrific rise at William Morris and never regretted my decision to stay.

DEBLASIO: Even though I never worked on Phil Weltman's desk, I went to him more than anybody. You could say exactly what you felt; that's why Ovitz and Ron Meyer and Rowland and all those guys loved him.

Yet years later the company started giving Weltman shit that he wasn't one of them, and let him go. In the end he was a better one of them than they were, and his boys, the guys who started CAA, left soon after.

WIZAN: The way William Morris treated Phil Weltman helped create CAA.

PERKINS: Over the years Weltman and I talked a lot. There's not very much I didn't say to him, or he to me. At one point he made a big push for me to be president of William Morris. Traditionally they waited until you were eighty and then handed you the baton, and he told them they shouldn't do that. This was at the time when Sid Sheinberg, at thirty-nine, was made head of MCA, under Wasserman. But Weltman was trying to convince a bunch of guys, all of whom were older and had aspirations of being president themselves, and there wasn't a chance his idea was going to fly. He had no ambition of being president himself. Phil Weltman was really pure of heart.

SHAPIRO: Phil Weltman got to be very proud of us. He had me as the head of Warner Brothers, Joe Wizan as the head of Fox, and Barry Diller as the head of Paramount. All of us his trainees, all of us from his desk.

DEBLASIO: When I was a new agent, Phil Weltman called me and said, "Listen, you do a good job with these guys." He meant the trainees. He had one in mind that he wanted me to oversee: Barry Diller.

"I don't want you to train him, but I want to give him an office near you and I want you to help him," Weltman said.

I guess Diller went through the mailroom, but I never noticed. It must have been only for a minute and a half. Next thing I knew, he was up on the third floor with me pretty fast. Diller then was like Diller today. He spent an awful lot of time making sure he understood what was happening. He read a lot of files. He was very focused. He had definite likes and dislikes, but he didn't voice them as much because he wasn't that well established yet. He was a good, good judge of people. He did not suffer fools gladly at all, and there are a lot of fools out there. I liked Diller a lot. I was a big jazz fan; he introduced me to the Beatles.

BARRY DILLER: Phil Weltman was a direct and decent man who truly enjoyed developing people, giving them discipline and order and a sense of values—he was the best kind of teacher, and those who were

lucky enough to have him in their life at such a formative stage are forever grateful. I was a bit more than that, as I'm sure were a few others; I was one of his special charges, and his great expectations, and eventual pride, both shaped and gave first confidence to my business life. In addition to all that, he was loved because he had a great and easy laugh, and beneath his outward drill-sergeant shield he was a warm, kindhearted man.

PERKINS: Before he died, Phil Weltman told me that somebody had once asked him, "Phil, do you know Barry Diller? Did you ever *talk* to him?"

"Well," he said, "when I used to want to talk to him, I'd buzz him."

SWINGERS?

PERKINS: Frank Sinatra—like Peter Lawford, Milton Berle, and others—had offices at the William Morris building, on the third floor, with secretaries and private phone lines. Sometimes the occupants would even show up. Sinatra owned part of a restaurant called Puccini's, on Beverly Drive. A phone line from his office went directly to the restaurant. Occasionally, when we'd saved some bucks, three or four of us would go to lunch there.

One day I picked up the Sinatra line to Puccini's and said, "This is Mr. Perkins over at the William Morris Agency. There will be lunch for four at twelve-thirty."

They said, "Yes, sir, fine. We'll be waiting for you."

The minute the maître d' saw my friends and me, he knew the truth: I had nothing to do with Frank Sinatra. But he said, "Mr. Perkins! Come this way." As he turned around, at the very first table I saw a girl I was going out with and her mother. Boy, did I feel good, because I knew they'd heard him say, "Mr. Perkins!" I stopped to greet them, and the maître d'—I love him to this day—came up and said, "Excuse me, Mr. Perkins. The other gentlemen would like a drink. Would you care for your usual?" I said, "Thank you, that would be nice." He made me feel ten feet tall. I think my usual was a glass of water.

FLY ME TO THE MOON

SHAPIRO: I was in the mailroom for only five months when they decided they needed someone to take the vaunted position of head of the Transportation Department. In plain English that meant I was still in the mailroom but also the liaison to the Morris office's travel agency. When Sam Weisbord wanted to fly to New York, rather than his secretary calling the agency, I'd call. The same with all the hotshot agents. I got on a first-name basis with everyone except Mr. Lastfogel.

In those days an ancillary benefit of flying first class from New York to Los Angeles, or vice versa, was that the airline would automatically give you a free first-class leg from Los Angeles to San Francisco and back. The agents would never use those, so they'd give them to me. I had a stack.

I made $37.50 a week, I was single, and I dated a lot. But I didn't have enough money to take a woman to dinner. So when they'd ask, "Where are we going?" I'd say, "Don't worry about it." We'd drive to the airport and go on a first-class flight to San Francisco. I'd go under the name Mr. Lastfogel or Nat Lefkowitz or Lou Weiss, or whoever the executive was. (I'm very straightforward, and I always asked the agents, "Will you ever use this?") I'd have another ticket for my date and find a way to change the name. In first class they'd give you lots of food, and we'd have more drinks than you should in an hour flight. We'd get there and I'd say, "San Francisco is so romantic, let's just walk around."

Sometimes I would save my money and we'd stay over at some rattrap place that I said Hemingway had slept at—to make it sound a little more romantic—but the joy and the excitement was usually going up and back in one night. These girls were young actresses and models, and they'd never gone first class. I never dated a secretary. I never dated a client.

Well . . . I say I never dated a client—until I dated a woman who was flown out here to test for the series *Gidget*. She was a dancer for Jerry Robbins, for *West Side Story*. I married her, and we've been together for thirty-seven years.

THE TRICK OF GETTING AHEAD

MARDIGIAN: The big competition was to get on a desk. Phil Kellogg, a big-time movie agent, wanted me to work for him. I turned it down because I didn't want to get into actors. Writers were more interesting. I loved the creativity of making those deals. Plus, the literary side was much less competitive and in the spotlight. That appealed to my personality; I don't seek attention. Dick Patterson was head of Literary, and I waited for his desk to open. Unbeknownst to me, that turned out to be a gutsy move.

Patterson had a sense of humor, which I played into. We even socialized. But then he was hired by Paramount, to work in their European office, so I moved to Arthur Kramer's desk. He had recently come from Columbia Pictures, was there about ten minutes, and then died.

When Mike Zimmering got the Literary Department, I worked for him. After a couple months he promoted me to junior agent. I had moved ahead rather quickly, but some assistants don't because they don't really understand the trick of getting ahead: Don't make yourself invaluable as a secretary—because then you're invaluable as a *secretary*. The better you are, the longer you stay on the desk and perhaps die there. I'd be helpful in certain areas and fuck up in others, especially clerking skills. I realized it wasn't a great idea to spell too well. Guys too obedient to authority succeeded more slowly. If you were slightly incompetent, it was, well, "Get outta here." The tradition passed down to me was, "Don't get too serious."

DEBLASIO: I finally got promoted out of the mailroom to Shelly Wild's desk in the Literary Department. Shelly was a nice guy, a New Yorker, a liberal, a Stevenson Democrat, a Jewish intellectual, and I really liked him a lot. But politically speaking, he was the odd man out because, interestingly enough, the Morris office hierarchy was mostly Republican.

I know "Republican Jew" sounds like an oxymoron, but I think the reason was that Mr. Lastfogel had done so much work for the military. He was a founder of the USO, and his best friend was General Omar Bradley. Many of the Jews in the motion picture industry were Republicans. Some even wanted to be gentiles.

The 1960 Kennedy-Nixon presidential race presented an interesting

complication for the Morris office hierarchy. I overheard Mr. Lastfogel say about Kennedy, "We must support this man." Morris Stoller said, "You know, if a Catholic can get in, it may not be that long before a Jew can get in." With classic agent-think, they recognized the opportunities and they wanted a new spirit.

• • •

I wanted to be promoted to junior agent off Shelly's desk, but one day one of the partners' sons—Sid Kalcheim—showed up and needed a job, so they put him in the Literary Department. The vacancy that might have been mine was taken. I was despondent. I couldn't get over the idea that I was totally dispensable. I thought I was used to it; in the army they never stopped telling us how low we were. But at least in the army they had to feed me and clothe me. This was lower than that. Finally, as a compromise, the company agreed to float me. I'd move from desk to desk, where needed. That's when I worked for Mr. Lastfogel.

I ended up on Elliot Wax's desk. Elliot was a TV agent, newly arrived from the New York office. He was trying to fit in but ran into a bit of a stone wall because he did it the New York way. I worked for Wax for about a year. He was a good salesman. I listened in on his phone conversations and learned how fast you can tap-dance out of something:

One afternoon about two o'clock the studio had some script pages for Tony Franciosa. I had to get them to him or at least tell him about the call. I phoned his house—I think he was married to Shelley Winters, or they were living together—and I got Shelley. I said I needed to have something delivered to Tony, and since he wasn't working that day, I wanted to make sure he got the message. She said, "What the hell are you talking about, not working today? He left this house this morning and went to the studio. He *is* working. Did that son of a bitch lie to me?"

When Wax came back from lunch, I said, "Elliot, I think I erred." Sure enough, we got an angry telephone call from Franciosa; who knows what he was up to. Then I got a lecture about how I had to be more aware. Part of it was Elliot's fault. I said, "But you don't tell me things."

I got promoted to agent about four years after I started. The long process took its toll. After a while you're just marking time. Your friends from college are in big jobs and making good money. If you meet for dinner, you can't pick up the check; often you just show up for drinks.

At parties the only thing you can contribute is talk about the clients. But even that was boring because in those days all anyone wanted to know was if Rock Hudson was gay. Did I care? No.

PERKINS: I never had to be in a hurry. I started on November 9, 1959. Because of all the new guys they brought in when the five in front of me quit, I was head of the mailroom by March. In June I became Stan Kamen's assistant. The next June I went to Hawaii on vacation. When I came back, there was another guy on Kamen's desk. I was really upset. He said, "Calm down. We've decided to make you an agent." *Bing.* I felt charmed.

LIEBERSON: My first desk was Lenny Hirshan. I wasn't a very good secretary, but Lenny couldn't complain because I'd come from working in Mr. Lastfogel's office. But because Lenny is a great politician, he did something very smart: He tolerated me and, to get rid of me, got me promoted as soon as he could. It took only five months.

SHAPIRO: In 1968 the Morris office sent me to London. Before I left, I hired Fred Specktor to take my place. I came back in 1974. I was head of the International Motion Picture Department and still wanted to be president of the company. When I realized it wasn't going to happen, I decided to exercise my creative juices and be a producer, and I left in 1977. I didn't have a job, although I got one at Warner Brothers so quickly that I think the Morris office thought I left because I *did* have a job. The agency was unhappy, but they're always unhappy when you do that. The thing about William Morris was that they pretty much expected you to join for life. Leaving was a betrayal, and they turned your picture to the wall—like they did with Ovitz. But when they heard I'd made an overall deal to be a producer, it wasn't so bad. Two or three months later I became head of production at Warner Brothers. Now they were *proud* of me. Some of the first congratulatory letters I got were from people at William Morris. They were smart businessmen: If you left to run a studio, then you were a *buyer.* Your picture got turned back around a little bit.

• • •

SANFORD LIEBERSON has had a long and distinguished career producing many popular and award-winning films. He also cofounded Creative Management Associates, which eventually became International Creative Management, and was for a time president of production at Twentieth Century Fox, where he oversaw *Chariots of Fire, Nine to Five,*

Quest for Fire, and Akira Kurosawa's *Kagemusha,* among others. He still produces independently and teaches at the National Film and Television School in England. He lives in London.

RON MARDIGIAN left William Morris as a senior vice president of Motion Picture Literary, West Coast. He is now head of Mardigian Management and is on the faculty of the USC School of Cinema-Television, where he teaches "The Business of Writing."

JOE WIZAN was, in the eighties, president of Twentieth Century Fox. He currently produces movies (*Along Came a Spider*) and for a time had a radio show called *The A List,* on which, in a Charlie Rose–type format, he interviewed everyone who was anyone in show business.

RON DEBLASIO is president of Shankman/DeBlasio/Melina, a management and publishing company based in Los Angeles.

ROWLAND PERKINS cofounded Creative Artists Agency. After leaving in 1995, he became an independent producer of feature, TV, network, and cable films. Currently Mr. Perkins is chairman and also sits on the board of ieProducer.com, an integrated Internet company, and is president of ieProducer.com's wholly owned subsidiary Talentclick, an Internet company servicing the casting needs of the motion picture, television, legitimate theater, and commercial worlds.

BOB SHAPIRO became president of worldwide production at Warner Brothers. He is currently a producer (*Pee-wee's Big Adventure, Empire of the Sun, Black Beauty, My Favorite Martian*).

AMBITION

THE MAN WHO LOVED SHOW BUSINESS

General Artists Corporation, New York, 1962

SANDY GALLIN

I was born in Brooklyn, raised in Lawrence, Long Island. My mother was a housewife; my father was a builder. I was in love with show business. I always wanted to be Paul Anka, Fabian, Ricky Nelson. In high school I'd been offered a few record contracts, but I knew my mother was going to put her head in the oven if I didn't go to college. During my senior year at Boston University I finally realized that I wasn't a pretty boy, so I switched gears and decided I wanted to work behind the scenes in the entertainment industry. My fantasy was to live in Hollywood, be rich, have a big house, and have stars know me, like me, and recognize me on the street.

My cousin Ray Katz, a big-time manager with the firm that handled Jackie Gleason, Allan Sherman, Jack Carter, and Eva Gabor, said that if I wanted to learn about show business, the best place to start was a mailroom. William Morris was going to hire me, they said. I waited three weeks, then they told me I wasn't qualified. I cried hysterically. I was *very* disappointed.

I shared a dingy one-bedroom apartment in Forest Hills with my brother, his roommate, and my mother, who moved in because she was getting divorced. I took a job in Gimbel's training program. My rise was meteoric. In six weeks I got three raises and eventually made $375 a week. They announced I would be manager of the third and fourth

floors. When I got home that night, I got a call from Larry Louis, the controller at GAC, where I'd also applied to the mailroom. He said I could start on Monday for $50 a week. I didn't think twice. I was the happiest person in the world. The next morning I told my boss at Gimbel's I was leaving.

I was the first kid in the GAC mailroom training program and was happy as a clam, sorting and delivering mail and doing errands for the agents. At night I went to secretarial school for speed writing and typing. Within six or seven weeks I decided that I wanted to work for Abe Newborn in the Legit Department, or Buddy Howe, who was head of the whole company and ran the Variety Department; or Tony Ford, who was the head of Variety Television and Television Packaging. Eventually I chose Tony Ford because he serviced *The Ed Sullivan Show*. I became friendly with a secretary named Rose, who helped me convince Tony Ford's secretary to quit. Then Rose would ask Tony Ford to interview me.

When the time came, I told Tony I had graduated from Boston University and that I would be his slave. He said, "Well, I don't know if that would work."

I begged. I said, "I promise that I will not let you down and that I'll be here twenty-four hours a day, seven days a week, if you give me the opportunity."

He said yes—and then he made me keep my promise.

I was a great assistant but a horrible secretary. Tony dictated in the morning. While I rolled his calls, I dictated to Rose whatever he had dictated to me. She was a spectacular secretary, a great, hip girl. She could type a letter in two minutes. Anyway, it's not like the correspondence was difficult. It was like: "Dear Shirley MacLaine: Enclosed please find your three copies of *The Ed Sullivan Show* contract. Please sign and return two."

Because I serviced them when they appeared on TV, I got close to many of the very big stars: the Supremes, Nancy Sinatra, Phyllis Diller. After eight months, when GAC brought in some of the MCA agents and acts after MCA broke up, they made me a junior agent. I got all of the Goodson-Todman game shows and *The Tonight Show,* and I assisted Tony on *The Ed Sullivan Show, The Garry Moore Show*, and *Kraft Music Hall*.

Once, I went to see Paul Anka at the Waldorf-Astoria. I had a

104-degree fever. I wound up in the hospital with mononucleosis, and it got so bad, it turned into hepatitis. When I came back, I got a $150-a-week raise, which was unheard of, and they made me a full agent. It was 1963, and going to work was just like going to a party.

• • •

SANDY GALLIN became a senior vice president and board member of GAC, then ICM, before leaving in 1969 to pursue personal management and production for thirty-six years. Along the way he guided Cher, Joan Rivers, Whoopi Goldberg, Neil Diamond, Barbra Streisand, Mac Davis, Mariah Carey, Patti LaBelle, the Pointer Sisters, Michael Jackson, and Richard Pryor. He also produced twenty-one movies and thousands of hours of television—specials, series, and movies—and had a very successful production company with Dolly Parton. Gallin recently spent one year in Las Vegas as chairman and CEO of Mirage Entertainment and Sports. Today he produces Broadway shows (*Hedda Gabler, The Shape of Things*) and pursues his love of designing, building, and remodeling houses.

SONS OF THE TRIPLE CROSS

William Morris Agency, Los Angeles, 1961–1963

**BARRY DILLER, 1961 • JOHN HARTMANN, 1961 • GARY EBBINS, 1961 •
MICHAEL McLEAN, 1961 • LARRY FITZGERALD, 1962 • HERB NANAS, 1963 •
STAN ROSENFIELD, 1963**

*We called ourselves the Sons of the Triple Cross. Look at
the William Morris logo. There are four Xs. The first three
stand for WMA. The fourth stands for the truth—about
the other three.*
—*John Hartmann*

JOHN HARTMANN: I spent my Saturdays in Brantford, Ontario, at the movies. It cost a quarter. I'd see a cartoon, a newsreel, a serial, a feature, maybe a live stage show. I also acted in school.

My family eventually moved to Los Angeles. After Boston College I followed them on the last TWA prop flight between New York and the coast. It was the summer of 1959. I walked two steps down the gangway and looked around. I'd just left drizzly, dark, ugly old New York, and I was now in the middle of sunshine and pastel buildings. I became a Californian in that moment.

At home I shared a room with my younger brother Phil. He was in high school, and we collected funnies, then we'd try to crack each other up, tossing jokes and one-liners. When my father pounded on the wall—"Stop that laughing in there!"—we'd clamp the pillows over our faces. Phil imitated all the Jonathan Winters records—he could do it perfectly—and he could crack me up anytime. Even though he's gone now, I've always been his most hysterical fan.

I never expected to be a professional actor, but at Santa Monica College I ended up winning a couple of Best Supporting Actor awards, got an agent, and stumbled around to fruitless auditions. I blamed my agent for my lack of success. I was so upset that I decided to find out what an agent was *supposed* to do, and applied for a position in the William Morris mailroom.

I never heard back.

In 1961 I decided to move back to New York to rise from the streets and become a star. I was literally leaving the campus to drive east, with barely enough money to survive, when this older woman I'd befriended in class called out to me. I didn't want to stop. She ran after me. She said, "I heard you're going to New York to be an actor."

"Yeah, isn't it great?" I said uncertainly.

She said, "No! Don't do it. It's not for you. That's a terrible life. I know. My husband is an agent at William Morris." Then, "Have you ever thought of being an agent?"

"Well, actually, I applied there. Never heard back."

"Talk to my husband," she said. "He'll set up an interview."

It didn't take much to convince me.

For the interview I wore my one mohair suit, my chain-link watch, my pinkie ring, and my one good shirt with monogrammed initials. I didn't need a college degree; they were just looking for cheap manpower at fifty bucks a week. But once in the building, I saw the hustle and the bustle, and I was really excited.

BARRY DILLER: Of all my Beverly Hills kid interests, the entertainment business was the one I was *most* interested in. I interviewed with the very nice and mildly passive head of Personnel, Mr. Leff—he wore a bow tie—who'd done my family friend Danny Thomas the favor of meeting with me, and the greater favor of hiring me on the spot. I was nineteen.

GARRY EBBINS: My dad, Milt Ebbins, was a personal manager, and most of his clients were clients at the Morris office: Count Basie, Billy Eckstine, Sarah Vaughan, Peter Lawford, Mort Sahl, Vic Damone.

HARTMANN: Milt was the guy who dressed Marilyn Monroe for the night at Madison Square Garden when she sang "Happy Birthday, Mr. President." He went to the hotel and she was there, naked, and he had to help her into her dress. Imagine this little, bald Jewish guy down on his knees—she had no underwear on—shimmying her into the dress, looking right into her full frontal nudity.

EBBINS: My dad never had a real office. Instead he'd put on a suit and go to the Morris office. He'd spend hours making calls, stalking the halls. For a long time I thought my dad worked there. Sometimes I'd go with him. I got to know a lot of the agents, especially the boss, Mr. Lastfogel. He was about five foot three, and all the furniture in his office

was scaled down because of his height. I knew him as Uncle Abe. When I was little, I'd play on his office floor. Later my dad would leave me in the waiting area, and I'd talk to the switchboard operators and the receptionists.

I started working at the Morris office in the late 1950s, when I was fifteen. I wasn't thinking about being an agent; my dad just wanted me to earn my own money. I cleared $41.20 a week. Other guys in the mailroom were Frank Sinatra Jr.—for the summer; we were best friends—Joe Wizan, Sanford Lieberson, Marty Elfand. We all brought our lunch and ate it in the conference room, around the big table, and playacted about making deals. It got to be a ritual. The only tough part for me was that nobody else knew my name. They only knew me as "Milt's kid." For a while I didn't have an identity at all.

LARRY FITZGERALD: One of my best friends and I were in a band—he was the drummer, I was the bass player—and he moved from our hometown of Oakland, California, to New York City to be an actor. I followed him. We did summer stock in Massachusetts, then came back to New York. But I couldn't find a job, and I didn't like the city. To get home I drove the actress Vivian Vance's Caddy to Los Angeles. There I did odd jobs and had a pretty good time as a young bachelor. Robert Vaughn was part of our group. This was before *The Man from U.N.C.L.E.* One day he said, "Why don't you become an agent? I'm with William Morris. I'll call my guy over there."

His guy was Rowland Perkins. I got half an hour, which was a lot for a big agent. He explained that agents were basically salespeople. He said, "Do you think you'd like this?"

I said, "Sure."

He said, "Are you a college grad?"

"Oh, yes," I lied. "USC." Luckily nobody ever checked. Rowland told me I had to meet the Personnel people, Kathy Krugel and her boss, Ed Levy. Just to be safe, I also applied to the telephone company to be an installer. They made me take a big test, which I failed. Luckily, I got the Morris job.

MIKE MCLEAN: My parents were from Ogden, Utah. My mother did Busby Berkeley films and was the lead dancer in a sequence that won an Academy Award in a film called *The Great Ziegfeld*. My father started as a mailboy at the studios and worked himself into the Extra Casting De-

partment, then became a casting director. The last thirty-five years of his career he was the senior vice president in charge of talent at Twentieth Century Fox.

I had summer jobs in the Fox mailroom and as a tour guide. I worked in the Greens Department, landscaping. Show business was our life, but I went to Santa Monica College to study oceanography and marine biology, then I enlisted in the Coast Guard. When I got out, I needed a job. My dad called somebody at William Morris. During the interview Ed Levy asked me *really important* things, like "Can you drive a car?" Yeah, right. I figured the mailroom was a way to make some money and maybe find myself.

HERB NANAS: I'd done some off-Broadway, some summer stock as a teenager, then, on the spur of the moment, I went into the military with a bunch of guys from the Bronx. I'm from that PS 80 crowd on Mosholu Parkway: Penny Marshall, Ralph Lauren, Calvin Klein, Howard West, George Shapiro.

After the military I had a wife and three kids. I moved to Los Angeles. I was twenty-two. I wanted to act again and started a theater group on Vine Street called the Company of Angels with Vic Tayback. But we struggled because at the time the actor stereotype was all Troy Donahue, Tab Hunter, Rock Hudson—and we looked nothing like them.

The only person I knew in California was George Shapiro. He was like my older brother. George said, "Listen—you're a great hustler, you'd be a great agent. Lemme get you a job." George brought me in to meet Phil Weltman. He liked me, but he knew I had a family. He said, "How are you gonna be able to do this?" George thought fast. "His father will send him twenty-five bucks a week." That was it. The fifty dollars from William Morris and the twenty-five from my father made life livable. I gave my father's money to my wife, and it was enough to buy food for five people to eat for a week.

STAN ROSENFIELD: It seemed like there were three Jews in Oklahoma City, and they all lived on my block: Jay Bernstein, who became a huge publicist and manager; Alan Hirschfield, who eventually became president of Columbia Pictures; and me.

I was supposed to go be a stock underwriter. They're far more edgy than brokers, and that appealed to me. But in May 1962, after I'd spent a year in a candidate program, the stock market took its worst dive since

1929, and the company said, "Nothing personal, but don't come back." With that I went to California, figuring as long as I didn't have a job, I'd rather struggle there.

I lived in an apartment complex in Brentwood. I asked another tenant, Sandy Freidman, what he did. Sandy worked for a public relations company called Rogers and Cowan. Coincidentally, Jay Bernstein worked there. But PR had never seemed challenging or interesting, so I took a job at a computer accounting company. I'm sure they were all very nice people, but I couldn't stand any of them. They fired me after three months.

I considered law school, then someone suggested ad agencies. But they were difficult to get into if you were Jewish. I sent out résumés anyway, got a couple of calls. During one interview the guy suggested I try a theatrical agency.

I called the Morris office, filled out an application, let it sit on my table for three weeks, sent it in. One day, just like in the movies, the phone rang. A woman said, "Mr. Rosenfield, this is Jackie Secaris from Ed Levy's office."

I couldn't quite connect the dots. She said, "The William Morris Agency? You applied for a position in our training program? There is an opening. Would you like to come in?" Of course I would. She said, "Before you say yes, let me tell you that the job pays fifty-five dollars a week."

I did the math. I took the job.

THE MOLE

EBBINS: I spent one summer in the basement Photostat room making copies. Some of the guys nicknamed me the Mole.

One day a very sexily dressed young woman came down and said she was looking for the Mole. She said Pat Rothkins, from the Acts Department, had sent her. Rothkins was a real character who booked nightclubs and Vegas. He'd been an agent since vaudeville.

I said, "What can I do for you?"

She came right out with it: "I want to interview Frank Sinatra." She said Rothkins had told her the way to get to Sinatra was to get to me, in order to get to my dad, because my father and Frank were real close.

"Why?"

"I'm writing a book."

"Oh."

"And I will do anything to get you to help me."

"Anything?"

"Anything."

I was scared to death. Seventeen. Naive. Not exactly slick.

"Well . . . maybe we should, uh . . . have dinner or something," I said. God, I was pathetic.

We didn't have dinner. In fact, nothing happened. When Rothkins asked me about it, he said, "Whaddaya mean, nothing happened? Whaddaya talkin' about? *She was ready*. Kid, you blew it! I gave it to ya on a silver platter. What the fuck are ya doin'? Christ!"

THE FLY

EBBINS: I tried college for one year and decided I wanted to work at the Morris office full-time. My dad was not happy. My argument was, "Hey, did *you* finish school? Did Abe Lastfogel finish school?" Being a summer camper wasn't enough to get me in. I had to apply officially for the training program. Ed Levy and his assistant, Kathy Krugel, interviewed me. She had black hair, and she wore it up, well sprayed. We called her the Fly.

HARTMANN: She was a wreck, hyper, everywhere all the time. Hence her nickname.

EBBINS: The Fly was very straitlaced. We acted like we lived in a frat house. We made fun and terrorized her, down to throwing spitballs. Amazingly, the Fly secretly married a guy from the mailroom, Tom Krugel, and that caused some scandal. I have a vague picture of Tom as lanky and goofy.

ROSENFIELD: I was already gone when she married Tom, but I remember he was there when we would blast her, and he wouldn't say a word. Before that, I think the Fly actually lived with her mother, but she'd be the type who would. I remember looking for something in her drawer one day, and I came across a little notebook with entries that read "Tom Krugel was late today" and "Gary Ebbins was late getting back." Kathy

had an artificial, saccharine quality, and nothing could faze her. She probably was so repressed that . . . nah. I don't need a visit from Tom Krugel. If he was nuts enough to marry her, he's nuts enough to come after me.

CRUEL SHOES

HARTMANN: The guy hired just before me was Barry Diller. Diller was kind of introverted, *seemingly* cold, kind of sarcastic—as he's remained. But he and I were close for some reason. I could befriend anyone.

EBBINS: You had to be conservative at the Morris office. You could wear only blue or gray suits, and a sport jacket on Fridays. People shopped at Sy Devore, in Hollywood, and Tavelman's, an upscale Sy Devore in Beverly Hills. Diller prided himself on wearing clothes from Tavelman's. Who bought clothes from Tavelman's? Bankers.

HARTMANN: The guy hired before Diller was Terry Melcher, the son of Doris Day. Melcher was the spoiled brat of the group. He didn't have to do the grunt work like we did. He was anointed keeper of the film room instead. We were peons, but he had his own little office, where all the kinescopes were stored, and a desk. We had to be there at nine o'clock, but he could come waltzing in at ten-thirty with his coffee and dough- nut because there were morning meetings in the conference room, so no- body could watch films earlier. Melcher's habit was to sit in his office with his shoes off. If he had to get up, he'd slip them on and walk away. But not always. Once, he was out of the office in only his socks. Rumor has it that Barry Diller sneaked in and glued Melcher's shoes to the floor.

DILLER: Not true. It wasn't me.

HARTMANN: That was a rare practical joke. The William Morris mail- room was very much like West Point or freshman year at Harvard Law School. No one wanted to do anything that could get him into trouble, because it was very easy to get dumped. Guys were cut all the time. The other big concern was keeping your place in the lineup so that nobody got out of the mailroom before you. I remember being so paranoid when Larry Fitzgerald was hired. We were afraid he was somehow re- lated to JFK and would pass us all.

NANAS: I used to go to lunch with mailroom guys who'd been there

longer than me and try to convince them to quit. I told this one dope who'd been around three years: "You got a fucking Ph.D. in philosophy? You know what a stupid business this is? If I had that degree, I'd be out . . ." I worked him. "What are you gonna do, stay here for twenty-two years? I have no choice, but you . . ."

HARTMANN: I had a different agenda. The mailroom guy may be the lowest-paid in the building, but he still has infinite potential. There's a certain power and prestige in the possibility that he could run things one day. It made me feel like I had class, that I was somebody. I wanted everybody on my team because just by looking at who else was there with me, I figured I could win it all. I was handsome, intelligent, and charming. For obvious reasons I didn't announce my candidacy for greatness, but it was the first time I'd ever been so totally confident. I could be *Hartmann,* and everybody would buy it.

DILLER: My first day on the job I was so excited, it was like being blown out of a cannon. The only game I played was how to spend the least time on mail runs and the most time reading the files. My great strategy was to take what was seen as the worst job in the building— photocopying—in the worst place in the building, the dank basement, in a little room with the machines and a big, comfortable chair. I'd collect things to copy, along with as much of the file room as I could carry, and hole myself up for most of the day reading through the history of the entertainment business as seen through every deal, every development, every contract: for Elvis Presley, Milton Berle, Frank Sinatra, Marilyn Monroe, Garson Kanin, James Michener. I mean, you go to college to read, and that's what I did at William Morris. I read their entire file room. It took me three years. I didn't care whether I was noticed as much as I cared about learning as much as I could every day.

A LITTLE EXTRA ON THE SIDE

NANAS: The routine was that every few days you had to come in at six o'clock in the morning to sort the mailbags. We rotated. I went to the head of the mailroom and said, "I'll do it every day, and the other guys won't have to. Would you pay me overtime?" For some reason he agreed.

The first morning, at ten to seven, Phil Weltman came walking in. We said, "Good morning," then he went to his office. A half hour later he came back and checked his mail. The second morning there he was again. The third day, same thing. Then I figured out the game. The fourth day I came in at five-thirty in the morning, went through hundreds of fucking letters, and as he walked by I said, "Here's your mail, Mr. Weltman." He looked at me and said, "Oh, thanks."

Bingo. From then on, every morning, *bang,* the mail was in his hand. That was the beginning of our relationship.

At the end of every day I'd walk around the building and introduce myself to every agent. "Hey, how ya doin'? I'm Herbie Nanas, I'm in the mailroom. Can I hang out? Can I sit on your couch and listen to you?" Put me in a room with three strangers, and I'll be the one who talks. Weltman used to tell me to relax, but I was driven.

HARTMANN: I charmed the secretaries. Dated some. They can make you or break you. One of them was Regis Philbin's current wife, Joy. She was a wonderful girl.

SONS OF THE TRIPLE CROSS

FITZGERALD: William Morris considered itself a family, and the mailroom was where that sensibility first took hold. It mirrored the entertainment world on a smaller scale. Everyone knows it's a closed little unit, hard to get into, and there's a real bond between people. The mailroom was my fraternity, and through it I established friendships that have lasted forever.

EBBINS: Larry Fitzgerald, Hartmann, and I rented a house together in Laurel Canyon. This gets fuzzy—maybe Hartmann and I lived in one house, and then Fitzgerald and I lived in a different house. Anyway, I was a pot smoker in those days—which probably explains the fuzziness—and knew a gal named Arlene who booked the acts at the Whisky A Go-Go. One night we were up at the house Hartmann and I shared, and I had a little bit of grass in a plastic bag, hidden in a shoe. I said, "John, want to smoke some?"

Hartmann freaked out: "You've got to get rid of that. You're going to ruin my career. You cannot smoke that shit. If anybody found out, we'd get fired."

I rolled a joint anyway, then Arlene sat on Hartmann's chest and forced him to inhale. He'd never done anything like it in his life; his biggest vice was buying ten dollars' worth of candy at a drugstore before we went to the movies, because it was cheaper.

NANAS: I saw John Hartmann go to the fucking Twilight Zone. I sat with him in a room one day on an acid trip. I actually watched his brain leave his head. He said, "I'm going!" and was never the same ever again.

MCLEAN: I bonded with Gary Ebbins immediately. I hung out at his parents' house. We both loved the music business, and while we were in the mailroom, we put together a proposal to take over Twentieth Century Fox's dormant record label. We labored over it and were really proud of it. I bet we could have turned that label into something, but when it came to music, William Morris often said no.

One Friday night I had just cashed my forty-dollar paycheck. I went to a poker game and got shit-faced drunk. I lost all forty dollars in five minutes. I got up from the table and walked out through some French doors but forgot I was on the second floor. I fell off the balcony, hit a lamppost, and fractured my clavicle.

I remembered that Larry Fitzgerald had been a corpsman in the navy. God knows how I didn't kill somebody in the car, but I drove up to Ebbins and Fitzgerald's house, still shit-faced, knocked on the door, and said, "You guys gotta help me." They took me to UCLA. I was the happy drunk—until they set my shoulder. They said they heard me scream all the way out in ER reception.

Afterward they put me in one of their bedrooms at home. I snored so loud that I kept the whole house up. That they still fucking speak to me proves what good friends we are.

Ebbins and Fitzgerald and Hartmann and I still have an occasional dinner. We call our little group the Sons of the Triple Cross because of the logo on the Morris stationery.

HARTMANN: There are four *X*s. The first three stand for WMA. The fourth stands for the truth—about the other three.

EBBINS: Typically, it was Hartmann's idea.

THE ENDURING NAKED-ACTRESS FANTASY AND OTHER MISADVENTURES

FITZGERALD: We used to drive these gray Mercury Comets for dispatch runs. No air-conditioning, no heat. They were really trashed.

EBBINS: I still can't drive by the Morris office without remembering the time I pulled one of those rotten Comets into the parking lot with the entire backseat on fire from a cigarette I thought I'd flipped out the window.

ROSENFIELD: It's scary, but I still remember the license plate: JNV643. We had to gas the cars every day, at Red Man's Service. There were spies. If we didn't do it in the morning, the company knew.

EBBINS: Michael McLean and I had to take a couple of Oscars to be engraved at the Academy. We stopped by the Rexall Drugstore on La Cienega at Beverly Boulevard and took pictures of ourselves holding the Oscars in the twenty-five-cent photo booth.

ROSENFIELD: The big fantasy was that we'd deliver a script to an actress, and she'd be in a bathrobe and invite you in.

FITZGERALD: The closest I came was Natalie Wood in a bikini at her rented house on Summit Ridge Drive. Innocent enough, but still . . . She invited me in for some water, but I was so nervous that I said no and left as quickly as possible. I was an idiot.

ROSENFIELD: Actually, we knew a secretary at one of the studios who, word got out quick, had a thing for young guys. We would all stop by to see her, hoping she'd say, "Are they paying you enough to eat? Do you want to come over to my house for dinner?" I think McLean got lucky.

MCLEAN: I got lucky when I delivered to Kim Novak and she came to the door in an open robe, with nothing on underneath. I don't think that was an accident. I'm sure she looked out the window and thought, Oh, there's a young guy from the William Morris office, let me see what *this* does to him—just for fun. Some fun. I was dumbfounded. I probably limped back to the car.

EBBINS: Many of our errands weren't exactly orthodox. We used to pick up jars of chicken soup from the Hillcrest Country Club for Sam Weisbord, may he rest in peace. Once I bought some condoms for an

agent. But those were nothing compared with driving the comedienne Martha Raye's husband, Nick Condos, home. Condos had come to the office drunk. He was trashed; I mean drunker than shit. It was a little dicey because this guy was ranting and raving one minute about "these fucking agents," and the next minute he was crying.

FITZGERALD: I took a script to Spencer Tracy. I had gotten a ten-minute lecture about how I was supposed to go around the back to the gardener's shack and leave it with him. Well, I screwed up and knocked on the front door. Then I saw Katharine Hepburn through the window, doing the dishes. I thought, Oh, gosh, I'm getting fired. They really liked their privacy.

Hepburn came out, wiping her hands on a towel. She smiled, said, "Thank you very much," took the script, turned around, and called out, "Spensah. Spensah, your script is here."

EBBINS: One morning Michael McLean said, "It's a beautiful day today. Let's go to the beach."

MCLEAN: We hired Red Arrow Messenger Service to do our run. Then we took my boat out and had a day in the sun. But when we came back, we were in deep shit.

EBBINS: A check from Paramount Studios for Elvis Presley, for a million dollars, was missing.

MCLEAN: No one could actually cash the check, but we had to cop to what we had done.

EBBINS: We had to see Mr. Lastfogel, confess, and make our mea culpas. Neither of us got fired over it. I think the reason was obvious: Michael's dad was head of talent at Twentieth Century Fox. I was Milt's kid. For once it came in handy.

DRIVING MR. LASTFOGEL

EBBINS: Mr. Lastfogel's limo driver, Eddie Miller, used to disappear every now and then. I think he got drunk. When that happened, they'd get someone from the mailroom to drive the big black Caddy. One day they called me. The first stop was the Hillcrest Country Club, where Mr. Lastfogel had lunch, and then we went to MGM. We drove down Motor Avenue, not a straight or level road, and at some point I had to

hit the brakes. Mr. Lastfogel, sitting in the back, flew off the seat and onto the floor.

I panicked and said, "I'm sorry, Mr. Lastfogel!"

He said, "What's your name, son?"

"Gary Ebbins, sir."

"Ah, that's right. *Milt's kid*. Watch that, will ya?"

THE LETTER

FITZGERALD: My roommate, Bruce Johnson, had just gotten a job with a TV show shot on the Paramount lot. One day I saw in a trade publication a picture of a black guy—his name was Popcorn Wiley, a piano player—and he looked *exactly* like a black version of Bruce. I mean exactly. It was bizarre. I cut out the picture and I wrote a prank letter to Bruce on William Morris letterhead. It explained how I had seen him perform and thought he was fabulous, and I was going to do wonderful things for him. I signed it "Abe Lastfogel" and sent it to Bruce's office.

Bruce was new at Paramount, and their mailroom didn't know who he was yet. Since the letter had supposedly come from William Morris, they sent it back. But there was no agent's name on the envelope, so the Morris mailroom opened it and, seeing the Abe Lastfogel signature, sent it to his office.

He read it and was horrified.

Mr. Lastfogel decided to find out who had written the letter by having the FBI come in and test every one of our manual typewriters. They narrowed it down to mine. First I got called into Morris Stoller's office. He asked me if I knew anything about the letter, and I said, "Yes, sir. I wrote that letter."

"What?"

I explained that it was a joke written to my roommate, and that I certainly didn't mean to impugn Mr. Lastfogel's reputation or character. And gosh, I never expected that it would be returned. I was horribly apologetic and embarrassed. Stoller gave me a stern lecture, but to my surprise, he didn't fire me.

He said, "You're going to have to see Mr. Lastfogel. When he has time, he'll call you in."

He didn't have time for a couple days, and I just had to sit with my fear. Then I got the call.

Mr. Lastfogel wore his little bow tie and his glasses, and he sat behind his little desk. And he seemed gracious and charming, not mad. He said, "Larry, I've done a lot of investigating. I understand the intent of this and I know it was a joke. I just want to impress upon you the fact that you used my name. I have a certain reputation, and the William Morris Agency has a certain reputation. Some of the racial implications and the humor I find not very amusing."

He also told me he knew his wife liked me; I used to drive her around. Sometimes we'd just sit in the soda shop at the Beverly Wilshire and chat.

"I understand from Frances that she thinks you're a pretty good worker. She has asked me to talk to you but not to let you go." He paused. "I want you to go back to work. I'm hoping there will never be another incident like this, ever."

"No, sir, Mr. Lastfogel. There certainly won't be." I walked out of the office and almost passed out.

Frances Lastfogel never mentioned the incident.

ANOTHER STARTLING RESEMBLANCE

HARTMANN: I covered *The Ed Sullivan Show* when it came to Los Angeles for a few weeks. I could end up spending the day with acts ranging from Sophie Tucker to the Marquis Chimps. At one point I found myself standing in the wings as they walked the chimps offstage. I had to help. The trainers and I held hands with the chimps, and the chimps held hands with one another. Just then Judy Garland and her entourage came the other way. She'd never met me, didn't know I was a William Morris agent, but she'd been a client of our office for thirty years until a falling-out with Mr. Lastfogel—who was a very short guy. As she passed by she stopped right in front of me, looked down at my chimp, and said, "Hi, Abe."

IF LOOKS COULD KILL

MCLEAN: Phil Kellogg was head of the Motion Picture Department, and I had to pick up his tickets for the Academy Awards show and banquet. The tickets were printed in black and white. I photocopied them, mounted them on heavier stock, took a razor blade, and made a perforation so they'd tear. Then I called Cheri, a girl I had dated in high school, and said, "I've just forged tickets to the Academy Awards and the Governor's Ball. Do you want to go?" Before she answered, I added, "By the way, we could be arrested."

She said, "Yeah!" A beautiful girl.

We went to the Oscars. Phil Kellogg didn't show up, so we sat in his seats. We went to the banquet afterward, and Phil Kellogg *did* show up. Gary Ebbins was there—he had his father's tickets—so we sat at his table until the people whose seats Cheri and I were in showed up. We walked to the back of the room, and I said, "Cheri, the game may be up here."

We were standing at the bar, about to leave, when I saw Charlie Brackett, an old producer I had known when I was a mailboy at Fox. Charlie was the writer-producer of *Journey to the Center of the Earth, State Fair,* and *Sunset Boulevard.* He and his wife were leaving, so I introduced myself. He remembered me. He said his wife wasn't feeling well. I said this was our first time and we were sitting way at the back, so could I trade tickets with him? He gave me his tickets, and Cheri and I sat in front at a table with Sophia Loren, who had just won Best Actress for *Two Women.* She was there with her husband, Carlo Ponti. Maximilian Schell, who had won Best Actor for *Judgment at Nuremberg,* was also at the table, with his mother. He started hitting on Cheri.

I had a few drinks and asked Sophia to dance. She had on an ostrich-feather-boa kind of thing, and as we swirled around the dance floor I kept blowing the feathers out of her cleavage. She was in hysterics. Carlo Ponti stared daggers at me.

At the end of the evening all the waiters came out with what they called the Parade of Cakes. Each cake had a wax Oscar on top. I believe the penalty was death if the waiter didn't return with that wax Oscar, but I was able to steal one and give it to Cheri.

I've been to the Academy Awards a number of times since. I've been

there with clients. I've been nominated. It was never as much fun as going on those forged tickets.

EBBINS: Years later, when I managed Dwight Yoakam, I told him that story but said it was *me* dancing with Loren. Then Dwight, not knowing the truth, told the story to Michael and his wife, and Michael cracked up. When Michael and his wife were alone, she said, "Wasn't that *you* who danced with Sophia Loren?"

He said, "Yeah, but Ebbins and I have been friends for so long, we're telling each other's stories."

TO TELL THE TRUTH

DILLER: I had a terrible early experience. I was very naive. Somebody had stolen documents from William Morris and had leaked them to the press. This turned the office into a police state. I was called in to take a lie detector test. First they asked me if I'd ever taken anything home, and I said yes. They almost fired me right there, but they didn't. It was understood that reading the files was appropriate behavior for mailroomers. I had taken files home to read when I couldn't finish them during the day, and returned them with their confidentiality intact.

THE COLONEL AND ME

HARTMANN: After six months in the mailroom I was chosen to work for Colonel Tom Parker, who managed Elvis. The Colonel was an amazing character who never made a deal in which he didn't get something for free at the end. He'd say, "Okay, but I need one more thing . . ." When he signed Elvis to William Morris for films and television, the "one more thing" was a full-time guy on his staff, paid for by William Morris, plus a car paid for and insured by William Morris, and an office in the building that he could use anytime he wanted. Mr. Lastfogel told the Colonel he could have the guy and the car, but when it came to the office, he said, "Colonel, there's no office in this building good enough

for you except mine. Whenever you're in, come and use my office. I'll step aside for you."

Irv Schecter, who'd started in the mailroom before me, was the Colonel's full-time William Morris guy. When he went into the reserves for two weeks, the Colonel demanded someone to fill in. Ed Levy called me.

Every square inch of the Colonel's seven-room office suite at Paramount Pictures was covered with pictures of Elvis, from wallet size to near billboard size. The Colonel's office itself was full of pictures of him with heavyweights.

The Colonel had a bicycle-type horn on his desk. When he squeezed it, we'd all come running and line up in front of him. He'd say, "I've got Mr. So-and-So on the phone, and it's his birthday today, so we're going to sing him 'Happy Birthday.'" Then we'd sing into a microphone while he held up the receiver to a speaker.

My position was flunky. I aimed to please, and I did. I had to go to all the studios where Elvis had made pictures, pick up his fan mail, bring it back, read it. If there was anything unusual, I told the Colonel's secretary, Jim O'Brien, then packed up the letters and sent them to a warehouse in Madison, Tennessee. I also had to buy every newspaper and magazine and cut out anything written about Elvis and send it to the warehouse, where it was put into big scrapbooks that ultimately became a show that the Colonel toured through convention centers.

When my two weeks were up, I thanked the Colonel and said, "Irv will be back on Monday. Thank you for the opportunity. I hope to see you again someday."

He said, "Oh, no, Johnny. No, no. You can't leave."

I said, "Colonel, they're expecting me back."

"Don't worry, I'll handle it."

That was it. No more discussion. I was eager to return to the career I'd planned out for myself, but I wasn't able to debate the issue. Now the Colonel had *two guys* paid for by William Morris.

• • •

The Colonel played the game of celebrity like a magician. Every day he'd say to Jim O'Brien, "Give me the list," meaning the list with everyone's birthday on it. He also had a deal with RCA to get anything they manufactured for free, and he'd send radios, TVs, fridges to placate the nerve center of not just Hollywood but politicians, senators, governors,

sports celebrities. Anybody who was a star of any sort got this treatment. It was a lot of work.

Each year the Colonel also sent a Christmas greeting from him and Elvis. And he was big on calendars because he knew people kept them all year. As Christmas approached we had to address manila envelopes to all the celebrities and politicians, and the Colonel filled them with goodies. But we kept having to reopen the envelopes because he kept adding things, like one of those little sticks that you rub with another stick and the propeller goes around.

The envelopes were saved in big trunks. Just before Christmas we had to deliver them all at once to the Paramount mailroom. To the Colonel it was a big joke: "The mailroom guys are gonna shit when all this stuff gets down there!"

• • •

I was more or less the Colonel's slave. When he moved homes but wouldn't hire professional movers, Irv and I had to cart everything out of the apartment except the furniture—but only because the place had come furnished. The highlight was finding a gold lamé jacket in his closet. I put it on for a thrill.

The Colonel also had a house in Palm Springs, where his wife lived. She was bored, especially when he went to Las Vegas to gamble. He'd make Irv and me go to Palm Springs and play Parcheesi with his wife on the weekend.

• • •

I wanted to go back to William Morris before I had no career. I told Tom Diskin, the Colonel's longtime associate from his carny days, "I've got to get out of here."

Eventually the Colonel called me in and said, "Thank you" and "Good job." Because I was leaving, I mustered some courage and said, "So, if you're the Colonel, are we privates?"

"No," he said. "You guys are nothing."

THE PERFECT PLAY

NANAS: When Barry Diller moved from Weltman's desk to Joe Wizan's, Weltman had a woman secretary for two or three months, then me.

Weltman had a special thing for me. I always believed I was a winner, and he made me feel that even more. So I did a great double cross to show him how I felt.

Ron Mardigian was a terrific agent; he was mellow and always had great clients. He worked for Mike Zimmering, the head of the Literary Department. Mardigian walked by my desk one night and said, "We had a meeting, and we're either gonna bring in someone from outside, or if we go inside, we want to bring you in as a junior agent."

I didn't realize then that Literary was the basis of all of show business. No script, no movie—no nothing. I still wanted to handle the biggest star in the world. I said nothing. Mardigian said, "Just think about it." I waited a day, then said, "I'm in." He asked me to meet with Zimmering, who asked, "Do you like to read?"

I said, "Yes." In truth I don't think I'd read my first book until I was in my thirties. I read screenplays before I read books. Mardigian and Zimmering were all excited. A week later Zimmering went into Weltman's office to say, "Phil, I know you love this kid, but let me have him in the Literary Department."

Weltman would think it was what I wanted, because every day I pestered him, "Hey, Phil, when you gonna make me a fucking agent? I'm a better salesman than all these guys." Years later he used to say to Meyer and Ovitz, "This stupid kid always had to do it his way, but he was a better agent than all you fucking guys ever were."

Weltman called me in. He gave me the speech: "The Literary Department likes you a lot. I think it's a great opportunity. I think you'd be sensational. You should take some time to think about it."

"I don't need to," I said.

"What do you mean?"

"You know what, Phil?" I said. "You brought me into the business. You've been a talent guy all your life. You're my guy. Do I want to be an agent tomorrow? Yes. But I'll wait and I'll sacrifice until I can be an agent in your department, not Mike Zimmering's department."

The next morning Sam Saks, the head attorney, walked by my desk. He said, "Good move." Sam Weisbord walked in, put his arm on me, and said, "I'm glad you're not in Literary." Mardigian came by and said, "You fucking set me up, you little cocksucker."

I did. I did set him up. It was a perfect play.

Working the system from the bottom up was all about those moves.

When you're a secretary on the first floor and you look at the players, you realize that's where the power is. These guys decide when you get paid, when you don't get paid, how you get your raises, where your career goes. That's when I realized that the only power in Hollywood is money and the talent you control.

DIASPORA

FITZGERALD: After the mailroom and Dispatch, I floated for a while, hoping to work for one of the movie guys. Instead I was assigned to Milton Berle, who had an office in the building. He and his cronies were in there all the time, smoking cigars. He wasn't a real pleasant guy, and I was treated like a schmuck kid. Then they put me with Marshall Berle, his nephew. Marshall was a music agent. I'll never forget him pleading with Morris Stoller to send him to London. He'd heard about a band there that was making everyone berserk. He wanted to try and sign them to William Morris, but the company wouldn't let him fly to London. For the Beatles.

EBBINS: Unfortunately, the Morris office said no too many times. When John Hartmann became an agent, he went to San Francisco and came back on fire. He said the next big music explosion would come from Haight-Ashbury. "We should open a Morris office there now." He was right on the money. And they said no, just like they said no to the Beatles.

HARTMANN: By the time I came back from the Colonel, I had learned speed writing and taught myself how to type. I ended up temping for Sy Marsh, a movie agent. His big client was Sammy Davis Jr. at the height of the Rat Pack. Marsh was kind of a frustrated comedian, and I was his best audience. He decided I should stay permanently. I did, for several months, but eventually everyone realized we were having far too much fun. I went back into the floating pool, and Sy took a girl. I had an affair with that girl.

Next I floated for Jules Sharr, head of the Variety TV Department. It was a huge business. The guys who worked there were George Shapiro, Elliot Wax, and Fred Apollo. Sharr was a terror. He yelled and screamed and threw stuff, and lived on the edge of anger all the time, meticulously clean, and very precise. He'd come around the corner every day at

the same time, and I had to have coffee and a bran muffin ready. Then I'd pull the phone sheet out of the typewriter. If there were more than two calls there, he'd go, "Oh, fuck, it's one of those days!" His big clients were George Chakiris, Jane Powell, Burl Ives—actor-singer-dancer types. He'd go into his office, drink his coffee and eat his muffin, and read the trades, *Variety* and *Hollywood Reporter*. Every time a call came in, he'd make a note of how many times the phone rang.

After a couple days of this I told Ed Levy in Personnel that I wanted to work for Sharr permanently. He said, "Are you kidding? Everybody who works for him leaves crying." Sharr also found it hard to believe, but I started the next day, a full-time secretary again, with a desk of my own. For six months the guy tried everything to break me. I met him at the line every time. Once, I had to yell at him, and that seemed to earn his respect. From then on we were more like partners.

In the wake of the MCA breakup Sharr was offered a job as head of all variety at IFA, the company created from the merger of Famous Artists and International Artists Agency. He took it. Fred Apollo and George Shapiro became the coheads of the department. Shapiro brought in his boyhood friend Howard West. Before he left, Sharr told Phil Weltman, "Promote the kid, he's ready." Weltman called me in and interviewed me. He was probably only vaguely aware of who I was, but when I walked out that night, I was a junior agent. It was the biggest achievement of my life.

DILLER: I was an assistant agent, but since I had never had or signed a client, I doubt any halfway self-respecting agent would say I passed the bar. In fact, I can't say I really *wanted* to become an agent. I was only after the education.

I left in 1965 to join ABC as assistant to the head of programming. But the years at William Morris gave me my beginning, and every day at the beginning remains a vital and enduring lesson.

EBBINS: I was in the mailroom for so long that the running joke was that I was the only mailboy with profit sharing. I never became an assistant. Part of me wanted to be an agent, part didn't. But the idea of being a secretary for a few *more* years didn't appeal at all. Plus, the Morris office had been so much a part of my life that I felt I could never become my own person in that environment. Unless I got out of there, I was going to be Milt's kid forever.

MCLEAN: I left William Morris when I was still in the mailroom to

take a job in casting. I don't think they missed me. I was just another body, and after the incident where we hired the Red Arrow Messenger Service and went to the beach, they were probably going, "Oh, good, we got rid of Owen McLean's son without having to fire him!"

I later discovered I got the casting job because the head of the department didn't like children. They were about to do *The Sound of Music,* and he didn't want to interview the kids for the von Trapp family, so he hired me to find the seven singing, dancing von Trapps.

Gary Ebbins became a manager. He handled Chad and Jeremy and the Buckinghams. When I cast the *Batman* TV show, I hired Chad and Jeremy to be guest stars. There was always a crossover between us.

My whole life has been that way. Somebody says, "You want to try something? I think you might like this . . . ," and I've just very successfully fallen into things.

ROSENFIELD: When the new "black tower" office building at Universal Studios was going up, you couldn't get on the lot to deliver mail. So we took our stuff to the Universal mailroom, and they would distribute it for us. We didn't tell Ed Levy or the Fly that was the deal; they wouldn't have understood.

One Friday the thirteenth I had the San Fernando Valley run. The Fly said I had to see an agent, Joe Schoenfeld, before I left, because he had an urgent letter he needed delivered to Universal. The studio was to be my first stop. When I got there, I told the mailroom guy, "This is *really* important, can you take care of it?" Yes, okay. Got to the next stop, Disney, and they said to call my dispatcher. It was the Fly, and she said, "We're pulling you off the run. Come back right away." I knew I was in trouble, and I knew why. I figured I'd get a ten-minute ass chewing and then go back to business at usual.

Ed Levy started in on his lecture, and I had answers for everything. He got really pissed off and finally said, "It doesn't really matter, because you're through. You're outta here."

I was devastated—and did a dumb thing: I left the building. By the time I thought to call anyone to appeal, it was too late. Schoenfeld had gotten his ounce of flesh, and that was that.

The next day I ran into Barry Diller at Ben's of Hollywood, the hairstylist we all went to. Ben Ogus, the owner, gave trainees a special rate, knowing that when we started to make money, we'd come back and generate new business. Diller said, "I heard what happened. It's too bad."

I said, "Yeah, it is. And what really hurts is that not one guy came to my defense."

"You don't understand," he said. "You're out of the way. Now everybody is one step closer to getting out of the mailroom."

He was right, and it pissed me off. I wrote a letter to Mr. Lastfogel and copied Morris Stoller, Doris Levitt, Stan Kamen, and the head of the New York office. I said that I had been fired without being heard and that I didn't think I had done anything wrong. I said I'd like them to hear my story. The letter created so much intraoffice turmoil that any chance I'd ever had of being hired back evaporated. The weekly memo of staff additions and deletions didn't even list my name.

• • •

BARRY DILLER is currently chairman and CEO of the Universal entertainment group, with responsibility for Universal Studios, the film and TV operations, and theme parks. He is also chairman and CEO of USA Interactive. Diller has headed Paramount and Fox, invented TV's "movie of the week," and generally made a name for himself in show business.

JOHN HARTMANN has worn many hats, from high-powered talent manager to his current job as president of Topanga Pictures.

GARY EBBINS is a personal manager, representing country singer and actor Dwight Yoakam.

MICHAEL MCLEAN spent twenty years as a casting director and counts among his credits *The Sound of Music, Butch Cassidy and the Sundance Kid, Patton,* and numerous other movies. He is also a personal manager for talent that includes Dennis Hopper, Paul "Pee-wee Herman" Reubens, Armand Assante, Nicole Kidman, and Peta Wilson, as well as the late musician-songwriter John Phillips of the Mamas and Papas.

LARRY FITZGERALD is president of the Fitzgerald Hartley Company, based in Nashville, a management firm that represents country star Vince Gill among others. They are also involved in music, TV, and film production.

HERB NANAS is president of Mores/Nanas/Hart Entertainment. He produces films and manages actors.

STAN ROSENFIELD is the owner and president of Stan Rosenfield and Associates, "the entertainment industry's leading—if not the best—public relations company."

EVERYBODY LOVES RONNIE

Paul Kohner Agency, Los Angeles, 1963

RON MEYER

I've lived my whole life in Los Angeles. My house was on Pandora, a narrow little street off Beverly Glen, near the Twentieth Century Fox studios. In those days Fox extended as far north as Little Santa Monica Boulevard and covered all of where Century City is now. It was a huge back lot and an extraordinary place. When they filmed a movie, I could see the lights from my house. If it was a war movie, I could hear the explosions.

On weekends, when I was probably twelve or thirteen—this was 1956—friends and I would climb over or under the Fox fence, or get clippers and cut a hole in it, and wander around the lot. I guess that's where my interest in the entertainment business started, except for two things: I didn't really know about the business part, and I didn't go to the movies much because we couldn't afford it. My father was a traveling dress salesman. My mom was basically a housewife. They came from Germany, and although they were fascinated with movie stars, the closest we got were telethons sometimes held at the Carthage Circle Theater, on Olympic near Crescent Heights. I'd go with my father to get autographs.

When I was seventeen I joined the Marine Corps. At some point I got the measles and was quarantined. To pass the time, my father sent me a couple of books to read, and both had a great influence on me.

The first was *The Amboy Dukes*, about that era's version of street

gangs. They were certainly nothing like gangs today, so I don't mean to glamorize, but I *was* one of those guys: a high school dropout who thought he was tough and was always in trouble. I related to the torn jeans and the fighting.

The other book, *The Flesh Peddlers,* by Stephen Longstreet, was a story about a young guy in the talent agency business. He drove a fast car, worked for a fictitious company called COK—for Company of Kings—like William Morris or MCA, made big money, and lived a glamorous life. It took place a little after the *What Makes Sammy Run?* era, but the stories were different. Sammy Glick was not an attractive character to me; this kid was. I don't remember how the book ends anymore*, but what impressed me then was that the entertainment business seemed like a way for me to make a buck. When I got out of the marines in 1963, I went looking for a show business job. I combed through the yellow pages and went to every agency, literally door-to-door, in my one suit, which didn't fit very well, saying I'd just gotten out of the service, hoping people would relate to me. No one would hire me.

In the meantime I had to make money, so I sold shoes, was a short-order cook, cleaned duplicating machines. I was selling suits at Zeidler and Zeidler when a friend of a friend's in-law got me an interview with Walter Kohner, the brother of Paul Kohner, who had his own talent agency. Kohner was a small company on Sunset Boulevard; they represented Lana Turner, Charles Boyer, Maurice Chevalier, William Wyler, John Huston, Billy Wilder, Ingmar Bergman, Jean-Paul Belmondo, Ursula Andress, Charles Bronson. In other words, he was a premier international agent with a great list.

Walter Kohner was very nice, but he said, "We already have a young guy who's been working with us for many years." I said I'd clean toilets, whatever there was to do. The kid in *The Flesh Peddlers* had inspired me with a vision, and I just wanted to be in show business. But when Kohner said no, then *everybody* had said no, and I thought it was over with.

Maybe a month later, out of the blue, Walter Kohner called me. He said he'd remembered "a guy named Ron" who worked at Zeidler and

*The main character, Gary James, rises meteorically at COK but leaves the company when, while having to decide between the seduction of his career and doing the right thing, he realizes he doesn't like who he's become.

Zeidler. Kohner didn't recall how he'd met me, but he said that their mailroom guy had just quit and they needed someone desperately. Did I want the job? Kohner offered me sixty-five bucks a week and said they'd pay for my lunch. I couldn't believe it. I was working on commission and made probably thirty bucks a week. I lived in an apartment that cost fifty bucks a month, and made my rent by saving my lunch money. That was on a Friday. I quit on the spot and started at Kohner on Monday.

From early in the morning until late at night, sometimes seven days a week, I did everything. Mailroom. Messenger. Kohner had a Cadillac; he'd get in the back, and I'd drive him everywhere. Once, I drove him to Cuernavaca, Mexico. When Kohner left town and needed someone to house-sit, I did it. I walked his secretary's dog every day. I was a switchboard operator. I drove around picking up checks. I delivered scripts. I got people at the airport and took packages there, like the first Federal Express courier. There were no metal detectors, so I'd walk to the plane and explain that I was a messenger for a theatrical agency and that if they would take the script to Europe, someone for Maurice Chevalier or Charles Boyer, or whoever, would pick it up on the other end. I'd say they could read the script and see that it wasn't contraband.

In other words, I did whatever job they wanted done. There was never any thought of *my* life. But I had a great time. Part of it was good people skills. I could talk to anyone, like my father the salesman. But I was also very protective; I would never do anything over the edge. The clients knew they could depend on me. I became well known within the agency as the go-to person.

My direct boss was Kohner's secretary, Irene Heyman. She was a really tough taskmaster. When I did something wrong, she'd yell at me, embarrass me, like a drill instructor who could reduce someone to tears.

After I'd been at Kohner about three years—and was still the lowest-paid person—I had a meltdown. As Irene shrieked at me about something I finally broke and said, "Take this job and stick it up your ass. Go fuck yourself." I believed the office couldn't live without me because I was the best messenger on the planet. I could do alone what years later it took the entire CAA mailroom to do.

I had said it loud enough so that everyone in the place heard me . . . because what I really wanted was someone to run up to me and tell me

they loved me. No one did. So I got up, grabbed my coat, and walked out onto Sunset Boulevard. I lingered, waiting for someone to come out and apologize, to give me a raise, to beg me to stay—you know, change my life. Nobody came. I started walking slowly to my car in the Schwabb's parking lot. Still no one came. I waited by my car for a half hour. Nobody came. *Nobody came.* I got scared. I realized that they weren't concerned about my coming back. They'd just hire somebody else. Apparently only *I* thought I was brilliant and that they couldn't live without me.

I was at a crossroads: either get another job or go back—if they'd even take me. I went back. Irene was still at her desk. I started filing again, like nothing had ever happened—and that was that.

They just let it go.

I'd been at Kohner four years when I decided I couldn't do the same job forever. Kohner had said to me, "You'll be an agent here," but I knew the reality. There were two parts of the agency: Kohner and his great clients, and his brother and Carl Forrest, who worked on commission. They had to represent a great assortment of people in order to make money, mostly European actors who did day parts. I really didn't know where I'd fit in.

I said, "If I'm going to be an agent, I've got to have somebody doing my job," and I convinced them to let me bring in another person to work in the mailroom under me, to free me up to be part mailboy, part messenger, part agent. Robert Stein was a friend. Our families were very close; also European, similar background. He's with William Morris now.

My career as an agent there never turned into much, as I'd always known. If I wanted to grow, I had to leave. But I was afraid. It's like that joke about the circus guy cleaning up after the elephants. They say, "If you hate it so much, why do you do it?" He says, "What, and get out of show business?" But I couldn't shake myself loose. I was living well, making seventy-five bucks a week and a free lunch; I even met girls at the medical center next door. In many ways it was paradise. But the handwriting was on the wall, so I looked for opportunities. I wanted to work at CMA, but they weren't interested. Then I wanted William Morris. I knew a guy there, Paul Flaherty, a publicist and a very nice fellow who I used to see at the studios when I picked up checks. He was an agent. I begged him to get me an interview. He set up a meeting that

started a dialogue between me and Phil Weltman. For my whole life I'll be grateful.

Over a six-month period Phil and I met often. They had never hired anyone from the outside to be an agent, but in 1969 he took me on as a talent agent in the TV Guest-Shot Department.

Once I was in, I thought I would spend the rest of my career there. I really believed that. It was a big, powerful agency, an institution, and it felt like I had found a place where I could grow.

Phil Weltman was an extraordinary guy, an amazing man. He loved the agency business. He was tough on me, too—but not like Irene. His heart and soul were into nurturing young people. That's nurturing in the truest way. I learned a lot from Kohner, but he didn't mentor me. He was not a guy to sit and teach; you had to pick it up wherever you could. Phil and I spent a lot of time together and became very close. We even went to baseball games. It was very much father and son—though it was always "Mr. Weltman," even at the ball games. If my hair got too long, he'd send me home and say, "Don't come back until your hair is cut." I had to wear a suit and tie every day.

To the day he died we had a connection. It was just one of those things. I guess we just loved each other. He certainly gave me great confidence in myself and in my ability to succeed.

At Kohner I'd been to "agent college" for six years and gotten a real education. I completely understood the agent's role and the agent's responsibility, and I knew my way around town. I knew what to do and what not to do. But that didn't qualify me to *be* an agent. It's hard to say what makes someone qualified. There's much more to it than just knowing the lingo and knowing your way. The joke is that agents have no soul. But in truth, to be a good agent, you have to have a lot of soul. You don't get that in the mailroom. You either have it or you don't have it. If you're a bum, you're a bum all the time. To really be successful and do it right, you have to care seven days a week, twenty-four hours a day. There are a lot of good deal makers; there are not a lot of people who are good at caring. You don't grow into caring.

Kohner was never political; the Morris office was, and by the time I realized how much so, I understood I'd never win and I had to get out of

there. I had started disliking people I worked with. I didn't like the way Sam Weisbord treated Phil Weltman. Yet I didn't want to go out on my own, so in 1974 I convinced Mike Ovitz that he and I should start a company—Creative Artists Agency. With Mike Rosenfeld, Rowland Perkins, and Bill Haber there were five of us, so it wasn't very complicated. The first office was in what they called the Hong Kong Bank building, on Wilshire and Rexford. We had five offices and a conference room, and a little closet as a mailroom. Mike Menchel was our first full-time trainee.

I was important in developing the philosophy behind the service CAA required and expected. People had to be honest and work hard and to care. Nothing very complicated, unless you don't have those qualities. I used to tell people in the mailroom that assumption is the mother of all fuckups, and if you fuck up, you'll be judged on that much more than the work you do. For instance, suppose your boss tells you, "Get me a tuna on rye with ketchup, and get it from Louis's Deli. I get the same sandwich every day." When you get there Louis is standing at the door saying, "Here it is!" You'd better open it and peek in and make sure there's ketchup, because if you assume that Louis did what he's supposed to do—which most of the time he doesn't; most people don't—and you bring it back and it's got mayonnaise—which is what people usually put on tuna sandwiches—your boss isn't going to blame Louis. He's going to think you're an idiot.

Working hard and getting noticed is great, but most bosses couldn't care less. It's the fuckup they remember, even if the actual circumstances are forgotten. Do what you say you're going to do. People may not always appreciate that you do, but they will always *remember* that you didn't.

At CAA we spent a lot of time with the trainees. We talked to them often, we interviewed them intensively. The first five years, Mike Rosenfeld, Ray Kurtzman, and I spent a lot of time making sure the people we liked were people we thought would fit in with us. Probably more than anything we were looking for a personality type. Someone who could communicate. In this business you've got to be a salesman, and you start by selling yourself. If you can't, it's pretty hard to go out and sell others. Even if you're not consciously selling yourself, just having a distinct personality and a certain warmth helps the interviewer realize that you might be the right stuff.

A lot of people can't stick it out in the mailroom. But you can't move kids through too fast, because you want them to be educated. You want them to understand the business. Of course, none of the people in the mailroom think they're moving too fast; they all think they're moving too slow, and they probably are. In a three-year period there's probably one year during which they are way overqualified. But you need to make sure a trainee has endurance. You don't want to invest the time and money into training somebody and then have him go to work at another company or find a different career. You want people who love what they're doing.

It's also a young person's business. You don't want thirty-five-year-old trainees. If they're too old, they're not going to tolerate it—and shouldn't. You need kids fresh out of college who can live in an apartment three at a time.

The guys who run CAA now were all mailroom people. Richard Lovett, particularly, was a quality guy the day I hired him; and he's a quality guy today.

The kids in the mailroom are your future.

• • •

RON MEYER, Michael Ovitz, Mike Rosenfeld, Rowland Perkins, and Bill Haber left William Morris to form the Creative Artists Agency. Twenty years later the founders had all departed. Meyer joined Universal (then a division of Seagram, then of Vivendi) and is currently chairman of Universal Studios.

AMBITION

William Morris Agency, New York, 1961–1967

**STEVE PINKUS, 1961 • WALLY AMOS, 1961 • SCOTT SHUKAT, 1962 •
DAVID GEFFEN, 1964 • DAVID KREBS, 1964 • ELLIOT ROBERTS, 1965 •
JEFF WALD, 1965 • PETER LAMPACK, 1967**

*I don't think the rules of ambition have changed. If you want
to succeed, you'd better not care too much about what other
people think about what you're doing.*
—David Geffen

Failure is the only modern disgrace.
—*from* The Flesh Peddlers: A Novel About a Talent Agency,
Stephen Longstreet, 1962

WALLY AMOS: I got out of the air force in September 1957 and came to New York. My plan was to live in Hawaii, where I was once stationed, but one thing led to another, and I got married and was stuck. I needed a job.

A friend told me to check out the Collegiate Secretarial Institute, owned by Sadie Brown. She came to work in a limousine. Always wore black. Strong, bright, sensitive, maybe five feet tall. Collegiate had their own placement service, and if you showed Sadie that you were industrious, she'd do anything to support you. Through her I got a temporary job at Saks, unloading trucks and working in the Supply Department at Christmas. I was one of the better workers, and the department manager asked me to stay, and when he got transferred, he recommended me to be manager.

In 1961, after four years at Saks, I made eighty-five dollars a week. I had a little gold executive card that gave me some status. I got a 30 percent discount on as-is stuff. But I needed more money. I had a two-year-old son, and my wife was pregnant with our second child. I'd done a great job. I had a great personality. Everybody liked me, so I asked for a ten-dollar-a-week raise.

They said no.

I told them if they didn't give me at least a five-dollar-a-week raise, I would leave. They said, "Wally, we can't do it."

My brother was a handyman, and I worked with him for a while. I considered the sanitation department—those guys made a hundred and twenty-five a week—but in New York the smell of garbage in the summertime was not appealing. I thought I'd drive a cab, but as I filled out the application I realized I didn't want to drive a cab, so I threw it in the rubbish. I sold vacuum cleaners. I sold mutual funds. I took the New York State insurance exam to sell life insurance. While I waited for the results, I went back to Collegiate and they promised to find me something. Finally they did. The civil rights groups were applying pressure to the theatrical agencies to hire blacks. They had a lot of black acts and no black agents. I was sent to William Morris for an interview.

I had no idea about show business; I just needed a job. I was a high school dropout with a GED. Sid Feinberg in Personnel said they only wanted trainees with college degrees. But he thought I had potential, so if it was okay with Howard Hausman, the executive vice president, I'd get the job. He approved. The pay was fifty-three dollars a week, but by going back to school on the GI Bill to brush up on my secretarial skills, I got a supplement of fifty dollars a week.

STEVE PINKUS: We lived in a poverty belt in Brooklyn, and everyone in the family had to work. Through school I got to choose between a job at a printing company or the Theatre Guild. The latter was made up of the biggest Broadway producers, and they owned a TV show called *The U.S. Steel Hour*. The choice was obvious.

From 1954 to 1958 I worked there after school, on Saturdays, and on vacations. I was a little kid, only four eleven; I started when I was thirteen. Lawrence Langner—he coproduced *Oklahoma!* and helped create American musical theater—took care of me. I got to work for Katharine Hepburn on Saturdays, watering her plants. I was Judy Holliday's baby-sitter. Before he made big money, every once in a while James Dean came home with me to Brooklyn. The guild also sent me over to *The U.S. Steel Hour* every other week, and I learned a bit about television.

When I got out of the navy on January 18, 1961, Langner called Nat Lefkowitz, the president of William Morris, and said, "I have a young man here who's going to take your job." Lefkowitz hired me. I was twenty. I had to be there at nine; I got there at six-thirty. I knew I was in the right spot.

SCOTT SHUKAT: I was born in Brooklyn, too. I went to the High

School of Performing Arts, then Columbia. I acted, studied history and music, and graduated in 1958. Did summer stock. Studied with Herbert Bergoff and Sandy Meisner. Got an Equity card. Played at Jilly's and Pillow Talk in New York. I was one of the first acts at the Playboy Club in Chicago. But the work was unpredictable, so I got a job at CBS Television, in their mailroom. Going up and down the elevators all day made me sick to my stomach half the time, so I quit and went back to acting.

After I got out of the army, I went back to performing and got really far down the line in the auditions to replace Bobby Morse in *How to Succeed in Business without Really Trying*. I thought things might go my way, but I got cut. I stood in the long hallway of the Forty-sixth Street Theater, crying and thinking, I don't know if I have the guts to do this anymore.

One night as I played piano at Jilly's, a guy named Dennis Paget, from the Morris office, sat at the bar, and we got into a conversation on my break. He said, "You're gonna do this for the rest of your life?" I said, "I don't know. I'm a little mixed up right now." He said, "Well, if you're college-educated, you can go over to the Morris office and maybe start in the mailroom."

Ironically, I had been to William Morris earlier that year to play some of my original comedy songs for Larry Auerbach. I sang "Please Don't Sing Along with Me," which was a parody of Mitch Miller, whose NBC show Larry handled. He offered to sign me as a writer. I didn't think I'd feel comfortable just doing that special material, so I didn't sign. I still wonder what would have happened if I had.

At the Morris office I met with Neil Felton in Personnel. Nice guy. Australian. He said, "You're hired. You can start Monday." There was only one problem: The pay was fifty dollars a week. I told him I was married and couldn't live on that. "What I'd like to propose is that you allow me to work on the weekends, playing bar mitzvahs, clubs, and wedding dates." He agreed, and that's how I made another two hundred dollars a week.

DAVID GEFFEN: In 1963, when I was nineteen years old, I got a job quite by accident as an usher at CBS Television City, in Hollywood. The first day I was assigned to *The Judy Garland Show,* she had Barbra Streisand and Ethel Merman as her guests. I thought, Wow, I'd pay

them for this job. It was the greatest job I'd ever had. That was the beginning of my career in show business.

Of course, I didn't think of it that way then. This was just an usher's job that *happened* to be in show business. But from that job I got another, in New York, at Keefe Brasselle's company, Richelieu Productions. Their series *The Reporter* hired me as a receptionist. I got fired, but I asked a casting director there I'd befriended, Alex Gordon, if she could recommend another job. She asked what experience I had and what I knew about anything.

I said, "I don't have *any* experience and don't know *anything*."

"Oh, well," she said. "You could be an agent."

She referred me to the Ashley-Famous Agency.

I met with Al Ashley, brother of Ted Ashley, who owned the agency. Al looked at my résumé, which was completely accurate—I listed all my jobs, wrote that I hadn't graduated from college—and he said it was terrible, that he'd never hire a person like me.

I felt bad I didn't get the job, but I didn't take it personally. My first thought was, Oh, this résumé is a mistake. Next time I'll give them *exactly* what they want. So I made up a new one. Now I had a *college degree* in theater arts from UCLA, and I'd worked as a *production assistant* on Danny Kaye's and Judy Garland's shows. I also made myself two years older, because I was actually too young to have had all those credits. Then I made an appointment with the William Morris Agency and gave them my perfect résumé.

Neil Felton interviewed me. He was very impressed with my résumé, as he should have been. It was designed to be impressive. He hired me instantly.

DAVID KREBS: I'm from Sheepshead Bay, Brooklyn. I went to Columbia and got three degrees: a bachelor's, an M.B.A., and a law degree. Then I went looking for a job. I thought that growing up Jewish in the 1940s and 1950s meant that you could go into the entertainment business and find unlimited possibility. In the waiting room of an ad agency—where I discovered that they didn't hire Jews—I saw a copy of *Television* magazine with a cover story on the William Morris Agency. I'd never heard of it. I read the article and thought, That's where I want to work.

At William Morris I met with Neil Felton. He insisted I actually

bring in my three college degrees to show him, because someone had recently pulled a ruse and turned out not to have the educational background he claimed. I lugged them in, mounted. I think the company was impressed that they'd attracted someone with my educational background. With my law degree, I figured I'd go into business affairs or legal. But there were no openings. Felton said, "Do you want to work in the mailroom?"

JEFF WALD: I went to DeWitt Clinton High School in the Bronx. My brother and cousin went to the Bronx High School of Science. I got accepted there, too, but before I started, somebody hit my brother, so I grabbed the guy by the hair and dragged his head along a chain-link fence, nearly wiping his nose off his face. The kid's mother made a big deal, and Bronx Science wrote my mother—my father, a doctor, died when I was eight—telling her to let me go somewhere else. They didn't want discipline problems. I didn't give a shit, to tell you the truth.

I had a great time at Clinton. You couldn't walk fifty feet without running into a doo-wop group. I started booking these groups into the YMCA and the YMHA for twenty-five bucks, took a five-dollar commission. It was fun. It was rock 'n' roll.

I wound up moving to Buffalo, New York, after my junior year of college. I thought I'd finish school there, but it never happened. Instead I went to see Oscar Brown Jr. play at a tiny club. After the show we hung out. I was a huge fan, but the immediate connection was that he smoked pot and I had plenty. I drove back to New York to see him at the Cafe au Go-Go and hung around backstage again. He told me he made $2,500 a week. My mother, a schoolteacher, made $110 a week.

In 1963 I moved into Oscar's house in Chicago and became his gofer. He paid me $110 a week, same as my mother.

When Oscar got into a beef and fired his manager, I "managed" him for close to a year. I didn't know what the fuck I was doing, so he told me what to do. We had a great time on the club circuit: the Cellar Door in Washington, D.C.; Mother Blues in Chicago. The occasional college concert. There was pot, acid, lots of women. It was fucking heaven. Met Jack Jones, Jill St. John. It was very glamorous and exciting for a kid from the Bronx.

One day Oscar decided to leave his agency and go to William Morris. He wanted to be with Harry Kalcheim, a really important guy who had Elvis Presley, the Smothers Brothers, Sid Caesar and Imogene

Coca, Sergio Franchi. I left a message with Kalcheim's secretary that I wanted to set up a meeting. The next day I got a phone call from Wally Amos and the meeting was set.

I walked into Wally's office and immediately laughed. Wally asked, "Why are you laughing?"

"Because you're black," I said. "This is ridiculous. I've got a black act, so they send me to the black guy?"

It must have been the right thing to say. Wally and I instantly hit it off. He sent David Geffen, Hal Ray, and Chris Winner to see Oscar at the Cafe au Go-Go. Geffen especially wanted to sign Oscar.

Geffen, Winner, and Ray fascinated me. Hal Ray's still at the William Morris office. Chris Winner got fired and became a dishwasher for a time. Geffen, everybody knows. They seemed to dress nice and they had apartments in Manhattan. Hal and Geffen lived in the same building. I remember nice carpeting. No linoleum.

I decided I wanted a job at William Morris. I thought that, based on my show business experience, they'd make me an agent right away and pay me a lot of money. After all, I'd been managing for over a year. I thought I was big-time.

Geffen set me up with an interview. Wally Amos endorsed me. The company offered me a job—in the fucking mailroom. Fifty-five dollars a week to be a fucking flunky. I was shocked. I already made close to three hundred dollars a week. But they gave me the whole spiel about all the people who started in the mailroom, and how you got to some-body's desk, then you become an agent. I figured I'd be an agent in a week, so I took the job. Even Oscar thought it was a good idea. I sold grass in the mailroom on the side.

ELLIOT ROBERTS: Jeff Wald and I lived across the street from each other as kids. We were good friends. I wanted to be an actor. I went to Bradley University in Peoria, Illinois, but was asked to leave after I was arrested for leading a civil rights demonstration over a barbershop that refused to give haircuts to the black athletes. I transferred to Grinnell, in Iowa, but left after a year to act.

I was twenty years old. I had already done *Bye Bye Birdie* in Chicago. In New York I attended the American Academy of Dramatic Arts at night and got a job at NBC as a page. After hours I managed a band called Nickel Misery. I lived in the Village. I was also in an Elaine May revue called *The Third Ear*. Hal Ray, Jeff's good friend from William

Morris, came down to see it. Afterward he told me, "Give up this acting shit. I can get you a job in the mailroom. There are two openings coming up soon because some kids are being promoted."

Jeff had told me the same thing. I didn't really want to be an agent, but I also knew that the William Morris mailroom was a prestigious little job that everybody's son wanted, so I went in.

I lied about a college degree. So had Jeff. We never assumed that they would check, because we didn't think showbiz worked that way. We got lucky, but David Geffen, who was already an assistant when I started, found out they *might* check, and wrote a letter from UCLA to cover himself. But he can tell that story.

It was a legendary period in the New York office. Lefkowitz ran it. The Kalcheim brothers were big. Jerry Brandt ran the Music Department. The modern music business was just forming. There were no rules yet.

Well . . . there was one. The week I started I got on the elevator, on the thirtieth floor, with Mr. Lefkowitz. I pushed thirty-one. When we arrived, Lefkowitz said, "Go down to thirty and walk back to thirty-one. When you're in the mailroom, you don't take the elevator one floor." That was the only time he ever talked to me, and it scared me to death. I remember waiting all day to be fired.

PETER LAMPACK: I came out of Hobart College, in Geneva, New York, with a degree in English. My father and two of my uncles were lawyers, but I didn't want to do that. I tried premed for a couple years but didn't have the stomach for it. I floundered, to be honest.

My uncle, a playwright, suggested a career in the entertainment business. I was intrigued. He set up a series of chats with show business executives and an interview at William Morris. I met with Marvin Mann in Personnel. He wanted to make sure I didn't have three arms and six legs, that I spoke with some degree of fluency, and that the possibility existed that I could benefit from the mailroom program and potentially become an agent. Maybe because my uncle was a client, or because Mann was in a good mood that day, or because I did well in the interview—or all three—I got hired.

HUSTLERS

PINKUS: I knew right away that I fit in. Abe Lastfogel never went past the fourth grade. Sam Weisbord never went past the fifth grade. But they were still streetwise and very smart. I dug the tradition and history. I figured if I worked hard and was honest, I'd make it. No matter what anybody asked me to do, I never said no.

AMOS: I wasn't concerned with the history of William Morris; I was busy trying to get the hell out of the mailroom. I worked all day and went to school at night. I didn't take lunch; I set up a typewriter in a corner of the mailroom and practiced. I figured that when you show initiative, people automatically respond. After two months I became a floater because my skills were comparable to any of the secretaries'. I worked on many desks and got to prove to everybody what Wally Amos was about.

GEFFEN: I didn't know enough about the process at the beginning to have a goal. I just observed those who had accomplished something—Lou Weiss, Wally Jordan, Lee Solomon, Steve Jacobs, Marty Litke, Murray Schwartz—and tried to act as much like them as I could. I thought Larry Auerbach and Tony Fantozzi were very stylish, plus they were accomplished *young* guys. Every office I walked into, as I delivered the mail, I saw some person who didn't look that much different from me, talking to somebody famous on the phone. It seemed so cool. I thought, I know how to do that; I can talk to famous people on the phone.

SHUKAT: The mailroom had a real hustler sensibility, not a sense of educated people. It was mostly "I want to be in show business and I want to make money." Look through the annals; there are many hustlers, even former furriers. Guys who can't read scripts and don't understand story have run studios. Their lack of schooling doesn't affect their enormous success. They've taken gambles. They're chums, pals. I was always surprised at the lack of depth. Many of the guys I met were good talkers, good spinners; they could have been car or insurance salesmen. That was always the object, I guess: make the sale. I had a different sensibility.

ROBERTS: To get noticed, I tried to be funny, witty, and knowledgeable and show the agents that I knew more than I knew. I tried to create

ways to define myself as an up-and-comer, to suggest that in ten years *I'd* be in the big seat. I wanted the agents to know I could get tickets for clients who needed tickets; I could get them to the Knicks or the Rangers game. When I delivered scripts to artists, I tried to act like I wasn't just a messenger boy; rather, an *agent trainee*. Plus, I read the product—at least ten pages on the way to dropping it off—and could convincingly tell them, "It's fabulous. You're gonna love it. The characters are so well drawn."

LAMPACK: The mailroom was the civilian version of basic training: they broke you down before they built you up. For somebody like me, who came from a decidedly middle-class background and for whom graduate school was certainly a possibility, to suddenly be confronted with pushing a mail cart seemed not what I was raised to do. Yet there was great knowledge to be gleaned.

It didn't take long for me to decide that being an agent was for me. Within the first six months *Fortune* magazine put the William Morris TV agents on the cover. The article was about how many hours of prime-time network television the agency directly controlled. The attention seemed very sexy, and being an agent, the best of all worlds: you had the glamour of the entertainment business, the potential to make a substantial income, and could do it in essentially an entrepreneurial environment where there were not tremendous restrictions on your comings and goings. I was seduced.

SOMEBODY'S GOT TO DO IT

SHUKAT: The lowest guy in the mailroom got to run the wet Xerox machine. It was poisonous. You had to wear gloves.

WALD: I detested changing the liquid soap in the men's room. I thought, What the fuck am I doing? But everybody did it, and after a couple of weeks it was somebody else's turn. Another awful job was going out in the afternoon to get theater tickets. Nat Lefkowitz would service whoever the fuck was in from California with theater tickets, so I had to stop at five or six different places. I hated that job, especially in the wintertime—walking in the cold and standing in line. The William Morris rule was that even though the tickets were for the agency, you

couldn't cut in line. Most of the time I tried to figure out how to cut in anyway.

SHUKAT: I picked up tickets for Irwin Winkler. Then he'd say, "I want you to go back to the box office, return them, and give me the money." The truth is, nobody was making enough money. Everybody lived off their expenses.

GEFFEN: The work was more tedious than it was tough. I had to change the toilet paper in the bathrooms and fill the soap dispensers. It wasn't challenging, just what I had to go through to get to the next step—and I was *always* willing to do that. I would have done anything, even if I thought it was shitty. The mailroom is where you learn that if you haven't got the patience to go through the shit, you're not going to get to the cream. It's a test. It's about humility. Lots of people complained, though, and quit because they thought it was demeaning. I kept hoping *everybody* would quit, because the more people who quit, the higher up on the list I got toward getting a desk. I can't remember if I actively encouraged their dissatisfaction, but it wouldn't surprise me.

YOU KNOW YOU'RE IN THE RIGHT BUSINESS WHEN . . .

WALD: Julie Newmar lived on Sutton Place, and I had to deliver a script to her. She came to the door in a fucking negligee. She just acted like she was dressed. I thought I would drop dead.

SHUKAT: I heard a story about one guy sleeping with Shelley Winters. It might have been Harvey Kreske. Supposedly he went to her house, she said, "Stick around," she put on a negligee, and they got into bed.

PINKUS: George Wood was one of the great old-time agents. He took care of Frank Sinatra for years. I think Frank even lived at his apartment at 40 Central Park South. I lived at 230 Central Park South in a rent-controlled sublet I got the first week I was at William Morris from a very pretty dancer who was leaving for Las Vegas on a fifty-two-week contract.

Wood called me one day and asked, "You got a suit?"

I said, "Yes, sir."

He said, "All right. I want you to meet me at eight o'clock at the Round Table." It was a club in New York City. "I'm taking out Rita Hayworth and her daughter, Princess Yasmin, and I need you with me." Yasmin was about fourteen, and I was about twenty-one. From the Round Table we went to Basin Street East, and my job was to dance with Hayworth or Yasmin—she told me to call her Yazzy. That's when I knew I was in the right business.

LAMPACK: Sometimes I wasn't sure. Once, while pushing my mail cart down the hall, about to make a turn, a chimpanzee on roller skates, wearing clothes and smoking a cigarette, flew by me. I thought I'd imagined it. Maybe it was a little kid. But what was a kid doing on the executive floor? On skates? And smoking? I turned the corner and there was his trainer, talking to an agent. William Morris represented the chimp.

PRYING EYES

GEFFEN: I learned to read memos upside down, not to show off, but because I'm curious about everything. I also read the room: people's tastes, the pictures on the walls, the suit and tie or dress someone wore. Even their shoes. I took mental notes on everything, and I pretty quickly came to believe I could succeed at William Morris, because I didn't see anybody there who I thought was that much smarter than me. I don't mean that arrogantly: I've never gone to my doctor's office and thought, He's not so smart; *I* should be a doctor. But after reading the mail I sorted, and reading the files and memos I found lying around—and things were *always* just lying around—I knew I could do it. The idea of being a William Morris agent was extraordinarily appealing. I had visions of a respectable career and making lots of money. I remember thinking: I'll be here the rest of my life.

After I was at William Morris a week or two, the guy who had showed me around got fired. I knew how much he loved the job, so I asked him what he'd done. "I made up that I'd gone to CCNY [City College of New York]," he said. "The company checked my references."

I got a pit in my stomach. I thought, Oh, shit. So I came in early every day for six months, until all the letters had arrived from the places

they had written, asking for my references. I steamed open the envelopes from UCLA and CBS, who said they'd never heard of me, and substituted confirmations and recommendations on fake stationery that I'd had made up at a printer.

SHUKAT: David Geffen told me he needed only one sheet of UCLA stationery, but the printer wouldn't do less than a gross. But David would pay whatever he had to in order to get that one sheet so that he could send it to his brother in California and have it sent it back with a Los Angeles postmark: "Mr. Geffen graduated . . ." I remember being stunned that anybody had that kind of nerve, both to lie *and* to be so resourceful.

GEFFEN: I never gave a shit if anyone understood or thought it was a bad thing. My intentions then were simple: I was happy to do whatever I had to do to keep the job. What's more, when I became successful at William Morris, I *told* them the truth: that I had never graduated from UCLA. *I told the secret; I informed them.* So it's not something somebody unearthed about me. And I've continued to tell the story for this reason: People say, "Oh, his entire career is based on a fraud." That's such nonsense. If *only* you could make it by lying about your past history, *everybody* would make it. No. You make it because you either have the ability or you do not. Without having a college degree, I couldn't have gotten in the door. I needed to get in the door.

ROBERTS: David also came up with steaming open other mail at 6 A.M. to see who was doing what to whom, then resealing it and delivering it. We all did it.

SHUKAT: Unlike David Geffen and others, I didn't open the mail. It would have been against the way I operated on a human level. I think David referred to me as a Boy Scout, but there's no shame in operating the way you think the people who are paying you expect you to operate.

AMBITION

GEFFEN: I don't think the rules of ambition have changed. If you want to succeed, you'd better not care too much about what other people think about what you're doing. I *was* ambitious. Some people thought, Who is this guy? He didn't go to college. He's short and ordinary-looking.

How dare he! But that some people were put off did not deter me. I was, of course, *surrounded* by other ambitious people—the very ones complaining—and the only difference between me and them was our willingness to display our ambitions. That's like life, isn't it?

However, I did think I'd figured out the game: The people who did the best were those who *signed* the artists, rather than just *booked* them. I decided to be a signer. Starting in the mailroom, I spent a lot of time going out and looking at talent. It was kind of cool to be able to go to clubs and say, "David Geffen, William Morris Agency," and just get right in. I loved that.

ROBERTS: The music drew us together. We had group dinners, would go to Hal Ray's or David's apartment. Larry Kurzon and Jay Jacobs came, too. Our whole social life was based around the business we were learning. I lived in the East Village on Seventh, between A and B, and we'd go to the different cool clubs. We could get high, hit eight or nine acts every night. We didn't have William Morris business cards, but the doormen and owners knew who we were. We were young, single, aggressive guys.

GEFFEN: I also tried to become friendly with everyone I could, like Hal Ray and David Krebs, who were in the mailroom with me. I was also friends with Elliot Roberts, with whom I later went into business; we've now been friends for thirty-seven years. I was also friendly with Larry Kurzon, who was already an agent, as well as Jerry Brandt and Steve Leber in the Music Department. I did the best I could to engage as many people as I could so I could learn as much as I could. Some responded negatively; some asked me to come into their office and sit down. Some thought it was wrong for a guy in the mailroom to socialize across "class" lines, but I wanted to know and become friendly with the people I thought would be important to my career. Some didn't want to know me, so I forgot about those people. I stuck where I found a warm welcome. That's hardly unique.

For instance, I wanted to get to know Nat Lefkowitz, who was head of the New York office. I quickly learned that he came in on Saturdays, so I came in every Saturday and would have lunch with him. Why? *Because he would always ask whoever was there to have lunch with him.* I certainly wasn't the only person who tried to create a relationship with him, but had somebody suggested that I *not* try to get to know Nat Lefkowitz because it wasn't proper, that wouldn't have made any differ-

ence. I made the effort and I succeeded, and Nat Lefkowitz was extraordinarily nice to me. In fact, it seemed to me that the people I admired the most were not that difficult to get to know. I did it because I quickly figured out that if I was going to be an agent, the one ability I'd *better* have is to create relationships. It isn't about how tall you are or how good-looking you are or whether or not you can play football. It's about whether you can *create a relationship*.

THE PLANT LADY COMETH

SHUKAT: The other guys used to hang out after work, have a drink, dinner, stay up until the middle of the night. I didn't socialize. I had no time. I was married. Sometimes the guys—David—would call and wake me up because they were sitting around drinking. They enjoyed teasing me. But it stopped. The morning after one call I went into David's office and I said, "It doesn't matter what happens to me. You call me ever again, I will throw you right through the plate-glass window, physically." His office was on the thirty-third floor, facing east. And the windows in the building *weren't* designed to open.

ROBERTS: A lot of people didn't like Scott Shukat. We thought he was the kind of guy who treated his assistant and the mailroom people with disdain. He thought they were spoiled brats. Jeff Wald was into pranks, and we'd hide in the office until we knew everyone was gone. Then we'd go into Scott's office and pee in his plants. There was this urine stench in his office all the time, and he never could understand what it was.

WALD: He said that Abe Lastfogel had given him the plant. What that really meant was that when Abe Lastfogel visited the New York office, somebody gave him a plant he had no use for. He handed it to the first guy who walked by, said, "Here, do you want this?" It could just as easily have been the janitor, but it made Shukat feel important. He gave me detailed instructions to feed and water this plant, but when he was gone, the first thing I did was piss in the pot. Regularly. I think I even stabbed it with a letter opener.

THE LIST

SHUKAT: I got out of the mailroom in three months. Dennis Paget was promoted to Ben Griefer's assistant, and I got to be Griefer's secretary. When Dennis became an agent, I became Griefer's assistant. Again he needed a new secretary. He told me, "Get someone from the mailroom."

I chose David Geffen. I first noticed David delivering the mail. He made sure people got to know him. He stood out from the gang. Something about him was different. It's the same reason Dennis picked me. Working with David wasn't especially remarkable, though, except when I'd find him at eight or nine o'clock at night on the WATS line, talking to John Hartmann, an agent in the Los Angeles office. I wondered, What is going on here?

GEFFEN: I wanted to work in the Movie Department. Griefer was in the talent area, a booker for TV variety shows. But I didn't want to stay in the mailroom any longer than I had to, so when I was assigned to Griefer's desk, I took it. But I quickly got the sense that Scott Shukat genuinely disliked me and didn't want me around. He constantly tried to make Ben Griefer not like me, too. At some point he succeeded.

SHUKAT: We—Griefer and I—were buyers. We bought talent for the Jimmy Dean and Sammy Davis Jr. shows, for *Sing Along with Mitch*. You could say to the agent you were buying from, "Why don't you send me a list of your clients so we can talk it over with the show's producers?" and they'd send it. We kept these lists in a file cabinet and once or twice a year got a phone call from Nat Lefkowitz: "Let's take a look at other people's clients. Is there anybody vulnerable? Anybody they're not doing the job for?" One day, to get ready for the call, Ben told me to get the lists. I couldn't find them. Everything was gone. I turned around and there was David, blathering. I said, "Oh, my God. What did you do with the lists?"

He said, "I brought them to Nat Lefkowitz."

I immediately went to Griefer and told him. I was really embarrassed.

GEFFEN: That's all nonsense. Nat Lefkowitz already had every list there was. Why would I think, I'm giving this list to Nat Lefkowitz so that he'll think good of me? It's a silly story.

Still, the turmoil Shukat made created a lot of problems for Ben Griefer, and so he fired me. I went to Nat Lefkowitz and begged him not to let me go, and he instantly agreed to transfer me to another office. Why? Because I had previously created a relationship with him. It was not possible, finally, for Scott Shukat and Ben Griefer to get rid of me, which is what they wanted to do.

SHUKAT: Nat assigned David to Arnold Sank's desk, where he flourished. I think David played the son thing with Nat; it was always his card.

GEFFEN: Nat Lefkowitz was smart. I mean, what's the bottom line of this story? He kept me, and I turned out to be one of the most successful people that had ever come through the William Morris Agency. Scott Shukat and Ben Griefer . . . they had their careers; I had mine. What can I say? If I were Scott Shukat and I felt that I had not reached the level of success that I had hoped for myself, I might be bitter, too. The problem is that the message there is "If I am willing to be as much of a scumbag as this guy, I, too, could be successful. But I [Shukat] am a good person. He [Geffen] is a piece of shit, that's why he succeeded." Again, nonsense.

People of a certain level of ability and accomplishment are threatened by people who seem to have more fire and more charisma, more of whatever it takes to make it. They sense it and they're afraid of it. Then what they want to do is kill you. My transparent ambition antagonized Scott Shukat tremendously. He found it threatening. But my friends didn't resent what I did; they never treated me any differently. I wasn't the leader. I was an ordinary guy in extraordinary circumstances who lived it one day at a time. We all wanted to make it in the areas we were interested in. We all rooted for one another. But everybody's writing his own movie, I guess.

ROBERTS: Everyone at William Morris knew that David Geffen was the rising star. David had this incredible mind and great focus. He was sensitive yet aggressive, and already mythic. But he was also a regular guy. He was a role model for us and the class after him. We all learned from watching what happened to David, and we all emulated what we thought was the best way to get what David got. It was pointless to be intimidated by him, because he was so good that it was never a matter of burying him; you weren't going to. You'd only bury yourself if you tried to bury him. David and I were close friends right off the bat. He

turned me on to Buffy Sainte-Marie, which is how I met Joni Mitchell, and started my career. Later I partnered with David, and we were, for a time, the most successful personal managers in the world.

RESTLESS BEHAVIOR

KREBS: My mailroom stay was no more than a couple of months. I took an assistant job in Business Affairs. Four years later I told the company that unless they made me an actual agent, I'd leave. They agreed. I'm sure they were surprised when I chose the Rock Music Department. It was the lowest of the low at the agency. Rock was the stepchild. It was, "Why would you do that?" Here's the answer: It was a brand-new field that had only one step. You were either an agent in the department or the agent who *ran* it. There were no other layers. To have any real power in the other departments, you had to be in your forties. Someone in his twenties doesn't want to wait that long. In retrospect it was a good move. I could make significant decisions when I was very young. If you wait until your forties or fifties, you may not have the energy anymore.

GEFFEN: After Griefer, I worked a year for Arnold Sank. He was incredibly nice to me, very accommodating, and not concerned about my ambition at all. He got who I was. Afterward I became Harry Kalcheim's assistant, then an assistant to Lou Weiss. Kalcheim was extraordinary and also incredibly generous. If anything, he was amused by my ambition. Kalcheim was one of the great talent agents of that period. He signed Elvis and all the Second City people. But while I worked for him I decided I wanted to be in the Television Department, because that seemed to be where all the money was. So even though I was already a junior agent, I went to work as Lou Weiss's assistant. And while I worked for all these men I watched them.

ROBERTS: I spent very little time in the mailroom. I might even have broken David's record for getting out quickly. I wanted to be in the Music Department, but they needed someone in Legit Theater, so I took it. One day a guy named Joel Dean at Chartoff-Winkler, a management company Irwin Winkler had started, called and offered me a job. They were getting into the film business, doing an Elvis movie at

MGM in Los Angeles, and they wanted to get out of their management business. But they had contracts with their comedian clients, so they more or less hired me to destroy the company by getting all the comedians to leave.

WALD: To get a desk you were supposed to learn shorthand. I went to Sadie Brown's secretarial school for a day. Then I said fuck it. After five months I got a desk anyway with Murray Schwartz, a pompous prick and petty despot who hated me and got rid of me in a week. I had opinions and he didn't want to hear them. Murray had fired Geffen, too. Murray handled *The Merv Griffin Show,* which, in those days, wasn't the high end. Then he became president of Merv's company and wound up with a ten- or twelve-million-dollar score when Merv sold out. He's still a prick.

Next I got put with a guy in the Legit Theater Department, who was an ex–army officer. Also gay. Those were the days when guys didn't come out of the closet, but you just knew. Most of the Legit Theater Department was gay. Ed Bondy, who was married and had two kids, would come by and crack amyl nitrates under my nose. I loved Ed Bondy. I gave him his first joint. My boss handled Molly Picon and Claude Rains. We became friends much later, but in those days he wasn't someone you could get close to.

Legit theater bored the piss out of me. I couldn't stand to sit through a whole show. I wanted rock 'n' roll. Hal Ray booked colleges and hung out with the Beach Boys and Simon and Garfunkel. I wanted that instant gratification and the tumult of the action, so I went to work for George Kane in the Nightclub Department. That was more fun.

I really wanted to be Jerry Brandt, who ran the rock 'n' roll division. He wore cool suits and sunglasses and sat in the dark because he was stoned all the time. He got away with murder and was one of my idols. Jerry was responsible for my first ride in a limo. When I became a secretary, he sent me to service the Rolling Stones when they were on *The Ed Sullivan Show.* I broke out the dope right away and got everybody high. But there was no room in his department. Hal Ray got the last opening. Steve Leber was there. Larry Kurzon. A Puerto Rican kid named Hector Morales. Wally Amos. Guys didn't leave.

I kept moving around a lot, but I didn't feel like I was getting ahead. One of my biggest problems was that I thought most of the agents were

dumber than dirt. My disrespect was enormous. They weren't bright. They weren't aggressive. They weren't ambitious. They had nice expense accounts and lived on Long Island in nice houses that William Morris had loaned them the money for. From day one the tradition of the office was drilled into everyone: pension and profit sharing.

One of the few guys I admired was Harry Kalcheim. Harry had a great letter from Abe Lastfogel framed on his wall, dated 1947. It read: "Dear Harry: The Morris office will not loan the young comic Jackie Gleason $5,000. We're not a bank." Blah, blah, blah. And "I don't think he has much talent or will go very far."

LAMPACK: I became David Geffen's assistant. He was the ultimate seduction.

David was five times brighter than anybody else in the place, without exception. You only had to spend a few hours with David to understand that you were dealing with somebody who was playing in six dimensions when everybody else was playing in three.

David was actually a terrific boss for a lot of reasons: He was my age, though I didn't know it at the time; I thought he was three years older. He was loose in a very stiff place, and he was an iconoclast. He broke all the rules. And because of that he was a mentor whose example showed me that you could push out the edges and perhaps rise more rapidly by doing so. You could take some risks and not simply be dismissed as being arrogant or foolhardy. You could take the risks—even if you were not David Geffen. That inspired me.

What David expected from me was absolute discretion and absolute loyalty. You didn't gossip about David, you didn't talk about what he was trying to do. You respected his boundaries. He would have had no tolerance whatever for perceived disloyalty. That would have been a death sentence. But if you showed up when you were supposed to, did what he asked you to do, were pleasant and responsible, he responded to that and was loyal to you.

After a year David said, "You can work for me forever, but it is healthier for you to have other experiences in this company, with other bosses."

I agreed, and I went into the Motion Picture Department and worked there for maybe six or seven months. When David left the Morris office, they promoted me back into Television as an assistant agent.

WALD: One day Hal Ray told me about this party on Fourteenth Street for a hypnotist from Australia named Martin St. James. Hal Ray had his own apartment and was fucking a lot of great girls; we were always looking for action. Elliot and I crashed the party. I met a girl there. She came up to me and said, "This is my party. It's my birthday. It's to raise rent money." I didn't contribute, and neither did Elliot, by the way. Later she said, "I'm going to fuck you tonight." I married her three days later. Her name was Helen Reddy.

Helen had a two-year-old kid. I moved in with her at the Hotel Albert, on Ninth Street and University Place. What a fucking shithole. You'd be in the bath and the cockroaches would scurry up the wall. Every day on the way home from work I stopped at Ruben's Supermarket and Deli to buy a can of Black Flag. It was my biggest expense. When we emptied the can, we threw it at the fucking cockroaches.

I remember telling Helen, "If I could ever get promoted . . ." Agents got a hundred and a quarter to start in those days. That was fat city. I had a new Ford Galaxy, for which I paid $32 a month. Helen was singing in strip bars. We'd work four-bungalow colonies in the Catskills for $125. Take the piano player, drive up, sleep in the back, do "Bei mir bist du schön" and some other crap. A fucking nightmare.

Finally I was the next guy slated to become an agent. People knew me. But I could see I was going nowhere. Shukat was my undoing. The Morris office didn't represent artists for recording contracts, just for personal appearances. They had the Beach Boys and they had the Temptations and others, but they didn't have a piece of their record deals. Scott Shukat was trying to set up this record division, but he was going about it by representing the *comedy* people. I thought that was fucking ludicrous and wanted to fix it. Geffen set me up with a meeting with Nat Lefkowitz. I said, "I'm working for an idiot who doesn't get it. Why don't we have the Beach Boys' *recording* deal?" It was a mistake; I should have known better. I got stepped on pretty good. You don't go over your boss's head. I guess I tried to fuck him, and I wasn't very subtle or creative. Geffen protected me a bit with Lefkowitz, but Shukat hated my fucking guts and wanted me out. I knew it was time to leave. David recommended that I go to Ashley-Famous. I knew a guy there whom I'd met in the Village, and I got the job as a junior agent making $125 a week. I lasted about a month, got fired because of something I

said, but before I left, I introduced Ted Ashley to David Geffen. I said there was a great agent over at William Morris who wasn't happy because he wasn't moving fast enough. David came over right after I left.

GEFFEN: Ashley-Famous was a tremendous opportunity and much more money. I made five hundred dollars a week at William Morris; Ashley offered me a thousand a week and the office next to his. I went to Nat Lefkowitz and explained the whole thing. Nat was upset. But for some reason he was not angry with me, as he had been with others who had left.

I guess he knew that I was on a fast track with my career, and that in order for me to stay with William Morris, I would have had to tone it down. He wanted me to stay and told me that if I did, one day I could run the place.

I told him that I was in a hurry.

He let me go, and we remained friends until he died.

AMOS: When I stopped floating, I became Howard Hausman's secretary. He had an insatiable appetite for work. Howard became a mentor, almost a surrogate father. He was a great influence.

After five or six months William Morris brought in a Rock Music Department. I actually mean *brought in*. Rock 'n' roll then was Bobby Rydell, Bobby Vee, and Bobby Vinton, and our company was not a part of it. So they hired Roz Ross from GAC, and she brought her own secretary, Esther, and Jerry Brandt. Jerry needed a secretary, and Howard suggested me.

I hated rock 'n' roll music, so I turned it down. I said I'd like to wait and see what came up in the Movie Department or in Television, and that I'd prefer to keep working for Howard until then. Howard sat me down for a heart-to-heart talk. He said, "Wally, we don't know when something is going to come up, and this is here now. You've got a family. It's an opportunity for you to advance. I think you ought to take it."

Six and a half years later the Rock Music Department had gone through tremendous changes, I was tired, and I wanted to do something else. I asked Howard Hausman to transfer me to motion pictures. He said, "Wally, we don't feel that the motion picture studios are ready for a black agent."

I said, "What about television?"

He said, "Well, we don't feel the networks are ready for a black agent."

I said, "Then make me the manager of the Music Division. Where do I go?"

He said, "Well, we don't think the guys are ready to accept direction from a black guy."

"That's really crazy," I said. "I trained them. They worked for me and now they can't take direction from me?"

It was clear then that I'd gone as far as I could go at William Morris. I made more than twenty thousand dollars a year, I had profit sharing and a pension and an expense account. But I was miserable. I lived at 100th Street and Central Park West, and on nice days I'd walk to work simply because I didn't want to get there.

Finally I couldn't take it anymore and told Howard I had to leave because there was no future for me, just like at Saks. Howard did his damnedest to talk me into staying, but he couldn't offer anything.

I left William Morris in 1967, moved to California, and started making cookies in 1970—just because I liked chocolate chip cookies. But there's no way I could ever have been Famous Amos without going through William Morris. They prepared me to sell cookies. I was an agent for the cookies.

SHUKAT: I remember seeing Wally at his first store. I said, "After everything at William Morris, what made you do this?"

He said: "The cookies don't talk back."

• • •

STEVE PINKUS is vice president and managing director of National Entertainment, a television production company.

WALLY AMOS is a motivational speaker, an author, and the chairman of Uncle Wally's Muffin Company. He lives in Hawaii.

SCOTT SHUKAT is based in New York and works for the Shukat Company, literary representatives–personal managers and music publishers via two companies: Trunksong Music and Otay Music. His clients work primarily in the theater as directors, composers, lyricists, playwrights, book writers, and so on.

DAVID GEFFEN has done extremely well for himself, thank you. From agent to manager to record mogul to art connoisseur to political

contributor to film and theatrical producer to the "G" in DreamWorks SKG, he is the consummate show business insider.

DAVID KREBS is president of Krebs Communications, an artist management company based in New York.

ELLIOT ROBERTS is owner and founder of Lookout Management, and partner with longtime client Neil Young in Vapor Records. He lives in Los Angeles.

JEFF WALD is president of Jeff Wald Entertainment, a management and production company. He is also a boxing promoter.

PETER LAMPACK is a literary agent and president of the Peter Lampack Agency in New York.

THE GOOD MIKE

William Morris Agency, Los Angeles, 1969

MICHAEL PERETZIAN

Mike is the classiest guy on the planet.
—Bruce Brown

I grew up in New Jersey and had two stepsisters who moved to Los Angeles. They'd send home letters postmarked Hollywood, CA, and I thought wouldn't that be great to go there, to UCLA, to major in motion pictures and become a director.

I was thirteen years old.

When my dad died, my mother did move to Los Angeles. I went to Hollywood High School, then to UCLA for seven years, majoring in motion picture production. I took another year to get a teaching credential and yet another year to get a master's degree in history of the theater, and another master's in fine arts and directing in the theater.

Now I had to figure out how I could be involved in the business. I taught for two years at the Pasadena Playhouse. One of the instructors knew some television producers, and she asked, on my behalf, who I should talk to. These producers mentioned two agents; one was Ron Mardigian at William Morris. When I placed the call, David Guiler, a very hot screenwriter, was in his office. I had been in high school with David, and he urged Ron to pick up the phone and talk to me. He did, perhaps thinking I was another potentially hot new screenwriter client—and Armenian like him. That was fate! I told him that I was looking for a job, and I could hear his voice go, "Oh. Well. All right. If you want to come in, let's talk."

During my interview, Ron asked how old I was, and I told him

twenty-eight. "That's a little old," he said, "but if you're really interested, I'll try to put it through."

I think Ron was impressed with my education, as I was quite qualified. Perhaps overqualified. But because of my credentials, my salary was five dollars a week more than the other trainees—and there I was, with two master's degrees and a teaching credential, with a job in the mailroom, making a fraction of what I made teaching play analysis, acting, and directing, not to mention substitute teaching around the city, including at Beverly Hills High School, where I soon found myself in a night course taking speed writing, which all the William Morris trainees had to do so they could take dictation from their bosses, as well as typing classes. At least I already knew how to type.

The day Neil Armstrong walked on the moon was the day I walked into personnel to start my career. July 20, 1969. I met with Kathy Krugel. I think her hair then was deep red, and she was always overdoing it on the diet pills. We had a funny line about her: only shrews and hummingbirds have a metabolic rate faster than Kathy Krugel. She had these strange mood swings. I once had an accident with one of the messenger cars, and she said, "Oh my God!", and then she lowered her voice and then she lowered her voice some more and said, "Are you okay?"

The first day of work, the projectionist left on vacation, so for two weeks I operated the projection room. During that time the East Coast television agents came in for their annual strategy meetings about the selling season, and various things had to be in paper bowls within reach of everyone: pretzels, peanuts, and matzo—though I don't think it had anything to do with the time of year. Keeping the bowls full was my job.

Most of the people in the mailroom with me are now gone. Michael Ovitz also started there in 1969, but he might have gotten out before me. I don't remember him.

I wasn't sure at first that I wanted to be an agent, and six months later I still had no idea of what I had gotten into. That changed when an agent asked me to take Steve McQueen's profit participation check from *Bullitt* to his accountant, ten blocks down Wilshire Boulevard. The envelope wasn't sealed, so I looked inside. It was well over a million dollars.

Suddenly I realized that *the money* was what it was all about. I'd seen McQueen before in the hallway, and it was no big deal, but carrying that check was the most anxious walk of my life

Other incidents reinforced the idea that maybe being an agent was more interesting than I'd imagined. I was told to bring the script of *Myra Breckenridge* to Mae West. Several weeks later I was asked to take something to Warren Beatty, in his penthouse apartment at the Beverly Wilshire Hotel. I looked inside the bag; it was stuff for sunburn! I rang the doorbell and I heard scurrying feet. Suddenly, there was Warren Beatty, wrapped in just a towel, his skin a little red. He gave me a wink and said, "Thanks, kid!" I figured that he and Julie Christie were sitting there naked and sunburned, waiting for the William Morris kid to come up with the stuff so they could get some relief.

Sometimes I didn't really feel I fit in because my interests were so specific. When desks would open, all the other guys wanted to work in motion pictures, representing movie stars. That is where the money and the glamour was. I wasn't interested. I was the only one in my class who wanted to train on a literary agent's desk. When Ron Mardigian's desk became available I was the only candidate for it, and I was promoted before a lot of people in my class because they were holding out for the talent agent ladder.

Ron Mardigian was like the older brother I never had. Or a surrogate father. He wanted me to succeed, and he suggested that I cultivate social contacts with studio executives, especially the females, as a way of schmoozing. In this business you create a lot of artificial intimacies and it can become very confusing. But I'm not that good at socializing and schmoozing. My power as an agent has always come from my relationship with clients.

While I was in the training program, I went through a very difficult time. There was a problem developing in terms of my dealing with my own sexuality. In short, I was scared shitless about it. I didn't know what to do, especially when Ron suggested that I go out and schmooze some girls. This put me in great conflict. To help myself, I entered group therapy, which started around six o'clock on a Tuesday or Thursday. Ron very graciously let me get out early in order to make that appointment. The session before mine was another group, and they exited by a

separate door, so we never saw them. But I was told by the therapist that someone in that group was *also* a trainee at William Morris. That made me even more nervous. I didn't want to run into him. Fortunately, we never met each other, and I don't know to this day who that person was!

Eventually, in a roundabout way, this led to a problem at work. Bill Haber decided that he had a lot of issues with the way that the Literary Department was run. He took it upon himself to tell the literary agents that he was going to have his own department meeting with us, and he picked a time that was in conflict with my therapy sessions. It was a dilemma because, first of all, he was encroaching on Ron's domain. Second, Haber's meetings were mandatory and as I told Ron, I could not go because I had an appointment with a psychiatrist. He asked me then why I was going. I would not tell him. He seemed to understand it was important to me and he let it go.

When Ron found out from someone else that I was gay, he was really upset with me because I hadn't shared with him that part of myself. He was very sympathetic.

It was so freaky then if you were gay. It was terrifying because you couldn't be one of the guys. They would make jokes about gays and I was not comfortable with that. It took several years of therapy to finally come out and acknowledge who I was.

My sexuality is, of course, extremely personal, but I share the story now because many of the same issues apply today if you are "different." Even in this day and age there are probably guys in mailrooms whose sexuality is very guarded. Here's the reason: When you're an agent, being gay is fine. But as a trainee you could feel that it may not be politically wise to declare yourself. Yes, at the time there were others at William Morris, higher-ups in the company, who were deep in the closet. But for a trainee to come out could cause problems. I was very nervous.

MARDIGAN: *Mike is right. Had he let it be known while he was a trainee, it might have hurt him. Not only that, but there was a policy—not written down, but stated—that was a* bigger *secret than which top executive was in the closet. I knew it, and eventually everybody found out about it, but if Mike had come out, he would have been fired in two seconds. The old guard—some of whom never*

declared themselves—was still there and watching out for that stuff.
Only Ed Bondy was so far out that you knew, but that's who he was.

Ron also taught me that when you leave for the weekend, you don't talk to clients. You don't take those calls. He would go out of town to his cabin, and there was no way even I could call him in case of any emergency; he had no phone by design and I had to handle the rare emergency. This taught me that it's crucial to have a personal life in this business. As much as you may love your clients and their talent, it is *not* all about that. You had to keep your personal and professional lives separate because one day the latter will be over and you'd better have something left.

One Saturday, I got up and realized that something was wrong. I felt dead. I took the phone off the hook, turned off the stereo, and I promised myself that I would not leave my room until I found out. I started taking inventory of my life and asked myself when I last felt alive. When did I feel passion? I realized that I didn't have any hobbies; I didn't even collect stamps! It was just William Morris and that was it. The last time I felt passion was during a summer workshop at UCLA. In the morning, we made props for a Brecht play. In the afternoon, we rehearsed yet another Brecht play, and in the evening we performed a third Brecht play—and then we went someplace and drank beer until two o'clock in the morning. Then we went back to the dorm, got up the next day, and did the whole thing all over again! I loved that! I could do that forever.

Some of my old UCLA friends had called a couple of months previously and asked me to direct some plays at Beverly Hills High School. My first reaction was that I was now in the real world as an agent at the William Morris Agency, a grown-up now, not in school anymore, thank you very much. Then I decided to call them and they told me they were doing a production of *Uncle Vanya*. I said, "Why don't I do a workshop of Chekhov's *The Seagull*. That could be done in conjunction, on the same set."

I directed *The Seagull* and then that led to directing *The Shadow Box* and a few other plays, and I was starting to get excited. No one at work knew. I would leave the office around 6:30 at night, grab a bite to eat, go to Beverly Hills High School, start there at 7:15, work until 10:00. I

did it for four weeks, Saturdays and Sundays, too. Then the reviews came out in the trades and the *Los Angeles Times*. Thank God, they were all raves!

Larry Auerbach called me into his offices, showed me one of the reviews, and asked me, "Is this you?"

"Yes, it is."

He asked me why and I told him that it was like playing golf, a hobby. They were worried, I could tell, that I was just looking for an opportunity to bail and become a director, which was ironic because that is what I started out to do in the first place. Then one day, I was asked if I would like to direct some projects at the Mark Taper Forum. I did, and one, *A Life*, was nominated by the Los Angeles Drama Critics as one of the best-directed shows of the year. Now William Morris was impressed. From then on, if anyone came in and wanted to do theater or serious acting, I would be pushed into the room like downstage center.

The whole episode was a great lesson because it reminded me that my life had to contain some passion. Thereafter it was not unusual for me to go to the Mark Taper Forum and see a play written by, say, an English playwright, find out he was interested in American representation, sign him, and eight years later see *The English Patient* pick up nine Academy Awards. Anthony Minghella did not have an American screenplay; he did not have anything to sell except his talent. I had been vindicated by my philosophy of what a talent agency is for: to find talent and nurture it.

• • •

MIKE PERETZIAN, after years at William Morris, became a motion picture literary agent at CAA in February 2000. He still directs plays.

TIES THAT BIND

TIES THAT BIND

William Morris Agency, Los Angeles, 1974–1977

**BRUCE BROWN, 1974 • ALAN IEZMAN, 1974 • JACK RAPKE, 1975 •
DENNIS BRODY, 1975 • ALAN SOMERS, 1975 • GARY RANDALL, 1975 •
CHUCK BINDER, 1975 • SHELLEY BAUMSTEN, 1975 • RICHARD MARKS, 1975 •
BOB CRESTANI, 1976 • GARY LUCCHESI, 1977**

*Randall, Rapke, Somers, Brody, myself. The chemistry was
undeniable. We were emotionally connected. Every one of us
liked every other one of us. Our mind-set came out of the
sixties. For us it was Woodstock. It was about embracing the
good things in the world, not the bad things. We took that
peace-and-love notion fairly seriously.*
—Alan Iezman

ALAN SOMERS: I was politically active, a surfer, and into the vegetarian communal lifestyle. After graduating from UC Santa Barbara with a degree in psychology, I still didn't know what I wanted to do. I took the year off, an *Endless Summer* sojourn, surfing my brains out, trying to get a handle on my life. I came up with the idea of med school in Costa Rica and then realized I was kidding myself. I tried law school at Southwestern, but it also wasn't for me. I gave the media a try and did graduate studies at the Annenberg School at USC. But after a big disagreement with my faculty adviser I began to get a little desperate. I'd kicked around *too* much. I needed to create a career opportunity for myself. The twist is that there had always been an opportunity in my family, but I'd never looked at it that way.

Abe Lastfogel was the great-uncle of my best friend, Robert Elswit. Robert's a director of photography who did *Magnolia* and *Boogie Nights*. Mr. Lastfogel's sister, Sarah Elswit, was Robert's grandmother. She raised him after his parents died in a plane accident. Robert and I went to Sunday school together. I went with him to the Hillcrest Country Club on special occasions. Over the years Sarah and I also got very close. One Friday I was so despondent, I told her, "I think I want to be an agent."

"Do you *really* want this?" she asked. Robert's older brother had gone

into the mailroom and had crashed and burned. I said yes. Sarah called Mr. Lastfogel that afternoon, and on Monday I was at William Morris.

I did a rubber-stamp interview in Personnel with Chuck Booth, a guy who had worked at the phone company for twenty years and had sold the Morris office its own repeater phone system. Then I was ushered into Mr. Lastfogel's office. I was petrified. He didn't ask me much; he just told me in so many words that William Morris was his family, that being an agent is a life choice. He never asked me if it was something I wanted to do.

Did I? Was being an agent a career goal? No. If on my way to William Morris someone had said that he thought I'd make a great actor, I probably would have made a U-turn and found a drama school instead.

BRUCE BROWN: When I was approached by Norman Brokaw to work at William Morris, I thought it was an insurance company. Norman and my parents belonged to Hillcrest Country Club. I taught tennis there in the summer to make money before going to law school. Brokaw's wife was my student.

Brokaw thought I was an affable young man with relatively short hair for the early seventies. I didn't know much about the entertainment business, but he pressed me. He said, "William Morris will be your master's program. If you don't like it, you can always go back to school."

My first interview was with Kathy Krugel. Her hair was sort of blackish red and cut in a Daisy Duck kind of thing. She would come in perfectly coiffed, and by the end of the day she'd be totally disheveled, like she'd been in a wind tunnel. Kathy was also the only woman I knew who could have chalk on her body, even if there was no chalk in the building. Later I learned that her nickname was the Fly because she could not stop blinking. No one ever called her that to her face, of course.

I met with Chuck Booth for about two minutes. He was hale and hearty, a get-along-go-along guy, typical for human resources. Looked like a greeter. Because Brokaw had recommended me, I was pretty sure I'd make it in unless I spit on the floor. Booth told me to come to work the following Monday.

My parents were happy. After my first day they took me to Trader Vic's at the Beverly Hilton. Abe Lastfogel ate there every Monday night

because Hillcrest Country Club was closed for dinner. Sam Weisbord was with him. And there I was, with my parents: the new mailroom kid, sitting next to the most revered agents in show business. All I could think was that I made eighty bucks a week and they made eighty bucks a second.

ALAN IEZMAN: I majored in international relations, wrote papers about the Middle East, and was fascinated by the CIA. But when it came right down to it, I thought: Name one Jew in the foreign service. I couldn't. So I had to ask myself what I liked to do most in the world besides smoke dope and have sex. *Go to the movies.* I changed my major to film and after graduation took what was left of my student loan, moved to Westwood, and looked for a job. Couldn't find one. I was about to give up when I opened the Westwood yellow pages and saw three companies under "Film." One, Lion's Gate Films—Robert Altman's company— was right around the corner from my apartment. I walked over and said, "I'm looking for a job. I'll do anything."

They didn't have a position. I went back every week for five months, and finally they gave me a job as a production assistant on *California Split,* with George Segal and Elliott Gould. Then they asked me to go to Nashville in the middle of the summer with a bunch of crazy people. I declined—and turned down *Nashville.* Instead I wound up as an assistant director on an independent feature, *The First Nudie Musical.* The night we wrapped, someone said, "You know, you should be an agent."

I said, "That's the most insulting thing I've ever heard. They're sleazy guys with cigars. They have bad reputations. Everybody hates them."

A week later my girlfriend said, "I have this friend who works at a company where they sell actors." She gave me the name: Barry Solomon, at William Morris. He spared a few minutes and told me about the mailroom program. He also said, "You're wasting your time. Forget it." But I needed desperately to make some money, and I figured I'd at least end up with an overview of the business.

DENNIS BRODY: After college I went to Colorado to clear my head, then found out that my uncle, who was very influential in California politics, had a relationship with a judge whose brother was Sam Peckinpah, the director. We set up a meeting. It was a wild thing. I wore a three-piece suit and looked perfect. I walked into Peckinpah's office at the old Samuel Goldwyn studios and found him lying naked on a convertible couch, like he'd slept there all night. The sheet was only up to

his ankles. He told me stories about how he and my uncle used to piss on people's lawns after important political parties. I felt like I was in a Woody Allen movie. I tried to find in that moment some clue as to how I might fit into the business.

My father turned out to be the key. He was a stockbroker. His client Ruth Engelhardt was head of business affairs at William Morris. He set me up, and she got me the interview with Chuck Booth.

People always talk about how they had to wait to get into the mailroom. It's changed significantly, but then it was a matter of timing, and of something else: Certain types were shoo-ins, like the young Jewish man, a college grad, and anyone who was reasonably attractive—or at least not scary-looking. Occasionally they would stretch it because, with a mix of personalities, you never know who's going to make a good agent. The day I started, Jim Houston, the first black in the mailroom, also started. Within a month Shelley Baumsten, the first woman in the William Morris training program, was hired. Things were changing.

SHELLEY BAUMSTEN: I got out of college with a degree in literature and no thought given to what I wanted to do in life. Getting into show business had not been my life's ambition, but I met a woman who suggested I might want to get into a literary agency. Okay, good idea. My brilliant follow-up? I opened the yellow pages and looked under "Agencies."

I wrote a particularly literate letter and got a couple of positive responses. One was from the firm Adams, Ray and Rosenberg, which at the time was a really top-notch agency. The senior partner, Adams, wrote, "Dear *Mr.* Baumsten: We're interested in your qualifications. We have an entry-level position, so please phone for an interview."

Mr. Baumsten? Clerical error, not important.

Adams was an elderly, portly guy, and the entire interview consisted of "I'm not going to hire you because you're a woman." Straight out. "When your kids get sick, you're going to have to stay home with them."

I said, "I don't have any kids."

"When your husband gets transferred, you're going to have to leave with him."

"I don't have one of those, either."

I knew I could sue, but I didn't want to waste my time. Besides, on

some level I appreciated the fact that he'd been straightforward. I didn't have to rack my brain about why I didn't get the job.

I finally went to work with Jane Jordan Brown; she had a one-woman operation. A year later I ran into a woman I'd grown up with. She was married to Ron Mardigian, an agent at William Morris. When she heard that I was in the agency business, she suggested that I meet with her husband. We had coffee at my mother's apartment: Merle, Ron, my mom, and I. It was very casual. Ron told me that the company had brought people through the mailroom for fifty years, give or take—but never a woman. They'd decided it was time.

CHUCK BINDER: I was already in law school—actually, getting thrown out of one after the other—and made money teaching tennis in Beverly Hills. Most of the teachers in the seventies were guys who didn't make it on the tour, so they gave lessons and hit on the rich guys' wives and daughters. Through some doctors I knew, I ended up teaching Eva Gabor. I didn't even know who she was, but they said she was a big star, and gave me some advice: "You charge us ten bucks an hour to hit the ball. Charge her twenty-five bucks. She won't think you're a high-grade tennis teacher otherwise." When I went to her house, I was stunned. I'd never met anybody with a tennis court in her backyard. Her servants gave me Coke in a crystal glass.

I was thrilled to be in the center of a wealthy environment making my hundred bucks a day. Mel Brooks and his wife, Anne Bancroft, took lessons. I taught people who ran studios. I hung around Bob Evans's house. I taught Larry Gelbart's kids. They hated tennis, so they'd say, "Take us down to Thrifty's and buy us an ice cream cone."

But my dad wasn't pleased and said I had to find a real job. He was a tough guy from New York's Lower East Side who liked to say, "If I could just have put you in the army for two years, they would have made a man out of you." He wanted me to go downtown to the garment industry, but I wasn't interested. I was thin, in shape, had long hair. I said I would marry a Beverly Hills girl and that would be it for me.

"You're a dreamer," he said. "Come into my company." My dad was a window cleaner, and compared with standing in someone's backyard hitting tennis balls, that was really hard work.

Then Bob Shapiro, the number-two guy in the William Morris

Motion Picture Department, said, "I'll get you into the Morris office mailroom."

I thought, An agent? All I knew was that the guys I taught tennis to who ran studios made jokes about agents, called them jerks and stupid. But I decided to give it a shot, just to get my father off my back. Of course, he thought it was great: I'd get a haircut, clean up, and become part of the world.

JACK RAPKE: I'm from Miramar, just north of Miami, by way of the Bronx. When we moved to Florida, my father opened a couple of businesses that went bust, then became sales manager for the Florida Smoked Fish Company. He never made a lot of money, but he always brought home good fish. They wanted me to be a doctor; I decided to go to NYU film school. My parents didn't understand how I'd make a living, but they were supportive. I think they realized the ship had sailed.

The war in Vietnam was going on, and I felt rebellious and outraged. I wanted to make political films. Film school was great, but afterward I couldn't find work, so I drove a cab at night in Manhattan and tried to get into the cameramen's union. Then a light came on in my head: I had to go to Hollywood, because that's where the movies were *made*.

I came west and sold real estate a few days a week. Then, somehow, a guy I knew from film school, Richard Katz, got ahold of me. He worked in the mailroom at William Morris but was unhappy. He also wanted to be a cameraman. After we hung up, I remember wondering why he'd called. We really weren't that tight. But for some reason the conversation seemed otherworldly. I felt it would change my life.

We met for lunch, and I quizzed him about the agency. Then he said, "I'm going to a party. Some of the guys in the mailroom will be there."

I met his friends, checked out their style and energy, and thought, Okay, I get it. I see myself in these guys. We're kind of cut from the same cloth.

Richard Katz got me an application and an interview. I didn't own a suit, so I bought one in navy blue, sort of a Madison Avenue look. I had read that Frank Yablans, who ran Paramount at the time, always wore a polka-dot tie. I got a polka-dot tie.

On interview day I got to William Morris an hour early. I was beyond nervous. To calm myself, I walked around the residential streets. I went over my strategy. Before I realized it, I found myself on Beverly

and Wilshire—and I had stepped in some dog shit. There I was, on the corner, wiping off my shoe ten minutes before I had the biggest interview of my life. I started to laugh at the absurdity of it all.

When I met with Chuck Booth, he said, "I think you're a little bit overqualified."

He wasn't going to hire me, and in that moment I understood how much I wanted to be part of Hollywood: I needed it like you need sex, water, food, and sleep. It had become a need to the death. I said, "Please, let me be the judge of that. If my qualifications are greater than what you believe the normal applicant has, then allow me to step down in class. Don't take it away from me. I'm willing to do anything, and if I'm willing to do anything, then that should be enough."

The thing is, when you're young and you want to be in the business, you often say "I'll do anything." Oh, so you'll do anything? You don't know what anything is until you're doing *anything*.

RICHARD MARKS: I had just graduated law school and had an interview at the entertainment division of Loeb and Loeb, a Beverly Hills law firm. Either I was cheap or I didn't have the money to park in the garage, so I parked blocks away, in a residential area. Walking to the law firm, I passed the William Morris Agency. On the way back to the car I went in for an application, filled it out, and never thought about it again. A couple of weeks later I got a call.

A woman said, "This is Kaaathy Kruuugel." I thought it was a friend playing a joke, so I said, "Well, it's niiiice to meeet you, Kaaathy Kruuugel." But when she said, "I'm from William Morris, and we want you to start in our training program in the mailroom on Monday," it dawned on me that I was being a jerk and I'd just been offered a job.

BOB CRESTANI: My mom was a homemaker, my dad a superintendent at Bethlehem Steel. I grew up in Portage, Indiana, about thirty miles from Chicago. A very rural area. I went to Indiana University and got into radio/television. When I graduated, my dad asked, "You gonna get a job in the mill?" I said no, packed my Volkswagen with everything I owned, towed it behind a drive-away car—a Camaro—and headed for California. I ended up in a little studio apartment on Second Street in Santa Monica. I looked for work and night-clerked at a Holiday Inn to pay the bills. Then a distant aunt who worked in the travel industry told me I should try the talent agencies. "Try to get work as someone's secretary," she said. "It'll help you get a job in the business."

I applied to both William Morris and ICM. They told me there was a four-month waiting list before I could even get an interview, and it would be a year before anyone would make a decision. I felt completely defeated, but the next day I called both companies again just for the hell of it and got interviews right away.

ICM offered me a job immediately, at $110 a week.

At William Morris I met with Kathy Krugel. She tried to scare me away: "It's no picnic. It's going to take three years. You may never make it." Then: "Who do you know?" I said I didn't know anybody. I knew she just wanted to see how I'd take it. That was the easy part. I didn't know any other way to react than "I want the job."

GARY RANDALL: After college I knocked around and sold insurance to pick up some spare change. My stepfather said I had a distant relative in Los Angeles, Mike Marcus, and I should visit him and see if he could help me get work. That sounded fine; I was a pretty brash kid, and I figured I might even be able to sell him some insurance.

Mike was from Pittsburgh, like me. He lived in Topanga Canyon, and he invited me out for dinner. When I walked in, he was lying on his living room sofa, wearing jeans and a flannel shirt, smoking a joint—and reading a script. I asked, "What do you do for a living?"

He said, "I'm a talent agent."

It looked cool. I smoked a joint with him and spent the rest of the evening picking his brain. It was 1974—who wanted to be selling insurance? Mike offered to call a friend who ran the training program at ICM, to get me an interview.

At ICM I threw out buzzword after buzzword, with no idea what they meant. The personnel guy looked at me like I was insane. "Who the hell are you and why am I meeting with you?" he said. "You don't know *anyone* or *anything* about the entertainment business. In fact, the *only* person you know in Los Angeles is Mike Marcus. I got Lew Wasserman's best friend's kid in here, and the kid of a senior agent's buddy who just graduated from film school. Forget it, kid." And he was right.

I called William Morris and got Kathy Krugel on the phone. I said, "My name is Gary Randall. I've been referred by Mike Marcus. I recently moved to Los Angeles. I've just been offered an opportunity in the ICM mailroom, and before I take that opportunity, I'd like the opportunity to meet the competition."

She put me through to Chuck Booth, and he said, "Come on over." My meeting with Booth was virtually identical to the one at ICM. He said, "Why should we hire you?" This time I was ready.

"A talent agent is a salesman," I said. "I've been selling life insurance to college guys in exchange for their beer money. I have to believe that if I can do that, then I can sell a writer to a producer or an actor to some studio. All I need is to be educated about your product, and I guarantee you I'll be a spectacular agent."

Booth said, "Yeah, but how can you prove you're a good salesman?"

"I'll tell you what," I said. "If I can convince you to buy an insurance policy from me, you give me the job in the mailroom." Fortunately, I worked for an extraordinary company, Northwestern Mutual Life Insurance, that had great corporate plans.

I'm sure he did it for the pure entertainment value and never thought he'd have to pay up, so he said, "Go ahead."

I said, "Tell me about the insurance package you have here." When he did, I realized William Morris didn't have key-man policies in place for their senior executives.

I said, "Who's the most successful agent you've got here?" He mentioned some guy named Stan Kamen. I said, "So, if Stan Kamen drops dead tomorrow, how much revenue does the agency lose?" It was something like ten million. I said, "Well, do you have a policy on Stan Kamen that will offset the loss of income to the agency?"

They didn't. Booth was in charge of all the human resources, including the benefits. He called Walt Zifkin while I waited. Afterward he said, "This is a great program. You draw up the contracts." The policy was a blanket retirement/key-executive/long-term-care benefit package for their senior management.

When I left, I said, "Remember our deal."

Two days later I had the job.

Here's the funny thing: I made more money from the premiums on that policy than I did in the three years I was in the training program.

GARY LUCCHESI: My father drove a bread truck for Kilpatrick Bakeries in San Francisco, and I worked in a grocery store as a kid. I was the first in my family to go to college. At UCLA, in a course called "The Speeches of Abraham Lincoln," a student told me, "David Geffen is teaching a course on the entertainment business; last week Joni Mitchell was there. Want to go?" Of course.

Geffen also brought industry figures as guest speakers: MCA's Sid Sheinberg; Steve Ross, who owned Warner Brothers; Ned Tanen, who ran Universal; Bob Shapiro, from Warner Brothers; Mike Medavoy; superagent Sue Mengers. It was the first time I had ever encountered real rich people. Back home the rich people were the ones who owned A. Sabella's Restaurant. Listening to them, I figured out that some of these people weren't any smarter than anyone else, and I thought, What do these rich guys have that I don't have, besides money? The class gave me the opportunity to be a little bit arrogant and to think that maybe I could compete in that world.

One day I raised my hand and asked, "Where do you go if you want to go into the business side of entertainment?"

Geffen said, "It's very simple. Do what I did: go to the William Morris Agency, start in the mailroom, and work your way up. I did it, Barry Diller did it, Mike Ovitz did it, Irwin Winkler did it." On my application, in the space for who you knew in the entertainment business, I put "David Geffen."

When I got the job, I called my folks. My father said, "Jesus Christ. You put yourself through college and you're working in the mailroom? Are you sure that's the right thing?"

"Pop," I said, "there's a pot of gold at the end of this rainbow."

FIRST IMPRESSIONS

RAPKE: Elmer Silver ran the actual mailroom. He was a retired postal worker with a horrible toupee. He smoked a pipe that drove us all out of our minds. Elmer was well known by the secretaries for his shoulder and neck massages. He even gave some girls Valium to help them relax. Watching this seemed to us like a scene out of *Cool Hand Luke*. These women weren't coming in simply to get their bodies rubbed; they had come to torture us. We'd stand there, grimy and disheveled, while Elmer ran his old hands all over some hot chick's back as she purred and looked at us like we were behind prison bars.

BRODY: My first day is indelible. There was a guy in the mailroom who looked like Ron Howard. He worked the Xerox machine. Two FBI special agents stormed in and, without any fanfare or explanation,

pushed this guy facedown onto the copier, handcuffed him, and took him away. The kid didn't say a word. Later we got letters from prison saying he'd been framed for extortion.

After the FBI left, Jimmy Houston, who'd started that same day, decided he would show everybody his bullet-hole scars. I thought, Where am I? I'm a nice Jewish boy from the Valley; what's going on in this place?

That same day two assistants were made agents—and mailroom guys took their places. Before I went home, I'd already moved up a couple of notches.

CRESTANI: I showed up at eight-thirty, wearing a suit and tie. When I walked in, the first questions were "Who are you?" and "How long were you on the waiting list?"

"What waiting list?"

"The waiting list to get in." Their surprise was palpable. Each had been waiting at least six months just to get into the program. I said that I'd waited only two days.

"Two days? Who do you know?"

"I don't know anyone." From the way they huddled together and whispered, I could tell they didn't believe me.

BAUMSTEN: As the first woman in the training program, I was the source of a lot of curiosity. Everybody just wanted to get a look—including the other women in the company. They wanted me to do well. The guys in my mailroom group weren't as curious as the rest of the company. To them it was no big deal. We understood we were all in it together. Only Jimmy Houston kept talking about my being the "first chick." I'm not normally sensitive about what people call me, but that irritated me. I said, "Tell you what. I won't constantly talk of you as the first darky in the mailroom if you will not refer to me as the first chick in the mailroom. Okay? Is that a deal?" Later Jimmy and all the guys gave me a necklace with a little cracked egg with a chick coming out. It was sweet.

RAPKE: When I started, it was Christmas and the gifts that arrived for the agents were unreal. They kept on saying, "Jack, go out to the curb, there's more gifts." I was outside picking up packages and Clint Eastwood walked in. I think I turned to the nearest agent and said, "Hey, Clint Eastwood's here!" The guy said, "So what? If you're going to be in the agency business, you can't be like, 'Hey, that's Clint Eastwood.' He's just another actor." I couldn't feel that way.

THE CRUCIBLE

BINDER: The program required college grads, but they didn't actually care if you became an agent or not. The whole thing was just a way of getting cheap but qualified help. Getting ahead was all up to you. Nobody would guide you through. Nobody said, "I'm going to take an interest in Chuck Binder and turn him into the next big agent." Faced with that, I realized, This isn't for me.

BRODY: What we did was not hard. Yeah, sure, maybe on the Valley dispatch run, because you had twenty-five stops to make in two and a half hours and you'd get stuck behind a cement mixer going through Coldwater Canyon. But please, was that digging ditches? No. It wasn't abusive. It wasn't like the marines. The worst thing was that we got paid too little. If we had known how much we would actually benefit down the line from the experience, we probably wouldn't have complained that much.

RAPKE: The system wasn't designed to be a psychological crucible—it was designed for someone to do the menial tasks. It was "Hey, you want to learn the business? You learn it from the absolute bottom up." Abe Lastfogel started as William Morris Sr.'s mailroom boy on Tin Pan Alley, because even then they needed someone to do the shit work. Some people can't take it, can't stand the ego reduction. Those people are weeded out. But the big secret is that if your ego is out of it, then you can represent people.

RAGE AGAINST THE MACHINE

RAPKE: My first job was running the A. B. Dick machine, an industrial offset printer with open inkwells. It always broke down. Elmer told me the guy from A. B. Dick would stop by to show me how to work everything. He also told me that six months earlier a guy from the mailroom had lost his finger in the printer.

BROWN: You always had to wear a white shirt and a tie to work because in the afternoon you might have to cover an agent's desk. If an obvious brownnoser was in charge of printing that day, we'd fuck up his

ink rolls and make sure ink spilled on his shirt. Or brush by him while wearing an inky apron.

CRESTANI: When agents were fired or quit, they still got mail for a while. We didn't care about most of it, but when the Academy screening invitations came in, the guys would fight over them. These were free passes. When Bob Shapiro left for Warner Brothers, right before *Star Wars* came out, I watched for his pass and grabbed it the minute it came in. But it was such a hot ticket that I also decided to do something nice for my pals in the mailroom.

The A. B. Dick machine printed on card stock. The guy from the paper company came in every week, and we'd order card stock for making people's note cards. I showed him a piece of the *Star Wars* invite and asked him if he had any paper like that. He did, so I made ten bootleg *Star Wars* tickets, which meant twenty more people could see the movie early. They looked perfect. We all got into the big theater on the Fox lot. Jack Nicholson and Warren Beatty came in but couldn't find seats. Beatty and Jack decided to sit on the floor. The next day there was a big story in the trades that, somehow, somebody had bootlegged the Fox tickets and left the stars without seats.

RAPKE: The best A. B. Dick story involves Chuck Binder. He had a very cavalier attitude toward work and loved getting Elmer's goat. One day Chuck snapped.

BINDER: The moment I got into the mailroom, I tried to figure a way to get out. You've got to understand: I was like a king in Beverly Hills, teaching tennis to stars, and at William Morris I felt like I'd been demoted. Clients would drop by the mailroom and say, "What are you doing here?" To me, being in the mailroom was like being a janitor. I had on my apron and my tie. I was trapped in a room ten feet by twenty feet. It was awful. I hated every minute of it.

One day I had to run over to Dino De Laurentis's office on Cañon Drive, get a stack of checks, and get back within twenty minutes. At his office I saw a *King Kong* poster and said, "Oh, you guys produced that? Can I get a poster for the mailroom?"

Later that night I put up the poster. I'd been working the A. B. Dick and had ink all over myself. Suddenly something took ahold of me and I put my inky handprints across the carpeted, soundproof wall, leading up to the poster.

The next morning Elmer Silver said, "Chuck, you were the last guy

here. What happened? The whole wall has handprints. What did you do?"

"I didn't do anything."

"But you were the last one here."

I said, "Maybe the ape got off the poster."

Elmer didn't think it was funny. He wanted to fire me.

I was hauled in front of Kathy Krugel and Chuck Booth. I wasn't ready to lose my job, so I sat there, sweating, while she lectured me. She said I was one of the worst people they'd ever worked with. "Do you think you fit in? Do you want to stay here for the long term? Are you really sure you're happy here?"

I said, "Oh, yeah, it's one of the great experiences of my life. It's fabulous. I'm making a hundred bucks a week, I'm thrilled to death. I'm in show business."

I don't think she believed me.

"Why don't you quit?" she asked. "It will be better for your reputation."

"What reputation?"

"Within the *entertainment community.*"

Yeah, but if I quit, I wouldn't be in the entertainment community.

The only thing the company thought I *did* care about was fan mail. Every day the agency would get gray, filthy postal bags full of thousands of fan letters for two hundred different clients, like Elvis and Ann-Margret. Kathy Krugel said, "Nobody has ever kept it up the way you do." I was supposed to sort and put them in boxes for the dispatch guys to deliver. Honestly, I would have been there for the rest of my life had I actually sorted that mail. Instead, I'd just dump it. Shred it. Throw it away.

To me, Booth and Krugel and the other people at the company were like from another planet. I knew if I quit, I'd never get unemployment insurance. I said, "If you want me out of here, fire me. I'm not walking out."

They gave in and fired me.

I had to tell my father, and that really bothered me. But he kind of expected it. He figured I was like Peter Pan and I was never going to grow up.

THE COURTSHIP OF EDDIE

LUCCHESI: My first day I came barreling out of the mailroom and ran into an agent with a Van Dyck–ish beard and pushed-back hair, slightly balding. He was talking to a British woman, Judy Scott-Fox, also an agent. As he talked he squeezed her breast. When I bumped into him, he said, "Who are you?"

I said, "I'm Gary Lucchesi, I'm in the mailroom."

"You're cute," he said.

Then he put his tongue in my ear. I couldn't fucking believe it. He completely freaked me out. I almost hit him. Meanwhile, he laughed hysterically. Later I found out he was Ed Bondy, a powerful agent. And, obviously, flamboyantly gay. I'd never known anyone gay. In fact, I knew only one Jew—my high school librarian. Boy, was I green.

BRODY: Eddie was the last of a dying breed, a New York theatrical agent who *really* knew acting. He could say just about anything and get away with it. My first day floating on his desk, Louise Fletcher called. She had just won the Academy Award for *Cuckoo's Nest*. I stayed on the line to listen. The first thing he said was, cooing: "I send you these scripts with offers. You pass on them. The problem with you is, you spread your legs, the wind rushes up your cunt and rattles your brain. You've got to start saying yes to some of these things." In that moment, in that split second before her reaction, I thought, Oh, my God. But she just laughed hysterically.

RANDALL: One day I got in the elevator and pushed three. Eddie got in behind me and pushed two. The doors closed. He looked at me and said, "I'll give you a hundred dollars."

Eddie had just moved out from New York. I didn't know who he was. I said, "For what?"

"If you'll let me suck your cock."

Then the doors opened and he walked out, not waiting for the answer. I pushed one and went immediately to Kathy Krugel and said, "You are not gonna believe what just happened in the elevator!"

"Oh," she said. "I see you met Ed Bondy."

Ed and I became friends after that because we would constantly rib each other and he would up his offer. By the time Eddie died, the deal

on the table was my own Mercedes, my own room in his house, and twenty thousand dollars a month.

MARKS: Ed was into shocking people for fun. He could be a good guy, but he also screamed and threw things. That was his way of intimidating his assistants, like me. His procedure in the morning was to start by throwing papers at me: "Monday. Two weeks from now. We'll deal with this today," while yelling, "Can't you keep up? I'm so irritated!" Once, he picked up a paperweight, a gold star that said FUCKER, and made as if to throw it. I said, "Ed, if you throw it at me, I'm gonna shove it up your ass."

He said, "Do you promise?"

One day Ed got sick, and the doctor told him he couldn't yell anymore. When he finally came back to work, twice a day, in late morning and late afternoon, he would go off to another office to meditate, to calm down.

IEZMAN: Eddie died suddenly, of a heart attack, at fifty-one while standing at his sink. The memorial service was a standing-room-only crowd at the old Huntington Hartford Theater on Vine Street. The stories were funny and incredible.

MARTY LITKE: Eddie was a very dear friend of mine—I'm the godparent of his children—and a terrific man who discovered incredible talent. Eddie wrote three wills. The first will said that his ashes should be scattered in Switzerland. My wife said, "Well, Eddie, you know if we're going to Switzerland, we have to go first-class." As only Eddie would do, he rewrote his will. The second will said a group of people would scatter his ashes at the Ventana Inn in Big Sur. Then he realized that with twenty people going, it would also be expensive. So he rewrote his will a third time, choosing the Santa Monica Pier. That's where we scattered his ashes.

THAT SEVENTIES SHOW

RANDALL: Seniority in the mailroom got you only so far. You had to network the agency. A big part of that was schmoozing the secretaries and the assistants. It was a pretty incestuous environment. In the mid-1970s

it was still a relatively free-love world. I didn't have sex in the office until I was an agent, but I think Rapke did it once while he was a trainee, in Mardigian's office, while Ron was out of town. And Iezman did it on a run one day; we stopped by the apartment of a girl he was seeing, and they had a quickie. Otherwise, you spent all your time in the building, so the only place you were going to meet anybody was in the agency. Most of us dated the secretaries, and they looked at the mailroom guys as the future of the industry. If they had a relationship with one who was on the right track, they could ultimately have a relationship with an agent.

BROWN: One secretary, Barbara Bell, had the longest legs anybody had ever seen. When we found out she took a tap-dance class, we all enrolled. She looked at us like, Who are these nerds? It made her a little uncomfortable, I think. But it was a great moment, to see her dancing. The view was everything you could ask for.

RANDALL: Dating secretaries meant access to information. You might read a deal memo in the mailroom and know that the secretary had been listening in on her boss's phone conversations. You'd have a drink after work and say, "I see we made this great deal at Warner Brothers for so-and-so. How did that deal coalesce? Tell me about the inside workings." You'd have pillow talk: "How did this television package happen?" You put together the pieces of the puzzle.

Iezman had a long-term relationship with Jamie Shoup, an assistant in the Music Department. She had a phenomenal body. Everybody wanted her. Brody met his wife, Ruth, on his first day in the mailroom. She worked for Ron Mardigian. Rapke had a relationship with Laurie Perlman, an assistant at CAA, whom he ultimately married.

RAPKE: I first met Laurie when I was at NYU. I was reintroduced later on, when she was a secretary at CAA working for Ron Meyer, and I was working for Ron Mardigian. I knew a personal relationship between people at competing agencies could be sensitive, but I didn't think anything was wrong with it. In fact, I told Mardigian about it.

MARDIGIAN: Interoffice dating was really frowned upon. Ruth Daniels worked for me, and even her seeing Dennis Brody was kept hush-hush. But the intraoffice thing would not have incurred as big a penalty as dating the competition. In my time that meant going out with someone from MCA. That was grounds for dismissal, and that old-fashioned concept permeated the company.

SOMERS: It could be quite incestuous. Gary Randall was sleeping with Bruce Brown's girlfriend. Bruce was clueless, but all the guys knew about it. It was such a scandal. The girl was a secretary at William Morris. She'd leave Bruce's place and go into Gary's place—right across the hall in the same apartment building.

BROWN: Oh, I knew. When I'd open my front door on Sunday afternoon and see Gary's newspaper still outside, I knew he was sleeping with the girl I was crazy about. She liked Gary, she liked me. She had trouble deciding. But Gary and I also liked each other. It was a friendly rivalry.

Eventually she became my first wife. For a wedding gift Mr. Lastfogel gave us cash. A year and a half later we got divorced. Gary ended up marrying Lenny Hirshan's assistant, Patricia.

GREMLINS

BRODY: When I left the mailroom, I became the dispatcher. We had a fleet of Gremlins that took a lot of abuse because the guys often took their frustrations out on the cars. One guy ran into a wall on purpose. Another opened a door into traffic, and the door came off. A third guy drove up a winding Hollywood Hills driveway and took out the right side of the car. He knew it was happening, but he just let the wall do its damage.

RANDALL: The Gremlins were total pieces of shit. The transmissions sucked. The cars had no power. And they didn't have any air-conditioning or radio. We drove in hundred-fucking-degree heat, wearing ties, drenched in sweat, trying to look like professionals. We complained, but they didn't give a shit. The only way to vent was to destroy the cars as quickly as possible. It was always an "accident." I not only opened a car door into a light pole, but I have the rather dubious distinction of trying to figure out how fast you could go down the Santa Monica Freeway, slam the car into park—and see whether or not the transmission would blow out.

BROWN: Some guys were whiners: "I got to go out alone in the rain?" When I ran Dispatch, if I didn't like someone, I'd send him into Hollywood at five o'clock, when the traffic was terrible, in the rain, by him-

self, with a big package. Or I'd make up a story so that he'd have to deliver a fake package to a fake address. Or if I didn't like a guy—say, he always wanted to leave early—I'd give him the Friday five-o'clock deliveries to people who wanted to get their scripts before they went to Palm Springs for the weekend. I did this to Steve Epstein. He complained a lot. He was from Pittsburgh. We nicknamed him Sluggo because he talked and looked like the comic-strip character Sluggo. He'd say, "Don't call me Sluggo."

We'd say, "Okay, Sluggo." It drove him crazy. Even Barbara Bell called him Sluggo.

Other guys were creative slackers. Marty Rosenberg, a relative of Danny Thomas, was into visiting graveyards. Marty knew every graveyard in town. Sometimes we'd leave early just to make a run. Or we'd finish the night before, type up a fake run sheet to make it look like we were busy the next day, and go graveyard hopping.

BRODY: There was always a temptation as a messenger to look at what you were delivering, and sometimes I couldn't help it. I can't tell you how many times I picked up drugs. But I have to make this very clear: As heinous as that might sound now, drugs then were very out in the open, and it was hip and chic to do them. Users and nonusers interacted. There wasn't a drug subculture, it *was* the culture.

SOMERS: The William Morris receptionist was rumored to have gotten into Quaaludes, because at times she would nod off. But I don't think management had a clue. Unlike our group, who had come straight out of the sixties, the senior agents had no drug experience. People would do blow prior to a meeting; one agent even shot up heroin in the bathroom. Then he'd piss alongside senior executives, who never noticed.

RANDALL: Snooping is how we learned that one of our good friends who had recently graduated from the training program sold drugs. He ended up being *our* top supplier. He wasn't yet an agent, but he was on the fast track to becoming one. It was very surreptitious. But it was an era when people referred to the snowcapped mountain of Paramount's logo as being the cocaine mountain. It's not like we didn't know what we were delivering. We knew.

ROSHOMON, OR THE MOST FAMOUS MAILROOM STORY EVER TOLD

RAPKE: I'm now going to tell the most famous mailroom story ever. It happened. *We were there.*

There was this older agent, in his mid-sixties at the time, who covered CBS. They called him the Silver Fox. His secretary was Michelle Triola Marvin, who was famous for the Lee Marvin palimony suit. She used to push us around: "He has a run. Come and get it immediately." Not once or twice, but ten times a day: "He has a run." She used to beat the shit out of us. We were like, "Fuck her. Fuck him."

Dennis Brody was head of Dispatch. The town was divided into three runs: Hollywood, Valley, and Beverly Hills. We were all out of the mailroom and in Dispatch—me, Iezman, Randall, Bruce Pfeiffer, Somers—and we got a call from Michelle Marvin: "I have an *immediate* package that has to go *immediately,* first stop." Where's it going? Century City, so it's the Beverly Hills run. Who's on the Beverly Hills run? Gary Randall and Bruce Pfeiffer. Gary Randall was driving. Bruce ran the packages.

They went down to the guy's office. The rest of us went outside, on a break, to the catering truck. We were hanging around the roach coach when Pfeiffer came out carrying a white paper bag like you'd get at a pharmacy. The dispatch slip read CENTURY CITY HOSPITAL. Bruce carried the bag at arm's length. He didn't know what was in it, and he didn't want to know. He got in the car with Gary and put the bag on the floor between his feet.

Gary and Bruce left the lot and turned up Charleville, heading east, then to Olympic and the hospital. But before they arrived, curiosity finally got the better of them. They had to stop and check out what they were carrying. They figured it was a urine sample.

It wasn't.

It was a stool sample.

They literally delivered shit. When they told us, we were outraged at the thought that a big-time agent couldn't take the dump himself at the hospital—or, conversely, take in his own stuff.

BROWN: *I* drove with Gary Randall. Gary was a volatile guy. Instead

of making the delivery, he took the bag to the agent's office, put it on his desk, and said, "I'll eat shit, but I won't deliver it." That's pretty much verbatim.

RANDALL: This story is legendary. Every trainee has heard it. There are many different versions, all horseshit. It was just me.

Part of our responsibility was the bank run in Beverly Hills. Every day, two or three times a day, someone would be sent upstairs to Accounting and given a package to go to Bank of America or Union Bank. These deposits were mind-boggling. A $10 million check from CBS to the agency. An actor's check for $1.6 million. An agent depositing $450,000 in his kid's trust account. We were already aware of being in the middle of Beverly Hills, surrounded by astounding wealth, at an agency through which zillions of dollars were funneled. But these bank runs, *handling* all that money, were when the stardust really hit. It was the top of the heap. That's when it hit me that I *had* to make it in the business. That's when I found my desire.

One day I got a call from Kathy Krugel: "There's an important package that needs to be delivered." This wasn't a typical dispatch assignment. Dispatchers drove. Mailroom guys walked. Michelle Marvin handed me a brown lunch bag and said, "Take this to such-and-such address on Bedford." I also had a couple of bank deposits to make.

The delivery was only six blocks from the agency. I strolled along holding the bag, not curious at all about what was inside. I stopped at the banks, dropped off huge checks, and finally got to the building on Bedford where I was supposed to deliver the bag. When I got off the elevator, I realized I was at a doctor's office. I walked up to the nurse at the front desk and said, "I'm here to deliver the package from William Morris." She looked over her shoulder to somebody else and said, "The stool sample has just arrived."

I went, "You've got to be kidding me!"

She didn't even smile or answer, just shook her head. No, not kidding.

I walked all the way back to the agency thinking, This is the absolute lowest. I was *appalled*. Not only had I delivered someone's shit, but I hadn't known it. I walked into the mailroom and said, "You guys are not gonna fucking believe what I just did!"

Of course Rapke, being the street-smart New Yorker, said, "Asshole. Why the fuck didn't you open the fucking package? You could have

dumped it out and put some dog shit in there, and he would have gotten a call that he has worms."

Everyone cracked up and ribbed me like crazy.

I went to Kathy Krugel and said, "Don't you ever call me to do something like that again." She said she hadn't known what was in the bag. But it never happened again. I'm sure someone told the agent, "You cannot use the mailroom guys to drop off your shit for you."

Later it struck me that on that afternoon between the shit run and the money run I had held the absolute bottom and the absolute top of the entertainment industry in my hands simultaneously. In terms of a metaphor for mailroom existence, nothing prior or since comes close.

TIES THAT BIND

SOMERS: Our group bonded because we all had similar goals. We lived near one another, partied together, decided to make something of ourselves.

IEZMAN: Jack was the street smarts. Somers was the surfer. Randall was the salesman, the rainmaker, like the Burt Lancaster movie where the con man–hero comes to town. Gary could sell ice to the Eskimos. I was the wise father. Brody was the quiet entrepreneur who didn't want to be noticed but was always working a deal behind the scenes. We all had lunch together almost every day at a little coffee shop called the Four Corners, two doors down South Beverly Drive from Charleville. It was cheap enough that we could afford it. The waitresses were eccentric old ladies—and our friends. We'd eat, swap stories, tell about our day and our dreams. When Jamie and I broke up, I turned to Rapke—this despite that macho thing of not revealing emotion and vulnerability when you're young. When *any* of us had a problem, we would coagulate like blood.

SOMERS: I think part of it was that there was such a need at William Morris for people because of the void left in the middle of the company when the Creative Artists guys left. Loads and loads of people came through our mailroom. At one time I put a list together. If we took a ballroom at the Beverly Wilshire Hotel and had a reunion—and not

just the people who got to desks and got to be agents, but anyone who came through—it would be huge. And each era had its thing. In the Music Department you'd find the faint smell of marijuana in the afternoon. Elsewhere some of the older guys were having their three-cocktail lunches. With the disco era it was cocaine.

IEZMAN: Every year our little group will have an anniversary lunch at the Palm. Nobody else. Just us. We always start out with a toast. We still talk about everything.

ALL THE RIGHT MOVES

BROWN: Everyone thinks the idea is to brownnose your way out of the mailroom, but there's a fine line between obnoxious and aggressive. Too many of the guys were not that sophisticated. I wasn't from a showbiz family, but at least I knew how to use a knife and a fork.

Because I was an excellent tennis player, I started getting calls on Thursday or Friday to play on the weekend with Norman Brokaw and Roger Davis. Sometimes General Al Haig would come out, because Norman had started making all his Washington connections. When Larry Auerbach and Lee Stevens were in from New York, I'd play with them. I didn't particularly enjoy it. It screwed my weekends, but I'd do it.

RANDALL: Another way to network was to get involved with charities. Stan Kamen ran the Jewish Big Brothers of Los Angeles operation, and every year there was a big stag party held at the Beverly Hills Hotel. Somehow our class became the guys responsible for helping put the bash together. We had to go to the hotel and make sure the tables were set up properly, get invitations out, keep the RSVP list. Then, because we had done it, we were invited, and surrounded by every major guy in the business. We were the blessed kids, the next generation of Morris agents. Unless you were a fucking idiot or an asshole, you had to think you were going to get somewhere.

BROWN: Even though in the mailroom we made only eighty, a hundred dollars a week, at the Big Brothers event *everyone* was required to put fifty dollars in a drum—cash before taxes—there was a drawing and

someone would win it. They called my number. I won four thousand dollars. At first I was embarrassed. I was a William Morris employee, and we were sponsoring the event.

Cut to the end of the night. I was walking down the street outside the hotel. Walt Zifkin was on one side of me and Roger Davis was on the other.

Roger said, "I hope you know you're giving that money back."

Walt said, "The kid makes eighty a week, leave him alone."

Then the two of them got into it. It was like who had a bigger dick. I felt like a Ping-Pong ball. I didn't know who'd been drinking and who hadn't. All I knew was, four grand was a lot of dough to me. Roger finally said, "What's your decision?"

I didn't know if they were just playing with me or if it was a test. I said, "It's my money, I'm keeping it." Davis asked why. I said, "Like Mr. Zifkin said, I'm making eighty a week, so this would float me for fifty weeks. If you were to fire me today, I could get a job tomorrow and still keep the four grand."

Just like an agent. That was the end of it.

RAPKE: Steve Reuther, who was Stan Kamen's assistant, would come into the mailroom and say, "Who wants to read?" He meant scripts. I'd volunteer and ask when he wanted it. "As soon as possible." I figured that meant read it after work, finish the synopsis at 2 A.M., and give it to him when I came in. I didn't know that other people took two or three days. Then other guys started getting in their coverage the next day. I didn't want to be with the pack, so I did *two* scripts a night. On the weekend I'd sometimes take home eight to ten. I'd be up until three-thirty, four o'clock in the morning, typing away. One night the police came because the elderly woman in the next apartment had complained that my typing kept her awake. I said, "What do you want from me? I'm working." There was nothing they could do.

I think that's when my girlfriend and I broke up. I don't blame her for being unhappy. I was twenty-five, and nothing was more important than getting my career on track. On the weekend I worked, worked, worked, and did the laundry. I was motivated not by the love of where I wanted to go but by hate. There were many nights that I would go home and pound my fists on the wall, saying, "They will not break me. I will die before they will break me." A monster had consumed me,

because there was never anything I wanted more in my life than to succeed at William Morris and be in the movie business.

SOMERS: My big move was for all the right reasons, but it couldn't have seemed more inadvertently political. I was already an assistant when Sarah Elswit passed away; I was there at the end, holding her hand. I wrote a eulogy. I asked my mom to read it because I knew it couldn't sound like it had any other purpose than to express my love for Sarah. But somehow I ended up reading it at the funeral in front of the whole William Morris executive board. I even cried. Everyone was touched and I got promoted.

BAUMSTEN: I just assumed that if I presented myself appropriately, I would get an opportunity. I didn't think about it in terms of maneuvering. It's not that I'm ethically superior; I'm just not very good at it. Fortunately, I couldn't help but be very visible. I was a head and a half taller than most of the senior agents. They loved it. Sam Weisbord came up to me one day and said, "Are you still growing?" One day as I pushed the door open to leave the building I heard someone call to me. I turned back and stood there for a moment, holding the door, answering. And while I stood there, Abe Lastfogel walked out the door, under my outstretched arm.

BRODY: I read scripts for Stan Kamen, who was the head of the Motion Picture Department. Then they told me that his assistant, Steve Reuther, would be promoted and I could have Stan's desk—if I could wait. Of course I'd wait. I ended up waiting a year, but I became Stan's gatekeeper when he was at the pinnacle of his career. It was a prestigious, ego-satisfying place, and as a result some trainees didn't care for me, and some agents as well.

• • •

One day Stan came back from a lunch date and I said, "Stan, what are you doing here? It's two-thirty. You're supposed to be at Paramount now."

He said, "What are you talking about?"

I explained. He started screaming. "How dare you book me into lunch with a long-winded person like"—the guy he'd just had lunch with—"and expect me to be at Paramount at two-thirty?" He stood in the doorway, turned red, then purple. I said nothing. By the time he turned white, all I could think of was, The guy's going to have a heart

attack and it's going to be my fault—and I'll never become an agent. Then he turned away from me, leaned his arm against the doorframe, and grew quiet. When he turned around again, he said, "By the way, we made you an agent in the Motion Picture Department." Then he started screaming again.

SOMERS: I went to work for Barry Solomon in TV Talent. Barry had married the daughter of one of the senior agents—Mike Zimmering— had a kid, and gotten divorced. He hated his ex-wife. I mean viciously. They had screaming matches. As his assistant, I'd close the door, buffer him, then do whatever I could to get him back on track for business. But the pain affected him emotionally, and he drank and he did other things. I became his baby-sitter. He'd lie and I'd cover his lies. Needless to say, he never really trained me to be an agent. I would do things— like contracts—just because *somebody* needed to do them. He had enough good clients—Elizabeth Montgomery, for one—and he made enough deals. But I couldn't intervene or get him clean, so I just maintained him in a codependent way.

BROWN: Sometime in 1974 I went to Rowland Perkins, because I thought he was a classy guy, and said, "I'd like to work for you."

He said, "Uh, it's really busy now, I'm not really looking for anybody." Blah, blah, blah. I asked again, but Rowland kept putting me off.

The next thing I knew, Perkins, Haber, Ovitz, Meyer, and Rosenfeld were all gone, and I realized Rowland saved my ass because he knew he was leaving. In fact, I was in the mailroom the day it happened. I heard screaming. I walked into the lobby, turned right, and looked down the long hallway to the executive offices. Ray Kurtzman, a big Business Affairs guy who would later also leave for CAA, was about halfway down and to the left. Weisbord was in the corner. The screaming got louder. "You guys are nuts! What, are you crazy?" Then I heard, "Fucking Ovitz!" and thought it was about one person. I had no idea it was about five or six guys.

After the dust settled, some of us in the mailroom thought, Great! Openings for us. Some said, "Hey, let's go to work over there at CAA."

I said, "They might not be around tomorrow."

I stuck around and worked for Herb Karp, then Mike Peretzian, in the Literary Department. I liked Mike enormously. He was a very sharp, classy guy who set the example of integrity in an agent. He

wouldn't take any crap from anyone. As a result, his clients respected him. He didn't have a lot of turnover. He had clients that lasted.

CRESTANI: When I worked in Dispatch, I was asked to temp for Sam Weisbord for a few days. He was president of the company and ran the agency day to day. One reason they picked me was because I didn't smoke; he was a big health nut. Weisbord did most of his business behind closed doors. I sat in the outer office. I did his mail. He'd give me a list of calls and I'd make them. At the end of my first day there he called me into his office. He said, "Most people who work for me are afraid of me."

I said, "Why would I be afraid of you? I want your job one day." I didn't think about it. It just came out of my mouth. But he was right; most people were afraid of him. I was probably too naive to be afraid.

When Sam asked me what I wanted at William Morris, I said, "I want to work for Jerry Katzman in TV." What I didn't realize was that Weisbord had been Katzman's mentor; they had a father-son bond. Weisbord said, "Send me a memo." That made me nervous because I had already begun to talk to Katzman about interviewing for his desk. I must have stayed until nine that night, trying to perfect the memo.

Weisbord worked out of his house until about ten every morning. He'd do his exercises and make his calls to New York, then he'd come in around ten-thirty. I got the mail ready for him and put my memo in about halfway down the pile.

Weisbord was in his office no more than fifteen minutes, doing his mail, when he buzzed me. "Get me Jerry Katzman." At first I didn't think it was about me, because I couldn't imagine that he'd gotten that far down in the mail stack. Katzman came rushing in with a look of fear in his eyes, like, "Oh, God, what did I do?"

The meeting seemed to last forever. Occasionally I'd buzz Weisbord with a phone call. Forty-five minutes later Katzman came out with my memo in his hand. He said nothing to me, just walked by. All I could think was, It's over, it's done, I'm a dead man, I'm toast. Sam Weisbord's telling him to hire me? "Fuck you."

The next day Katzman saw me in the hall and said, "Come in here." He let me twist a little bit, but that's his way. He said, "I'm going to put you on my desk. But it's probationary, and your memo had nothing to do with this."

• • •

Jerry soon became head of the Television Department. It was good for me, though I never looked at it as a positioning move. He was just a straight-ahead guy who worked hard and was skyrocketing within the company. I was on his E-ticket ride.

Eventually he offered me a job as a casting agent in the Talent Department. I turned it down. He asked why. "Because I'm not ready to leave. I'm learning too much here."

He said, "Yeah, but we may not have another opening."

I said, "You'll create an opening."

The opening was a new assignment. One of our agents, Steve Konow, was a real character. Ambitious, Gucci-ed, great salesman. Jerry said, "I'm thinking about having you work for Steve so you can teach him how to do a deal memo."

I worked for Konow for six weeks, then he told me to go see Jerry. He tried to act nonchalant, but he had a smile on his face. I knew something was up.

Jerry said, "You're being promoted."

"That's great," I said. "Where?"

"We're putting you into the Variety Department"—this was specials, game shows, everything.

I went from never working a day in any of those businesses to booking *The Tonight Show*, among others, myself. I didn't even have a secretary. I had gone from the pinnacle of packaging to the lowest level, with no contacts. But I didn't care. I finally had my shot, and I was going to take it.

IEZMAN: Let me be blunt: I was desperate. Like everybody else, I wanted to go into motion pictures, but there were no openings. TV talent would have been my second choice. Nothing there either. A new theater agent named Jack Grossbart had just come out from New York, and I took his desk. Then I got lucky. Very quickly we moved from theater to motion pictures and television. I stayed on his desk for fifteen months. Then APA, an agency down the street, started sniffing around about me. I told William Morris, "If you don't promote me, I'm going to leave." They still wanted to make sure I was appropriate agent material. What's appropriate? Aggressive. Articulate. A good salesman. People have to like you. You have to be able to get in a door through a small opening. I guess I passed the test.

LUCCHESI: When Dennis Brody was promoted, I wanted to take his

place on Stan Kamen's desk. Working for Stan was like clerking for the chief justice of the Supreme Court. I was a wreck. I'd sleep only two nights a week—Friday and Saturday. I had such anxiety about whether I would be able to cut it. I didn't feel comfortable in my own skin. I was afraid of screwing up; I was afraid he was going to yell. After about four months I had such a stomachache that I called my mother and said, "I don't know if I can put up with this anymore. I think I'm getting an ulcer."

She said, "Gary, you're anticipating the worst. You think the sky is going to fall in. Maybe it won't."

My mother was right: You're paralyzed if you constantly anticipate the worst. My philosophy became to *attack* the work. I used to say: Pretend you're in a red Ferrari, the top is down, you've got blinders on, and you're going straight ahead just as fast as you can. From that point on I relaxed.

• • •

The most important thing Stan passed on was to mind your reputation. I remember him arguing with someone on the phone and saying, "I'll put my reputation up against yours any day." I've used it a couple of times myself. If you actually have a good reputation, it's a real winner. Stan was a role model and a gentleman. To this day I keep his obituary in my desk drawer.

RANDALL: I really wanted to be in TV. The William Morris Agency had created TV packaging. It wasn't as glamorous as motion pictures, but it was the mainstay of their business. There were still only three networks and this little thing called HBO starting to percolate. There was also great opportunity in TV at William Morris because the CAA people had left. They were replaced with a bunch of guys from New York, headed by Larry Auerbach.

Auerbach's son Bruce was a few years younger than me. He'd worked at the agency part-time in the summer. We hit it off, and he told me that he wanted to go to the University of Arizona, like I had, but he didn't have the grades. I had been an executive officer of the student government, and I knew the university president and the admissions people. So I picked up the phone and called the president, and I pulled whatever strings I had at the time. I guess they were sufficient enough to get Bruce admitted to the University of Arizona.

After Dispatch, I became Auerbach's trainee. He terrified me until I

was invited to his house one day to hang out with his sons. Then I realized that his job was to be my father. His job was to kick my ass until I got it right.

• • •

I was still on Auerbach's desk when Rapke, Iezman, Somers, and Brody got promoted, so I told him, "This is bullshit. All the guys in my mailroom class have gotten promoted. Where's my promotion? I'm ready to go."

Auerbach said, "Look: It doesn't take a rocket scientist to book an actor on an episode of *Laverne and Shirley*. Your friend Iezman, while he's been made an agent, is going to have to make his bones doing guest-star bookings for a while. Your friend Rapke, all he's got to do is take a fucking script and send it out to some asshole at a studio to see if they'll finance it. That doesn't take a rocket scientist, either. The lifeblood of the agency is TV packaging. It's more complicated than just booking. Be patient. I'm going to make you a TV packager and you will own the fucking world."

I was brash and young, and I didn't want to be patient.

I called my cousin Mike Marcus, who was then at Kohner-Levy, and said, "Mike, I've been here three years. I want a shot at being an agent, and these guys aren't going to give it to me right now." Marcus brought me over to meet with Levy, and they offered me a job in the Literary Department. I came back to William Morris, typed out a letter of resignation, and sent it to all the big muckety-mucks on the first floor. Pretty quickly I was called into a summit meeting with the senior members of the agency and Auerbach, who was furious.

They said, "Okay, fine. You want to be an agent? We'll make you an agent. Right after the holidays, you're an agent. Congratulations. That's what you want, that's what you got. But," they said, "you're got to pick up the phone, call your friend Mike Marcus, and tell him that you're turning down the job."

They made me do it right there. Mike got pretty pissed off at me, but I got what I wanted, or so I thought. I was dealing with professional negotiators. They made me an agent, all right: I came back from Christmas break and I was suddenly a *variety booker*. My job was to book talent on *The Tonight Show* and Alan Hamel's show out of Vancouver. It was basically "Fuck you, kid. You want to be an agent? Go be a grunt."

I finally said, "Fuck you guys," and left.

RAPKE: I thought I could get greater and quicker visibility if I handled written material instead of talent. That way I could talk to studio presidents and to all the producers. If I handled the talent, I'd be talking only to casting directors. The only agent who knew me prior to my arrival was Ron Mardigian; Ron was in Literary and open to a relationship with me.

When he took me on, I was nervous because I wanted to be perfect. Ron approached my training almost like a fraternity hazing. I think he found it funny to take an aggressive, bright, goal-oriented person who wanted success, and put him into a subservient situation. Ron always made sure that I knew he was the boss. His attitude was, "Okay, kid, *I* went through it, so now *you're* gonna go through it."

When they wanted to promote me to a TV variety agent, I said no. That caused a whole stir. I didn't want to book acts. That's not why I had gone to film school or come to Hollywood. Ultimately they acquiesced because my godfather, my mentor, Ron Mardigian, fought for me. If he hadn't, I probably wouldn't have continued at William Morris, and I don't know what my destiny would have been.

THE BIG CHILL

RANDALL: I was still in the mailroom when William Morris celebrated its seventy-fifth anniversary. Everyone was invited to Hillcrest Country Club for a party honoring the agency and Abe Lastfogel.

Jack Rapke, his then-girlfriend Laurie Perlman, Alan Iezman, and I went together. I borrowed a friend's Caddy and drove. We were still pretty fresh and still believers that William Morris was where the action was. It was hard to resist. Back at the office Sam Weisbord used to address us like we were a fucking military battalion.

Lastfogel was on his last legs. He stood and, in the middle of some speech about the Danny Thomas era, completely lost his train of thought and suddenly sat down. Everybody was, like, "Is that it?" My friends and I looked at one another and realized we were surrounded by a bunch of senior citizens who were completely out of touch and rapidly approaching *ancient*.

The place was not unlike the Politburo: The only way to really

succeed was to sign a lifetime contract, and when you were sixty or seventy years old, if you were lucky enough to still be around, you would be paid for your long-term career. We didn't want to wait until we were as old as our grandfathers to be successful. We realized that we'd been sold a bill of goods and the only way to really score was to go off and do our own thing. The industry was changing, the world was changing. William Morris knew it had to keep up. But the thought of change when you're seventy? Who needs change? The board members had their stock, the company owned all this real estate. They made a fortune. The company style had worked for so long that their attitude was "The industry will come back to us. We're not changing our ways."

SOMERS: Almost all of our group wanted to be producers. Anything but agents. The longer I was at William Morris, the longer I knew that I didn't want to be there. I saw a lot of unhappy people, taking drugs, living lives that I wouldn't want. Nobody talked about their family. Nobody talked about their sports, their avocations, their interests. It was all about the business, always, and that was way, way too consuming.

Yet in my dreams I would always hear Abe Lastfogel telling me, "This is my family." That scared the shit out of me.

• • •

BRUCE BROWN founded the Bruce Brown Agency, handling literary and talent.

ALAN IEZMAN is owner and president of Shelter Entertainment, a management/production company in Beverly Hills.

JACK RAPKE is a partner in ImageMovers, a film and TV production company affiliated with DreamWorks SKG. His productions include *Cast Away* and *What Lies Beneath*.

DENNIS BRODY is a theatrical talent manager and runs Dennis Brody Management.

ALAN SOMERS is a founding partner of Pure Arts, an entertainment management company, and its production company, Pure Fiction.

GARY RANDALL runs Grand Productions. He is a producer under contract to Universal Television and a director. For years he co–executive produced the series *Any Day Now* for the Lifetime cable network.

CHUCK BINDER is president of Binder and Associates, a management/production company.

SHELLEY BAUMSTEN WAGERS: Since fleeing the entertainment industry, she has served as investor relations officer and vice president of corporate communications for a NYSE-listed technology company. She is happily married to a Presbyterian farm boy–scientist–investor.

RICHARD MARKS is a vice president of business affairs at NBC in Burbank, California.

BOB CRESTANI gave up his job as worldwide head of television, executive vice president and member of the William Morris board of directors in 1995 to become a media entrepreneur. He is currently CEO of Inter-Content Group. He invests in and builds ventures for cable and new media.

GARY LUCCHESI is president of Lakeshore Entertainment, a highly successful film production company based in Los Angeles.

THE GUINEA PIG

Creative Artists Agency, Los Angeles, 1976

MICHAEL MENCHEL

Menchel was the first regular mailroom employee hired at CAA.

I grew up outside of Philadelphia. My parents got divorced when I was a sophomore at American University in Washington, D.C., and I decided to use that as an impetus to change my life. In 1974 I packed everything in my Datsun 240-Z and drove to San Diego.

Not long after, my sister, Susie, moved to Los Angeles. One day she asked me to come to an afternoon gathering at Stockard Channing's house in Beverly Hills. At the party I saw this guy working the guests, talking to movie stars, doing business. I didn't know anything about him except that he seemed dynamic and not much older than me. Susie said, "He's an agent."

"A travel agent?" *Susie* was a travel agent. She explained as best she could.

I introduced myself. His name was Mike Ovitz. We talked about what he did—he was still at William Morris—and I hit him up for a job. Any job. I had no plans for the future yet, but I thought if I could hitch my ride to a guy like that, I'd be pretty good for life. I said, "Listen, if ever you're looking for a young guy who'd do anything for you, I'm the guy you can depend on." He seemed appreciative. I gave him my phone number.

A year later I was working like a dog for Budget Rent a Car, jockeying cars back and forth from the airport. One night the phone rang. A woman said, "Is this Mike Menchel? Will you hold for Mike Ovitz?" To

be honest, I didn't get the lingo—"would you hold for"—and I didn't really remember Mike. But when she said "head of Creative Artists Agency," I said, "Sure."

Mike said, "If you're still interested in that job, I'd like to see you tomorrow morning at eight A.M. for an interview. You'll meet some of my partners."

I called in sick to Budget and left San Diego at 5 A.M. I got to Century City early and waited. Eight o'clock came. No Mike. Nine, ten, eleven, twelve o'clock. Finally at a quarter to one I was told, "Mike's very busy today. You should probably go home and we'll call you again."

I said, "You're nuts. I drove up here from San Diego. I was here by eight A.M., just like he told me. This is a big opportunity for me. I'm going to wait."

She said, "He's got a lunch now and he won't be back for a while."

About two-thirty Ovitz came breezing through the doorway, looked at me, and said, "I'm glad you're still here. Come in.

"So," he said. "You want to be an agent?"

"Always wanted to be an agent."

He looked at me askew. "You know what an agent does?"

"You're an agent, right?"

"Yeah."

"I want to do what you do. I don't know what exactly, but if you teach me how to do it, I'll do it. I'll work here forever. This is a far cry from Philadelphia. I could've been a shoe salesman."

The whole time he never apologized for making me wait. Today I'm sure it was intentional, part of my training. I would have waited fifty hours, as long as I got hired.

Next I met Mike Rosenfeld Sr. and Ron Meyer. Both told me I'd have to be there first thing in the morning and about the late hours I'd keep. They explained how tough the training program was—at William Morris—and that I was the first trainee at CAA. I was the guinea pig.

The story about CAA is that at first the partners didn't have desks. They worked off card tables they'd brought from home, with their wives as secretaries. By the time I got there, they'd moved to Century City and had offices, but it was still a very young company. The corporate culture was just coalescing. You had Mike Rosenfeld in blue jeans. Michael

Ovitz always wore a suit. Ronnie was in blue jeans. Rowland and Bill wore suits and ties. They all owned Jaguars with license plates that read CAA and their initials. They were together all the time. They went out en masse.

The first thing I did was buy a Pitney Bowes postage machine. A week later the mailman brought back all the mail I'd sent and asked me if I recognized it. I said, "Yes."

He said, "Well, you bought a mail machine, but you never bought any postage." Everybody thought it was funny except for Mike Ovitz. He thought my ineptitude made us look like a rinky-dink operation.

There were compensations. I delivered a script to Yvette Mimieux. I rang and rang her doorbell, but nobody answered. I walked around the house and kept yelling, "Miss Mimieux? Miss Mimieux?" When I got to the backyard, there she was, lying naked by the pool. I ducked behind the gate and knocked loudly. She put a towel around her, said, "Hellooo?" When our eyes met, she knew.

When I got out of the mailroom, I was assigned to Bill Haber's desk. I would rather have been in Vietnam walking on land mines every day of my life than work for him. If the mailroom was hard, working for Haber was impossible. He's a very particular, demanding, and brilliant man. Nothing I could do was ever right for him. He threw things: pens, pencils, once a chair. He had a riding crop with which he hit his chair and his desk. When he came too close to me with it, I'd tell him to cut it out, but he never did. What was I going to do? I couldn't quit. My inspiration was Michael Ovitz. Every day I'd walk down the hallway, and he'd look at me and see that I was either close to tears or I had steam coming out of my ears and I was going to kill Haber. I'm not saying I didn't learn or wasn't trained well, just that Haber and I were ill suited.

Once, I had a bad stomach flu. I was home because I couldn't leave my bathroom. About one in the afternoon the phone rang.

A voice said, "Hi! Is Mike Menchel there?" I recognized the voice.

I said, "This is me, Bill."

"So, they told me you were sick."

"Bill, I am *so* sick. A stomach flu. Or maybe something I ate. I don't know."

He said, "You having diarrhea?"

"Yes, Bill."

"You throwing up?"

"Yep."

"You doing it in the bathroom?"

"Yes."

"Your bathroom at home?"

"Of course."

"You know, we have bathrooms here at CAA."

"I know."

"I would advise you to put on a suit and tie and be here by two o'clock—or don't ever come back. You can throw up in our bathroom."

I was perspiring, aching, and ready to vomit any second, but I trudged into that office. I presumed he was serious about it and never had reason to think otherwise.

Ovitz would always pass through my cubicle to walk into Bill's office, and as he went by I'd say, "I'm here because you inspired me to be here. But I don't need crap like that," and cock my head in Haber's direction. "I'll be a shoe salesman. I'll work at See's Candies. I'll go back to Budget Rent a Car. A job's a job."

"A job is not a job," Ovitz said. "This is a great job. Don't quit this job."

• • •

MICHAEL MENCHEL didn't quit then, but he left CAA in 1999 to work again with Ovitz at Artists Management Group, which went out of business in 2002.

THE WILD EAST

International Creative Management, New York, 1978–1981

GEORGE QUENNEVILLE, 1969 • ROB LIGHT, 1978 • LEE KERNIS, 1978 • JAIMIE ROBERTS, 1978 • JOEL GALLEN, 1979 • TIM SARKES, 1981

ICM was the Wild West. The idea was beg, borrow, and steal—just don't get caught.
—Lee Kernis

LEE KERNIS: I knew when I graduated from the University of Maryland that I wanted to be in show business. I wasn't sure I wanted to be an agent, but I had heard the story of the MCA mailroom kid who supposedly picked up Marlon Brando at the airport and ended up being his agent by the time he dropped him off at the office. I thought maybe I'd also meet a star who would say, "Hey, you've got it on the ball. You want to work with me, kid?"

I managed the comedian Rich Hall, whom I'd met in college, so I decided to contact Jack Rollins, who managed Woody Allen. After five or six calls he came to the phone. Rollins is like a Damon Runyon character; he had the cigar, and even on the phone you could hear him spitting in the background. I had an act and therefore something to talk about. He said to see him when I was in New York.

To thank him for the meeting, I brought a cake from Cake Masters. Why? What does your mother say? "Bring cake." In Rollins's waiting room I kept looking at the cake box, embarrassed, like, I can't give him this; it's ridiculous. Then all through the meeting he kept staring at the box. Finally he asked, "Who's the cake for?"

"My mother. I'm going out to New Jersey."

"Really? What kind of cake is it?"

"Black-and-white cake."

"Hmm. I like black-and-white," he said. Even with the opening I still couldn't summon the nerve to say, "This cake is really for you."

A year later I asked for a job. They didn't need me, but when I applied for the training program at William Morris and ICM, Rollins said, "You can use my name." The first to set up an interview was Arthur Trefe at ICM. He was head of Personnel.

JAIMIE ROBERTS: My real last name is Rifkin. My grandfather, Harry Rifkin, booked nightclubs and was familiar with all the agents. My dad, Roy Rifkin, was a manager. He handled the Shirelles, Flip Wilson, the McCoys, the Strangeloves. He and my uncle, Julie Rifkin, had a record company, Spring Records. Today my brother is in the record business; my cousin Steven Rifkin owns Loud Records. And yet my father tried to discourage me from getting involved in show business. Seems hard to believe.

Like Lee Kernis, I went to the University of Maryland. I graduated summa cum laude and planned to be a psychologist. I even received grants from the National Science Foundation. But after graduation I decided to go to law school.

During my sophomore summer I was offered a job at a very prestigious Wall Street firm, as well as a mailroom job at ICM. Show business was not my goal, but I thought it wise to check out all my options. I met my dad for lunch at the Friars' Club to ask for his advice. He was there with a guy named Jerry Brandt, a former William Morris agent who had, with my dad, produced *Gotta Go Disco,* Broadway's first disco musical. I said, "Dad, I really don't know what to do."

He said, "You have the rest of your career to be a lawyer. Give ICM a try." The implication was that only while I was still in school could I get away with the *humiliation* of working in a mailroom. Jerry explained that he'd started in a talent agency mailroom himself at GAC, and that when he worked at William Morris, he'd met David Geffen and convinced him to be in the music business.

My father talked to Jack Green, who ran the International Department at ICM, and I met with Arthur Trefe.

TIM SARKES: I wanted to be in the record business and interned at A&M Records, but when I got out of George Mason University in 1981, the record business was in a downturn. I sent résumés anywhere entertainment-related: record companies, concert promoters, book

publishers, talent agencies. I never heard anything back. Finally I called Arthur Trefe at ICM and said, "I've sent in three résumés over eighteen months. Either you haven't hired anybody, or you have and you haven't given me an equal shot."

He said, "So, when are you gonna be in New York?"

I lied. "I'm going to be up there Monday."

"Okay," he said. "Come see me."

ROB LIGHT: I grew up in Westchester, in the era of Watergate, and went to Syracuse University to be a writer and journalist. My first assignment from the college paper was to write a story on the concert committee. I was so fascinated that I quit the paper to work on the committee and ran it for two years. After graduation I went to the alumni office to find out which graduates had gotten into the entertainment business. Jack Rollins's partner, Charles Joffe, was on the list. I called Joffe and he told me to start in a mailroom. "You'll learn more there than anywhere else, and then you'll decide what you really want to do."

I met with Arthur Trefe at ICM. He was very dignified. Very suit-and-tie. Intimidating. He said there was no guarantee that I'd ever get out of the mailroom and go on to do anything. In fact, he tried to talk me out of it, as did the William Morris guy, saying that it was demeaning and horrible, and that the people already in the mailroom were much more talented and had much better résumés than I had. He also said that starting in the summer was the worst time: I'd be on the streets making deliveries, it was humid, sticky—he tried to make it sound awful.

I didn't believe him.

JOEL GALLEN: I was a marketing and business major at the University of Rhode Island. I also worked on the student entertainment committee. My job was promoting new music on campus. Friends thought I should be in the music business, but I knew absolutely no one. I sent letters but mostly got ignored, so I pursued marketing, did interviews. Xerox in Boston expressed an interest.

The last weekend before graduation we had a big concert and party. A girl, Janet Koenig, who really believed in me, said, "There's an agent here, Rob Light, from ICM. You should talk to him."

I said, "Agents just want to sell me another band. They don't want to help me; they're not interested in my career. I'm not into it."

Later that night I just happened to sit next to Rob. Janet came up

and said, "Oh, I see you've met Rob." Turns out we had a nice chat. He said, "When you graduate, send your résumé and call me when you get settled." I didn't tell him about Xerox.

A few weeks later I gave Rob a call. He'd given my résumé to Arthur Trefe, and we set an appointment. Mr. Trefe's office was like a dark cave; maybe there was one lamp, otherwise it was pitch black, nothing on the walls. I was scared, like I'd been sent to the principal's office. The job sounded miserable. Even so, there were no openings. He said to call in a month. I figured he said that to everyone.

Xerox hired me. It was July and I'd start in mid-August. I was about to go to Boston and look for an apartment, but because I'd promised, I gave Mr. Trefe a call. He said, "We have an opening. Can you start next Monday?"

"Next Monday? Well, uh . . . sure." I figured I'd say yes and think about it when I got off the phone. My parents thought I was crazy. I said I'd work there for one week, and if I hated it, I'd go to Boston and work for Xerox. If I liked it, I would see.

After the first week I was miserable. Grunt work. Sweating. Riding the subway in one-hundred-degree heat. I was a 3.53 magna cum laude student with a marketing degree, and now I was just a messenger. Degrading.

My sister, Barbara—wiser, older—said, "Look. You wanted to be in this business. For all those people who don't have relatives or friends inside, this is how they start. At the bottom. You're young. If it doesn't work out a year from now, that's one thing, then get a regular job. But to give up after a week . . . you owe it to yourself to stick it out. This is your foot in the door. An opportunity that lots of people don't have." She convinced me to stay.

YES, VIRGINIA, THERE REALLY IS A MAILROOM

LIGHT: I didn't think I'd *really* be in a mailroom. I thought it was a fiction, or like a fraternity initiation: once the hazing is over, you're a brother. My first day I wore a jacket and tie and dress shoes, expecting to work at a desk.

The mailroom was really a supply room, with Xerox machines on

top of everything and a half-dozen guys my age crowded in. Their facial expressions ranged from dull to dazed. I don't think I was there twenty minutes before George Quenneville, who ran the mailroom, said, "Here's six packages. Go deliver them."

"You mean, like, go walk on the street and deliver them?"

"Yeah," he said. "Walk in the street and deliver them."

I spent the whole day hoofing around Manhattan, sweating my nuts off. I'd been a messenger in the city during high school, and it was an awful flashback. I knew I hadn't gone to college for this. When I got home, my feet were blistered beyond belief. I wanted to quit.

ROBERTS: George Quenneville was used to years of all these wanna-bes coming in with big dreams. He looked at me with a weary amusement, as if to say, "Let's see how long you can take it."

GEORGE QUENNEVILLE: I started in 1969, part-time, an after-school job. I was sixteen. I grew up in Queens. Dad was a truck driver, Mother was a housewife. I'd been working at a store, but some of my friends who were already at the agency said I should come work with them because I'd make fifty cents an hour more. The company was CMA then, owned by David Begelman and Freddie Fields. In '71 or '72 we merged with IFA, owned by Marvin Josephson, and became ICM.

After I graduated from high school, my boss decided to leave. They offered me the permanent position of running the mailroom.

I've seen hundreds come and go [*laughs*]. I've interviewed almost everyone who started in this mailroom, after they saw Arthur Trefe. I've always wanted to make sure they understood the kind of stress they'd be under and the kind of work they'd be doing. Was this where they really wanted to be? Were they willing to do whatever it took?

KERNIS: George would line up the trip tickets—they looked like phone message slips—and divide them by what side of town they were on. Invariably someone would say, "Oh, fuck. I'm not going to Wall Street!" However, a Village trip might be to Lauren Hutton or Cheryl Tiegs or Mariel Hemingway. Guys used to fight for those. There were definitely stories of guys who did the model run who said they got laid. Were they true? Who knows. But I can't count the times I heard, "I could've. She came on to me. She was smoking dope. She was drinking. She was this. She was that."

To get those trips, you'd have to work George.

I'd say, "You see the Yankees game last night, George?"

He'd say, "Can you believe that Reggie Jackson?"

Then you'd say, "By the way, George, do you mind if I go downtown and take that . . . ?"

GALLEN: You wanted to get on George's good side, because if you got on his bad side, he'd give you the big stack of routing slips all over the city. You didn't want to get the big pile.

QUENNEVILLE: People tried to influence me any way they could: drum up conversation, ask if I needed anything, talk baseball. Unfortunately, schmoozing didn't really work. When trainees first arrive, they know the least of what has to be done day to day, so when there are trips to make, those guys are the most expendable. The easiest way to stay inside is to learn everything on the inside as quickly as possible. Some guys would ask for lists to try and memorize everyone's names and locations. We'd make maps of the floors. Some guys did the outside work, then just came back and sat around. I'd say, "If you'd jump up and do stuff around here instead of just sitting, you'd be more valuable to us." Hard work always impressed me more than getting an apple.

TO BE OR NOT TO BE—A SCHMUCK

KERNIS: Less than a month after I started, there was a garbage strike, a newspaper strike, and an elevator employees strike. The garbage strike probably lasted the shortest, but still, it was bad news. I had to hustle around the city in the heat, smelling that smell.

Doing runs during the elevator operators strike was even worse. I took a package to a building on Central Park West. They had their mail spread out on long tables in this beautiful old lobby. The tenants had a sign-up sheet to work the elevator. But during lunchtime maybe there was a twenty-minute lapse when nobody was around to operate the lift. I had to deliver a script to Marlo Thomas. She lived on the twenty-fifth floor. The doorman called upstairs and said there'd be a package waiting in the lobby when she came down. She said, "No, I want it now." I looked at the guy and said, "I'm just supposed to leave it." He said, "Well, she wants it, and she wants it right now."

It wasn't as if she had to come down to get it either. She could have waited twenty minutes for the next resident who had signed up—

former New York mayor John Lindsay; I saw the list—to start his shift. But no. The stairwell was not air-conditioned, but I did it. She opened the door, grabbed the package. I thought I could at least get a glass of water or a "Thank you," but she slammed the door right in my face.

ROBERTS: I went to Barbra Streisand's apartment on Central Park West to pick up and return a bra to Bloomingdale's. I was a little taken aback.

SARKES: Try going to a junky hotel on Eighth Avenue to pay somebody's day rent.

GALLEN: I delivered to Candice Bergen a lot. You'd think we'd just have to leave it with the doorman, but sometimes they'd let us upstairs. She answered the door in her silk robe. She'd just gotten out of the shower and her hair was wet. It's almost the naked-actress fantasy. She wasn't naked, but it was enough that you could tell that she was recently naked.

ROBERTS: Sometimes Quenneville would give us subway fare. Because we got paid so poorly, we'd often just pocket the fifty cents and walk to our destination if we could.

KERNIS: Thank God for the young secretaries. They knew we were broke and that we couldn't afford to go out on dates with civilians. Most of them were a few years older than us, and they were, like, "Hey, let me take you to dinner," or, "Hey, stay over at my place." I exploited it as much as I could.

ROBERTS: I was on a run uptown and saw Sam Cohn coming out of the Dakota on West Seventy-second Street. Cohn was Mr. Agent at ICM. The top clients. He had a car waiting. It was a hundred degrees, my feet were throbbing. I had walked so much that I finally understood why ladies who worked in retail wore orthopedic shoes. I don't know what possessed me, but I yelled out, "Sam. Sam. Mr. Cohn. Jaimie Roberts from the mailroom. Can I get a ride back with you?" I know he heard me, because I was loud—but he never even turned around.

KERNIS: I delivered a package to Maureen Stapleton, and she wanted to tip me, but Arthur Trefe told us we couldn't accept tips because we weren't professional messengers. Miss Stapleton lived in a town house on the West Side. She was getting ready to go to the theater and answered the door in her slip. I was, like, "Whoa!"

She said, "Ah, kid, just give me the package." Then she held out some money.

I said, "I can't accept that, Miss Stapleton."

She said, "Just take it."

"I really can't accept it. I'd get in trouble."

She said, "If you don't accept this, you are a schmuck. And you know what? You'll be a schmuck all your life."

I grabbed the money and said, "No one calls me a schmuck."

A year or so later, when I was dating an assistant in the Theater Department, I ran into Miss Stapleton. She gave me a glimmer of a look, and I said, "How are you, Miss Stapleton? You probably don't remember me."

She said, "I do. You're the schmuck with the tip."

HELLO, MY NAME IS . . .

ROBERTS: I loved pushing the mail cart and talking to people. I'd introduce myself to the agents. That annoyed Mr. Trefe, who'd say, "Who is this little pisher running around acting as though he's best friends with these people?"

KERNIS: At the end of the day the agents would start to let their assistants go. Jaimie would walk into the agents' offices and go, "How you doin'?" and call them by their first name. He even walked into Sam Cohn's office—Cohn was on the phone—and said, "Sam. How are you?"

I said, "Wow, Jaimie, Sam Cohn. You know everybody."

Jaimie said, "I really don't know him. I just say hello because I want him to know who *I* am." That was the ballsiest thing.

SARKES: Everyone politicked to position themselves with the agents or their assistants. You'd even jockey to take the mail to the department you wanted to be in.

KERNIS: If somebody got sick and an agent couldn't get an outside temp—*and they were desperate*—they'd get a guy from the mailroom. Otherwise you trained in the fine art of moving furniture, stamping envelopes, taking the meter to the post office. That kind of work had nothing to do with what we were hoping to do as agents.

SARKES: Except that if you could take the shit thrown at you in the mailroom, you could take the shit thrown at you on a desk. But once there, if you wanted anything out of the place, you had to get it yourself.

It was not a formal program like at William Morris or CAA, where they beat the crap out of their people, and those people know they've got a good shot of getting a desk after they eat shit for a year or two.

KERNIS: In fact, a lot of agents in the film and TV departments, and especially books and theater, wanted career assistants—not mailroom boys who wanted to become agents.

THE WILD EAST

SARKES: Occasionally we had fights in our mailroom over the stupidest stuff. There were only two phones you could use: in the conference room if it was empty, or in the mailroom—but that was always ringing. One guy would tie up the phone, another guy wanted to use it, someone would get mad. Maybe a pack of cigarettes went missing. Suddenly there was a wrestling match on the floor.

KERNIS: Sometimes we'd haze a guy into leaving, but it had to be someone George didn't like, like the fuckup kid in *Full Metal Jacket* who brings everybody else down. We took our marching orders from the top.

One ritual was the fishy cake. We'd order a cake from Wolf's Deli. We'd put it on the conference table. Everyone would gather. Then Jaimie would say to me, "Come here, smell this cake. Can you believe this?" I'd smell the cake. Someone else would smell the cake. "Jesus Christ, it's like fish." Then we'd call over the schmuck who was bothering us the most, and Jaimie would say, "Smell the cake." When he did, Jaimie would tap his head and the guy's face would go fully into the cake.

QUENNEVILLE: Once, a guy came up swinging.

ROBERTS: He chased me around, screaming, "How dare you?" He caught me and had to be pulled off. I had to apologize.

KERNIS: A mailroom guy once told me about a box that had arrived in the pouch from Los Angeles. The packing tape had come off. While trying to rewrap it, he saw inside. It was a Tiffany sterling silver box. His job was to deliver it to an actor that afternoon, at a theater, as an opening-night gift. As he rode on the subway the wrapping kept getting loose, and he hadn't covered the box with anything else. When the train

jolted, he dropped the package, the wrapping came off, the two halves split open, and about twenty Quaaludes rolled out—in twenty directions. The guy fell to his knees and crawled around picking up pills from between people's feet while the passengers read their papers or slept or ignored him. Then he put all but one—it was too dirty—back in the box and resealed it.

GALLEN: Actually, I'm not sure it came in the pouch, only that it came from a Los Angeles agent who was in the New York office at the time, hence the confusion. Lyle Halperin was the mailroom kid who delivered the Quaaludes. They were in a tin. Sometimes you were curious about what you were carrying, and we'd hear rumors. . . . He opened the tin on the subway, and the pills dropped on the floor. I know this because a couple of days later I had to go to the actor's apartment to bring back a package—a return gift—for the agent. It was a joint. Sinsemilla. He gave me an envelope, and you could smell the skunk odor through the paper.

ROBERTS: Sam Cohn had a telescope, so at lunchtime we'd go in and peer into people's apartments to see if we could catch any activity.

KERNIS: One of his big clients gave it to him. It faced the Park Lane Hotel. We'd try to zoom in on chicks all the time. I had a friend who had an office near the Sheraton, where all the stewardesses used to stay. We'd have bets about who could find a naked woman in the windows.

ROBERTS: Even if you didn't, it would be hang-out time with the rest of the guys. We never got sloppy or stupid or crazy, though Cohn did come back from lunch early one day and catch a few of us in his room. He yelled at us and kicked us out. I don't know where I got the audacity to do this, but as I walked out I turned around and said, De Niro–like, "Are you talking to me?" and to my surprise, he chuckled. Then he said, "Yeah. Just get out of here."

KERNIS: Some guys used to smoke pot in the stairwell at the end of the day. Another group did coke off Sam Cohn's marble desktop. Sometimes it got out of hand. One mailroom guy did so much coke, he had to go into rehab. He was from a very wealthy family. I thought he was going to be the hugest success in the world, but he was in fact homeless in the mid-eighties. Today he's a rehab counselor.

Another guy, just about to get out of the mailroom, hid a major coke problem. I saw him on Friday, congratulated him on his promotion. He died the next night. Nobody knew he had a problem. He was a Harvard

grad. His brothers came up and interviewed people who knew him. They couldn't believe it. I loved the guy. He was like Charles Bukowski. He'd do anything for a lark.

GALLEN: His name was Sam. He had a teddy-bear quality. Very New York, Jewish, Woody Allen–ish, though he didn't look like Woody. He just had that personality. We hung out a few times. I remember speaking to him that Friday because I told him I was having people over on Saturday and did he want to come? He said he might stop by. He never made it. He was a bit overweight, so it could have been a heart thing— which coke can do to you. It was a tragic story. He'd gotten a promotion to the Literary Department and was really excited.

A mailroom guy named Michael Fox got the call at work: Sam's brother saying, "He's dead." I was there. We were blown away.

MORE THAN ONE WAY TO GET AHEAD

KERNIS: One mailroom guy showed up with a top agent at the Bottom Line. People were like, "Why's this agent with a guy from the mail-room?" It was pretty shocking, then suddenly understandable. The mailroom guy was great-looking, a model. At night he tended bar at Studio 54 and Xenon. The agent in question was single, but until then nobody thought he was gay. All these agents covering the show were like, "What the fuck?" It was a more homophobic time. It's not like they were so cool about that kind of stuff. Eventually the mailroom guy left, and the other guy continued to be an agent, but he held a big meeting and he came out of the closet.

SARKES: One mailroom guy, Christopher Radko, started a Christmas ornament import business in the sixth-floor mailroom. It's now top of the line. Disney has a piece of it. It was a wonderful ending to a sad story. The guy wanted the Theater Department or the Film Department, and it just wasn't going to happen for him. He saw his dreams dwindle. So he decided to use the company and began importing trinkets. He stayed at ICM for three or four years while it grew.

QUENNEVILLE: He asked us at lunch one day what we thought. We said, "It's seasonal work. How are you going to make real money?" Now look at him. He's huge.

SARKES: I began politicking immediately. After a week in the mail-room I asked George to go to lunch. My pitch was, "Keep me in mind. If you know somebody needs somebody, let me get on his desk." George was a big guy, but he was on a diet and having half a melon. I had a burger. I always shake ketchup before I put it on food, to mix up the water. I started with my speech as I shook the ketchup. Someone hadn't put the cap back on tight. The ketchup went flying, hit George in the face, got all over his shirt, and filled up his melon. I figured right then I might as well pack it in, because I was fucked.

Luckily it didn't kill my career. About a month and a half later Quenneville told me to work at Sam Cohn's desk because his second as-sistant was gone for the day. I didn't know Cohn, only his reputation as an animal. He humiliated people. But I didn't want to be in the Movie Department anyway, so I figured I wouldn't schmooze him. I'd just keep my mouth shut and do a good job.

That afternoon, about five o'clock, Cohn asked me to bring him a book of matches. I did, and as I turned to leave he said, "Hang on," and ripped the cover off the book and started chewing it—that's his big thing. He waited for my reaction. I said, "Is there anything else?"

He said, "No."

The next day I got a call. Cohn wanted me back on his desk. I was there for the next two months. When people realized I could stay at Cohn's desk for two months, it did my reputation and status a world of good.

KERNIS: My uniform, when I got there, was khaki pants, a pair of brown cowskin bucks, and a Brooks Brothers shirt or something. Then, as the summer and fall passed and the weather got crappy, I didn't want to go out on trips anymore, so I started dressing up really, really nicely. I spent a fortune on clothes wherever I could get stuff on sale. I had a pair of leather half boots, cordovan color, and I'd say to George, "I can't go out with these boots, they'll get ruined." I only meant to stay inside, but dressing up had an unintended consequence. Because I looked good, the agents and assistants started to recognize me less as a schmucky mailroom guy and more as assistant material.

THE MEANS JUSTIFY THE ENDS

LIGHT: By the end of the first week I was really depressed. I saw no light at the end of the tunnel. I couldn't imagine being in the mailroom for four or five months, let alone eight or nine months, which most did. I was already thinking I should get a job in a manager's office or at a record label.

Then I heard that the Music Department was transferring a guy from the West Coast to New York and he would need an assistant. The day he started, another mailroom guy, Mark Siegel, and I got a set of deliveries. We went to the elevator together and rode down eighteen floors. Mark said, "That new guy started in Music today."

I said, "Yeah, I saw."

He said, "Trefe set me up an interview with him when I get back from this run."

I said, "That's great!"

The elevator doors opened. Mark left, and I went back into the elevator. I went upstairs, right into the new guy's office. His name was Terry Rhodes. I closed his door. "Hi, I'm Rob Light. I'm the guy you want for the job."

Rhodes was from Macon, Georgia, a warmhearted but redneck Southerner who was almost a fish out of water in New York. After asking why I wanted the job, he said, "Are you married?" I said no. He said, "Good. I wouldn't hire someone who was married." I asked why, and he said, "Because you're married to this job." I got it. "Everything you've got is in this job," he said. "You work for me twenty-four hours a day." I was so excited to be out of the mailroom, he could have told me forty-eight hours a day.

Terry told Arthur Trefe he wanted to hire me. When Mark Siegel came back from his deliveries, I was on the desk. I'd been in the mailroom only eight days.

I've always felt bad about Mark, but I also rationalized that he missed his opportunity. He'd already been out of the mailroom once and got put back in. I don't know if he looked at it like I screwed him. I told him what had happened, that I had to take the shot because I *had* to get out of the mailroom. I was desperate. It's like signing a client: If a client's

looking for an agent, you don't wait for them to call you. You call them. I figured Terry would want someone who had a little chutzpah.

In hindsight, after getting to know Terry, I don't think he and Mark would have jelled anyway. I think, as fate would sometimes have it, that I *was* the right guy at the right place for the right person.

GALLEN: I'd been in the mailroom about eleven months and had been on a few interviews to be an assistant. I really wanted to be in the Music Department, but I didn't dazzle them enough. I was frustrated. I wanted out of the mailroom, but I wasn't even the number-one guy; that was Michael Fox.

When George Quenneville went on vacation, the senior guy ran the mailroom. On Monday I walked in, expecting Michael Fox to be in charge for two weeks—only to find out that he'd quit. All of a sudden I was number one. Mr. Trefe called me into his office and said, "Joel, you're the guy."

I seized the moment. I ran that mailroom like it had never been run before, and all of a sudden I became a commodity around ICM. The assistants who had sort of known me *knew* me. When they needed something done [*snaps fingers*], it was done. It took a few days to figure out what to do, then I was rocking. It felt really good. I had responsibility. I could show people that I could lead and manage.

When George got back, Mr. Trefe told me he could not believe how many calls he'd gotten about how smoothly the mailroom had run and how wonderful I was. Mr. Trefe was normally a crotchety old guy who never really got excited, but now he was promising to get me an assistant's job. He said, "Are you flexible? Do you only want to work in Music?"

The company had just started a division of the Television Department called ICM Television Marketing. It was syndication. They had hired three executives—two from the East Coast, one from the West. Their first project was the original *Richard Simmons Show*. Howard Mendelson was the VP of sales. I had interviewed to be his assistant, but he'd hired a woman instead. Two weeks later he walked into the mailroom and said, "I hate her. Will you be my assistant?"

"Definitely."

They got the Simmons show on but cleared only about 60 percent of the markets, and it mostly aired at six in the morning. Six months after

the division started, the company lost patience and shut it down. Everyone was fired except me. Mr. Trefe said, "I'm going to put you back in the mailroom until a job opens up because we really like you."

I said, "Thank you, but I ain't going back to the mailroom."

MISSION IMPOSSIBLE

LIGHT: After six or seven months Terry Rhodes went to Shelly Schultz, who ran the Music Department, and said, "We should promote this kid. He's booking up a storm. We're wasting him as a secretary."

Schultz said, "I'm not making him an agent after seven months. He's got to work for me." He already had a secretary, so he took me on as his second. I love him now, but then Shelly was an intimidating guy. A screamer. Some people emulate what they see; I went the opposite way. I don't think in twenty-three years I've raised my voice a dozen times.

I didn't have a territory to book. I handled his clients and the overflow of paperwork. Whatever crap came out of that office would fall on me.

That summer Shelly booked an arena tour for the Bay City Rollers when their new record came out. But it was 1979, they were over, and the tour proved it. A thousand tickets sold in twelve-thousand-seat arenas. It was horrible. But the band would not back out. They knew it was the end, and their attitude was, "Fuck it, let's just take the money." And agents had the clout to hold the dates in; nobody could cancel, because God forbid you canceled on ICM.

Shelly knew the band should come off the road, but he couldn't convince them.

I'm not embellishing this story: I was the day-to-day guy on the Bay City Rollers, talking to the tour manager and doing all the paperwork. Shelly called me into his office and said, "I'm giving you a plane ticket to Louisville, Kentucky. Go meet with the band. Convince them to cancel this tour. If you convince them to cancel the tour, I'll make you an agent. If you don't, don't come back."

On the flight I tried to think of every conceivable way to talk the band out of their tour. But if I've learned any lesson from being an

agent, it's that if you *listen* to the client, *they* will tell you what they want to be told. So ask a question before you make a statement.

When I got to Louisville, I went right to the hotel, to the suite where a couple of the guys were hanging out. The tour manager introduced me. They said, "If you're here to talk us into canceling the tour, go home now."

"No," I said. "I'm here to tell you to stay on the road. Let's take the money. You need moral support." They embraced me, and we spent the whole day together. "Screw the promoters," I said. "Your record company's an asshole." They were looking for anybody to be a compatriot.

As I watched the show I realized that instead of a teen fad band, the guys wanted to be serious musicians. They could never be, but that's all they wanted someone to tell them. We went back to the bar. The gloves came off. "You're a really good band," I said. "What's happened is criminal. You're more than just a pop act."

"You're right. We're more than that."

"But if you're going to have any chance of being legitimate musicians, you don't want to leave this trail of blood. If you take all these promoters down, no one will ever give you another shot. Come off the road, make a real record—a real rock record—change the name of the band, and let's start over."

It hit them: "That's what we should do. We don't want to kill all these promoters. We want a career." They played one more date, then canceled the tour. I went home, and Shelly made me an agent.

The band went into the studio and made a record. I booked them on a tour of all the punk clubs on the Elvis Costello circuit. It didn't work, but I did my part.

BRAVE NEW WORLD

SARKES: I was talking to Bernie Brillstein not too long ago and somehow George Shapiro's name came up. I said, "Where did you guys know each other from?"

He said, "Are you kidding? George and I were in the typing pool together at William Morris."

I thought, Typing pool? Holy shit! There are so many overdressed twenty-two-year-old agent wanna-bes now; the time when it was a gentleman's business is gone. Even for me there was nothing that compared with what it was like for them. And today's young agents and trainees have no sense of the history. I know only a small group at CAA who call legends like Robert Evans and Richard Zanuck and ask if they can get together for dinner because they want to learn the history.

Otherwise I wonder—if two guys in the mailroom today run into each other in ten years, will they even feel a bond because of how they started out?

• • •

GEORGE QUENNEVILLE is director of facilities at the New York office of ICM. He's been with the company nearly thirty-five years.

ROB LIGHT is head of the Personal Appearances Division at CAA and a member of the board of directors.

LEE KERNIS left the entertainment business after ICM and worked on Wall Street for seven years as a commercial real estate broker. In 1989 he returned to entertainment and opened a personal management business in New York, then the same in Los Angeles with Tim Sarkes.

JAIMIE ROBERTS is a prominent music-business attorney and partner in Liebowitz, Roberts, and Ritholz, based in New York.

JOEL GALLEN is a producer-director in television and film. One week after the September 11, 2001, attacks on the World Trade Center and Pentagon, he executive-produced and, in Los Angeles, codirected *America: A Tribute to Heroes*, a telethon broadcast on all the major networks, as well as independent and cable channels. It raised $150 million, and Gallen won an Emmy. Previously he majored in producing specials, among them the *MTV Video Music Awards* (1989–1993), the *MTV Movie Awards* (which he still does every year), and various music specials (featuring Santana, Mariah Carey, Dixie Chicks). He also executive-produced Ben Stiller's movie *Zoolander*. Gallen's feature film directorial debut, *Not Another Teen Movie,* was released in December 2001.

TIM SARKES became an agent at APA in New York in the Personal Appearances Department. In 1994 Kernis and Sarkes became management partners, representing clients such as Cheri Oteri (*Saturday Night*

Live), David Cross (*Mr. Show*), Andy Richter (*Late Night with Conan O'Brien*), Steven Wright, Robert Schimmel, and Dave Foley (*The Kids in the Hall, NewsRadio*). In November of 2001 Kernis and Sarkes moved their business to Brillstein-Grey Entertainment, where they are now managers.

THOUGHTFULLY POLITICAL

William Morris Agency, Los Angeles, 1978, 1989

SAM HASKELL, 1978 • ROB CARLSON, 1989

SAM HASKELL: My family wanted me to go into medicine, but I wanted to be in California, in the entertainment business, from the time I knew there *was* an entertainment business.

In the late sixties and early seventies I went often to the little movie theater in my hometown of Amory, Mississippi, and watched movies all afternoon. I also watched lots of television and read *TV Guide* and all the fan magazines. I made it a point to educate myself about the Academy Award nominees and would see all the nominated movies.

I did try to be a doctor because of my parents, but by the middle of my sophomore year in premed I was miserable. This caused a huge problem, particularly with my father. Sometimes being in show business seemed like a far-fetched dream, but I still dreamed it.

I moved to Los Angeles in the summer of 1978 to go to law school. I thought it might be a way to get into the entertainment business. To help my plan, I tried to get in touch with Ruth Englehart, head of business affairs at William Morris. I called a few times a week, and her secretary would never put me through. Finally, on the Friday before Labor Day, Ruth answered the phone herself. When she heard my accent and that I wanted to meet and talk about law school and the agency business, she saw me that day.

At Ole Miss I'd performed in several concerts and had produced a

couple of plays. Ruth knew that I had a basic understanding of actors, producers, writers, and directors. She spent almost three hours with me and by the end of the meeting said, "You've got everything it takes to be an agent. Do you know what an agent does?" I'd read some books, one of them Garson Kanin's *Hollywood,* when I was about sixteen. Kanin wrote that during the thirties and forties. The only agent Louis B. Mayer would allow on the MGM lot was Abe Lastfogel because he had character and integrity.

I said, "Well, what do I have to do?"

She said, "First of all, dismiss the whole idea of law school. And you'd need to start in the mailroom."

My last interview was with Walter Zifkin, the chief operating officer at William Morris. He said, "You're actually too tall to be an agent—but I guess I have to overlook that. I've been getting all these reports on what a nice kid you are. But don't you think this is going to be a culture shock for you? You're this white-bread, gentile kid from Mississippi, coming to Los Angeles to work for a primarily Jewish company in a primarily Jewish, liberal business. How and why do you think you're going to fit in?"

I told him the following story.

I was raised in a Southern Baptist church. We had a fire-and-brimstone preacher who, every Sunday, said, "If you don't believe that Jesus Christ is the Messiah and Jesus was born to save your sins, you're going to hell. Everyone." It's that sort of thing you see on the televangelical shows. One Sunday over lunch I confronted my mother, who was deeply spiritual and deeply religious. I was nine years old.

I said, "Mom, why is it that Mr. Smith, in the front row of the church every Sunday, who is mean to his children and gets drunk and does all these terrible things but proclaims to be a Christian, is going to heaven? And Mrs. Siegel and Mrs. Rubenstein, who open their stores on Christmas Eve and give all the poor black children coats and shoes, are going to hell?"

My mom said, "You're right. As long as we all believe in God, we'll all go to heaven. We must all lead our lives to be good people, and Mrs. Siegel and Mrs. Rubenstein are excellent examples." They were the only two Jewish families in town, and they had to travel an hour to get to a synagogue somewhere else.

Zifkin hired me on the spot. I'd let him know that I held no preju-dice and embraced all faiths. I am a Christian and I believe in my Christianity, but I don't believe that other people are wrong for not be-ing like me. We all base our religious feelings on blind faith. It's what our parents taught us and what their parents taught them, so who's to say anyone is wrong? As long as we believe in something.

Six years later Walt Zifkin took me to lunch. He said, "I want to tell you something. I almost didn't hire you that day. But after you told me that story, I realized I had to give you a try. I realize now what a mistake I would have made if I had not hired you." That was the supreme com-pliment of all time.

I started in the mailroom on October 23, 1978. I was there with kids who had silver spoons in their mouths, kids who were sons or nephews or grandsons of people in the business, kids who had plenty of money. My salary was $125 a week. I had to get a job at Universal Studios on the weekends, on the tour and in Professor Bloodgood's Olde Tyme Photography Shoppe, taking pictures of European tourists in funny costumes, to make an extra $100 a week so I could pay my rent. I worked seven days a week for a year. I didn't have the finest car. I didn't have the nicest clothes. But I always knew that I *would*. I knew that I could make it happen for myself.

At William Morris I dedicated myself to being the first to volunteer for the most menial of chores, from being the best pencil sharpener to the best Xeroxer. Other mailroom guys would actually sit on their butts and watch me do this. Fine with me. I knew hard work would be no-ticed. I was an Eagle Scout. I'd played football. I knew what it was like to be part of a team. I knew what it took to please a superior. I believed the only way to be promoted was to be willing to read three scripts in a night and get back with typed-up synopses the next morning. Or be willing to take the mail to Marina Del Rey on a Friday night, when everyone was leaving for their dates.

Instead of following examples, I set the example, and I think those who followed me benefited greatly. That doesn't mean a good work ethic didn't exist in the mailroom before me—but in my class no one worked as hard as I. I had to, because the mailroom is the armpit of the agency and I wanted to get out.

• • •

I believe, philosophywise, in the following: We spend the first couple of decades of our lives trying to figure out who the hell we are. Some people never find out. They keep searching and searching and searching. Or they'll be different people with everyone. Never any consistent presentation of who they are. But if we can realize by our mid-twenties who we are, we have to ask ourselves this question: Do we *like* who we are? If the answer is yes, then we should spend the rest of our lives maintaining who we are.

If you think about it, it's that maintenance of self that is constantly attacked, challenged, or compromised on a day-to-day basis—not just in the business, but in life. It's what gives you the hills and the valleys. But if you can maintain who you are, then you become a magnet of consistency to which all the inconsistent elements spinning around in your little hemisphere are drawn. Those elements—the clients, people in the office, your family—want to know who *they* are. Your consistency can bring the same to their lives, and if it does, they're going to want to stick with you.

It worked for me. After nineteen months I was promoted to agent. As for the people who didn't work hard, they were still in the mailroom. I was right and they were wrong.

What I try to give to trainees today is an understanding of the business and what it means to have power. There are two kinds of power. Your primary power is your character and your integrity. Your secondary power is your learned skills: your people skills, what you do to make a living, what you learned in college, what you've learned in dealing with other people. You must, in order to be totally successful, have control of both sets of power.

If I ask the question "What does it mean to be thoughtfully political?" the answer, other than "Being kind," is "To think." Think about what you want. Then think about the people who are going to help get it for you. Then be political and figure out how to make those people happy about giving you what you want. That's what it's always been about for me. If you can do that, you can do anything. That is the whole secret to Sam Haskell.

I don't believe in the pursuit of power. When it is earned and

deserved, it's just there. It's just got to happen as the result of other actions that you take. Whatever power I have is only because I've lived my life the right way, I've worked hard, I've had character and integrity in everything I do.

I didn't get into this business to get rich, not that I mind making a good living. I'm in it for the relationships with people I admire and to be able to help people with talent whom I dearly love.

The mailroom reinforced what I believe about life more than it changed me. I make things happen in my life. I planned who I was going to marry. I planned what job I was going to get. I planned which clients I would represent. I plan which charities I'm involved in. I work it all out in my mind, thoughtfully, politically, about how I can make things happen for me and, at the same time, make everybody happy about it.

ROB CARLSON: When I got into William Morris, I was interested in motion pictures, but a number of people said it was much harder to get promoted in motion pictures. So I made up my mind on day one to be in TV packaging or TV lit. It was the smartest thing I ever did. And by telling everyone I wanted to be in TV, I declared my major. A lot of people don't and seem wishy-washy.

After three months in the mailroom I graduated to Dispatch. I'd been there a week and a half when I walked by Bob Crestani's office. He called me in and said, "I'm going to tell you something, but if you tell anybody I told you, I'll deny it. Sam Haskell's desk is opening up, and I think you'd be perfect for it. Get over there and see Sam right now."

I had seen Sam in the hallway and said hello, but I could never get in his office because his assistant made it difficult. Still, I went right over. This time I got in. He said, "It's good that you're seeing me, because I may have an opening on my desk. The problem is, you've been in Dispatch for only a week and a half. You've got to be down there a month before you're eligible to interview for a desk. . . . But we'll figure out something."

A week later Sam announced his desk was available. Everybody went

for it because everybody was desperate to get out of Dispatch. In the end it came down to me and this other guy. Part of Sam's decision was based on a typing test he made everyone take. We had sixty seconds to write Angela Lansbury a congratulatory note for her Emmy nomination for *Murder, She Wrote*. Sam proofread it for mistakes and how clever we were.

I was very lucky to work for Sam. He never asked me to do anything personal, like pick up his dry cleaning. When he went home to Mississippi for two weeks, he gave me and my girlfriend his house. It happened to be over Thanksgiving, and I said, "Sam, I can't house-sit for you, her relatives are coming."

"Bring them all over!"

He stocked the house with food. I drove him and his family to the airport, and he let me keep the car for the week and drive it.

Sam was probably the nicest guy you could ever work for. And it rubbed off. When I had his desk, anyone who wanted to see Sam would get in. I wasn't afraid of their trying to take my job. In fact, I wanted them to take it, because I wanted to be promoted. I'd tell mailroom kids, "Read this stuff, then you can go in and talk to him. Don't just go in there with, 'Hey, Sam, I really like the new Ann Jillian show you put together.' Have something to talk about."

The training program altered my definition of what an agent was. Just from what I'd read or seen in movies I had this preconceived notion that agents were not always the nicest people and not always aboveboard, especially successful ones. Sam was from the South, he was supernice. I hate to say this, but at the time I wasn't sure he was going to be a great agent.

But the total opposite was true. Because of his attitude and his personality, his ethics and his family values, he turned out to be probably the best agent in that building, and he did it by being different from everybody else. That was the biggest surprise for me: that you could be that great a person and still be amazing at your job. You didn't have to be a jerk. You didn't have to treat people like shit. You didn't have to treat your assistants terribly. Every night Sam would walk out, and no matter how bad a day we'd had, or if I'd fucked up, he'd say, "Rob, thank you very much, my friend. I appreciate it. Have a good night. I'll see you

tomorrow." Every night. It's something I do to this day. When you're sitting behind that assistant's desk, not making anything, getting beat up all day long by clients and others, it's nice to have somebody who cares and understands what you're going through. I had it and I want to pass it on.

• • •

SAM HASKELL is executive vice president, worldwide head of television, for the William Morris Agency. He's been with the company for twenty-three years.

ROB CARLSON is a senior vice president and head of the Motion Picture Literary and Directors Department at the William Morris Agency.

IF I DO SAY SO MYSELF

William Morris Agency, New York, 1979

JEREMY ZIMMER

***People around the office felt I was a guy who would make it.
I shared that opinion.***
—Jeremy Zimmer

The way I ended up in the mailroom is a great story, if I do say so myself.

I come from a showbiz family, but by the time I was conscious of life, my grandfather, the producer Dore Schary, had long since left Hollywood and was living in New York City.

I dropped out of college. I actually flunked out; I had one semester on the dean's list and then two semesters when I just didn't go to school. I was too busy: I ran a couple of parking lots and valet stations around Boston and was also an attendant. I did pretty well. Then, in an attempted robbery, I got stabbed in the chest, a centimeter below my heart. Still have the scar. I was hospitalized for several weeks, then taken to my mom's house in Connecticut to recuperate. That's when I finally had time to think about my life and realize I had no idea what I wanted to do with it.

Going back to school didn't appeal to me. I was eighteen, nineteen. Distracted. It's not too hard to figure out by what. It *wasn't* art collecting. Girls, psychedelics, other recreational pastimes. I also didn't want to go back to the parking lot. The money was good, but I was scared. And it was not a great way of life, sucking exhaust fumes for hours in the heat. I knew that wasn't how a nice Jewish boy should spend the rest of his life.

During my convalescence my grandfather called and said, "Are you ready to get serious?"

"What do you mean?"

"What I mean," he said, "is that you're a complete fuckup. Are you ready to get with the program?"

"Absolutely." I respected him, and I could tell *he* was dead serious.

"Great," he said. "Then, you'll go into New York City and meet a man named Nat Lefkowitz at the William Morris Agency. You'll wear a suit and tie and be very polite."

"Yes, sir."

Nat Lefkowitz was a rather small fellow and was difficult to understand because he mumbled. Today I can't remember a word spoken in that interview. But I had on my game face. There was only one bit of a fudge involved—I don't know to what degree I lied and to what degree we all looked the other way. I hadn't graduated from college, a prerequisite of the program. I may have said, "Yeah, I went to BU," but I didn't *really* answer the question.

I interviewed with Steve Pinkus, who, it turned out, was Lefkowitz's son-in-law. Pinkus's biggest client at the time was Secretariat, the racehorse. There was a big picture of the stallion on his wall. I didn't know what he did as the horse's agent, but Pinkus had a big office, so he must have been doing something. Then I met with Ed Khouri; he actually hired me, but it was already a fait accompli.

As I'd walked through the thirty-third floor for the interview, my impression of the agency had been, Wow! This is nice. The day I started work, my opinion changed. I went to the thirtieth floor. There was no carpet. The hallway was dimly lit. I walked the length of it, heard the clatter of machines, saw some trash, turned right at the last door. There was the mailroom.

My grandfather had told me, "When you first walk in, step over the threshold with your left foot. It's good luck." I did as he told me, only to have some guy who could only be defined as crusty but lovable, sort of a Lou Grant with a more florid complexion, come forward and say, "Huh. So you're the new Chinaman?" His name was Ray Wilson, a retired fireman. He ran the mailroom. I presume by "Chinaman," Ray meant I was the new guy who was going to come in and work his butt off for next to nothing.

He said, "Okay, here's what I want you to do. Take off your jacket." I took off my jacket. He handed me a stack of packages. "Okay, first go

to Fifty-third and Seventh and drop this off. Then to Fiftieth and Sixth and drop this. Then take the uptown train . . ."

Ovid Odil and Roberto Tamayo—two professionals—also helped run the mailroom. Ovid was a crazy, drunken Jamaican who would send you down to the liquor store to buy him a two-dollar bottle of wine. Roberto Tamayo would watch the hot-shit Jewish kids come in and out, and two years later be delivering *their* mail. We had to "agent" Ray Wilson and Ed Khouri, but not Ovid and Roberto because they were cool. They just wanted to have fun every day, like us.

As tough as it sometimes was, the minute I walked into the mailroom, I felt like a duck in water. I knew where I was and how to operate. It felt completely comfortable. The work was hard, tedious, frustrating, but there wasn't a moment of, "Oh, my God, I don't know how to do this." I got it. I was around the best agents, I understood what they did—and more, that *I* could do it. I learned osmotically. I absorbed a great deal.

The mailroom was competitive, but I didn't really notice. If you're strung the way I am, and the way most successful agents are, you make a competition out of going to the grocery store. To me it felt natural. Now I'm calmer, but I used to have a reputation as a wild man. I used to be, um . . . highly aggressive.

I was in the mailroom less than six months. Originally I wanted to be a book agent, but the people in the Literary Department were reluctant to give me that opportunity, primarily because my mother, Jill Robinson, was an author and was represented by a competitor. They were afraid I'd steal secrets and give them to her agent. At least that's what Owen Laster, who ran the department, told me. But Owen also took me under his wing and tried to help me. I finally got the opportunity to work in the department on a trial basis, for a woman named Joan Stewart. I sat at that desk and in a week got only fifteen or twenty phone calls. A few were from her husband, a couple were from Tiffany's. I knew I could never work in publishing. I'd go out of my skull from boredom.

Then a shared desk working for Fred Milstein and George Lane opened in the Motion Picture Division. During my interview I noticed Milstein's chair was broken. The ball bearings were out, and I watched him roll around uncomfortably. When he went to lunch, I went to the

mailroom, took apart a chair in the supply area, extracted the ball bearings, went upstairs, and put the ball bearings in Fred's chair. I left him a little note: "I fixed your chair." He hired me.

Owen Laster's assistant, Robert Gottlieb, wanted to be my mentor and my friend. He'd ask me to meet him for lunch; we'd walk around the Central Park Zoo and eat peanuts, and he'd tell me all about how the business worked. It was nice, but he didn't really have what I wanted. It was 1979 in New York City. I was out every night. Drugs were good for you; so was sex. You didn't die from either. Disco was cool and punk was just starting. You could do anything. Gottlieb had a different life. He was definitely a nice guy, but he was married, and we were too dissimilar for anything to take hold then.

Gottlieb was the definition of a Morris man. To me, then, it meant a guy who wasn't destined to really make it. What the agency liked, traditionally, was a guy who looked like he would be happiest being there for fifty years. I once said—and I regret having said it—that at the Morris office you could die at your desk and they'd still keep handing you a check. If you had a lot of style and flair, it made them nervous. If you were too ambitious, they were, like, "That's not how we do it here."

Gottlieb, of course, did make it. Before he finally quit not long ago to start his own agency, he very successfully ran the book department, made it to the William Morris board, and achieved major status. At the time, though, I would have shot myself rather than have his life.

Marty Bauer was my first mentor, a terrific agent at William Morris, and a good friend. I spent two years with him as a junior agent, just sitting in his office, listening to him on the phone, and working with his clients. Marty and I fit. But that's as far as it went. I still didn't feel like a Morris man. The bureaucracy and the people not doing things the way I wanted them to was too frustrating.

A few years later I came to Los Angeles and worked with Jeff Berg at ICM. Berg is a brilliant guy and a good signer. At the time he represented Bernardo Bertolucci, John Foreman, James Brooks, John Hughes, Michael Mann, Ridley Scott: an unbelievable list. To see him in a room, the way he communicated, his ability to reference a contemporary piece of material and relate it to a classic, was beautiful. His was a fully integrated understanding of the arts and the business, and the

psychology of people, and way beyond how the Hollywood game is typically played.

Here's what I learned. Agenting is "I'm going to sell this. I'm going to sell it, I'm going to sell it, I'm going to sell it!" And yet you're never *selling*, you're seducing. That's this job, this way of life, *all of the time*. It's never overt. It's never, "I want you to buy this." It's always, "Gosh, I read this script the other day. Yeah, I'm talking to Columbia about it. Oh, would you like to read it? Sure, we can send it along."

Today I'm a partner at UTA. For some time I ran the training program. I got a lot of satisfaction because it's the lifeblood of what we do. The irony is that I never went to college, yet in a prospective trainee a good alma mater will definitely get my attention. However, a weak résumé will be overcome by a good interview. The characteristics of a good interview generally include energy, somebody who can make me laugh, who knows something about what I'm doing, who knows something about my company, who attempts to make an impression, or who's honest. Kids come in and say, "I want to be an agent. I've *always* wanted to be an agent. I've wanted to be in the entertainment business since I was eleven years old." I don't necessarily believe them unless they can tell me specific things about my business to convince me they're interested in it enough at least to have researched it. I'd rather somebody said, "Hey, I want the job, but I'm scared to death."

I like that. I don't like being bullshitted. On second thought, I don't like being bullshitted badly; I like being bullshitted well.

• • •

JEREMY ZIMMER is a partner, board member, and legend at the United Talent Agency.

PRESSURE, PRESSURE, PRESSURE

OUR JOB IS TO SAY YES

Creative Artists Agency, Los Angeles, 1982

JUDY HOFFLUND

Judy Hofflund was the first woman in the CAA mailroom.

I was the weird one who went to the movies by myself because I couldn't get anyone to go with me often enough. I saw movies four nights a week, probably, all through high school and college.

I grew up in Encino, went to an all-girls Catholic school in Woodland Hills, and graduated in 1975. At UCLA I majored in psychobiology. Studying the brain interested me, the woo-woo psychology didn't. I thought about being a lawyer, but by my junior year the law had become too trendy. I stuck with psychobiology and graduated magna cum laude in 1979.

I wanted to move to Europe for a year. Instead I landed in New York, and I fell into a job at a tiny company, working for two women producers. Until then I had never seen the entertainment business as a business. It seemed, well . . . fun. But I wanted to be in it in a bigger way.

I came back to Los Angeles, stayed with my parents. A guy who lived two doors down had a small literary agency in Century City. He said, "Why don't you be my assistant? I'll teach you what it's about." Mostly it was a terrible job. He constantly told me how awful I was and how I would never be promoted. In other words, he was an asshole. I also think he was hitting on me. Pretty soon I'd had enough. But one good thing came of it. While reading the trades, I noticed that sometimes an agency called CAA would run huge ads announcing that they had signed some big star. I knew my then-roommate, and still best friend,

was dating a CAA client. I wangled an interview. What I didn't know was that there had never been a woman in the CAA mailroom.

I met with Ray Kurtzman. I said, "Look, I will wash windows and wax floors. I'll wash cars. But I need to come in as a trainee, not a secretary. I need you guys to know that I'm going to prove to you that I'll go the distance. You may decide that I can't, and that's okay, but I need the chance."

Ray was discouraging in his curmudgeonly way. He said, "You don't really want this job. We pay you nothing. We make you work terrible hours." He was also asking himself—and struggling with—these questions: Can a woman deliver heavy film cans to a client at ten o'clock on a Friday night for a Saturday screening? Can a woman really go to questionable areas of town to deliver things at night? The idea that being a woman might be an issue never entered my mind.

Midway through my meeting with Ray he said, "Excuse me," and went to get Ron Meyer. I didn't know who he was except that he was charming and I really liked him. That Kurtzman brought him in signaled to me that the interview was at least going well. We talked more and they both smiled at me. I said I didn't want to interview anywhere else. I really had my sights set on CAA. Kurtzman said they didn't have an opening at the moment but might soon. I walked out convinced they would hire me. I wrote a follow-up letter and reiterated my interest.

They didn't hire me.

I was disappointed but didn't want to dwell on it. I called a friend who owned a restaurant in New York and said, "I can't be a waitress in Los Angeles, but I need to work. Can I work for you?" I slept on the floor of a girlfriend's apartment, and I worked at the restaurant for a while.

One night a guy from Paramount TV, one of my few friends in the business, called me. He said it was that time in New York when the networks picked their new series. Everyone was in town. Paramount—and this is really going to date me—was having a party at the Algonquin Hotel to celebrate the final season of *Mork and Mindy*. He asked if I wanted to go.

I was in heaven. At one point I went into the bathroom and wrote down the names Rowland Perkins and Mike Rosenfeld. They were

CAA TV agents at the party. I planned to send them letters telling them how much I still wanted to work at CAA. When I came out, I noticed a guy across the room staring at me. I smiled and he came over and introduced himself. "I feel like we've met before," he said. "I'm Mike Ovitz."

I shook his hand, and instantly all my enthusiasm spilled out of my mouth. I told him how CAA was the only place I wanted to work, that it was an incredible company, that I'd read all this stuff. I had done a little homework, reading every magazine and newspaper article that had been written about these guys, so I knew a bit about what was happening at CAA. We got into a pretty lengthy conversation.

Mike was as excited about everything as I was. He was energized and brimming over with confidence. I was rapt, the kind of innocent person he could be enthusiastic around. Even as the party thinned we were still talking in a corner. He seemed like a normal guy.

At the end he asked for my phone number in New York. He said, "You'll hear from us," then, "Good-bye." I don't remember the exact sequence of events, but very soon afterward Ray Kurtzman called and said, "Can you start tomorrow?"

It was a Sunday night. I packed up fast, took the red-eye out, and started work at CAA that Monday.

On my first day I realized I was the only woman in the mailroom. It was awkward. Mike Wilson, a TV agent, had a really long phone cord, so he could literally pace the hallway outside his office. I walked by carrying a bunch of scripts, and he yelled, "Hey! Are you the mailroom *girl?*" Everybody could hear. I was embarrassed. Occasionally I encountered the "Let's not ask Judy to do that" stuff—say, if a typewriter needed to be moved. But the typewriter wasn't that heavy. Otherwise, I didn't pay attention to being "the" woman and was determined simply to do the job. I think the bosses told the guys I wasn't supposed to do night runs, but I convinced them I'd be okay. Everyone would have hated me if I were the only one going home at eight o'clock without having something to deliver to a faraway location. Today being the first may forever be part of my bio, but it's embarrassing.

The very first mailroom job—always given to the lowest person—was the Century City delivery run. Eric Carlson took me out on Century Park East and started pointing out where everything was: the law firms,

Johnny Carson Productions in the Twin Towers, where to pick up the overnight ratings first thing in the morning. Right then Mike Ovitz drove up in his black Ferrari and turned into the parking structure. My first thought was, Here's the guy who, three nights ago, I spent so much time with, and he was so fantastic, so charismatic and interesting, and smart and passionate. So I went, "Mike! Hi!" and waved. Eric was shocked. "Do you *know* him?" I said, "Well, I met him." Mike gave me a cursory glance, so cursory that it surprised me. I didn't believe I had some special bond with him, but whatever had happened in New York was gone. Just gone [*laughs*].

When I got promoted to head of the mailroom, my speech to the people who worked under me was simple: "Our job is to say yes."

The day I found out I was being promoted to assistant, they didn't say who I'd be working for. Then I got called into Ron Meyer's office. He said, "So, I wondered if you'd like to work with me?" I was excited and delighted. He'd never had a trainee.

Ron's secretary, Linda Mentor, did most of his personal stuff. I made phone calls with him all day long. I did it for another nine months. I learned a tremendous amount from Ron: how to be decent, to tell the truth, to treat people well, to return phone calls.

Lots of people think the agenting business is like that movie with Kevin Spacey and Frank Whaley, *Swimming with Sharks*. That's not my personal experience. Ron was the exact opposite of the Kevin Spacey character in *Swimming with Sharks*. Ron was also the pacifier. He was always the one to make everything okay. He'd be embarrassed to ask me to go to the shirtmaker to pick up his shirts. He'd ask so sweetly, and I would do anything. But Ron could also be very tough; God forbid a name was left off the phone sheet and someone didn't get a return call. Then it was brutal. He would remind me for days, "Did you forget anyone *today?*"

I really loved working at CAA. They were really good to me. But I also realized, early on, that I wasn't a very good employee. I didn't like people telling me what to do. When I was twenty-nine, I left CAA to form my own agency, InterTalent.

• • •

JUDY HOFFLUND went on to form InterTalent Agency, part of which later merged with UTA, where she ran the Talent Department. She is now one of two owners of Hofflund/Polone, a management/production company representing clients such as Kevin Kline, Kenneth Branagh, Sally Field, Julia Louis-Dreyfus, and Alan Rickman.

FOR THE LOVE OF MIKE:
ASSISTING MICHAEL OVITZ

Creative Artists Agency, Los Angeles, 1982–1983

STUART GRIFFEN, 1982 • DAVID "DOC" O'CONNOR, 1983

STUART GRIFFEN: My dad died when I was fifteen. He was a school principal. My mother was a psychotherapist. I told them I wanted to be in the music business, but they wanted me to go to college. I won: I dropped out when I had only five classes left. But after trying the music business for a few years—and making a six-figure salary—I realized it wasn't for me. Instead I got a job with Irwin Winkler, who was in New York making a movie called *Author! Author!* I drove him around in a Lincoln Town Car. The salary was $250 a week. Irwin had gone through the William Morris mailroom, and when the movie wrapped, he suggested I come to California and do the same. We set up interviews at CAA, ICM, and William Morris, and he let me stay in his guest house.

I met Jeff Berg at ICM on March 5, 1982, the day that John Belushi died. Berg was kind of distracted, and the ICM training program wasn't really set up at that point. Norman Brokaw at William Morris was a ridiculous interview. A little guy sitting behind a big desk, he epitomized the old guard. He wore presidential cuff links because he represented Gerald Ford. He talked about himself the whole time, and I had maybe three or five minutes to say something. He asked me, "Do you know who Lynda Carter is? She's in the next office; we're just signing her to a ten-million-dollar deal." I was, like, Who wants Wonder Woman? I want Bill Murray.

When I met with Ray Kurtzman at CAA, the big question was

"What do you want to be?" If you said a producer or a director, they wouldn't hire you. I knew to say "Agent," even though I saw the agency business as a means to an end. Ray sent me to meet Ronnie Meyer, who was great friends with Irwin. They hired me.

My mailroom class included Tony Krantz, Mark Rossen, and Judy Hofflund, who was the first woman trainee hired by the company. She was a bulldog. Cute, and she knew it. Nice, but very focused. There was a lot of infighting—not in a bad way—but you knew you had to watch your back. I was this older New York guy who didn't have to worry so much about money, who knew the game before he got there. My go-getter attitude scared some people.

I drove an old green Volvo with expired plates. Got stopped by the cops all the time. Disregarded the tickets. There was no wheel booting in those days, so I didn't care. I sometimes drove up to three hundred miles a day making deliveries. I remember almost falling asleep at the wheel, then coming up the hill, opening my eyes, and seeing Century City. It was like Oz.

Personally, I was pretty wild. I had no life because my job was my life. I didn't have a girlfriend; I hung around with girls from the company. And I partied. It was still acceptable; okay, put it this way, they looked the other way. One agent used to have a giant bag of cocaine in his drawer, and we all knew it. I've been sober for almost five years now. Had to go through the whole rehab thing. But then . . . everything.

Very soon after my arrival CAA held their annual retreat in Palm Springs. Ovitz spoke. Around the office he was called the King of Shadows because no one ever saw him come in or leave. His spiel was about CAA's vision: "And you're all going to be a part of it." The message was "This place is special. Mike is special." Afterward I thought, This guy's got it. I'm gonna work for this guy. Most people were afraid of Ovitz, and he knew it, but I introduced myself. I was inspired but not intimidated; believe me, I'd already met people a lot bigger than Mike Ovitz. I said, "I'm really impressed with what you said, and I want you to know that I understand what you're talking about. I'm here one hundred fifty percent to do whatever I can do to be a part of the future of the company." Our moment was short and sweet. He said, "Thank you. When did you come here?" That's it. But I left feeling like if CAA told me to

shoot someone, I would kill for them. It sounds ridiculous now, but it felt like a highly energized family and a team.

After I introduced myself to Ovitz, his assistant, Rick Kurtzman, began to court me and ask me to do things. One day I drove Ovitz to Warner Brothers. My nickname, from being a tour manager in the music business, was Wheel Man. I got him to the studio very fast. Ovitz made phone calls and asked me about myself like you get questioned for jury duty. He was stern and serious.

It took me three months to become head of the mailroom, and Ovitz continued to ask me to do special things for him. I felt privileged. I guess he didn't want some less mature, less presentable guy to deal with Redford or Hoffman. It wasn't just dropping off a script or check. There were only two people that Ovitz was ever afraid of: Sydney Pollack and Robert Redford. Their attitude was always, "No fucking around. Don't give us any agent bullshit." I could handle that, and they were always nice to me.

I also made friends with Ovitz's assistants. They tested me, too, asking me to pick up flowers, bring chicken soup. In fact, taking chicken soup from Nate 'n Al's to sick clients was my idea. I also had a connection in New York for the Sony Walkman; they had just come out and were, like, five hundred bucks. I got them by the boxload from a friend who owned an electronics store, and for Christmas we'd do thousands of dollars' worth as gifts. I also managed to get the Harvard Hasty Pudding Man of the Year awards sewn up for our clients. I went with Bill Murray one year. I went with Sean Connery another. That's when I met Adam Isaacs—he was the star of the Hasty Pudding show, in drag; he's now an agent at UTA—and Tom Strickler and helped Tom get a job at CAA.

I pretty quickly got the sense I'd one day be Ovitz's guy. He knew I worked hard. He'd come back to the office at eleven o'clock at night, and I'd still be there. He'd come in on a Sunday, and I'd be there. I was in, both feet, plus 200 percent. I remember writing a note to myself: "Get anything, anywhere, anytime."

For months I played my cards and they played theirs. In the end I played my cards right. Getting Ovitz's desk was big news. Working for anyone else didn't mean shit.

When my promotion was announced, things changed overnight. Agents kissed my ass. Others were afraid of me because of my access to

Mike. We went everywhere together—Mike and I were *that* close. It was like brother to brother, like family. I sometimes slept at his house, took care of his kid. He was the first guy I talked to in the morning and the last guy I talked to at night. I didn't even speak to my family like that.

I loved him. I worshiped the guy. And everybody knew it, so they all wanted to know me. And to be honest, I didn't really care whose interest was real and whose wasn't. Working for Mike was a turning point in my life. I realized I couldn't look at older guys as father figures anymore. I hardly considered myself equal, but I saw Mike's foibles clearly. His vulnerability. All the cracks from day one—the self-esteem issues, the insecurities. He was completely insecure: "What does he think of me? What does he say?" I would literally tell him to shut the fuck up. "What are you talking about, Mike? You're out of your mind. Give me a fucking break; you're at the top of the class." No one talked to him like I did, but I saw that he was just a guy. I knew more than him in a lot of areas, was on top of things. I was the behind-the-scenes guy. I fed him information and kept him going on a daily basis.

In the end the job got to me. It became apparent to everyone that I lived a fast life. I never got to the depths Jay Moloney hit, but I did have some problems. I once went to a meeting with Mark Canton, who was at Warner Brothers then. He kept me after and said, "Listen, I need to talk to you about something. I think that they're . . . a little concerned." That upset me. Not only didn't I know Canton well enough to talk about my problems, but Ovitz, the guy I worshiped, couldn't even talk to me himself. He was like a parent who couldn't face the idea that his kid was on drugs. I thought, Is our relationship really that impersonal? But, of course, that's the thing about drugs: denial. Things *had* changed, and I couldn't cop to it. I had began to distance myself from him, and he from me. The more involved I got in the partying, the less I was the company guy. I wore the suit and tie, but I wasn't behaving. But instead of offering help or saying I needed help, they shoved it under the rug.

I picked David O'Connor to succeed me. I really liked him, but I made a mistake. He would agree. I thought he was more of a hustler than he really was. His brother, Bob O'Connor, was big at CBS, and I thought, Okay, this guy knows the business. Just as I eased him into the job I

could see it wasn't going to work. Ovitz hated David O'Connor—we called him Doc. When I trained him for the desk, Mike took his brief-case and threw it across the garage at his car because Doc had done something wrong. I had to calm him down: "You've got to give him a chance," I said. "I'll back it up, don't worry about it."

DAVID "DOC" O'CONNOR: In 1980 my oldest brother, Bob, was the head of comedy series development at CBS. I worked for public television sta-tions in New York and New Jersey. I really wanted to do documentary work, but the timing was bad. With my brother in Los Angeles, I de-cided to move west and give the movie business a shot.

Bob opened a few doors, and I couldn't believe how nice everybody was. I was just blissfully naive. People were nice, but no one offered me a job. I soon learned that in a business where things can turn around so quickly that your assistant one day is your boss the next, people don't want to be overtly bad to *anybody*—at least when that person is starting out.

I kicked around for three or four months. The more I talked to peo-ple, the more I heard, "Go to a talent agency. It's at the center of every-thing. Be a gofer. Deliver mail. You'll meet a ton of people." In other words, I had to start all over again.

I was supposed to meet Ray Kurtzman, who interviewed all prospective trainees, on a Thursday night. He kept me waiting in the lobby for an hour, where two assistants sat at the switchboard, answering phones, saying "CAA," "CAA," "CAA." Everyone wore ties. I kept wondering what it would be like to work there.

I finally got into Kurtzman's office and shook hands with this crusty, gruff guy. Conversation was tough because every couple of minutes someone buzzed him on the intercom and he was called away. Once, he left for a long time; it was all Ovitz-related stuff. Ovitz's office was right down the hall, and Kurtzman was Ovitz's consigliere.

In between calls Kurtzman kept telling me why I didn't want to be in the mailroom at CAA. I reiterated that I *did* want to, very badly, though

I think I worked harder to convince *myself* than him. Kurtzman said, "We don't have any openings here, but we'll put your résumé on file."

I also met with Ron Meyer on the strength of his knowing my brother. His vibe was completely different from Kurtzman's. Meyer was laid back, a great guy. We laughed and had a wonderful discussion. Maybe it was a good cop/bad cop sort of thing, but Meyer was someone I *wanted* to work for.

One Friday afternoon, while painting the house I lived in instead of paying rent, the phone rang. "Can you hold for Ray Kurtzman?" He told me to show up Monday at nine-thirty.

I began my trainee experience with an apology. I reported to Jim Caplan, head of the mailroom, at nine-thirty sharp. He looked me over and said, "This is the last time you're coming in at nine-thirty. We get here at seven."

Jim gave me a tour of the fourteenth-floor offices at 1888 Century Park East. The layout was roughly a square. Marty Baum had one corner, Michael Ovitz had another, Bill Haber a third. Ron Meyer was right next to Michael. Caplan introduced me to the assistants, and I met Richard Lovett. I vividly recall his big horn-rimmed glasses and that he was full of energy. He was immediately friendly. We talked, and he made a few wisecracks. He seemed like someone I could be friends with. Richard told me he had just gotten out of the mailroom and become Fred Specktor's assistant.

Right next to Richard was one of the small kitchens in which the trainees were responsible for keeping the refrigerator stocked and the coffee made. While Jim showed me the routine, I met my first agent, Judy Hofflund, recently off Ron Meyer's desk. I remember thinking, God, she's so young! In fact, everyone was young. All the agents, all the trainees. At twenty-five, I was off to a bit of a late start.

I became pretty good friends with Ovitz's assistant, Stuart Griffen, who brought me into Ovitz projects, like doing the *Ghostbusters* premiere. I didn't know then that Ovitz empowered his assistants to find their replacements, or that Stuart was grooming me, but soon I was firmly in the Ovitz orbit, especially when it came to delivering films to his house on weekends. Usually it was a quick drop-off, but every once in a while

Ovitz was there and we'd talk. And when things got fucked up, which they invariably did, I'd get the call from him at home—which was not very much fun.

Just when I began to get pissed that some people were being promoted out of the mailroom before me, Stuart said, "Ovitz has his eye on you. You're being held back, probably to be on his desk." I knew that was a plum job. Unlike other assistants, Ovitz's assistant didn't answer phones or type the phone sheet. He already had two secretaries. You even had your own office—a big perk—and got to go to the Wednesday staff meeting, which none of the other assistants could attend. I wanted it desperately, but nothing happened until one day when I was told to meet with Ovitz. I was on my way when I saw Robert Redford come out of the elevator and go straight into Ovitz's office. I followed him, but Donna, Ovitz's secretary, said, "It's not going to happen now. But hang out." I waited until about eight-thirty that night before the meeting was canceled.

Two weeks later they rescheduled. When I walked in, Ovitz was behind his desk, on the phone. He said, "Sit down." I thought he meant in front of his desk, but he said, "No, no—over there," pointing at the couch. Ovitz's office got pretty heavy afternoon sun, so by the time he took a seat near me, he was brilliantly backlit. I couldn't see his face, only his shadow, which I later learned was intentional. He also kept interrupting our conversation. He'd tap a phone next to him, and moments later Donna would come in. He'd say a few things, then she'd go. Then she'd come back. I later learned he was buzzing her in, for no real good reason other than to shake me up. He wanted to see if I could handle the distractions. He wanted to keep me on edge.

I had a speech prepared, but since he'd called the meeting, I waited for him to start. He did: "So, what's up?" Totally threw me.

Later I heard, secondhand, I had the job. Ray Kurtzman said, "You're going to be Michael's assistant, but Stuart's not being promoted yet. You two will do it together."

I moved to Ovitz's desk, and for the first month he never talked to me. He would interact only with Stuart. The reason: He didn't trust anybody. He was very distant and always testing. All our interactions were on note cards. Every few hours, if he gave me a task to do and it wasn't completed, I had to submit a card that said where I was in the process. I put it in his in-basket and he'd mark it.

As Ovitz's assistant, you did a lot of grunt work. I had to fill up his car with gas. Or get his shoes shined at some place on Pico, over by Hymie's Fish Market. Then there were the gifts: That killed you because he got them for people all the time. My first big test was his personal Christmas list. It was huge, and everything had to be perfect. But I did it well and finally broke through. From then on Ovitz and I interacted more. Sometimes he was even a little expansive and I could maybe joke around a bit. But it was always all about him, and our moments were hardly personal or intimate. He knew nothing about my life, which was fine except it seemed a little odd, given that I was with the guy twelve hours a day.

Ovitz wasn't that way with everybody. Not Jay Moloney, for instance. Jay had this boyish quality about him that made everybody want to take care of him. He also had a curiosity combined with fearlessness, which allowed him to ask things of and get involved with people who were in positions of authority. He ended up having a closer personal relationship with Michael. I never had that quality or that ability and was always uncomfortable in Ovitz's presence.

I still managed to learn a lot. Ovitz worked hard. He was prepared. He was aggressive. Diligent. Organized. Detailed. Ovitz saw a big picture and was a bigger thinker than I had ever thought an agent would be. He worked on a whole different level; to him, your career was your life. And yet that very intensity was the problem between us. The important things to him were just not important to me. Unfortunately it wasn't like a marriage, where you could work out issues. My job was indentured servitude. Ovitz could be intensely abusive. He could make you feel really stupid. He was very cold, manipulative, impenetrable. And he would scream. I'd stand up to him when I thought I was right, but it wasn't worth screaming right back at him.

I did some boneheaded things [*laughs*].

Anthony Edwards, from *ER*, is a friend. He invited me to the premiere of his movie *Gotcha!* costarring Linda Fiorentino. When you're an assistant, it is extremely difficult to find your way to premieres, but I knew the star, I had the parking pass, the assigned seat. I really wanted to go.

I never ever left the office *before* Ovitz. In fact, I usually stayed until he was at his destination, like a dinner, just in case he needed anything.

The premiere was at eight o'clock in Westwood. Bert Fields, the lawyer, came in for a meeting about seven o'clock. By seven-thirty they were still inside. Seven-forty. Seven forty-five. I knew that sometimes Ovitz would just go straight home and I'd never even see him, so I said to Donna Chavous, who was working late in the secretarial pod, "Cover me. Say I'm down in the library. Say you can't find me. You know I'm in the building, but you don't know where I am." And I left.

After the premiere I went to the party—it was a Thursday night— and was out until one or two in the morning. I got kind of drunk. When I came home, my answering machine rewound forever. Then it played back Donna saying, "David, are you there? Pick up. Pick up. Are you there?" *Click.* "David? It's really important. You have to pick up the phone, it's really important. Where are you?" *Click.* "Are you there? Pick up, it's really important. Do you have Michael's car keys?" *Click.*

I reached into my jacket pocket. I'd gassed his car earlier and kept the keys.

I woke up early Friday morning, slightly hungover, and called Ovitz just to get it over with. He wouldn't take my call. I dropped the keys by his house on the way to work. Then I waited with his secretaries for him to arrive. Ovitz walked in about nine-thirty. He looked at Donna and Susan and said, "Can you excuse us?" Their look said it all: "Oh, God, we're sorry."

Ovitz berated me for being an idiot: "This is the reason why you're not going to be an agent. You're not attending to details. This is important." All at the top of his lungs, veins bulging. He finished with, "Get the *fuck* out of my office, I don't want to see you." He was really abusive, but I had made a stupid mistake.

When Ovitz saw a StairMaster for the first time, he fell in love. In those days it was the old type; rather than the two footpads, stairs actually went around in a circle. He had me track down a unit to have installed in his home gym—and, of course, for Ovitz, you could never buy it retail. I got ahold of the manufacturer and convinced him that Ovitz was a big shot in the entertainment business, that they should sell him a StairMaster at cost and have it delivered, because then he'd give them as gifts to the most important people in the industry, and the StairMaster company would get more business. I unwound the whole spiel, and the guy bought it.

Jay Moloney and I waited in our shirts and ties at Ovitz's house for the delivery truck. The driver said, "I'm dropping it at the curb." We protested. These were huge machines. "Hey, it's my contract," he complained. "I'm not an installer. I'm just a delivery guy." But it was a hundred yards from the curb to the house, then up some stairs to the gym. I fished in my pockets. I said, "Jay, how much cash do you have?" We gave this guy whatever we had and begged him to help us.

He backed up the truck as close as possible to the door and off-loaded the machine. But it was too heavy to pick up and move, so we had to take it apart just to get it in the door, not to mention up the stairs. It was oily and disgusting to boot.

Ovitz had just installed an incredibly expensive marble foyer floor. Luckily we made it over that without a scratch. Then we started up the staircase. But the StairMaster wouldn't fit between the banister and the wall, or make the turn in the corner, so we had to lift the machine over the railing and almost push it up past the million-dollar works of art on the walls.

I lifted and pushed and was sinking under the weight, with a very sharp corner of the StairMaster in my palm. The back of my hand was up against the front edge of a canvas: a Jim Dine or a Rauschenberg. With every step up I felt the metal corner dig deeper into my hand, but I was ready to let it go completely through before I would ever let it touch that canvas.

It took a year to figure out, but I finally realized that my job was about having one client: Michael Ovitz. I took care of him from the beginning of the day to the end. I was his front man, and it was about greasing everyone to make him feel like a big deal, an important person in the world. If he went out of town and needed restaurant reservations, I'd call the maître d', say, "You've got to take care of him. He's an important guy," and send him cash. I began to excel at my job. I'd learned that Ovitz was all about style over content. Appearances were everything. The concept was totally alien to me personally, and Ovitz knew it. He would give me shit that it was the difference between Jews and gentiles. He would say, "You're the fucking *goyim* and you don't get it." He would make a lot of our cultural differences on a daily basis.

I accompanied Ovitz on a trip east for the first time, and in New York he said, "I'm going to make you an agent. What kind of agent do you

want to be?" I said Movie Lit. He said, "Okay, and I'm gonna kick your ass all over town before I let you fail." That was his way of being supportive. Then he said, "But you've got to find your replacement. I'm not going to let you be an agent until I'm comfortable with your replacement. Who should replace you?"

I said Jay Moloney.

At first he said no, then fired Jay for a day. And brought him back. And fired him again for a day. And brought him back. Like he'd done with me, it was all a game. Ovitz just wanted to break him down.

• • •

STUART GRIFFEN is an entrepreneur living in New York.

DAVID "DOC" O'CONNOR, one of CAA's Young Turks, is now a managing director and a partner at CAA.

PRESSURE, PRESSURE, PRESSURE

Creative Artists Agency, Los Angeles, 1984–1990

MIKE ROSENFELD JR., 1984 • JOEL ROMAN, 1984 • TOM STRICKLER, 1984 •
DONNA CHAVOUS, 1984 • MARC WAX, 1984 • JANE BERLINER, 1985 • JON KLANE, 1985 •
JOHN UFLAND, 1985 • MARTIN SPENCER, 1985 • DOUG ROBINSON, 1985 •
MICHAEL WIMER, 1986 • ADAM KRENTZMAN, 1986 • BRAD WESTON, 1986 •
TED MILLER, 1988 • MICHAEL GOLDMAN, 1989 • JEANNE WILLIAMS, 1990

*Hollywood mailrooms are by nature Darwinian; mine was also
Dickensian. We were there from seven A.M. — lots of times
earlier — until eleven at night, and lots of times later. We
worked Saturdays. But there were no questions asked. It was
pressure, pressure, pressure, and so intense that probably
two out of three people showed up for their first day and
within twenty-four to forty-eight hours were gone.
My mailroom was the last gasp of the original CAA work
ethic, yet even in the midst of the madness my group could
laugh. It was almost always gallows humor; it was bizarre
and insane, but we were on this merry ride,
and boy, was it fun.*
— Tom Strickler

JON KLANE: CAA was my father's agency. He wrote the novel *Where's Poppa?* and we moved to Los Angeles when it was made into a movie. I was ten. But it was the seventies, the Me Decade, when people paid therapists good money to give them permission to do what felt good. My parents got divorced when I was eleven or twelve. Just as the faces in my father's world began to get familiar, the door slammed shut. That was a life-changing experience. Out of necessity I began to define myself as a self-reliant person. I became a salesman, a huckster. I got into pocket calculators, vacuum cleaners, dope, catering. When I was twenty-one, I felt I'd finally achieved a level of parity with my old man. I had lots of bread put away. Lots of toys. But I wanted more; I wanted to kick open the door that had been closed ten years before. I reached out to my dad.

He said, "But what is it that you do, exactly?"

"Promotion. Marketing. Something."

"Okay. Call Ron Meyer at my agency," he said. "They're the best. They aren't number one yet, but they're like number three with a bullet."

I called. Ron said, "Come in and meet Ray Kurtzman."

I drove to CAA for my interview on a brand-new motorcycle that I'd paid for in cash, one of those red Kawasaki Road Rockets. There was no helmet law, so my hair was blown way back. I wore sweats. I was pretty relaxed, the king of my domain, and walked into a place where I would soon learn I was actually quite insignificant. I had no idea what I was in for.

Ray was like my grandfather, and he gave me the speech that I gathered he gave to just about everyone: "Are you out of your fucking mind? Do you know what this job is? This is really hard." I paraphrase, but it was a very discouraging monologue. Then he asked me, "Why do you want to be an agent?" I had no idea what an agent really was, so I said, "I don't know that I do, but I'm willing to work in the mailroom for whatever awful wage and in the conditions you just described to find out if that's what I'm interested in."

It was an honest answer. Ray said, "All right. Whatever," and I got the job.

JANE BERLINER: My father is the photographer who for years has been the guy hired by every studio to shoot at movie premieres. When I graduated from UCLA, I asked his advice on getting into the business, and he told me I could do publicity, work with a producer, or be an agent. When I said agent, he said, "I will let you interview only at CAA. It's the best place and it's on the rise."

I was so nervous before my interview with Ray Kurtzman that my stepfather, a psychiatrist, gave me a posthypnotic suggestion the morning before my meeting so that no matter what, everything I said would be golden. I just didn't want to blow it.

After my interview I went home and my mom said, "Ray Kurtzman's office called and asked for a photo." I thought, What the fuck does he want a photo of me for? He knows what I look like, I was in the chair right in front of him. Turned out he wanted to bring the photo home to his wife, Lynette. I sent the photo and soon got a call: "Of course you have the job. You car-pooled with my son Ricky." In fact, I hadn't. My sister Jill had. I remember because Rick Kurtzman and my sister used to feed my dog crayons to watch the color come out the other end. I wanted

the job on the merit of my incredible interview, but I had to admire Ray's poker face while my name rang bells in his head. He never let on.

JOEL ROMAN: I worked as an electrical assistant, schlepping instruments for a cartage service, when a friend mentioned that her former boyfriend's father, Mike Rosenfeld, had started a talent agency called Creative Artists. They'd just opened a music division and represented Madonna. I wanted to be in the music business. Luckily I called on a day they needed a body. I took out my earring and wore my only suit and tie. I got the job. My roommate and best friend, Howard Sanders, was totally surprised. He was in the mailroom at William Morris. He'd gone to film school and was a huge film buff. He had also interviewed at CAA, and he couldn't believe I got in.

JOHN UFLAND: Right out of high school my first job was a production assistant on a low-budget Roger Corman film. Five years later I'd worked on a handful of movies, a couple of which—*Bachelor Party* and *Moving Violations*—my dad and Joe Roth, who now runs Revolution Studios, produced together. One day Joe sat me down and said, "Okay, it's time to flee the nest."

I applied to William Morris, where my dad had been in the New York mailroom, and met with Stan Kamen. He said, "What would you like to do?"

I said, "Produce."

That pretty much ended the meeting.

Kamen sent me to Kathy Krugel, in Personnel. Another short meeting. Once I said I didn't have a college degree, she said, in that clipped, stilted, vaguely robotic tone of hers, "Oh, we don't accept people without a college degree."

I said, "My father didn't have one, Geffen didn't, Ron Meyer didn't."

"Well, things have changed since then," she said. "Perhaps we can find something for you in janitorial or custodial." That blew my mind.

I called my dad. He said, "Why would you tell Kamen you want to produce if you want a job as an agent trainee?" As for Kathy Krugel, he hit the roof and called Kamen, who called me and said, "Look, I'm really sorry. It was totally out of line, but the bottom line is that we're not taking anyone without a college degree." He told me to come back later when I'd been an agent for a while, and they'd hire me. I thought, Why would I need you people then?

I called CAA instead.

TED MILLER: I ended up here almost by accident. I grew up in Los Angeles; I was always around entertainment, but my family wasn't in show business. My dad didn't even look at it as legitimate or professional. Understandable. I majored in business in college and I really wanted to go to New York, so I worked on Wall Street for a couple of years in one of the analyst programs, but ultimately, I lost interest in business.

Back home, I got out a studio directory book and wrote letters to anybody who, in my perception, was on the creative side, which was producing. Most of the people who responded either flatly rejected me or said, "Why don't you go into home video or something like that." I got a handful of interviews. One guy told me about the trainee program and said he'd be happy to get me an interview at CAA.

BRAD WESTON: My dad, Stan Weston, created G.I. Joe nearly forty years ago and was one of the pioneers of the licensing and merchandising industry. He handled models like Twiggy, when she was quite the rage; Farrah Fawcett and that big deal she did for Faberge, and the poster phenomenon; Bruce Jenner, when he was in the Olympics. He also got into business with a toy company called LJN and a production company called Telepictures, and they got into the half-hour animated business with some very successful shows called *Thunder Cats* and *Tiger Sharks*. My dad was also involved with Bernie Brillstein on *Alf.*

I was a marketing major and played lacrosse at the University of Massachusetts. I wanted to get out of school and go into business, and I talked about business all the time with my dad. I also loved the movies. My older brother, Steve, lived in Los Angeles and had gone through the William Morris mailroom. He also gave me the novel *The Boys in the Mailroom*, and it started me thinking.

In January 1986 I came to Los Angeles to meet Ray Kurtzman. An agent my dad knew, Marty Baum, arranged it. CAA was a much smaller agency at the time. I walked to Ray's office, past all the assistants, wearing my little interview suit. Everyone looked at me and knew exactly what I was there for. They thought it was funny. I was scared as hell. I spoke to Ray for probably ten minutes. He's a business affairs executive, not an interviewer by nature. He was pleasant; he couldn't have been nicer. He said, "Okay, we'll hire you when a position becomes available." I got a call in April, telling me to come to work the first week in June. Five days after graduating from college, I was working in the mailroom at CAA.

MICHAEL GOLDMAN: I was a dumb jock, a 250-pound linebacker at Wesleyan. My older brother had become extraordinarily successful working for Salomon Brothers, and everyone figured I should do that, too. But the college course I enjoyed the most was theatrical writing. At the same time, people had begun talking about Michael Ovitz. I called CAA for an interview. My brother prepped me. "They're going to give you every reason *not* to take the job." He said I had to be adamant about my intensity and dedication. I told Ray Kurtzman I was born to be an agent and sold him on my incredible determination.

JEANNE WILLIAMS: Movies had always interested me. I watched them with my mother when she was in graduate school; I'd keep her company while she typed papers late at night. *Citizen Kane, Night of the Hunter, Imitation of Life.* I also went to movies all the time when I was in college, but I still hadn't made the connection that there was a way to make a career out of it. My parents were always academically inclined, pretty traditional. They didn't know anybody who worked in the movie industry. It never seemed a very practical business for someone from a middle-class black family.

Instead, I went to Harvard Law School. But during my first month I was already disenchanted. I thought the law was about being more political and making the world a better place; instead, the whole thing seemed designed as a feeder system for the major New York firms. Still, I got my degree, passed the bar in New York and D.C., moved to New York, and worked in mergers and acquisitions. My first year I had one day off: Christmas.

I left New York and went to D.C., and got into tax law. But again I thought, I hate this and have to get out. I was in my late twenties and it was either try the movie business or let go of the dream.

I worked on a few independent movies and productions in the D.C. area on nights and weekends, and got a good look behind the scenes. I also read William Goldman's book, *Adventures in the Screen Trade.* Then I read an article in the *New York Times Magazine* about CAA and Mike Ovitz. I didn't really know what agents did, but in the article Ovitz mentioned that he hired a lot of MBAs and JDs.

I sent my résumé to William Morris in New York, and they offered me a job as a trainee in the mailroom. I also sent one to CAA. Ray Kurtzman called me. He sounded surprised. "You want to work here?"

I said, "Yeah, I think so." Two days later, I jumped on a plane.

Ray tried to discourage me but I was already used to tough environments. Besides, it's what I wanted to do. I'd already made a lot of money, but it hadn't made me happy. I knew that the only way I could have a new life was to start at the bottom. My parents lived in Orange County, and they said I could live with them and commute. The drive was brutal, but I had faith that I would figure it out.

MARC WAX: My dad started in the William Morris mailroom and was an agent in New York and Los Angeles for a long time, ultimately rising to vice president of their TV Department. Ovitz, Haber, and Perkins worked with him or for him. When I was seventeen, he called up Mike Ovitz and got me into the CAA mailroom as a "summer camper." I came back in 1984, after college, as an official trainee.

MARTIN SPENCER: I wasn't sure what I wanted to do after college, so I went to see Bernie Brillstein. Bernie is my godfather, my Dutch uncle, the guy I go to for advice. He said, "You're gonna go work in a mailroom." I said, "What's that?" He called Ray Kurtzman, and I found out.

DONNA CHAVOUS: I think of myself as the typical Hollywood story. I grew up in Los Angeles, went to USC. My dad was a cop, my mother a teacher. They divorced when I was five. My dream was to be an entertainment lawyer, and my mom supported that. She also insisted I always have an after-school job, so from high school through college I worked at a law firm at 1888 Century Park East, in Century City. We were on the same floor as CAA. That meant nothing to me except that I thought their employees were weird because every time they went to the bathroom, they moved as fast as Speedy Gonzales!

Robbie, one of the legal assistants I worked for, began dating a guy from CAA named Todd Smith. They met because during the writers' strike that year he finally had time to stop and talk to her in the elevator. They eventually got married.

I was ready to go to law school, only I'd flunked the LSAT because I had no capacity for aptitude tests. I could have retaken it and started the following semester, but I was impatient. I was so stressed trying to figure out what to do with my life that Robbie said, "Why don't I have Todd get you an interview at CAA?" At that point anything sounded good. "Okay," I said. "Whatever."

MIKE ROSENFELD JR.: My father, one of the CAA founders, always told me, "I think you'd be a good agent." I guess it was my ability to talk to

people and make them feel comfortable. We also had creative discussions at the house, and I think he felt I had a knack for the business. But whenever he suggested I work in the CAA mailroom, like my older brother, Max, had done temporarily when the company started, I resisted the idea. I wanted to be a musician.

In 1984, after two years of college, majoring in music, a lightbulb went off in my head. I realized that I didn't want to wind up as a thirty-five-year-old struggling songwriter. I called my father, who had retired from the company two years earlier, and said, "I'm willing to try and work in the mailroom. Can you help me get a job there?" I felt like Richard Gere in *An Officer and a Gentleman:* I had nowhere else to go.

Even though he knew me, Ray Kurtzman put me through the interview grind. He was relentless and skeptical. Finally he squinted at me and said, "I guess I *have* to give you a job. Let's see if you can cut it."

MICHAEL WIMER: I went to Harvard undergraduate, to Spain on a scholarship, into investment banking at First Boston. But eventually it bored me. I quit and went to Stanford Business School. The summer between my two years there I came to Los Angeles, interned at Disney, and got the show business bug. I interviewed around town, and more than a few people said I should think about being an agent. I took that as a huge insult. I'd heard agents were hucksters, untrustworthy, slippery, unctuous. But I knew if I didn't like it, I could go back to Wall Street. I had nothing to lose.

I showed up to meet Ray Kurtzman wearing white bucks and a yellow tie, and I'm sure he thought I'd be eaten by the business. "You look like a nice kid," he said. "What are you doing here?"

TOM STRICKLER: When I was at Harvard, we gave Sean Connery the Hasty Pudding Man of the Year award. He came to the ceremony accompanied by Stuart Griffen, who happened to be Mike Ovitz's assistant. We spent the day together, talked about what he did. I told him I was coming to Los Angeles after I graduated. He told me to call him.

I drove into town on July 4. The sky was pink and orange, and Randy Newman's "I Love L.A." was on the radio. I got settled and called Stuart, but there were no jobs. He said he'd keep trying to get me in, and gave me two pieces of advice for my eventual interview with Ray Kurtzman: "Ray is a huge golf fan, so talk about golf. And no matter what, tell him you've always wanted to be an agent."

I said, "Why? What does that mean?"

He said, "They always try to trick people. They're afraid people will come to the training program and then go off and get another job."

I finally got a call from CAA asking if I could come in *that* day. I said sure. Once with Ray, I immediately started using a bunch of golf metaphors, just put them on the ends of my comments, like "It was a hole in one." Ray finally asked me if I played golf, and I said yes. In truth, I had played once or twice, when I was twelve. But in our conversation I *loved* the sport.

Then he said, "You don't want to be an agent, do you?" I could tell he was a little worried about my white-shoe background. Earlier he'd said, "You went to Harvard. Do you know what you're going to be doing here?"

I said, "I've always wanted to be an agent. I've always dreamed of being an agent. I grew up wanting to be an agent. When I was *six,* I wanted to be an agent."

He smiled, because whether he believed it or not, that was the answer he wanted to hear.

Then he asked a very funny question: "What religion are you?"

I said, "I'm Christian."

He said, "Well, I've got a problem. I've got five Jews in the mailroom, and tomorrow's Yom Kippur. If you can start tomorrow morning, you've got the job."

I said yes, and that was it. I made it in because they needed a *goy!*

THE NEW LEW

STRICKLER: My first giant mistake was a direct result of not being Jewish. They told me to set up a conference room with food for a morning meeting. Part of that was cutting the bagels. I'd never cut a bagel. I'd probably never eaten a bagel. Rather than cut them lengthwise, I cut them in half and put them out on a plate. After the meeting someone said, "You're a fucking idiot!" I'm sure everyone thought, Who is the moron who did *this?* He'll never go anywhere.

CHAVOUS: Tom Strickler was clueless when he came to work. There he was, six foot two, blond, blue eyes, Mr. Intellectual. On his first day I looked at him and said, "Hey, man, after you clean up the conference

room, you've got to clean up the kitchen. Load the dishwasher, wipe the counters. And it's got to be done *right now*." He looked at me like I had ten heads: What the fuck? This black chick is telling me to go fucking clean some shit up? He hated that part of the job. It was priceless.

STRICKLER: I didn't find it *that* tough. I thought it was part of the whole picture. It was like graduate school. I take pride in the menial tasks—or at least I did then.

DOUG ROBINSON: My first day I met Kirk Torres and Todd Margolis. They went, "Oh, look, it's the new Lew." They called everyone Lew. Kirk and Todd were the biggest characters in the mailroom, bar none. Nothing was serious and everyone was Lew. I still have no idea who the original Lew was unless they meant Lew Wasserman. Kirk and Toddy did their jobs, but it was obvious they didn't have the attitude it took to get ahead at CAA.

KLANE: Todd became a publicist, I think. Kirk had a wonderful sense of humor. One night at a company retreat he picked up a couple of girls, and the next morning there he was, sleeping in the room he shared with Martin Spencer, with his cock hanging out and over. It exposed him as the, uh, Dillinger of our crowd. Martin is English, and the boarding-school principle is to shout it in the hallways, so he took a Polaroid and invited people to come take a look. "Check out Frankie Perdue!" he said. Later we went to one of the early-morning meetings, and every time I looked at Ovitz and Meyer with their heads together, all I could imagine was them talking about Kirk's dick.

ADAM KRENTZMAN: Matt Loze took me out for the morning run. It was kind of a no-brainer. We even had extra time to have lunch together. He told me how the agency worked, and I told him I was there because a cousin had suggested I should be an agent—for actresses specifically. What I didn't say was that all I knew from being an agent was *Broadway Danny Rose*. You know, white leather shoes, a cigar, and you're in business.

Matt asked if I thought I could do the afternoon run on my own. I said sure; I'd lived in Los Angeles for years. I left about three-thirty but wasn't as familiar with the streets as I'd thought. Around eight o'clock it started raining. My car leaked and the windows fogged up. When I rolled down the window to see, more rain came. At eleven o'clock I called the mailroom. I still had a third of the packages left to deliver. I said, "What time exactly is it okay to call it a day?"

The guy said, "When you're finished," and hung up the phone.

I got home at one-thirty in the morning, took a shower, and slumped down on the tile floor, knowing that I not only had to be in the office at 7 A.M., but first I'd have to gas up my car and do the shopping for the morning staff meeting. I started crying. I thought, What have I gotten myself into?

THE RELUCTANT TORTURER

STRICKLER: Joel Roman was the senior trainee and ran the mailroom. He was our commander in chief and torturer. We hated him. He was not the kind of guy who wanted to get in the trenches with the rest of us. If there was a bad job, he would give it to someone else to do. When you run the mailroom and it's that intense, the best way to build loyalty is sometimes to take the shitty jobs and do them yourself. He took the shitty jobs and gave them away.

CHAVOUS: Joel was a mess. A nervous wreck. It wasn't his fault. He used to bite his fingernails down to the nub from the stress. It's obvious why: the company was just exploding. It seemed like things were moving faster and faster every single day, yet they were very frugal. They didn't want outside messengers, which increased the pressure even more. Every time Joel *had* to spend on something extra, they'd scream at him. Plus, he wanted to be a music agent, and there wasn't much movement there in terms of openings, so he was stuck in the mailroom.

ROMAN: After three months they offered me Rosalie Swedlin's desk in the Literary Department. I didn't know I *wasn't* supposed to turn it down, but I did, which created a big fuss because no one with the typical CAA mind-set and ambitions had done that before. Jack Rapke offered me his desk, and I passed again. I can't say it often enough, but I just wanted to get into the music business. My saying no to desks allowed the film school guys reviewing screenwriter flash cards to shoot past me. Because of my seniority I ended up running the mailroom.

It's okay with me if I wasn't a great boss. I wasn't cut out to do that. I had no conception of the importance of my responsibilities. I wasn't prepared for that type of stress. I got mononucleosis but was able to stay out for only a few days.

At CAA everything had to be done *right now,* no excuses. Because of the pressure from Ovitz on down I was forced to yell at these people, because someone was always yelling at me. I remember sending out a memo once. It was one line, and I was torn a new asshole because it was *one line on one piece of paper,* and I should have done it on *half* a sheet. I got fired once by Bill Haber because a package was mailed instead of delivered. The question begs to be asked whether it said DELIVERY or MAIL on the package, but Bill broke his phone and told me to get out. I went to Ray Kurtzman's office to collect my check, and he said, "No, no, don't worry. We'll fix this."

STRICKLER: Working in the mailroom was famously exhausting. This was because CAA was the new power. William Morris had gotten old and institutional; CAA was the young up-and-comer. A hotbed. Ovitz liked that type of corporate culture: "Okay, here's the bar; now jump higher than anybody else. Our people work harder, faster." Ovitz and Meyer ran a tight ship, and it was inspiring. But people in the mailroom would sometimes break down crying because it was tough, tough, tough.

ROBINSON: By the time I started, Strickler had become head of the mailroom. He tried to make it his fiefdom. Tom and I used to get into it. He was always going on about Harvard this and Harvard that. Finally I said, "Hey. I'm sorting the same mail you are."

THE FOOD YOU TAKE IS INVERSELY PROPORTIONAL TO THE MONEY YOU MAKE

WIMER: We made absolutely no money. The pay was so low that there was no way of putting pencil to paper and seeing it work out. I decided to go on fumes, and when I finally ran out, I'd be out. At least I wouldn't starve. I could always eat the chocolates and Martinelli apple juices we had to stock Ovitz's office with. And there were fruit trees at the guest house where I lived.

WESTON: I was new to Los Angeles, so I moved into an Oakwood apartments complex in Mar Vista. Doug Robinson used to come over to watch the Giants games. We were two lonely, miserable, twenty-one-

year-old guys from New York, making two hundred and fifty dollars a week, becoming friends. To blow off steam we socialized with the other assistants, went to parties, and drank. We got to know the assistants around town—who was cool and who wasn't. We had a blast.

CHAVOUS: The paychecks were $429.80 every two weeks. I lived by myself in a one-bedroom apartment on National Boulevard in Culver City, robbing Peter to pay Paul, fighting off student loans.

WIMER: Often we'd just wait until a night meeting broke, then get the DHL bags—not the FedEx bags, because the DHL bags were lined with plastic—go into the meeting room, and stuff all the leftovers into the pouches. I lived off leftover tortellini for a week and a half. Took it home and fried it up with some barbecue sauce. Mmm, good.

KRENTZMAN: On my second day Sally Field came for a meeting in the conference room. Hillcrest Country Club provided the food. Afterward the mailroom crew closed the door, pulled the shades, and ate everything. Being the new guy, I said, "Are you nuts? You're like a bunch of animals! You're scavengers."

After one week of rushing around I had lost eleven pounds. When Dolly Parton came up for a meeting, afterward, I got into the conference room as fast as I could, closed the door, shut the shades, and elbowed people out of the way to get to that chopped salad from Hillcrest.

KLANE: I didn't have a trust fund or anybody taking care of my shit. I'd come from running my own businesses, a place where I was king. That's probably why Ray Kurtzman once accused me of having a superiority complex. Maybe he was right. Corporate culture was completely foreign to me. I gather guys like Strickler, who'd gone to Harvard, were as fascinated by me as I was by them. But sometimes it felt to me like the whole place was Ivy League and their every move was planned out from birth: jobs, clubs, schools, associations. How I got in without a college degree is still a mystery to me.

WIMER: I was so overqualified that Ovitz didn't expect me to hang in. He got all the trainees together, and we went around the room, telling our backgrounds. Everyone else was local, most soft Beverly Hills kids. When I said "Harvard" and "Stanford" and "investment banking," no one seemed to mind, but after that I rarely brought it up. My education didn't seem relevant, unless I wanted to be thought of as a creep. I just stuck with being short and funny instead.

UFLAND: I immediately got all sorts of crap about my wardrobe. I didn't even own a tie. But when people complained, I said, "On nine hundred a month? You show me the money, and I'll buy the clothes." When I realized the salaries some of the MBAs and lawyers had given up to work there, I almost choked.

WILLIAMS: It's really hard for most people to understand what's so compelling about this business that someone like me would give up the law. It's a good question. I still ask it of myself every day, because there are days when I hate this business. I guess I just hated being a lawyer more. Yet there are also those moments when I've worked really hard for someone I believe is incredibly talented, and I see them achieve great things. Or the times when I sit in a theater, the lights go down, I see magic on the screen, and realize the power and the beauty of this medium and my part in making it happen. That's exciting.

SPENCER: I used to think they were crazy, giving up jobs in which they made four hundred thousand a year, for one that paid twenty-three thousand. But were they? *They just wanted to be in the movie business.* Going into the mailroom is like the romance of going off to war. It's only when you find yourself in battle every day that you realize that the romance is for shit. There's no such thing as romance when you're under heavy fire. You're just asking yourself, "What the hell am I doing here?"

DO IT RIGHT OR NOT AT ALL

JEANNE WILLIAMS: The person at the bottom of the mailroom had to do the grocery shopping. We'd go to the Ralph's grocery store in the Westside Pavillion early in the morning, and buy everything we needed for all the meetings that day. Because I lived in Orange County I'd have to get up at five, be on the road at five-thirty, get to Beverly Hills by six-thirty, do the shopping, and get to the office by seven. That was bad. Even worse, after I started there was a hiring freeze, and I was stuck. I was on the bottom of the mailroom for four months.

CHAVOUS: I had to go to I-'n-Joy Bagels and to the deli on Pico and Westwood to get the lox and cream cheese. Then to the market for fresh-squeezed orange juice and all the different kinds of milk. On

Fridays I'd add doughnuts. And there were special requests: Ron Meyer liked green apples.

GOLDMAN: I'm not the most domestic guy, but I thought I set a pretty nice conference room table on my first try. The head of the mailroom didn't agree. He said, "What's wrong with this sugar bowl?"

I looked at the bowl. "Nothing. It's clean."

"What's wrong with it?"

"Nothing."

"Wrong," he said. "The sugar has to be shaped like a nipple. Like a pyramid. That's the way they want it."

That's the mentality. You do things one way and one way only. Their way.

STRICKLER: Ron Meyer once said this to us, and I still say it to the trainees at my company: There are two kinds of guys in the mailroom. Here's how you tell the difference. I'll say, "Go get me a glass of water." One guy goes out and gets a glass of water. One guy goes out and puts exactly the right number of cubes in it, fills the water up to exactly the right level, cleans the spot off, gets a napkin, and makes sure he serves you the best glass of water you've ever had. That's the difference, and either you get that or you don't.

HAZING

CHAVOUS: We hazed one another all the time. Rosenfeld was always farting and waving the air at us. Ufland we called the Tasmanian Devil because he was so serious and intense about everything. Marc Wax was more laid back. We never thought he'd make it, because he was always so calm, whistling "Dixie" in his own world. I was the only black person in the mailroom, and I was very serious because I knew that all eyes were watching me.

UFLAND: Jon Klane was the laziest person I had ever met in my entire life. Now we have a great relationship, but in those days he drove me absolutely insane. His attitude was "Doody-doody-doo." The day a stack of scripts needed to be copied, Jon sat there stuffing his face with bagels, reading the trades. I said, "Are you going to do anything today?" We got into an argument, and I threw the scripts at him.

Strickler tormented me as well. Some nights I'd go home absolutely miserable because Tom was so incredibly intolerable. His whole existence was about how much grief he could throw at me and Klane. He used to razz us about our dads' movies; the high point of Tom's day was to say their movies were shit. Okay, so they wouldn't show them at Harvard.

KLANE: The best part of going up the mailroom ladder was fucking with the new guys or just watching them twist in the breeze. It helps to have a creative mind.

I made a new guy cry. I told him there was a special errand that needed his attention while he was on his regular run. "You've got a convertible, right?" He nodded. "Okay, good. You're going to need that today. Keep the top down. Do you have a towel in the car? No? Get yourself some towels, because these dogs drool."

He panicked. "What dogs?"

"Oh, Ronnie Meyer's Saint Bernards. You didn't know? Yeah, he's got three of them, and they need to go to the vet. Go out to Malibu, pick them up"—I'm making up this shit in my head, right?—"and while they're getting their treatment, right next door is the organic animal health-food store. Judy Ovitz's horse eats only organically grown alfalfa, okay? You're going to have to put two bales of that in your trunk. It won't be a problem. The Saint Bernards can sit in the backseat. Remember to use the towels, okay?"

His eyes got red. I said, "Hang in there, man, you can do this!" But he just started crying. Then everybody started laughing. I don't remember his name, only that he didn't last. In fact, he might have quit that day.

CHAVOUS: We all had our little quirks. One guy in the mailroom would always pull out his dick and wave it at me and Jane Berliner. Jane would be so offended; I would laugh hysterically. It was the best comedy I got all day. I also understood the motivation: He was stressed out! He was working eighteen-hour days. It got insane. I don't remember my quirk.

KRENTZMAN: Chavous would come into the office, pick up her skirt, wave it above her head, and say, "Just airing the kitty!"

MICHAEL EISNER, BIRTHDAY BOY

ROSENFELD: When Michael Ovitz threw a surprise birthday party for Michael Eisner, I got the call to help. The party was at Spago, at the height of Wolfgang Puck. Eisner had recently taken over Disney. On the guest list were Sue Mengers, Lew and Edie Wasserman, Ovitz, Ron Meyer, Bill Haber, Bernie Brillstein, Neil Diamond, Stanley Joffe, Sherry Lansing, Frank Price, Bob Daly, and many more of the top, top people from around the town. If we'd taken a picture, it would have been in *Vanity Fair*.

Ovitz said to me, "Okay, now gather everybody. Eisner's coming in a few minutes. Then a cake's going to be rolled in and Mickey Mouse will jump out. Mickey Mouse will start 'Happy Birthday.' "

I stood on a chair and spoke to the crowd. "Okay, everyone, Mr. Eisner's coming. He's coming!" I stepped down just as Eisner walked in and everyone yelled, "Surprise! Happy birthday!" The crowd began to move, and I got crammed in next to Neil Diamond, Eisner, and Ovitz. Everybody else faced them. The cake rolled in and a poor schmuck in a Mickey Mouse costume tried to jump out, but he got his leg caught, tumbled over, and the whole fake thing collapsed. Ovitz leaned over to me and said, "Mike, just start 'Happy Birthday.' " I guess he didn't want to bother asking Neil Diamond. But Neil and I exchanged looks, shrugged our shoulders, and started singing.

At that moment I knew I was in show business.

THE RUNS

ROSENFELD: Everyone's first job in the mailroom was delivering packages to all the studios and clients around the city. We called it "doing the runs." You got a clipboard, sorted your packages, wrote up your delivery route, and off you went. There was a morning run at ten-thirty and an afternoon run at three-thirty. You did two a day and had to be back from the first in time to do the second. Sometimes there were night runs. And believe me, you *actually* ran.

STRICKLER: Ovitz and Meyer liked to say that the messengers at CAA ran to deliver a package, and William Morris messengers walked.

WAX: I showed Strickler the runs. He had a new Toyota Tercel, and we got rear-ended by some fat guy in a Cadillac. We got a good case of whiplash, and Strickler screamed and yelled at the guy. We all drove crazy. I made U-turns in the middle of Century Park East. I crashed into some guy and ran out of the car yelling, "No harm, no foul!" and jammed off. I'm surprised none of us got killed out there.

ROMAN: Often I did my runs in shorts and a T-shirt. I was in an elevator at Universal with an armload of packages when my bosses, Ron Meyer and Michael Ovitz, got on. There were enough people around that they didn't see or recognize me. But at that moment I believe I came up with the concept of adult diapers.

WAX: When I'd deliver to Debra Winger's house in Malibu, she wouldn't open the door or she'd tell me to throw it over the fence. On the other hand, when I'd go out to Martin Sheen's on Point Dume, he was totally cool. He'd invite me in for a beer and introduce me to Emilio and Charlie, who, at that point, were just kids. He'd try and tip me, but we weren't supposed to take tips. I'd just take the beer and run.

ROBINSON: I had to deliver a typewriter to Bill Murray at an apartment building in Marina Del Rey. I was supposed to just drop it off and get back to the office, but when I started to leave, he said, "Where are you going?"

"I have to get back to the office."

"No, you don't."

"There's runs to do, copying to be done."

He shook his head and said, "No. You have to stay here and hang out with me."

I said, "But—"

"Trust me. If you tell them I made you stay here, no one's going to care."

We watched TV for a couple hours. He didn't touch the typewriter.

WILLIAMS: I had come back from the runs and saw Jay Moloney walking around the building with Bill Murray. Jay said hi and Bill said hi. I went back to the mailroom and two seconds later I got a phone call: "Come up to Jay's office." I went and Jay said, "Bill saw you and he thinks you're interesting. You're going to be his personal assistant when

he's in town. You're going to start now. Drop whatever you're doing. Your job today is to drive him around, all day and all night."

Some job: drive him to meetings, wait for him to come out.

Jay also said that when Bill was in town I was to stock his refrigerator at his hotel and do any personal errands he needed done. Jay put a spin on it, suggesting the exposure would be good for me.

I worked for Bill a couple times and that was it. He was nice. I think it all came down to this: he liked having company. He asked me what I thought of his movies; he asked me to read a script while I waited, and to tell him what I thought. He also offered four hundred dollars to buy myself something. I said, "No, no, no, no; no thank you; no, I don't want that." I didn't think it was the right thing to do.

BERLINER: Sam Elliott lived on the 33000 block of the Pacific Coast Highway. It is well past Zuma. Sometimes I had to go out there twice a day, which is why the address is still burned in my memory. Singed. Sam was a nice guy, but delivering to him was an ugly thing. Once, when my car broke down, I borrowed my brother's car without asking. While I was driving along PCH, it started to rain. The car had a hole in the convertible top. Then it got dark, but only one headlight worked. By the time I got to Sam Elliott's house, the brakes were almost out. I was afraid I'd die on the way back.

CHAVOUS: Jane's car would always break down. That meant one of us had to finish her run and another had to stay with her and get the car situation together so she could get back to the office. One day Rosenfeld and I had to rescue her. On the way we argued over who would stay with her and who would do the run. I said, "I'm not doing the rest of the fucking run."

"Oh, yes you are," he said. "I've been in the mailroom longer than you."

"Fuck that. I'm *not* doing the run!"

When we found Jane at Barrington and Sunset, she was crying, so we hung with her a little bit. Finally Rosie said, "What the fuck is wrong with your car?"

"I don't know. It won't start."

So she tried it again. *It started.* We immediately gave her shit: "Why don't you fucking take care of your car?" She finished the run that day.

BERLINER: Donna says my car *constantly* broke down. It broke down *twice.*

CHAVOUS: Jane was really sensitive. One time I screamed at her because she didn't want to do a night run. To hand a night run to a person who's been on the road all day is just cruel, but it had to be done. She said, "No, I'm not going to do this."

I said, "The fuck you're not going to do a night run. This is what you're fucking here to do." She broke into tears. I felt so terrible.

BERLINER: There were a couple of girls who came into the mailroom after me who wouldn't deliver when the sun went down, because they were terrified of being raped. It didn't occur to me. The only real drag, to be indelicate, was when you had feminine hygiene needs. You had to do things in the car you didn't want to talk about. So once a month things were different because I was a woman.

MY WORST DAY

WESTON: I was always frantic. I crashed my car twice. In the second accident I was coming down Queens Road in the Hollywood Hills. Jack Rapke's sister, Eileen, had given me a jacket to return to somebody, but the address was wrong. I sped down the hill in my little 280ZX, hit a patch of water, skidded about fifty feet, and smacked into a car with a Mexican grandmother, mother, and little kid inside. It wasn't a bad accident, but the grandmother banged her head. The little girl started crying her eyes out and screaming, "You killed my grandmother!" The mother was screaming at me in Spanish. The paramedics had to come.

I called the mailroom and said, "I just crashed for the second time in four weeks. Not only do you need to send someone out and finish the run, but I quit. This just isn't working. I hate this."

When I came back the whole agency knew what had happened. I had to see Ray. I tried to explain to him how nuts we were out on those runs. Ray tried to talk me out of it. He said everyone liked me. I got along with the agents and worked my ass off. But Ray also subscribed to the theory "If I did it, you can do it." Of course, Ray never had to do it. It's one of those things in life I wish I'd survived, but I just didn't. It wasn't for me. I didn't dig it.

In the end I actually caused some change because they added another

run. They split the town from three territories into four. And I haven't had an accident since I left the mailroom.

UFLAND: I had a package for Geffen Records. I parked on the north side of Sunset Boulevard, at Doheny, and crossed. The eastbound lanes were backed up. The first car let me go, but the next one began moving. I looked up. The driver saw me and stopped. I nodded and kept on walking, but the guy in the passenger seat opened his window and started yelling at me. I said, "Fuck you. Leave me alone." The next thing I knew, the guy jumped out of the car and smashed my head into the pavement. He was on top of me, in traffic, and the only way I could think to get him off was to pop him. I threw my elbow back and split his nose. He started bleeding all over me. I got up. My shirt was torn, I had scratches and bumps from hitting the pavement. I picked up my package and kept going. At Geffen Records they gave me some ice, then I got back in the car and finished the run.

BERLINER: My worst day was possibly the worst day of my life. It was hot as hell. My Volkswagen Beetle had no air-conditioning. And no radio. I was deeply into my ninth month of deliveries, driving down Burton Way in Beverly Hills, and the road was just packed. I wanted to change lanes, so I looked in my rearview mirror. There was a motorcycle way back, scooting between lanes. I had time, so I changed lanes. The motorcycle came up alongside of me, the driver turned to face me, and he hawked a gigantic, generation-old lugee through my open window and onto my face. Perfect target, perfect aim. Steam must have risen from my head, I was so angry, but there was nothing I could do. It was horrible. I was so demoralized. Not only was I physically exhausted—every day—but this guy had decided to give me a piece of his organs. At that moment I felt less than human.

However, from then on whenever I got really pissed at people's driving, I'd spit on them. I never hit them, and I never spit into an open window, but that guy *made me a spitter*. It's the most horrible thing you can do. Fortunately, I got over it. I don't spit anymore. But then—oh, boy . . .

THE WIVES

STRICKLER: Occasionally we had to pick up the partners' wives when they needed a ride. It was the political plum, the sought-after job. The fantasy was you'd talk to Judy Ovitz, then she'd get in the car with her husband and say, "I like that kid from the mailroom."

KLANE: Once, after somebody had smashed into my car and the passenger-side door wouldn't open, I was asked to pick up Judy Ovitz. I had to ask her to get in on my side and climb over. She did. Then she sniffed the air and said, "What is that?"

I said, "Gasoline. Don't smoke."

Next thing, Ray Kurtzman called me in and said, "Can you do something about your car?"

I said, "Hey, I make nine hundred dollars every two weeks, before taxes."

"Can't your dad help you out or something?"

"He was done helping me out when he gave me your phone number."

BERLINER: The first time I did a wife pickup, I was terrified she would say, "Never send that girl again; that car is a piece of crap." Instead the wives loved my '66 Beetle because they all remembered the boys they had necked with in the car when it was first out.

ROMAN: Whenever I had to pick up the wives, I always struggled with who I'd pick up first, because the other one would have to sit in the backseat, and I didn't have a four-door. Once, I said, "Hey, I'd be happy to sit in the backseat if one of you would like to drive," and there was deathly silence.

AN M. OVITZ MOMENT

STRICKLER: My first Christmas at CAA I had to deliver Ovitz's gifts. It took six or seven days, and the gifts were quite elaborate. I delivered a brand-new Sony television to Wolfgang Puck, an expensive stereo to Ovitz's litigator, an Exercycle to Bernie Brillstein's office. Neil Diamond got a pinball machine with all his songs on it. Typically you would go,

"This is from Mike Ovitz," and they'd say, "Oh, great—put it over there."

Very late one evening I got a gift basket and an address with someone's name I didn't recognize, an address far out in North Hollywood. I found the place in a very modest neighborhood. On a concrete pad in front of the house were two perfect Lincoln Town Cars. I realized this was Ovitz's driver.

I said, "Hi, I've got a delivery from Mike Ovitz," and I handed him the gift basket.

"Oh, that's great," he said. "Wow, that's so nice. Tell Mike thanks." Then he said, "Hold on a minute," and came back with a ten-dollar bill.

I said, "I can't do that. Mr. Ovitz wouldn't want me to take a tip." He insisted, but I wouldn't take it. On the drive back to the office I realized that I'd delivered to two hundred people, most of whom were multimillionaries, and nobody—*nobody*—offered to give me a tip except the *one guy* who probably couldn't afford to do it.

I was very moved. It was an O. Henry Christmas moment.

PRESSURE, PRESSURE, PRESSURE

STRICKLER: When CAA signed Michael Jackson, he was the biggest music star in the world. The company wanted to celebrate, so they arranged to get four hundred tickets to his stadium tour. A check for thousands and thousands of dollars was written to Avalon Attractions, the promoter of his Los Angeles show.

We handed the check to this new kid on the Valley run and told him to pick up the tickets. We stressed it was important. He'd been in the mailroom about a week, and already we could see him fraying at the edges. Plus, he was a weeper. If something went wrong, he'd say, "I can't believe this is happening! This is not right!" More than once we had to talk him down: "Don't worry. You'll get used to it." We tried camaraderie, but you could tell the guy was walking a real thin plank. The odds were against him.

The Valley run was a nightmare because it covered a huge amount of turf, from Westlake Village all the way along the Valley corridor to

the then-Columbia Pictures lot in Burbank. Adding to the pressure, our New York pouch left from Columbia at 5:30 P.M.

The kid's morning run began at ten-thirty. He came back late, hyperventilating, spritzing a little bit. I gave him a few minutes to compose himself, then gave him a big stack of packages and a check for $47,000. "Pick up the tickets," I said. "Bring them back. Be careful. Lock your car."

About six-thirty that night we got a call. The kid was on a pay phone on Ventura Boulevard. Crying. Screaming. He shouted, "I can't take it anymore! I'm not doing this. This is fucking crazy. I'm not doing this!"

I soothed him enough to ask the question uppermost in my mind: "Do you have the tickets?"

"Yes, I have the tickets."

"Well, why don't you come back to the office, drop off the tickets, and we'll have a conversation?" He refused.

I ran the mailroom, and I knew my head was on the line. The concert was the *next night,* and we still had to *send* out the tickets to all the important clients and buyers. Tom Cruise, for God's sake. Jon Klane said, "Keep him on the phone, and I'll go to him right now."

"Okay," I said, "but if you've ever driven fast in your life, this is the time." Meanwhile, on the phone, the kid began to get hostile: "Fuck you people! Fuck these people! I've never been treated so badly!"

I kept talking while Klane drove the fastest trip anyone's ever made to the Valley in rush-hour traffic. He picked up the packages and the tickets and saved the day.

No one else at CAA knew what had happened. We were too busy to tell the story. All I knew was that I had tickets by seven o'clock and I still had another six hundred packages to get out. At least it felt like that. I took a breath, and then it was, "Next."

To tell you the truth, the only thing we cared about were the frigging tickets. The kid never came back, just disappeared, but that wasn't unusual. He was just another guy down.

WIMER: He was also a knucklehead. He wore a big, thick knot in a really short tie, and he was the only guy who wore short-sleeved shirts. I once answered phones with him, and he had a seizure and swallowed his tongue. I had to pull it out of his throat. Another time, early in the morning, Kate Capshaw called in. You were supposed to just pass the call along, but he said, "Who's this? No! This is *Kate Capshaw?* I can't

believe it!" He went on and on. "I can't believe it's you!" I knew this guy was going to blow up.

UFLAND: One night a package had to get to the post office. It closed at five, and it was nearly that. I raced to my car, in the parking garage, but my pass card kept coming up as not valid. The attendant was new and didn't speak much English, and when I asked for his help, he just said, "This card is no good," and snapped it in half. I didn't have time to debate him. I thought, You break my card, I'm going to break your gate. So I drove my car right through the wooden gate arm. When I got back, people in the mailroom were smiling and laughing, except for Tom Strickler. He said, "Ray wants to see you."

By the time of our company retreat a few weeks later everyone had heard the story. People kept coming up to me and saying, "I can't tell you how many times I've wanted to do that."

ROBINSON: Tom Strickler was the only guy in Hollywood who ever made me cry. I'd been at CAA two months. I had friends, in from New York, coming to visit after work. Tom said, "You have to do a night run and deliver a gift."

I explained why I couldn't.

He said, "No. You're doing it." He was head of the mailroom, and he put the hammer down. I was so upset and angry that I cried.

The gift was an inflatable raft: an island with a palm tree in the middle. I had to blow it up and bring it to Mark Canton's house. Todd Margolis went with me. We stopped at the Chevron station on Sunset, near Nichols Canyon, and filled it with air. But then it wouldn't fit into the car because it was about nine feet in diameter. To get it to Canton's, we put it on the roof and I sat on the car window, my body outside, leaning over the roof to hold it. By the time we knocked on Canton's door, it was nine-thirty. Inside was a full-blown Hollywood party with all the usual suspects. We walked in like two morons, sweaty, disgusting, in our traditional mailroom outfits of tie, ratty slacks, and bad shoes, carrying a nine-foot island with a palm tree. Afterward there were more deliveries, and I never saw my friends.

STRICKLER: Wanting attention is good. Wanting it too much is not. Joey Plager, a guy behind me in the mailroom, was desperate.

David "Doc" O'Connor was Mike Ovitz's assistant. One day James Clavell's new novel came in. It was gigantic, about fifteen hundred pages. Clavell was a big author for CAA and an Ovitz client. Doc

approached Joey and said, "I want you to do the coverage on the new Clavell book." Joey was good at writing coverage, and it was an incredible opportunity because Ovitz would be reading it, which was his way of pretending to have read the book without actually reading it. That's the system with scripts, books, everything.

Joey said, "How many days do I have?"

It was a Monday. "You've got to get it done fast," Doc said.

Joey stayed home Tuesday and read. He worked on it Wednesday, all day long. He stayed up Wednesday night, typing and editing. After two nights without sleep he got it done. The book was so large that the coverage itself was fourteen pages. Basically, you wrote a page for every hundred pages.

On Thursday Joey gave the coverage to Doc, who said, "Great. Fabulous." He brought it to Ovitz later that day. Ovitz took it home, and the next morning talked to Doc. "David," he said. "The coverage is too long. Do coverage of the coverage."

Doc read the fourteen pages and distilled it down. Joey was crushed.

GOLDMAN: What's weird is that your life is such shit in the mailroom, but you still feel it's an honor to lock up the front door at 3 A.M. You should be thinking, It's fucking 3 A.M. and it's a Tuesday and I've got to be up in four hours to buy groceries for the company meetings tomorrow. Instead you feel it's amazing that these guys trust you with the keys. You're thrilled to be a fucking slave. Your reality and perception are extraordinarily narrow. It's almost like: God forbid you were not to have this piece-of-shit job, then your life would be worthless. It's like the red script covers are more valuable than any individual member of the company. Leaving CAA, whatever your position, was considered by them to be the end of your career, that you had failed.

THE SECRET OF MY SUCCESS

STRICKLER: At our corporate retreat I discovered on the first night that there was no *New York Times* at the hotel. It drove me nuts. I'd always been a big *Times* reader. Ovitz was, too, and the situation seemed to present an opportunity for me. I called distribution at the paper and asked where I could get it in Palm Springs. They said the airport at

6:30 A.M. The next day I got the paper, sat in the hotel courtyard, ordered breakfast, and started reading.

Just like magic, Mike Ovitz showed up. He nodded, sat down, and ordered breakfast. Eventually he glanced over again and saw what I was reading. "Is that the *New York Times*?"

"Yeah."

"Where did you get it?"

"Oh, at the airport this morning."

He came to my table and sat down. "Uh, can I, uh, read some of it?"

"Sure," I said. "Absolutely." He picked up the business section. We had what I'd call light conversation while he read, and had breakfast together.

The story would be great even if it just ended there. But there was a final beat. When I told Jack Rapke, he decided he had to let Ovitz know that it had been a setup, because Ovitz would really appreciate the fact that it had not been an accident. A week later Jack told me Ovitz loved it because *he* had been agented. Of course, Ovitz never mentioned it to me, ever.

KRENTZMAN: Every Saturday for about four months six of us would meet at my house and test one another with flash cards on CAA's clients. We had that kind of dedication because what we did was not a job, it was a way of life. Of course, you don't realize it's a way of life until you're in the middle of it. And once you're in the middle of it, you don't remember what it was like to have a life. A tornado is twisting around you, and you're in the eye of the storm.

WILLIAMS: They tell you to be prepared for a year in the mailroom. There weren't many exceptions, so there was no plan to get ahead. You just put in your time and hoped you didn't have to put in much more than that. I didn't see it as a game; I just realized what kind of girl I needed to be to survive. I observed the people the bosses liked and didn't like. Women fell into two camps: women they were interested in trying to date, and women who were buddies. They were more honest with and gave more information to the latter. That camaraderie gave me some insight into how the system worked. But I had to tolerate things that would have offended me before.

When you're black and have been in the environments I've been in, you become a chameleon. That's another whole discussion, about being black and being in these agency training programs. Very few have come

through. One reason is financial. Another is connections. Sometimes that has a racial face, but it's really about class. The mailroom is a great place to be if your parents can afford it. Many were rich, privileged kids who had nicer cars than some of the agents.

The racial part of it is complicated. It's tough because so much about being a middle-class black person, or from any ethnic group, is getting to a place where you don't have to push anybody's cart, where you don't have to be subservient, where you don't have to deliver packages. The whole reason you went to college and graduate school is to avoid that.

KLANE: In the beginning I didn't get the sense that it was competitive. But it was. There were two giant copy machines, as big as Buicks. If you were lucky enough to be in the office and not running around delivering packages, you copied scripts. Strickler and I would see who could copy the most without the machine jamming. We kept a Post-it inside with whoever had the record. You had to have a witness. I had the record.

Once, while copying a six-hundred-page book, I had a little competitive banter going with Kirk and Todd and said, "I'll bury you."

Someone snitched to Kurtzman that I had said "I'll bury you." He called me in and said, "This is the wrong attitude. You can't say that. These are the people you'll be working with throughout your career—if you make it here."

I went, "Whatever," and he accused me of having a superiority complex, because my reaction was dismissive. "Maybe the person who's accusing me of that actually has an *inferiority* complex," I said. "Have you considered that?" Kurtzman didn't like that too much.

• • •

Kurtzman got back at me when I was next in line to become head of the mailroom, by promoting Doug Robinson, who'd come in after me. I'm sure he thought I would quit, so I ran down to his office. I said, "How did you know?"

"How did I know what?"

"How did you know that I'd quit?"

He said, "Well, Jon, I have to do what I have to do."

But I didn't appear at all upset, which must have made him wonder. So I clued him in. "No, I'm serious, Ray. You're amazing. *If you had made me head of the mailroom, I would have quit. I'm not ready for that kind of responsibility.* You just amaze me."

In truth, there was no way I was going to quit, because I'd already invested a year of suffering. So I just totally fucked with him, looked him in the eye, and said, "You're amazing. I just want to shake your hand. Thank you."

It was like a chess game. Survival was the overriding object. And he knew it.

ROBINSON: I had no idea why Ray did it. I had not been a great self-promoter. I just believed in working hard and steady. Klane was a wild guy but also a hard worker.

Afterward I told Matt Loze, "Ray just jumped me and made me head of the mailroom. What do I say to Jon Klane?"

"Tell him to clean the kitchen," he said.

SHARON STONE'S BATHROBE
AND OTHER DISTRACTIONS

KRENTZMAN: There was a lot of sleeping around at the agency. In one another's offices, on the conference room table, in the mailroom when the offices closed. Trainees with agents, trainees with trainees, agents with agents, trainees with assistants. We all had a pretty active social life—and that was just inside the office.

There were suggestions of it outside as well.

Sharon Stone had an apartment on Camden Drive. Donna Chavous and Ron Meyer represented her. She wasn't *Sharon* yet, but she was a very attractive woman who had done a number of movies. Doug Robinson, head of the mailroom, said he had a special script that Sharon needed right away, and did anybody want to take it.

I'd delivered to her before, and Sharon and I had a little flirtation going. I volunteered. Doug looked at his watch and said, "She lives four blocks away. It should take you seven minutes."

I drove over. That took a minute and a half. I looked at my pager, debated a second, turned it off, and put it in the car.

I knocked on Sharon's door. She answered wearing a bathrobe: "Hey, Adam, how are you?"

"Oh, good."

"How's everything going? Want to come in?"

"Sure."

She made some cappuccino, and we talked while I weighed whether or not I should take the chance. I'd either sacrifice my job by being rejected and her calling Meyer, or I'd have a nice hour with Sharon. I think I probably got the signals but was too nervous to act. I was just a piece of shit in the mailroom.

After forty minutes I said I had to get back.

Robinson went berserk. Veins stood out on his neck, and saliva spit from his mouth. I said, "Hey, it was Sharon, what could I do?" I didn't say I had just sat there and had coffee. Two or three months later Chavous told me that Sharon had been into it. "You know, you blew your shot." I'd had an opportunity and missed it.

Later, when I got to know Ron Meyer, I realized that had I scored, he probably would have given me a raise.

BERLINER: I rang the doorbell of a home in Marina Del Rey, and the voice on the intercom asked, "Who is it?" I said, "CAA. Package." Then the door opened and there was this famous director—with nothing on. It was kind of staggering. I handed him the package and walked away. That was it. I didn't take the time to see if he was showing off.

KLANE: I brought a girl I'd met at the Red Onion in Beverly Hills up to the office. She'd said, "What do you do?" and I'd said, "Right now I'm making coffee, but pretty soon I'm going to be at the top, running Hollywood." I had no status, but I had the key to the office. We drove to Century City and rode up to the fourteenth floor. I fucked her on the Italian-marble conference table in the conference room. I had her ass right where Ovitz sat. The next morning, bleary eyed, as I'm refilling water glasses, there's Mike with his elbows on whatever we'd left behind. I thought, Life's good! From that point on, every staff meeting I ever set up or cleaned up after, or attended, had a special meaning for me.

GOD IS IN THE DETAILS

KLANE: One of the most sacred responsibilities was doing Ovitz's water. I got it after going off the runs. The routine was to get in very early and go into Ovitz's office. His was the corner suite with the shower. You

washed his water decanter—no soap, just hot water—and filled it with Evian water, but only from the full liter bottle, not the half liter. I still don't know the fucking difference, but the ritual was very specific. Monastic. I'm sure there was a Gregorian chant going on in my head: "The most sacred of jobs in the woooorld . . . MSOoooo . . . H$_2$Oooooo."

The water guy also had to refill Ovitz's candy dishes and stock his bar. If he was low on Glenfiddich, you'd make a note and have some ass-wipe in the mailroom pick it up on the run, as I did many times. Also Heineken, raw cashews, and Hershey's Kisses. You also checked the flowers. If petals had dropped, you'd want to pick them up and carry them out. You'd wipe down the bathroom counter and make sure there were no droplets. And, as it was passed on to me, when you were done you wanted to look at everything—take in the big picture—then walk out backward, stop, go back . . . and sit behind his desk and read everything. In Ovitz's office you felt like you were in the center of the universe.

Ovitz's desk was fascinating. He wrote notes on buck slips, with different-colored, very fine, razor-point felt-tip pens. You could read whom he was talking to, what deals were going down. Once I spilled water on the desk and all these things bled. I grabbed the Sharper Image air ionizer and went *bzzzzzzzzzz*, trying to dry off the paper. I could hear the clock ticking. I knew he would walk in any minute. I was convinced my career was over.

Later, I confessed to Ovitz's assistant, Doc O'Connor, and pleaded, "Please don't snitch on me." Then we had a good laugh. I asked him later if Ovitz had said anything. Yeah. "Who's the idiot who spilled water all over my desk?"

Doc had said, "I'll find out," and that was the last of it.

ROSENFELD: The attention to detail was the most important thing, and it made the biggest impression on me. The absurdity of putting raw cashews in the jar in Ovitz's office helps you prepare for the absurdity that you later encounter every day as an agent. It prepares you for the unbalance. It prepares you for anything that's crazy. In the mailroom you'd go, "Oh, my *God*. I have to go out to Malibu *again* today and deliver a *chocolate bunny* to Sam Elliott?" You just think that's crazy. But it prepares you for when some actor says, "I'm not taking this two-million-dollar deal unless my makeup person is taken care of."

People wonder if Ovitz intentionally set it up that way. I think as you grow older you naturally get more particular and more detail-oriented about your life. But I also think he liked the intimidation factor when a mailroom guy had to get everything right.

KLANE: For a while it seemed like I spent my weekends shopping for shit for the office. It was awful. Always on the list was toilet paper—Charmin—for Ovitz's bathroom. The first time I came back with the goods it wasn't long before Joel Roman came at me with a roll of toilet paper and said, "*What the fuck is this?*"

"It's toilet paper. It's Charmin. It's what you asked for."

"It's *yellow*. Yellow! You're supposed to buy *white* Charmin!"

I couldn't believe it. I'm sure Ovitz's asshole didn't care what color the toilet paper was, and he probably never would have complained. It's not like the door at the end of the hall where Ovitz always came out would fly open and Ovitz would slide out on the wood floor, with his pants around his ankles, holding a roll of yellow Charmin, screaming, "*Yel-looooooow!???*" like a wounded animal.

Eventually I passed on the job of caring for Ovitz's office to Kirk Torres. I told him that the last thing he had to do was take the *white* Charmin and wipe everything before he left. I walked him through the ritual, taking it very seriously. Then I said, "Now you want to check for flower petals, look around, walk out backward. You think you got it?"

He said, "Yeah, I think I do."

I said, "Good, let's go." We backed out and he threw the wadded-up Charmin on the carpet. I laughed so hard, my knees gave out and I hit the deck.

STRICKLER: One day Ovitz complained that his Hershey's Kisses had turned white, that we must have been buying the *wrong* Kisses. We hadn't. We just put them in the big jar and two days later he'd scream, "The chocolates are white!"

I thought it was too weird and I was sick of getting screamed at, so I called up Hershey's, in Pennsylvania, and said, "Listen, what's going on here?"

I got transferred to five people and eventually talked with someone in the product development group who said, "Tell me the environment they're in."

I said they were in a glass jar.

He said, "What's the lighting?"

"Incandescent spotlights."

"Oh, you have the greenhouse effect." He explained that because it was a glass jar and the chocolates had heated up by two or three degrees, the cocoa butter had come to the surface. He said if I opened the top of the glass jar, the problem would go away.

I wrote a memo to Doc O'Connor, explaining, then added: "Don't blame me for the chocolates turning white, it's your problem."

KLANE: Mike Ovitz was a superb leader. And smart. He knew the secret that great leadership is predicated on great followership. He knew how to pick people who needed that. It doesn't make them weak people or bad people, just people who can in some crucial way surrender themselves. They loved him. That's what love is: You surrender your identity and you rediscover yourself as part of a unit.

Ovitz made everybody feel special and just a little bit insecure at the same time. Ovitz's whole thing was "You are the chosen people and I am your magnanimous leader. You're all on a train. You don't know where that train is going, but that's not what's important. What's important is that you're on the train for a reason, because you've been selected, because you're the very best."

To me that implied, "Don't make waves. Don't fuck around. You could find yourself let off at the train's next stop."

NEXT STOP, LOSERVILLE

ANONYMOUS: The guy who had Jack Rapke's desk before Strickler made one of the great mistakes of all time.

One day he told me, "I gave Jack a present that he's really going to like."

"Oh, yeah?" I said. "What's that?"

He said, "I made him some special brownies."

Brownies? "Oh, that's nice."

"Yeah. I put a little marijuana in them."

"*What?* You're working for Jack Rapke, a fantastic desk, your relationship is very, very important—and you've just given him marijuana brownies?"

"We've talked about marijuana," he whined. "He's gonna love it. He'll love it!"

A couple days went by. Then he called me and said, "I need your help." Big surprise. "Jack called and I'm really scared. He said, 'Hey, uh, what was in those brownies, Mike?' I said, 'Well, Jack, in the note I gave you I kind of alluded to the fact that I put marijuana in them.'

" 'You put marijuana in them? My kids *ate* those brownies this morning!' "

KRENTZMAN: The grandmother had eaten them, too. Laurie Perlman, to whom Jack was married at the time, called Jack at the office and said his mom and the kids weren't feeling very well, that they'd thrown up and were a little dizzy. Jack left work and took them to the hospital, and it was tracked back to the brownies. I've never heard anybody scream and yell at a trainee like Jack did that afternoon.

ANONYMOUS: The kids had to get their stomachs pumped. Mike got moved to Mike Menchel's desk for about three months, then he was out of the agency. I don't know why they didn't fire him right away.

WIMER: He was such a knucklehead. Jack told me the story, but not with the moral being "So don't ever make marijuana brownies." It was more like "This is how stupid some people can be." Jack wasn't even angry as he told me. The truth is that Jack was trying to be groovy: "Hey, Mike, you're always having these parties. Next time you have one, invite me." That's pretty groovy. A little too groovy. I think it was Jack saying that kind of thing that got Mike to make him some brownies.

JACK RAPKE: Okay, here's the real story. It was 1982. Mike and I were talking one day and the subject got around to the sixties, the music, smoking pot. I might have been lamenting the sixties, about how great they were. It was one of those moments where you're in a reverie. The next thing I know, Michael came to my house and gave me some brownies. I said, "Thank you, Michael. This is really sweet of you. You didn't have to do that." I did think it was really nice, and not in a million years did I suspect a thing.

I didn't eat them that night. The next morning, I was in our little breakfast room at our house. My daughter was at the table, as was my wife, Laurie, and my son was in a high chair. Laurie said to my daughter, "Do you want a brownie?"

She said yes and took a bite. Then we gave a tiny bite to my son. He chewed for a second and then spit it out. It didn't make sense. Right away I grabbed the brownie from my son, looked at it closely, and said, "Laurie, there's grass in these brownies!"—as in "Get it away from my daughter!"

We called the pediatrician. He said, "How much did she eat?"

I said, "One little bite." He started to laugh and said, "It'll be okay."

Stories get exaggerated, but there was no trip to the hospital, no stomach pumping. There was, however, betrayal. If Mike had said he had made grass brownies, I would have said, "Take them back!" I didn't know what to do. I thought about it for two days. Would I give this guy a second chance? No, it was beyond that. I'm benevolent but I just couldn't live with that. I decided to fire him. If he was that stupid, I had to fire him.

OUT OF THE FRYING PAN, INTO THE FIRE

WILLIAMS: Ari Emanuel, who had started in the mailroom a few years before me and become an agent—he now runs Endeavor—took me aside. He had incredible energy and he interested me. He'd always been really nice to me and would always answer any questions I had. Plus, he was from Chicago, too. One day he said, "Keep your eyes open around here." He asked me a few questions about myself and then said to watch everything, so I did.

Then Ari left for InterTalent. Tom Strickler ended up there, too, after he was fired, and later partnered with Ari in Endeavor. Ari had been gone two weeks when he called me out of the blue, at home. He said, "I need to talk to you. You're smart, and they're wasting you in the mailroom. You're going to come to work over here. Bill Bloch needs an assistant, and I think he'd really like you. Would you talk to Bill on the phone?"

I spoke to Bill and he said, "Meet me." One night I left CAA early, at eight o'clock, to meet Bill at Love's Barbeque, on Pico. He picked the place, insisting nobody we knew would be there. He was right. After a fifteen-minute conversation about the business, and my experience, and

what I wanted to do, he said, "I want you to be my assistant. Go in tomorrow and quit."

The next day I told Ray Kurtzman I was leaving.

"What! What?" Ray flipped out on me. "Where are you going! What are you doing?"

I said, "I'm going to InterTalent."

"What!? Get out of the building! Now!"

STRICKLER: I was in the mailroom for a year and learned that the hot desks were Ron Meyer, Mike Ovitz, Bill Haber—the guys who ran the business. Also, the most powerful agents—Jack Rapke, Fred Specktor, and Rosalie Swedlin, though her desk wasn't perceived as *that* good because she was so tough.

I wanted to be in the Literary Department and got Rapke's desk.

Jack had great people skills and was a decent guy. He returned everybody's phone call. He was always gracious irrespective of whether they were powerful people or not. He also made me do a tremendous amount of reading, which was a good thing.

Rapke kept a running list, on a yellow pad, of everything I had to do: pick up the laundry, send this script out, do this coverage, retype the phone sheet. He'd add and subtract items, and every day I'd rewrite that list. Sometimes there'd be twenty-five tasks, sometimes twelve, occasionally only four or five. Toward the end of my tenure with him, all I wanted was to get the list down to nothing. It wasn't easy, but I kept my goal in mind; I called it "reaching ground zero."

The day I finally made it I had nothing to do for fifteen or twenty minutes. Then Jack came out and started adding tasks. I'll never forget laughing and thinking, That was it, never to return again.

WIMER: I probably got out of the mailroom because Ovitz liked that I'd gone to Harvard and Stanford. I was a potential weapon for him. He always asked about my business school contacts, and could I get him information on Kohlberg Kravis Roberts. He wanted a Rasputin to work side by side with him. But I decided early on that I wanted to be in the Literary Department. At that time, Jack Rapke was the best literary agent in the company. I got his attention by reading scripts for him. I made it my job to make sure there were never any scripts on his desk. I was diligent and my coverage was good, but he never said, "This is great." He followed the Ovitz model: It's not a friendly hug and "You're doing great work!" It's "I'm letting you into the power room," with the

subtext being to take that as acknowledgment enough. All I knew is that it felt like a step in the right direction.

Tom Strickler got promoted, and Jack took me on. I think he appreciated that Ovitz liked the fact that I was a Harvard guy, and Jack felt he would rise a little bit above by getting a Harvard guy on his desk. I loved Jack because he always aspired to be as clinical as Ovitz, as ruthless, as cold, as powerful, as fearsome. Yet he would never, ever be that person. Ovitz was heartless. Jack's a really sweet guy. It was funny, like seeing a guy in a suit that's one size too big. You can tell he really wants it to fit, that he really wants to look like Richard Gere, but it doesn't and he's not.

There was something likable about that.

MILLER: I had made friends with Mike Ovitz's assistant, Dan Adler, one night when I stayed late to help him with a mailing of maybe five hundred envelopes. Everyone else in the mailroom took a step backward when Dan asked for help. It made all the difference for me, because after only six months in the mailroom he got me onto Michael's desk as the next trainee.

• • •

Michael had been built up as an intimidating figure. My first meeting with him was scary. You don't know what to say, so you wait for him to talk. I had a quick in-the-hall meeting, not even a formal sit-down; he just didn't have time. I think Dan made the decision to pick me; I don't think Michael had anything to do with it. And nothing I did or said to him got me the job.

What I think Dan liked about me is that I was very meticulous about double-checking. He thought it was a good skill set for working with Michael. Dan is very careful himself. He told me I had to work around the clock, had to be on a beeper, would be at Michael's mercy. "Whatever you do, just fucking do it right."

Michael dealt with me fairly, but he was very demanding. The word "no" didn't exist. The word "excuse" didn't either. And if there's a problem, he wants a good explanation. I was scared shitless when the phone rang and it was him calling. He'd just say [briskly]: "What's going on? Who's called? Tell me everyone who's called." You couldn't chit-chat. There was no opportunity to ask him a question. He isn't a guy who wants to share. He'd just say, "Give me this person . . ."

Every Saturday I'd take the mail to the house and spend a fair

amount of time there. His wife, Judy, was great; she'd always offer something and talk to you. Michael was very businesslike and matter-of-fact. Wanted to get through it.

• • •

I got very involved in Michael's personal life. I had to help plan his son Christopher's eighth or ninth birthday party, which was going to be at Medieval Times, a jousting place in Anaheim. Thirty or so people were going, and Michael wanted to get a custom bus. My job was to track down a company that had one and would go to his house to pick up the people. I found a company, and Michael said, "I want to see them. Give me pictures." I had the buses come to the office and I took Polaroids. He said fine. It was all set for a couple of Sundays later.

Carrying one of those massive, first-generation cellular phones, I got to Mike's house about fifteen minutes before the buses, to supervise. I was afraid something would go wrong, but the buses showed up. It was a balmy afternoon. I got on a bus and thought it seemed hot. I told the driver, "It's hot on this bus. Can we have some air-conditioning?" He said the air-conditioning wasn't working. I panicked. "What? What do you mean, the air-conditioning isn't working? The air-conditioning has to work. I can't tell my boss that the air-conditioning isn't working."

I thought my life was over. I thought, Fuck! Of all things to go wrong, this is it. I asked if there were drinks on the bus and he said yes, absolutely, to look in the fridge. I did and found one sad Tab with sweat pouring off it. All I could think was, Fuck!

Michael was really pissed off at the bus company. We ended up cara-vanning down. I went with Judy and Jane Eisner in Judy's car. I was sure I'd had it. I'd blown it in front of Ron Meyer, in front of Michael. I had to sweat it out through the car ride down, through two hours of jousting and bad baked potatoes at Medieval Times, and the ride back. But Michael never said another word about it.

KLANE: In the "humble beginning" days, the founders were essentially TV agents and they had no Motion Picture Department. Wisely, they approached Marty Baum. This was the mid-seventies, and he had a nice little seventies-era group: Sydney Pollack, Peckinpah, Sidney Poitier, Blake Edwards, Peter Sellers, the Dereks.

But by the time I got there ten years later, Marty was a guy they just put up with. Sometimes he would fall asleep at meetings. But so what? He wasn't a team player in the way that Ovitz reinvented it with the

whole Oriental philosophy thing. He was an entrepreneur. He'd run a studio. He'd made *Cabaret* and *Straw Dogs* and *They Shoot Horses, Don't They?*

Marty had a reputation for killing assistants. There was a famous story—apocryphal, but still great—about an assistant who jumped out of a second-story window and broke his leg when Marty worked at ABC. Marty went to the window and said, "You putz. You can't even do *that* right!" Working for Marty was almost too hard, but some pretty well known people survived it: When Marty worked at GAC, Mike Medavoy and Sue Mengers both had his desk.

When I was in the mailroom, the guy working for Marty clearly wasn't going to last very long. He wore his pants way up above his waist, like an old man. We called him the Neck. He was somebody's kid and too old for the job. When the Neck took some personal time, Marty came into the mailroom and said gruffly, "Who wants to cover my desk? This putz just left me alone." Everybody got really busy . . . except me. I went, "Hey!" My attitude was, Anything to get out of here. The deal was to cover the desk for one week.

My week with Marty was hell.

When my time was up I walked into his office and stood at attention. He was sitting in a stupid-ass chair that massages you; it was some client's blow-job gift. I said, "Marty, I just want you to know that this has been the greatest week of my life. I've been waiting for an opportunity like this." In other words, I did with him what I'd done with everyone: blow smoke up their ass. He looked up, laughed, and said, "Thank you very much. What was your name again?" I wrote it down and gave it to him.

I knew the Neck wouldn't last long, and sure enough, two weeks later, the guy jumped out a window—figuratively. Marty told Ray Kurtzman, "Get me . . . get me . . . oh, God, get me the kid with the . . . uh . . ."

Ray Kurtzman gave me the news as if telling me that my family had just been killed by wild dogs. "Jon, um, I'm putting you on Marty Baum's desk. I think it's the thing to do." I don't think he knew I'd tried to engineer it.

I learned more don'ts than dos from Marty. He always got a lot of things done and performed no small number of miracles because he didn't know it was impossible to do those things. He was completely

naive in that way and different from most everybody at the company. They were mostly buttoned-up, corporate, and personality-free. Marty was bombastic. Out there. In your face. Marty's reputation as a screaming, infantile personality was real. But I loved it for the same reason: It was real.

Even though he was a little bit nuts, Marty had my respect immediately. He was a legend. He was the keynote speaker at every retreat. He was the guy who would deliver the color, and I'm pretty sure that's the main reason they kept him around. He was the éminence grise. He was so much larger than life that just by surviving his tirades, which were usually public, I'd gain stature. I was on that desk for a record three and a half years, and it was great.

• • •

I never did make it to agent at CAA, though. A year into working for Marty it was pretty obvious that my choice was either to work *for* him or inform on him. I could have used my perch there to trade information and power. Since my entrepreneurial spark had been reignited into a flame upon contact with Marty, there was never a question of choosing. Marty was an outsider. He was like an agency with an agency. Marty did fight for my promotion. He said, "This guy is great." But in hindsight that was the worst thing he could have done. I don't think it was ever in the cards for me to make it at CAA.

SPENCER: When Mike Rosenfeld got promoted to agent, Amy Grossman needed an assistant. Amy asked me to tell her about myself. Then she said, "Yes, but what do you bring to the party of life?" I'll never forget that question because I had no idea how to answer it. I tried something about being a hard worker, having common sense, blah, blah, blah. She said, "But what *extra* thing do you have?"

I said I could speak French.

I got the job.

I didn't know how much I wanted to be an agent until I'd worked for Amy. The first six months with her were the worst six months of my life. She was incredibly meticulous, pointed out every single mistake I made, and was right on every single thing, which really drove me nuts. I must have lost about fifteen pounds and I didn't sleep. Talk about anxiety. Every day I came to work I knew that something would be wrong and that I would get in trouble for it.

Then it changed. One weekend I read all the clients' scripts, knew

what she was reading, and read that, too, in case she asked. I knew where all the money was. I knew where all the clients were. I lay in bed that Sunday night, about eleven o'clock, and I suddenly realized I didn't have that Sunday night anxiety. From then on, working for Amy was great.

Well, almost. Amy had a producer client, Tom Kune, who was at the Cannes Film Festival. Amy said to get Tom at the Majestic. We were in her office, she at her desk, I on her really low, soft, uncomfortable couch. It was like *The Tonight Show,* where Jay Leno is always about three feet higher than anybody else. I called and said, "Hello, I'd like to speak to Mr. Tom Kune."

Amy interrupted and said, "Hang up the phone! Hang up the phone!" I hung up. She said, "You have to speak French!" I asked why, since they all speak English. "No. You have to speak French! You have to get him in French! I want to hear you speak French."

I dialed the number again and with a faux French accent said: "*Bonjour.* I would like to speak to Monsieur Tom Kune."

Amy barked, "Hang up the phone! Hang up the phone! You told me you could speak French!"

"Okay, I lied. I cannot speak French."

"You *lied* to me?"

"I lied to you."

"Why would you lie to me?"

"I wanted the fucking job, Amy. I didn't want to be in the mailroom anymore. They all speak English in France. I've been there, and they all speak English."

She fumed and laughed at the same time. I picked up the phone again and did Inspector Clouseau: "I would like to speak to Monsieur Kune."

"*Ah oui,* Monsieur Kune, I will get him right away." Thirty seconds later he was on the phone.

Amy did her business with Tom and I walked outside to my desk. When she hung up she yelled, "Martin, come back in here!"

I went in and she closed the door. "You lied to me! Don't ever lie to me again."

By that time she was laughing. I never lied to her again. And she didn't ask me to speak French, either.

BERLINER: People got desks pretty much by seniority. When Ron Meyer's desk opened up, there was, at the time, an edict: He did not take men as assistants, he took women. But not trainees. However, his assistant Suzanne told him, "You have to hire Jane, she's the only one who's ever gotten your food orders right."

The way to a man's heart, honey.

WAX: Todd Harris, who is now a producer at USA, was on Bill Haber's desk and getting ready to move on. Kevin Cooper had been there before him, and together they figured that since my dad was a TV agent I should work for Haber. In truth, they kind of bushwhacked me into it. They said I'd be great for the job, that Haber was a partner, that I'd move up fast. I thought it was a great way to get out and get in. I'd heard that Haber was a little out there, but, stuck in the mailroom, I really didn't know the truth or the extent of it.

At first I was really excited to be on the desk, thinking, I've got it made, I'm working for a partner. But Haber turned out to be an SOB. After four months either I was going to throw him out the window or he was going to do it to me. He hammered me every day. He loved to yell and scream and call me names. Maybe he thought it would be kind of fun to flick me shit after my dad had been above him at William Morris, but I got tired of the abuse. I figured the assistant thing was just like being a pledge: They yell for a while, but then they give you the keys and let you in. With Bill it never came full circle. I wanted to be his assistant, not his fucking whipping boy.

• • •

Ken Howard, who starred in *The White Shadow*, was in the office early one morning. He was good friends with Haber, who had helped him out over the years. Haber sent me to get a specific bouquet of flowers for Ken's wife. But it was 9 A.M. and not many flower shops were open, and the shop nearby was out of what he wanted. I figured it was better to bring back a general bouquet than no flowers at all.

Haber called me every name in the book, right in front of Howard. I stood there and took it. Later Haber went to Ray Kurtzman and said, "I can't deal with this guy anymore!" Of course, the feeling was mutual. Even the other agents would roll their eyes when he screamed, like, "You poor bastard."

I moved to Rowland Perkins's desk. Haber would walk by and not

say anything. Just to bug him, I'd say, "Hey, Bill, how ya doin'?" Perkins had a lot of power but was more relaxed. I handled his desk with no problem.

I never became an agent at CAA. After a Palm Springs retreat, Rowland brought me into the office and said, "Well, it doesn't look like it's going to work out."

I said, "Why?" I did everything I was supposed to on Rowland's desk. Then it hit me: "Man, I never should have gone on Haber's desk." Rowland nodded. I said, "Fine, I'm outta here."

UFLAND: Bill Haber did one of the greatest things ever when I was an assistant. He invited the trainees and agents in the TV department on a secret trip for a weekend, to celebrate a terrific pilot season. We all showed up and got on a waiting bus, but Haber was nowhere to be found. As we drove down Santa Monica Boulevard to the 405, everyone tried to guess where we were going. We wound up at the Santa Monica airport. Three private jets waited on the runway. We boarded. They were fully loaded with food and booze. We took off with still no idea of our destination. An hour later we landed in San Francisco and were met by limos, again fully stocked, and then taken to the Fairmont Hotel, where we all got little bags full of chocolate and cheese and wine and shirts, and itineraries. There were also hooded sweatshirts that had "AL" in big black letters, and the CAA logo, and "TRAZ": ALCAA-TRAZ. Also a CAA watch.

The itinerary read: meet in lobby, go to secret place. Meet in lobby, go to secret place. With times noted. We met in the lobby and marched all the way down to the wharf, where Haber had chartered a boat, again stocked with food and booze, and took it to Alacatraz for a great private tour. On the boat ride back to the mainland, we realized that Jack Rapke's sister, Eileen, was left behind. She had to get another boat.

At the wharf we walked through all the different tourist shops. Then we separated into smaller groups. Me, Haber, Abby Adams, Leigh Brillstein, and some others walked into a record-your-own-song booth and did an a capella "New York, New York." We got the tape, bought a boom box, went back to the hotel, got ready for dinner. Later we met in front of the hotel and Haber marched us down the hill—all the women were wearing pumps—to a McDonald's at the bottom. We cut through—in one door and out the other—and across the street was a five-star Japanese restaurant. Got a private room. Had an unbelievable

meal of I don't know how many courses. Of course, there was booze, booze, booze. And a competition. Each table had to come up with a joke, and the table with the funniest joke would win the prize. I remember watching Leigh and Abby get up and leave the room. I followed them out. They'd found a guy whose name was Bob. He was from Nebraska and there on vacation with his wife and kids. Their plan was to have Bob tell the joke.

After dinner, thirty of us piled into cabs and went to an underground club called DV8 (Deviate). Another guy and I went up to the door and said we were from CAA, and they said, "Oh yeah, we know people from your music department. They book bands here all the time. Come on in." We danced all night and the next morning took limos back to the airport, flew back in the jets, and recovered before we had to go to work on Monday.

I never became an agent at CAA, either. After I decided to go I had a very nice conversation with Ron Meyer, and I sent Haber a memo, thanking him. He sent it back with a hand-scrawled "See me, end of day. Haber." That evening I walked into Haber's office. Closed the door. We stood face-to-face. Then he told me about me from his and his son's perspective—Mark was a mailroom summer camper. "My son thinks you're one of the smartest blah, blah, blah . . . but I think you're a very off-center human being and . . ." As he talked I looked down and saw the man was wearing Mickey Mouse slippers. And he called *me* off-center.

GOLDMAN: I wanted to work on Mike Marcus's desk. I ended up with Mike Menchel. I learned from him to be comfortable in my own skin without giving up being effective. He didn't come out of Harvard with an MBA or law degree. He was just a regular guy who became successful and did it on his own. But I was so caught up in achieving and working and making the grade that I never stepped out of my skin and asked myself if being an agent is what I really wanted.

While jogging one morning a car hit me. I went to the emergency room and my ankle was shattered, and yet I freaked out about what would happen at my desk that day. I showed up at the office, straight from the hospital, on painkillers, on crutches—and found some secretary doing my job and everything was fine. I realized that no matter how indispensable I believed I was, I was entirely replaceable. It was a horrible moment. I wanted to have a lot more impact. If I got hit by a car, I wanted someone's life besides mine to be affected.

I left CAA a month later and went to InterTalent.

CHAVOUS: I wanted to work in Talent, and Paula Wagner's desk opened up. It was scary. Paula's reputation was that she did not take any shit. Paula had gone through so many assistants, it was a joke around the office. On the back door of the mailroom were two fuzzy cotton balls stuck up with a pin, and a note that read: "These will be your balls if you get on Paula Wagner's desk."

I was a pretty ballsy kid, but I walked into her office and sat there freaked out of my mind, thinking about how all the guys had teased me, while she made phone calls. Then Paula said coolly, "Well, Donna, so, you're going to be on my desk."

I said, "Yes. I've heard that you can be a bitch, but I think that I can handle it."

She looked at me. "Excuse me?"

I said, "Well, yeah, that's, uh, what I've heard. But I think I can do a good job for you and I'm looking forward to being on the desk." Meanwhile, I'm thinking, Holy shit. I'm screwed.

Turns out, it gave her the sense that I might make it.

Within the first week I wanted to change desks. My predecessor, Kathy Anderson, who had trained me and then floated to another desk down the hall so I could do things on my own, checked in on me one day and saw the look of sheer terror in my eyes. Kathy went around the corner and started crying. Later she told me she'd thought: I don't think Donna is going to make it. I'll have to go back and I'll never be able to leave!

The interaction between me and Paula was riotous. I was stubborn and determined, and so was she. What Paula really wanted was for me to sit in her office with my phone book, at the telephone, all day long. I knew I'd never get any work done like that, so I'd do my best to stay at my desk. When she wanted me she would yell, "Donna? Donna?" You could hear her around the corner. I'd say, "Yass, Miss Paula." She hated that. "Donna, what are you doing calling me Miss Paula? I don't like that very much. What exactly does that mean?"

Then I started with "Yes'm, Missus Paula," and I found a plastic ball and chain. I'd put it on my leg, and anytime she called me, I'd drag my leg into the office and say, "Yes'm, Missus Paula?" The whole hallway would be in tears.

• • •

When Paula was happy with me she bought me lunch and talked to me about what it was like coming up as an agent. She truly trained me. She taught me how to speak on the telephone. About poise. About dressing. She also explained that it's tough being a woman and that you have to work a little bit harder than the men, and that the price is often being perceived as a bitch.

• • •

One afternoon Ovitz called me into his office and asked me to sit down. "We're really happy with you here," he said. "We'd like to promote you. You'll still be working for Paula until we get you an office. We'll figure out a way to get you some clients. You'll probably be servicing and working from within, but it's going to be great and you're going to be great." That's all he said. *Boom.* It took about five minutes.

That's the thing that makes me really crazy about this town: You work, you do the mailroom, you get your ass kicked on a desk, and then what's the big shebang? Five minutes in somebody's office listening to them say, "We've made you, baby!"

• • •

MIKE ROSENFELD JR. is a television packaging agent at CAA.

JOEL ROMAN is the vice president, Soundtrack Department, at William Morris.

TOM STRICKLER is a founding partner of Endeavor.

DONNA CHAVOUS is a personal manager who runs her own company, Undercover Entertainment. She also coproduced the film *The Wash,* starring Snoop Dogg and Dr. Dre.

MARC WAX is the owner of the Wax Agency and handles talent for television and motion pictures, writers, and directors.

JANE BERLINER recently left CAA to become head of production at Handprint Entertainment.

JON KLANE owns the Jon Klane Agency in Beverly Hills, a motion picture and television literary agency. He is both president and an agent representing writers and directors.

JOHN UFLAND is head of the Literary Department at Don Buchwald and Associates.

MARTIN SPENCER is a literary agent with CAA.

DOUG ROBINSON is a producer with Adam Sandler's Happy Madison Productions.

MICHAEL WIMER is a motion picture literary agent and partner at CAA.

ADAM KRENTZMAN is an agent at CAA working in international film financing and packaging.

BRAD WESTON is copresident of Dimension Films.

TED MILLER is an agent at CAA.

MICHAEL GOLDMAN is a partner and producer at Tollin/Robbins.

JEANNE WILLIAMS is a motion picture literary agent at CAA.

AS THE MAILROOM TURNS

OUTPOST ON SIXTH AVENUE

William Morris Agency, New York, 1981–1986

**KEVIN HUVANE, 1981 • MIKE MENDELSOHN, 1984 • ADAM ISAACS, 1984 •
ADAM BERKOWITZ, 1984 • GERRY HARRINGTON, 1985 • STEPHEN SANDS, 1985 •
MICHAEL GRUBER, 1985 • MERYL POSTER, 1986**

*At the time, there was no other major agency in New York. To
the uninformed—like I was when I started—William Morris
could act like they were* the *place. William Morris in New York
was about their office like the British are about their country.
"Forget these upstarts. We're William Morris. We've got a
hundred years of tradition." But it was a sinking ship.*
—Gerry Harrington

KEVIN HUVANE: I grew up in New York City. I went to Regis High, a
Jesuit school where I guess they were training nice young Catholic men
to be doctors or lawyers or on Wall Street. But they also had a huge arts
program. I took a class called "Theater in New York," and every week
we went to see something different. I loved the theater.

In high school and college I worked summers at the Wyndham Ho-
tel, on Fifty-eighth Street. It's a great place where many actors stayed
long-term. Hume Cronyn and Jessica Tandy lived there. Henry Fonda,
Laurence Olivier, Peter Falk, Ben Gazarra. Milton Goldman, the great
ICM theater agent who represented Meryl Streep, lived there for a time.
The hotel was warm and personal, like a family.

As the elevator operator and bellman, I was in the lift every day with
a legend, and I talked to everybody. Martin Sheen gave me tickets to see
him in *Death of a Salesman*. Diana Rigg gave me tickets to *The Misan-
thrope*. The Cronyns always gave me tickets to whatever they were in.
John Cassavetes, who lived there when he and his wife, Gena Row-
lands, were filming *Gloria*, invited me to the set. He even sent a produc-
tion car.

In college I worked at the hotel as the owner's assistant. One day a
star complained about his suite. After I talked him into taking another
suite, a woman I didn't know walked up and said, "You should be an
agent." Her name was Cynthia Freeman. She was the Jewish Barbara

Cartland and wrote books like *Come Pour the Wine*. She lived in San Francisco but was doing research in New York and staying monthly at the hotel. That night she went out to dinner with Nat and Sally Lefkowitz, from William Morris. The next day I got a call from his office. Lefkowitz said, "I hear you want to be an agent."

I said, "Yeah, sure, thank you," and hung up. I thought it was a joke. I guess he could tell because he sent me a note that afternoon: "It's not a joke. Cynthia Freeman is one of my wife's closest friends and she said you'd be a great agent. Why don't you come in and talk to me?"

I started at William Morris on St. Patty's Day, 1981. Being an Irish American, I thought that was a good-luck sign.

ADAM ISAACS: I always wanted to act, and when I graduated from Harvard I decided to pursue it as a career. I moved from Manhattan to Los Angeles and lived with Tom Strickler, my best friend from college. He was in the CAA mailroom.

It soon became clear that acting was a bad idea; the life just wasn't for me. I didn't like feeling I wasn't the master of my own destiny. One Saturday Strickler sat me down and said, "You're smart, you're great—why are you doing this?" Within a day and a half I had booked a flight back to New York with the intention of becoming an agent.

People wonder why I didn't just ask Tom to get me into CAA. Simple: That was his place—and it sounded awful. Some nights Tom came home in tears.

Stuart Griffen's aunt who worked at William Morris, as well as my former personal manager, who knew Robert Gottlieb, helped me get an interview at William Morris with Ed Khouri. But Khouri thought that because I'd gone to Harvard my ego would be too big to push the mail cart. I said his reasoning was ridiculous: "So what are you going to do? Hire somebody from Ed and Fred's College just because you think their ego *can* handle it?" I really wanted the job and nothing they could throw at me would scare me.

GERRY HARRINGTON: I was never very career-minded and had no dreams about being in show business. After college at Georgetown, I went to Europe for a couple of months, then figured I'd work on Wall Street. I took a job as a stock analyst at Value Line. After two weeks I hated it, so I quit.

My best friend then—and we're still close—was James Spader, the actor. He'd done a couple of small movies and been signed by William

Morris. We were walking down Madison Avenue and went into a store that sold Italian-designed gabardine gangster suits for nine hundred dollars. We both wanted to buy one; only Jimmy could afford it.

He said, "Johnnie Planko"—a big William Morris agent—"can walk in here and buy twenty of these suits anytime. You're perfect for that business. Why are these guys becoming gazillionaires and you can't even buy a suit? You've got to go to fucking William Morris and become an agent."

Spader called his agent, a very sweet woman named Katie Rothaker, and told her about me. She explained there was a six-month wait to get in, but she agreed to arrange an interview with Ed Khouri. She also told Spader to tell me to schedule my interview in the morning because Khouri, a mild, unassuming clerical sort, was much less receptive after lunchtime. I called Khouri, and sure enough, he said, "Do you want to come in tomorrow afternoon?"

"I'm not free in the afternoon," I lied. "I'll come in the morning."

When I did, as expected, Khouri said, "We don't have any openings for six months. Will you hang loose until then?"

"I can't," I said. "I appreciate it, but I need to start earning money. I need to get on a career path." I shook his hand and left.

By the time I got home to Bronxville, forty minutes on the train, I had a message: "Can you start tomorrow?" The waiting period had been bullshit, a way to separate the men from the boys.

MERYL POSTER: As a sophomore at Tulane, I was in a program called Directions that brought in speakers. I was hospitality chairman, which gives you an indication of my personality. One speaker was Alexander Haig. He came to dinner at the university president's home, and I was seated next to his aide, Woody Goldberg. We talked for a bit and then he asked what I'd be doing when I finished school. Woody said, "I think you'd make a terrific agent. I know someone at William Morris. I can put you in touch with her and maybe you can work there during the summer."

He gave me Carol Bruckner's number. She ran the speakers bureau. She told me that William Morris had already filled their summer jobs, but I should stay in touch.

That summer I studied at Lee Strasberg, and then I called Ruthanne Cionne, head of Personnel at William Morris, to ask if I could have an informational interview. It wasn't normally that easy, but as she was

new, she accommodated me. She told me that I was very nice, but to be honest, their summer hires were the children of William Morris employees or were otherwise connected. "But stay in touch," she said.

I went to Europe and sent her postcards from London, Scotland, Ireland. I came home for Christmas and saw her. Nothing was available but, again, stay in touch. I studied in Florence and sent postcards. I called that summer and still nothing was available.

I didn't give up. At Christmas break during my senior year I went to see Ruthanne. She said she'd love to give me a job when I graduated from college.

She had me meet Ed Khouri. He liked me but said I really needed some pull to get in. I asked my parents, "Don't you know *anyone?*"

Amazingly, they came up with this: The cantor of my temple, the Fort Lee Jewish Center, was good friends with Lee Solomon, from William Morris. The cantor put me in touch with Lee. We had a five-second meet. I got the job.

ADAM BERKOWITZ: My father's first cousin, Nat Lefkowitz, was the president of William Morris. At a family function, he and his wife, Sally, said, "You should work in the mailroom." I was still in high school. I didn't know what the mailroom was. I thought William Morris was an advertising agency. Nat told me he'd started in his early twenties. At first he didn't get the job, so he went around the corner and shined his shoes, then came back and met with someone else, who hired him. He'd worked his way up and had been there over fifty years. He still came in every Saturday and believed that hard work would make you successful. It was quite inspirational. I made an appointment to speak to Ed Khouri.

Khouri kept me waiting about thirty-five minutes, then said, "It's very hard to get into the mailroom. Very few people do it. It's a grungy job. And we won't know until the beginning of June if there's a place for you."

I needed to know much sooner. Khouri scanned my application and said, "I see you were referred by Mr. Lefkowitz. How do you know him?"

I said, "He's my cousin."

Khouri said, "So, let us know when you want to start working."

That was my first lesson about how the business works.

MIKE MENDELSOHN: I wanted to go to law school. A woman I worked

with three days a week teaching learning-handicapped children how to read recommended me to her husband, a Harvard law graduate in the litigation department of Henry Bushkin's firm. Their clients included Johnny Carson, John Travolta, Bill Cosby, Olivia de Havilland, Cheap Trick, Foreigner. I was sixteen. They gave me a job in their mailroom. It paid four dollars an hour. I remember making several copies of Johnny Carson's new deal with NBC. But ultimately the job did not make me want to be a lawyer. The deal makers were rarely in the office, but the regular lawyer was in the office from morning till night. He did not have a wonderful lifestyle. He was constantly under the pressure of putting out more and more paper.

Instead I moved to New York and ended up at Salomon Brothers. The lady on my right made nearly half a million bucks a year. She was single. I asked if she'd gone to any concerts or movies. No, she never left the office. Any cool restaurants? Not really; she ate in. The guy on my left was twenty-eight and pulling down a million a year. I said, "Going to any ball games?" No. "Got any chicks you're fucking?" "No. I don't really get out much."

I went into the managing director's office and quit.

Show business seemed interesting. I'd interned for Jonathan Dolgen at Paramount one summer after college, so I applied at the talent agencies. Also at MGM Home Video. Rather than give me an executive position, they asked me how I would feel about standing on a street corner in Manhattan, doing surveys on what movies people would like to see. I could get a clipboard and a pencil sharpener, and they'd have a position for me right away. Fortunately, William Morris gave me a job.

MICHAEL GRUBER: My father is a toy manufacturer and my mom a theater fan. We went to musicals and the opera. Once I met Ben Vereen backstage. I grew up in New York; went to college in Maryland; moved to Colorado after graduation, skied, and tended bar. When I came back to New York I applied for three jobs: at Shearson Lehman, Levi Strauss, and William Morris.

It turned out that Ed Khouri had been in the same fraternity as me, only at a different college. I thought having something in common would help.

Khouri said I seemed like a great kid but I wasn't getting in because he had twenty applications to fill two slots that month. I said, "Great. I don't care to be on a list or in competition. As far as I'm concerned, if

you want me, great. And if you don't, maybe it's not the right thing for me." I said it in a nice way.

Next I met with Alan Kanoff, who was in charge of hiring. He asked about my skills. I said I was smart about many things, but my only skill was bartending—which meant I knew how to listen to people and make them comfortable and want to come back for more. I thought I could do that at William Morris, too.

STEPHEN SANDS: I grew up in Manhattan and went to the University of Michigan, in Ann Arbor. I started out as an economics major, then took a psychopathology class and became a psychology major. I also ran the concert committee at school, and every Thursday we put on a show for a different population—Deadheads, jazz buffs, African Americans.

When I graduated I didn't see the connection between my major and business. I called up William Morris in New York—I'd heard through a friend of my father's that they had a training program—and the receptionist said, "Thanks, we're busy."

I said, "No, you can't hang up."

The woman said, "Why?"

I said, "Because I'd be good for you."

"Oh, really? What's your name? I'll see if we can squeeze you in."

Ed Khouri was a character. He kept me waiting, and when I finally met with him he called me the wrong name. He said he'd just come from a lunchtime appointment at the dentist's office and his tooth hurt. I'd come in full of enthusiasm, with my posters from all the concerts I'd promoted. He said, "Listen, I've had a bad day. You have the job. Start anytime."

It was late spring. I thought I'd wait until after Labor Day. Two weeks later he called and said there was an opening, so I had to come in right away.

AT LEAST YOU'RE DRIVING A JAGUAR

HARRINGTON: The hours were nine to six. We even punched a time clock. The mailroom looked like a set from *Barney Miller* or *Taxi:* a very run-down, blue-collar New York office building utility room with glazed

green industrial paint chipping off the walls. Linoleum floor. Outside the window was a wall and a fire escape on the building next door.

ISAACS: I stood in front of a huge wall of mailboxes trying to learn whose box was whose. It quickly became second nature. So did the realization that I would have to take the word *no* out of my vocabulary. I'd gone from Harvard to sharpening pencils and shit work. But it didn't scare me. I believed good work leads to good work.

SANDS: Roberto Tamayo ran the mailroom. He was a strong, virile Latin man who was also a rough-and-tumble soccer player. He fought hard for his trainees and ran an efficient place.

GRUBER: Roberto Tamayo set us on our path and always put us in our place: "Hey, college boy. Remember you're not better than anybody. Treat people with respect no matter who they are." We admired him. He didn't care what anyone else in the company did, he just cared about how he did his job.

Roberto also knew my scam, which was to get out quickly at the end of the day. As punishment for something I pulled, he gave me twenty-five packages and said, "Here's your day. Deliver these."

I said, "But we have a messenger service." It would have taken me twelve hours. I said, "Are you sure you want to do this to me?"

"Yes," he said. "Last straw. Do this."

I took the packages, walked around the corner to a buddy of mine who owned a messenger service, dropped them there, and took the day off.

HARRINGTON: The mailroom was like a bullpen. You got dispatched to do whatever ludicrous adventure the day held in store. One agent used to send me with a subway token out to Jersey, to the hinterlands, two hours away, to drive his Jag back because it was cheaper to get the car fixed out there than anywhere near Manhattan. That was a typical day. Just stupid, humiliating, idiotic work.

BERKOWITZ: One trainee had to drive an agent's white poodle to East Hampton in the agent's Jaguar, then take the train back to New York City.

HARRINGTON: The pay was twelve grand a year, gross. But I looked at it this way: If I went to law school, I'd have to *pay* money for four years. At William Morris I got money to go to school, so to speak. But I soon realized that getting in the door was no guarantee of anything other than twelve grand a year.

BERKOWITZ: It wasn't easy being broke in Manhattan. I shared a one-bedroom apartment with a guy I didn't know. It was incredibly awkward, especially if someone had a girl over. He was a First Boston analyst, making forty thousand dollars. I had to struggle for everything *and* eat his leftover Chinese food. I packed my lunch every day for work, and I couldn't take a cab.

For extra money, I was a waiter at a club during prom season. I'd work until three in the morning and make several hundred dollars in tips. I also worked late at night at the office, chauffeuring the executives around in their Jaguars. A couple of times after I dropped them off I used their cars to pick up passengers and take them around New York City.

HARRINGTON: One of the senior agents unfortunately didn't care for anybody but himself. I was his second assistant for a while. Every so often this guy would make me leave the office, go to his apartment in some shitty little building five blocks away, pick up his wife, come back to the office in his Jaguar, drive four blocks to the 21 Club, and sit outside while they ate. *But not in the car.* He took the keys and I'd have to cool my heels on the sidewalk, because he didn't want to waste gas keeping the car running and warm. Sometimes he sat inside for three or four hours in the middle of the day. I'd stand outside thinking, What am I going to tell my father when he says, "What are you doing there? And by the way, *you're not making any money!*"

ISAACS: The job was the ultimate in ego sublimation, but I was good at it, and it came in handy when I had to chauffeur the president's wife in the company limo around midtown while she went shopping. Driving a stretch limo in Manhattan in the afternoon is like driving a bus during rush hour. Then I'd put her bags in the car, take her to Le Cirque, and wait. There I was, with my little blue blazer and my khakis and my tie, standing outside, smoking cigarettes with the other chauffeurs in their livery. And I thought I was supposed to be training for something.

HUVANE: I drove once and only once. And then, in front of Roberto Tamayo, I ripped up my license. "See this license?" *Rip.* "I don't have a license anymore. I'm never driving any of these people again—do you understand that?" Roberto was a sweet guy, but I did it because one of the board members' wives made me drive her car around Bergdorf's

constantly while she shopped, and then yelled at me because I was at the wrong entrance to pick her up.

WHAT GOES AROUND . . .

HUVANE: A great thing about the New York mailroom was that we rarely made deliveries. But sometimes on crazy days there was overflow and we had to help out.

It was August, one of those days when the humidity matched the temperature. If you walked two blocks, you were gone. I had three packages. My last delivery was at the Plaza, and I was ten minutes late. When I walked in, the client—I'd mention her name, but she still works occasionally—was incensed and wanted me fired. She said, "Stand there," like I was a little Rottweiler. She picked up the phone, called William Morris, and said, "This . . . this . . ."—she waved at me, and I said, "Kevin Huvane"—"I have a Kevin Huvane here," like there were *many* Kevin Huvanes and she had just one of them. She said, "He's made me late, and I would like you to do something about this." Then she hung up the phone and said, "You can go now."

I walked back to the office thinking, I'm making two hundred bucks a week and I'm going to get fired because this actress was in a bad mood?

We had time cards at the office, like the Flintstones used. There was a note on my card: "Please see Ed Khouri."

Ed said, "I heard you were late."

I said, "Please don't fire me. I had three packages and I didn't mean to be late."

"Stop worrying," he said. "It's okay. She complains about everybody."

Fifteen years later, this actress and I were both at a big dinner, sitting around the table. She looked at me and then asked somebody next to her, "Who's that?"

"Kevin Huvane. He's at CAA." And then I heard my clients being named.

She came over and sweetly said, "Kevin, we've met before, haven't we?"

"You better believe we have," I said. Then I reminded her—and

everybody else at the table—how she'd treated me. She was shocked and astounded. I'm not sure she believed it really had happened, but, as a twenty-one-year-old kid, you never forget the pit in your stomach after something like that.

IT'S TODDY'S WORLD AND WE JUST LIVE IN IT

ISAACS: Toddy Armhouse was the receptionist on the thirty-third floor. She was in her eighties, an unbelievably crabby, amazing, terrifying woman who'd been there forever and knew everybody. Toddy was really savvy. You couldn't chat her up. She either liked you or she didn't.

HUVANE: She was a tough cookie, a great New York character. She always had a cigarette. Her husband, a dentist, was Abe Lastfogel's wife's brother. When she had trouble with her eyesight and had an operation, I was assigned to walk her home every day.

I didn't know who she was at first. But once David Geffen got off an elevator right in front of us and he shouted, "Toddy! Toddy, how are you?" I knew who *he* was, obviously.

She said, "David Geffen, you son of a bitch. How are *you?*" I thought it was hysterical. She used to tell me stories about Geffen, for whom she had a soft spot. She'd always say he was "hot stuff." I never told him that, actually, but those are the words she always used: "He's *hot stuff.*"

The thirty-third floor was her domain. Toddy was the law. Everyone was deferential, and I'd never seen that before. If she liked you, you were one of the chosen. Toddy loved me. Even though she was Jewish, I took her to my house at Christmas because she had no family. She used to look at my little brother's report cards—he's almost thirty now. If he got A's, she'd give him ten dollars. When Abe Lastfogel died, she gave me his bow ties from Sulka. I still have them.

DESK IN THE HEAD

HARRINGTON: An agent named Marty Klein needed a ride home. He shouldn't be confused with the late Marty Klein who worked at APA

(Agency for the Performing Arts), in Los Angeles. That Marty was a nice guy. This Marty looked like a cross between John Larroquette and Richard Nixon—a big, jowly, angry face. Plus he was always in a hurry and very self-centered. He thought whatever he did was the most important thing when in fact all he did was book Sammy Davis Jr. at the Sands before he was chic again. In the scheme of things it was minor business, but he carried himself like he was Ovitz. Klein lived in White Plains, New York, about ten minutes past my town, Bronxville. For some reason he needed a ride home one afternoon, so they told him, "Tomorrow Gerry Harrington can drive you home, take your Cadillac to his house for the night, then pick you up in the morning."

I took the train to work. That night I ferried Klein to White Plains and dropped him at his house. The whole way he wouldn't talk to me. From the way he acted, I expected to pull up to a mansion. In fact, he lived in a tiny shack—a two-family, aluminum-sided house. I've always believed in looking at the houses of the people who run the company I work at to see if, on the high end, there's something to shoot for. Is that the best they can do? Do I want that guy's life?

A couple weeks later, Marty Klein's desk had a wobbly leg. Two guys from the mailroom were sent to remove it. . . .

MENDELSOHN: We had a little storage area to the side of the men's bathroom, and I told Roberto Tamayo that we should move Marty's desk there and turn it on its side. Roberto said, "No, we're going to stand it up and put it in the hall, just in the front of the men's bathroom."

"Well, somebody's gonna run into this thing," I said.

Roberto told me that he was the boss, I was a trainee, and the way it worked is that I listened to him.

HARRINGTON: They stuck the desk in the corridor, on its end, with the legs sticking out, about ten feet back from the men's room door—far enough that most people wouldn't walk into it.

But Marty Klein did. He opened the door without looking up, and *bam!* Bopped himself in the head with the desk leg. He got knocked unconscious.

I was covering the reception desk during lunch. Suddenly I saw Klein wheeled out to the lobby with a bandage around his head. I called an ambulance, which took another hour and twenty minutes to arrive. Only in New York. The whole time, Klein was strapped on a gurney, mumbling profanities.

I covered for the receptionist again at five, during her coffee break. That's when they brought Klein back from the hospital. His head was all taped up. A little later I got a call: "Marty wants you to drive him back to White Plains."

It wasn't said like I'd be helping him, but as if the company had thrown me a bone: "You should get in good with Marty Klein; he's a senior executive."

Instead of repeating the silent treatment, this time he rambled. I guess he was comfortable with me because the last time I hadn't bothered to make eye contact or hassle him. Okay, so he was doped up on Percodan. He kept telling me how unhappy he was with his career.

The longer we drove, the more he loosened up. He said he'd started representing the trumpeter Al Hirt because he'd heard "Jambalaya" and it changed his life. He loved big Al, but in retrospect the future of the business was television: "We're going to make more money on this package for James Michener's *Space* than I'll make in my whole fucking career," he whined. "That tells you what kind of mistakes I've made in my life."

The guy was bumming out. Losing it. And I was on the receiving end of his stream-of-consciousness confessional. When we got to his house he finally got it together enough to say, "Pick me up tomorrow, seven-thirty sharp."

The next day it rained so hard that the Hudson River flooded over on the parkway. I had to take an alternative route to Klein's house and I got there at 7:35. I imagine that he had woken up, finally clearheaded, thinking, "I let this kid see me as a human being," and was mortified, because when I pulled up he flew out his front door yelling, "Where the fuck were you, you piece of shit!"

I said, "Excuse me, I'm five minutes late. Have you looked outside? It's pouring rain, sir."

"Don't give me that bullshit," he snapped. "Don't talk back to me, you fucking asshole. Get in the car!" Then he said, "I'm late. You can't fucking drive. You'd probably crash the car anyway." I got in the passenger seat and he drove. At the Hudson River Parkway he floored it and we hydroplaned while I seriously considered the possibility that I was going to die.

We took the exit for Willis Avenue and the Third Avenue Bridge, right opposite Yankee Stadium. It curves around a big stone wall that

holds back the embankment. Klein slammed into it. "You cocksucker!" he screamed at me. "Why don't you drive?" But instead of pulling over, he stayed behind the wheel.

Just as we made it over the bridge onto Second Avenue and 128th Street, he ran into the back of another car. This time Klein stopped, got out, swapped information with the other guy, then said to me, "I'm fucking tired of this. You drive now. If you hadn't been late, none of this would have happened."

I kept my mouth shut.

Before going to the office we had to stop at the Apollo Theater, where Sammy Davis Jr. was taping a special. I parked, we got out, and I locked the car. Klein wouldn't let me come inside the theater. He took the car keys and made me wait outside, in an alcove, in the rain.

Again, I kept my mouth shut. I was pissed off, but I didn't want to give him the satisfaction of arguing or asking for anything. I'd rather be wet than have to rely on that scumbag.

When we finally got to William Morris, I reported to the mailroom. Before long I got called in to see Ed Khouri and Ruthanne Cionne. They said Klein had told them that I had fucked up his car. He'd said I was half an hour late, that I had driven irresponsibly, that I'd crashed once into a wall and then hit another car.

"He's lying," I said. "That's bullshit and I'll prove it. Get him down here."

They seemed to already understand; maybe it had happened before. Khouri said, "Look, Marty's like that. Just take the rap. No one's going to fire you."

"Fuck the rap," I said. "I'm not taking any rap."

And that was that. Except for one thing:

I later found out that Marty Klein had called my house at 7:31 in the morning. My grandmother lived with us, and when she answered the phone he'd said, "Where the fuck is that son of a bitch?" She said, "Who do you think you're talking to, young man?" and hung up on him.

Fortunately, I never got assigned to his floor again, which was fine with me because it was full of guys with big jars of Tums on their desks; they all had ulcers from booking people in Atlantic City and siphoning money off. Eventually they all got let go.

The incident wasn't really good for my stock at the company, but at

that point I'd been there long enough to know I was going to leave sooner rather than later.

OUTPOST ON SIXTH AVENUE

BERKOWITZ: I worked for Len Rosenberg, who ran the TV Department. A year later he went to California. I tried to go with him but they wouldn't let me. Instead I was assigned to work with Ron Yatter. I wasn't a secretary and I wasn't an agent. I was just supposed to listen and learn. But when I walked into his office on a Tuesday to start, he said, "I'm really busy. Can you come back on Monday?" A week later? I went into my office, shut the door, and almost cried. But I made it work with Ron until I passed the bar in 1989. Then I moved to Los Angeles, spent two years in TV packaging, and quit to go to CAA.

HARRINGTON: The mailroom is like the minor leagues, the farm team: The goal is to make it to the big show. But after going through all sorts of shit in New York, I didn't believe that these guys really represented what being an agent was. I'd read the memos from the West Coast. They were putting movies together and handling big stars. I wanted to be in the movie business. New York handled publishing, Broadway, and Atlantic City. I didn't care about that world. I knew I had to go to Los Angeles—but not for William Morris. I hated the company. Most people were secretly—or not so secretly—miserable and looking to leave. I just had to wait until I had my vacation. My plan was to fly to Los Angeles and find work. I lived for that moment.

I became eligible for my vacation in November 1985. One of my best friends had become a producer on a TV show in Los Angeles called *Matt Houston*. He said, "Just get out here and get a job. We'll take care of the rest when you come."

My aunt was a travel agent. She got me a free courier ticket, for which I had to deliver an important envelope to a bank in Beverly Hills. I could only afford to stay five days.

I interviewed at Triad, ICM, APA, CAA, and the Gersh Agency. At ICM they said I didn't type well enough to be an assistant. APA was sort of chic; they'd just been fired by Al Pacino, but they had Steve Martin, John Candy, Rick Moranis, Vanessa Redgrave, and a lot of television

clients, including Pee-wee Herman when he was a megastar. APA of-
fered me $375 a week to be an assistant; Triad offered $350. CAA told
me I could start in the mailroom, but I wouldn't do that again.

I didn't even stop by the William Morris office.

I went to APA and worked as a secretary for a year. I increased my in-
come by almost 50 percent immediately. Then my boss, Ames Cushing,
became an agent at William Morris, and I got her job. I was an agent at
APA for two or three years before I went into management.

HUVANE: I lucked out. I had temped for Myrna Jacoby when she was a
commercial agent. When they moved her into theatrical she asked me
to be her assistant. Myrna was inclusive. She treated me like a colleague.
I didn't abuse it. I never overstepped my bounds. I never assumed that,
because they were giving me some leeway, I was more than what I was.
Nine months later, Johnny Planko's desk came up and the company
wanted him to have a male assistant.

Johnny was a character, heir apparent on the East Coast and proba-
bly the only rival to Sam Cohn at ICM. His client list was spectacular,
and he was still in his thirties. The first day I worked for him, he took
me out for Bloody Marys for lunch. We didn't come back to the office
until six o'clock. I thought, This is wild. Johnny was very kind to me. I
learned a lot working for him. When he was on, he had brilliant in-
sights and a knack for relating to people.

But I left William Morris in 1988 because I'd looked around and
seen a lot of old-timers who were not happy; they weren't valued the
way they should have been. I didn't want that to be me.

I met with Ron Meyer from CAA and thought he was the most de-
cent man I'd encountered in the business, as well as incredibly success-
ful. I figured if he could be that successful *and* nice, I not only wanted
to be at his company, I wanted to be *him*. I didn't want to be Mike
Ovitz. Success only exaggerates what you start with. Most people don't
just *become* assholes, they're assholes to begin with. If you said hello to
Ronnie, regardless of whether or not he remembered who you were,
you got a "How are you? Nice to see you." People were afraid to say
hello to Ovitz in the hallways. Ronnie was the soul of CAA. He has
heart. Ronnie invited us to his home. He shared his life with us. The
only time I was ever invited into Mike Ovitz's home was because I
represented Meryl Streep and he invited her to dinner, and she wanted
me to come. Ronnie is more genuinely concerned about people. At

William Morris, I didn't know anyone who had both success and concern.

MENDELSOHN: I floated on Dennis Arfa's desk. Dennis handled music and comedians. I worked closely with his clients: the Beach Boys, Billy Joel. I also had friends I tried to bring into the agency. Benicio del Toro. Stephen Baldwin. Musicians. Comedians. But my job was to be a good mailboy, not bring in talent. I was too ambitious and never as good a mailboy as they wanted. After six or seven months I was dismissed.

GRUBER: I was only in the mailroom full-time for twenty-five days. I scammed my way out quickly by working the morning desk for Fred Milstein, the head of the Motion Picture Department. I got him to give me enough to do so that he would have to call the mailroom every day and say, "Michael can't leave. I need him."

Right time, right place, right person. I made myself useful, wasn't a pain in the ass, didn't have attitude. At some point it became a problem because Fred wasn't supposed to have two assistants, but by then I was so ingratiated that they found a way for me to be the assistant for the entire group.

When Fred moved to Los Angeles, he asked to bring me. The answer was no. So I took on the toughest job in the office, working for Lucy Acedo in Variety Television. Actually, I was coerced into working for her by being told I'd have a lot more responsibility on the desk than a regular assistant. It was, "Wink wink, we're gonna make you a junior agent. You'll be able to go out, have an expense account."

Lucy's desk opened the door for me. I became the guy who booked *David Letterman* and *SNL* and *Friday Night Videos,* and I was at the comedy clubs every night. It took what was just my hobby and made it a career. I signed a lot of hot young comedians: Adam Sandler while he was still at NYU, Chris Rock when he was getting kicked off the stage at Catch a Rising Star, Ben Stiller, Will Smith, Cindy Crawford.

Eventually I moved to Los Angeles, too.

POSTER: I was asked to work for the boss, Mr. Stevens. I came in at 9 A.M. He'd call me from his house and tell me what he wanted for breakfast. The company cook had quit and I couldn't wait for anything to be delivered, so I had the mailroom pick it up from Joy Deli: usually coffee and toast. I'd transfer it to a china plate and bring it in.

My job was to open the mail and lay it out. I had to read magazines and highlight clients. I cut out gossip columns from the newspapers. Sometimes I ran calls. Otherwise I wasn't really part of the game. I

didn't feel competitive and the need to politick. At the time, I thought more about getting a boyfriend than getting ahead.

I never became an agent. The Motion Picture Talent Department was too crowded, so I left. I wanted to go to a smaller place where I could be part of something from the beginning and build it, where I could make a difference.

SANDS: I worked for Rob Prinz, in the Music Department. But we didn't get along and I moved to another desk, booking R&B acts across the country and trying to outhustle hustlers. When Dennis Arfa started his own agency and another guy got canned, I got promoted.

I lasted five years. In 1990 I hooked up with the chief psychologist at Bellevue—a character who drove a pink moped—and he took me under his wing. In college I'd been a psychology major and worked in a residential facility for women who had been deinstitutionalized, and in a children's hospital. He got me my first job at Bellevue, to work with homeless schizophrenic men. Now that I think about it, starting in the mailroom, being an agent, working with homeless schizophrenic men—it's all the same: taking care of unusual people.

HARRINGTON: There's a book Sparky Lyle wrote about the New York Yankees, *The Bronx Zoo*. It takes place in the seventies, when they won a couple of World Series with Thurman Munson, Catfish Hunter, and Reggie Jackson. It was this dysfunctional nut family that achieved greatness. But if you look at the afterword, at what happened to the people along the way, you see that most of them are has-beens or washed up; only a few of them are remembered as legends. William Morris was like that. It was a mess. They didn't realize it was already over for them. Ovitz had changed the agency business and they were a pale third.

I figured I'd stay in Los Angeles for five years and once I knew the business I could come back and be on the thirty-third floor with the lifers because I'd know how California worked. Of course, I got my own life in Los Angeles. I got on the treadmill and couldn't get off, nor did I want to anymore.

ISAACS: Lee Stevens needed a second assistant, and I wanted the job. Another assistant said, "Don't. It's a dead end. No one's ever made anything out of that job. You'll work for Vivian and you'll rot." Vivian Hall was Mr. Stevens's executive secretary; she'd been Nat Lefkowitz's secretary before that. She was the most terrifying human being I had ever met—all business, and if it wasn't done absolutely perfectly, she was all over you.

After passing muster with her I met Mr. Stevens. He asked if I understood the concept of a fiduciary responsibility: "That's what I expect from people who work with me." All he really wanted to know was that I'd be efficient and keep my mouth shut. He was a man of very few words. He only said three things to me during the first four months I worked for him: "Good morning," "Good night," and "Get me. . . ."

One day Vivian was gone and I was alone with Mr. Stevens after hours. It was nine o'clock and he was reading with the television on. I sat outside, doing paperwork. He walked out of his office, looked at me, and said, "I just want to tell you something: I think you're doing a sensational job here." Then he walked back inside. I rode on that for a long time.

• • •

I worked for Mr. Stevens until May 1986. May is TV sales season and the time that all the West Coast agents come to New York to romance network executives and do last-minute jockeying to get their clients' shows on the air. Every night it was parties. Then they announce the new TV schedule.

Everyone from the West Coast Morris office showed up: Jerry Katzman, Hal Ross, Larry Auerbach, Sol Leon. One of my jobs, as Mr. Stevens's second assistant, was to work for all of them. The phone probably rang as much during that week as it had for Mr. Stevens in seven months. I had to keep track of the calls. It was a blast. The pace was unbelievable. I felt completely alive.

Two days after they left, Mr. Stevens called me into his office and said, "How do you feel about California?"

"What do you mean?"

"I want to move you to California, to be Jerry Katzman's assistant. He really liked you. I need to know tomorrow morning."

I said, "That's amazing, but I can't tell you tomorrow morning. I've got to think about it."

"What's to think about?"

I went home and I realized, Yeah, what *is* there to think about? But it was done in typical William Morris fashion: Make a decision *now,* and then it was like pulling teeth. They had to have a board of directors meeting about whether or not they were going to move me out. It was insane.

I told Mr. Stevens, "Okay, I'll do it. I'll work for Jerry. But there are some things I need to know: Will I get a raise? Who will pay for me to

move? Who will move my stuff?" Ed Khouri said my father should pay. I said, "No way." Plus I wasn't going to negotiate with my own company when my moving was their idea.

Finally Mr. Stevens said, "Okay, what do you need?" and promised to take care of it.

But nobody did. A few weeks passed, and I was supposed to be at work in Los Angeles the following Monday, but I wasn't going to pack until they gave me some answers. Wednesday was a normal day. I said good night to Mr. Stevens and he said, "You know you're going to California this weekend."

I said, "Am I?"

He said, "Yeah, of course you are."

"Well, there are a couple of questions I still need answered."

"Oh, like what?" he said, as if I hadn't been talking about it for five weeks. I ran down the list. He said, "Of course, we'll take care of it. Just call Ed Khouri; he'll handle it." That was it. I was on my way to Los Angeles. New York was just a memory.

● ● ●

KEVIN HUVANE is a managing director of CAA.

MIKE MENDELSOHN is president of Patriot Advisor, an entertainment media merchant bank. He is also chairman of Patriot Pictures and chairman of St. Michael's Press.

ADAM ISAACS is a senior talent agent at UTA.

ADAM BERKOWITZ is head of TV packaging at CAA.

GERRY HARRINGTON manages Nicolas Cage and others at Brillstein/Grey Entertainment.

STEPHEN SANDS, PSY.D., is assistant professor in the Department of Pediatrics and Psychiatry at the New York University School of Medicine. He is also the director of the Behavioral Health Program at the Stephen D. Hassenfeld Children's Center for Cancer and Blood Disorders.

MICHAEL GRUBER spent many years at William Morris. He was an agent until 2002 at CAA. He knows Cindy Crawford personally.

MERYL POSTER is the longtime copresident of production at Miramax Films in New York.

CAME AND GONE

William Morris Agency, Los Angeles, 1980–1986

BRUCE KAUFMAN, 1980 • RICK JAFFA, 1982 • CARY WOODS, 1982 • BRYAN LOURD, 1982 • MARTY ADELSTEIN, 1983 • STEVE RABINEAU, 1983 • DAVID LONNER, 1984 • ANDREW COHEN, 1984 • NICK STEVENS, 1986 • MATT TOLMACH, 1986 • BETH SWOFFORD, 1986 • CHRIS HARBERT, 1986

> *Why did the company let the fact that it's old*
> *be used against it?*
> —Cary Woods

BRYAN LOURD: I didn't have much access to the outside world where I grew up, in New Iberia, Louisiana. When I asked my high school guidance counselor about taking the SAT, she said there was no such thing. My mother called our senator as a concerned citizen, to ask him, and I drove to Baton Rouge to take the exam.

I was ambitious, and probably the first to leave town in a hundred years. I came to Los Angeles to go to USC not knowing anybody or anything. Moved to Watts and didn't know it was *Watts*. Then I went to Cambridge and to George Washington University and came back with a few credits left to complete. Got a job at CBS, first as a page and then part-time in Benefits, where I had to fill out sick-day time cards with a little pencil. I never quite mastered it. When I became a gofer on the executive floor, I arrived every morning at six. There'd be one other car in the parking lot: Bud Grant's, head of TV. One day I worked up the nerve to say, "Hi, Mr. Grant. I'm really good with people—what should I do with my life?"

He suggested I look into the agency thing.

I went to William Morris after work, faced the receptionist, Becky, a cocky, beautiful black woman who ruled the roost in the atrium. I said, "Hi, can I get an application?" and she flat out rejected me. Totally blew me off and told me to get out.

I went back the next day and flirted and tried to charm the applica-

tion out of her. She laughed and handed one over. I was so naive. On the references line I listed my hometown sheriff and my high school English teacher, only to find out that everyone there was a son-of.

MARTY ADELSTEIN: I was about to graduate from UC San Diego and was going out with a girl whose family belonged to Hillcrest Country Club. Her mother asked me, "What do you want to do when you get out of school?"

My father ran a factory that made tablecloths and shower curtains. I said, "I want to go into the mailroom at William Morris."

She said, "I'm friendly with Norman Brokaw and I can get you an interview. One thing, though," she said. "Remember to stoop when you go in."

"Stoop?"

"Don't stand up straight. Most William Morris agents are very short, and Norman has a thing about his height."

Sure enough, I sat and Brokaw stood over me the whole time. He sent me to Kathy Krugel, who had crazy eyes and red hair and was covered with makeup. Ageless, sort of. She could have been anywhere from forty to sixty. Lipstick on her teeth, the whole thing. It was like lithium time. She tried to discourage me, but I'd been told she'd try that. I also knew that she'd write down the number of times I called to follow up. Six times a month was supposedly the perfect number.

On a Friday morning William Morris called and said to start work the following Monday. I was excited. That afternoon they called back with a problem: They'd checked my college records. I'd gone through graduation but was still one class short. William Morris wouldn't let me into the program until I had a degree.

I went to UCLA, browsed the extension catalog, and found a course for premed majors. I told the professor, "Here's my problem: I'm never going to be a doctor, but I have this job that I want and I have to do this course in two weeks."

He said, "No one's ever done that."

I said, "I will."

I passed the course in two weeks, with a B-plus. William Morris didn't believe me, but I brought them the certificate.

CARY WOODS: The notion that I would work in the movies was to my parents like saying I was going to be an astronaut. They were Polish immigrants. We lived in the Bronx and didn't have a lot of money. Their

attitude was, "Yeah, that's good—but how are you going to make a living?"

A USC law school friend was close to Ray Kurtzman's son, Rick. We met for lunch and he set up a meeting at CAA with his dad, who told me, "You're never gonna be an agent. Even if you become an agent, you won't stay."

Another school friend knew Elaine Goldsmith, then an assistant at William Morris, who later became Julia Roberts's agent. She got me an interview with Kathy Krugel, an extremely serious, formal, buttoned-down type. I also met Mike Simpson, an understated former filmmaker from Texas who had become an agent. I said I liked film and wanted to be involved, but I wasn't sure if an agency was the right move. He said it was okay not to be sure.

BRUCE KAUFMAN: I grew up in Westchester County, New Rochelle. I made home movies, three-reelers, when I was eleven and twelve. My bar mitzvah present was a sound camera. I used my friends as a repertory company of actors, and I showed the movies at local theaters. My father started to bring home *Variety* from the corner cigar store, and I read about the movie studios and the life in California. On a family trip west, when I was about sixteen, we went to Universal Studios. That was the beginning for me.

In college I promoted rock 'n' roll shows and put parties together. I was the guy who got your five-dollar entrance fee. A friend from Barnard was dating a guy from NYU whose parents were in show business and whose brother was at ICM. He was in town one weekend and told me, "You're a natural agent."

I had meetings in New York at William Morris and ICM, but I realized that unless someone keeled over in their sleep, there would be little movement up the ladder. I went to California. ICM had just stopped their training program. CAA was too small and filled up. I got an interview at William Morris.

ANDREW COHEN: My dad was a literary agent and a TV packager at Ashley-Famous—he packaged *Get Smart,* represented Garry Marshall—and then formed his own company with a partner. But I always hated the "love ya baby" show business thing, just like my father hated people who were always hitting him up for a job. Like we'd be on vacation and someone would find out he was an agent. Next thing they'd

show up with their little daughter and say, "Dance for the man, sweetheart."

I staffed for the California Democratic Party. I worked on Jimmy Carter's campaign as an advance man. I worked at a PR firm. They represented tobacco companies, oil companies, toxic dumpers, all kinds of special interests—not exactly Democratic. At twenty-five I was at a crossroads. I concluded that since Hollywood was in my backyard, it was like having a tennis court behind the house: You should learn how to play tennis.

My dad hooked me up with the Morris office, and I got an interview with Jerry Katzman. While waiting in the lobby an elevator opened and out came an agent, Marty Beck. He had long, hippieish gray hair, a wide-open shirt, a big gold medallion. To the receptionist he said, "Becky, baby, I need you to call Adriano's. Tell them I'm running about fifteen minutes late, and make sure they hold on to my table. It's table number two, the first table in the place, so everybody who comes in the place sees me."

My first thought was, Gotta go. I stood up. Becky, the receptionist, read my mind. "He's in the Music Department, honey. Go ahead and sit down."

Jerry Katzman and I had a great chat. He said I needed to meet Walt Zifkin. Walt had an oak-paneled office with no lights on except for a green table lamp. To my surprise, when I arrived, some of the board of directors were there. My résumé *was* sort of impressive, but still . . . They said, "We called you in here to talk to you about something serious. We're thinking of taking legal action against your father's company."

The contemplated action wasn't actually against my dad and his partner as much as the production company that wanted to acquire them. Someone said, "What would you do if you were in the mailroom and saw the legal documents?"

I said, "I've been keeping stuff from my father for twenty-five years. Why would I start telling him stuff now?"

They looked at each other and said, "Hire this guy!"

CHRIS HARBERT: My father was a press agent at MGM in the 1940s and 1950s. He worked with glamorous people like Elizabeth Taylor and Cary Grant. But my parents didn't want to raise their family near

Hollywood, so they moved to New York and then Connecticut. I'm the youngest of six. My brother is Ted Harbert, who came to Los Angeles in 1982 with ABC television and eventually ran it. My father worked at the *New York Times,* in the magazine division.

At Boston University I managed a restaurant and wanted to be in that business. But with a degree in broadcasting and film, and because of family pressure, I figured I might as well go to Los Angeles and meet some people. In 1986, during spring break, I stayed with my brother and his girlfriend for a week. He said he would set me up with a number of interviews. If I liked it, I liked it; if I didn't, I didn't.

I met Alan Berger, a TV movie packaging agent at William Morris. He and my brother were friends; Alan covered ABC for the agency. I sat in his office for a couple of hours one afternoon. I listened to him make a deal on the phone. I watched young agents come in and ask questions. Every conversation was different. He was selling, but his product was human, creative ideas, not widgets. And it was very fast-paced, a lot like the restaurant business, where you have to think on your feet constantly to keep people happy.

Berger sent me to meet Kathy Krugel. I got a short, encouraging speech, filled out some papers, and came back the next day for an official interview. They told me the process could take six months. I said, "I'm out here for a week. I graduate in six weeks. I'm going to get a job somewhere. Probably the first offer I get." I called Alan Berger and he pushed me through the system in a week's time.

RICK JAFFA: I grew up in a very small town in Texas, and I loved two things: sports and movies. I would never quarterback for the Cowboys, so I moved to Los Angeles to get into the movies. But first I enrolled at USC for graduate business school. It took two years to get my M.B.A. I hated it. Afterward I tried to get a foot in the show business door but had no luck.

Eventually I went broke. I was literally down to my last five dollars. I took the money, walked to Westwood, and saw *An American Werewolf in London.* I couldn't even buy a Coke, popcorn, anything. I was tapped out.

After the movie I walked around Westwood thinking, It's over. I'll go back to Texas. That's when I ran into a guy I knew from home who happened to have some experience in the business. He said, "Have you ever thought about trying to get into the mailroom at one of the agencies?"

I said, "Yeah. But I'd be a terrible agent." The image in my mind was

that they all grew up in New York or went to Beverly Hills High. They had a certain panache. A certain style. And most of them came from show business families, not Texas.

My friend loaned me fifty dollars. He said he'd call someone at CAA and I should call William Morris and ICM if I could think of someone I knew who could help me get in. I came up with a long, long shot. In college I was the softball coach for this girl's sorority and she'd had a blind date with a guy in the William Morris mailroom. Three years had gone by, but I called her and asked if she could remember his name. I said I was desperate. It took a while, but she came up with it: Sam Haskell.

I called Sam, not knowing if he was still in the mailroom or parking cars, or even at William Morris. His assistant answered. I left a message. After five times he very graciously called back and said, "What on *earth* do you want?"

I said, "Just give me five minutes."

Sam was from a small town in Mississippi where I actually knew people, which is bizarre because I only knew three people in the state. We hit it off. He's the greatest guy. I love him. He took me down to see the head of Personnel. We both had southern accents, so the woman must have figured we grew up together—and neither of us told her any different.

Three weeks went by. I did odd jobs to pay the bills. I was a Kelly Girl. I sold cookies at a Mrs. Fields–like store. I had to wear a shirt with a cookie on it that read EAT ME. The kids I worked with smoked dope in the alley on their breaks. Then I got the call from William Morris. I was in.

NICK STEVENS: My parents are still in the same North Philadelphia house that they built in 1962 and I grew up in. My dad ran Robert Bruce, a domestic menswear company that my grandfather started. Then he was an investor and started a real estate business.

When I was a film student at Boston University I made an absolutely horrible film that went to student festivals. I also booked, for no money, punk rock bands around Boston, New York, and Philadelphia. I didn't wear the punk rock outfit. I was more the Deadhead guy who had gotten tired of that game by the time I was eighteen.

Somehow people at William Morris heard that I had gotten a band to be the opening act for Tom Petty, and I got a call from Janice Merrill in the Los Angeles office, asking if I'd like to interview for their training program. I'm like, "William who?" I had no idea. I hung up.

Around graduation, a very smart professor told me about agenting, and I remembered the call from William Morris. I called Janice Merrill. "Hi, remember me? You called me two years ago." She said no, but come in anyway.

Janice gave me a typing test, which I failed. She asked me about any relatives in the entertainment business. I had none. I told her about the punk rock thing, because that was pretty much the only story I had. She said, "There are four thousand applicants for every spot. We'll have you come back eight or nine times. But everybody's uncle is somebody, and you have no uncles. And you don't type." I still remember the look on her face.

This was on a Monday. I said, "Look, I'm going to Philly on Friday. I'll have a job by Monday. It ain't happening for me, coming back every month or whatever." Janice sent my typing test and résumé to David Goldman, who ran the training program. He saw the punk rock thing and called.

A few days later, as I was driving up to William Morris, I saw someone I knew from Boston University walking across the street, carrying a mailbag. He had the Kennedy haircut, the argyle socks, the pink shirt, the striped tie, the khaki pants. It was Chris Harbert. I was on the scooter with long hair and a backpack. I hadn't even brought a jacket. I thought, These fucking people are not going to hire me. I went around the corner to Neiman Marcus and bought a jacket and a tie, and I got a haircut, then went to see Goldman.

We talked about music. He wanted to revamp the music department and get the company out of booking Dion at the Sands in Vegas and into the real world. I told him he was right. He gave me the "four thousand applicants" story. I gave him the "I'm going to Philly on Friday" story. Goldman took me to meet Jerry Katzman. Katzman didn't impress me, but I got the job.

BETH SWOFFORD: I grew up in North Wilkesboro, North Carolina. I worked at a theater the summer before I graduated from high school, taking tickets, selling popcorn, and fell in love with the movies. There was so much press then about George Lucas that I decided to go to film school where he had: USC. I fell into the agency business because I worked for some then-struggling young television producers who told me that if I started in the training program, I wouldn't be stuck in the secretarial ghetto. It sounded like good advice.

I interviewed at CAA and William Morris. CAA was full up, so I talked to Kathy Krugel at William Morris and got a job in five or six weeks.

DAVID LONNER: I was a mediocre student at Tulane University, changing majors all the time. It was the Reagan years. Everybody was going into the Salomon or Goldman Sachs training program. My junior year I went to Israel and Tel Aviv University, to study things that were meaningful to me, like the Arab-Israeli conflict.

My uncle came to visit. We had a cup of coffee at the Tel Aviv Hilton and he said, "So, what are you going to do with your life?" He started gouging me a little, saying, "You'd better start thinking about it."

I wanted to do something I was passionate about, and that was Israel. One idea was opening a fast-food-baked-potato restaurant because that was all the rage. I even looked at a little restaurant real estate on Wiesengof Street. Instead, I went back to New Orleans for my senior year, I got into the jazz and pop scene, went to movies. I read *Weekly Variety* and *Indecent Exposure,* David McClintick's bestseller, which described how the William Morris mailroom is where a bunch of the people I had read about had started. It seemed like the essence of the American dream.

I moved to Los Angeles in August 1984. I sold my parents by portraying the mailroom as graduate school. There was never an argument.

MATT TOLMACH: It's either a bit of a mistake or a matter of convenience that I got to William Morris. I went to Beloit, a tiny liberal-arts college in Wisconsin, as an English major. A week before I graduated, my mother, who grew up in Los Angeles, called and said, "Matthew, what are your plans?"

I said, "I'm going back to D.C."—where I'd grown up—"and I'm going to paint houses and write."

"Over my dead body," she said. She called my grandfather, Sam Jaffe, who had retired from Hollywood in the sixties, and said, "You've got to take Matthew under your wing. He's threatening to be a writer."

My grandfather was a great, gruff character. Larger than life. A legend. He produced *Born Free.* I revered him. He said, "What's this shit I hear about being a writer?"

"Well, Poppy, I love to write."

"Ah, that's crap. Come on out to the coast. You like writing? You can be a literary agent."

It was my first taste of how valuable connections can be in Hollywood. I agreed to check it out. In truth, my best friends in school were a year behind me and we had an elaborate plan to crew on a ship when they graduated. I had a year to kill, so I went to California to wait for the guys.

I met with Hal Ross at William Morris. He was sweet. I wore a khaki suit with rips in it and loafers with electrical tape holding them together. In my mind I was some cheap version of Tom Wolfe: nattily dressed, but clearly just off the college campus. I was a very idealistic, irreverent, liberal-arts kid. I didn't know what I stood for, but I was convinced it was something *else*. Hal talked about my grandfather and then said he would send me upstairs to meet David Goldman. Goldman said, "So, why do you want to be an agent?"

"Well, I don't, really," I said. "The truth is, my grandfather really wanted me to do this."

"Well, what do you *want* to do?"

I said I wanted to be a writer.

"The idea of our agents competing with our clients is troubling," he said.

"Well," I said, "I guess I can understand that."

We just looked at each other. He asked a couple more questions and then said, "Okay, thanks a lot for your time." I walked out thinking I had absolutely tanked the interview. I went to Hal Ross's office, ready to apologize and exit. He met me with open arms. He said, "David loved you!"

STEVE RABINEAU: My uncle was at MCA in the 1950s, but I had no interest in what he did. I grew up in Brentwood, California; my parents were in the schmatta business, my brother was an attorney, and I was a student at UCLA headed for law school because my parents wanted me to do it. I decided not to go, which left me floundering. Dan Enright, co-owner of Barry and Enright Productions, a game show company, is my second cousin; he was nice enough to give me an entry-level, cockamamie job. I worked as a contestant coordinator for *Tic-Tac-Dough*, hosted by Wink Martindale.

Meanwhile, my mother told me that some third cousin from Long Island was assistant to Martin Caan, a big literary agent at William Morris. She introduced me, and I somehow schmickled my way into his office. I sat on his couch and told him I was directionless. He said,

"Have you thought about being in the mailroom?" He described it as the epicenter of the movie business and a great stepping-stone. Marty jammed me in, and I started doing interviews. Eight months later they said, "Okay, you're in." I was thrilled, but not my family. From their point of view my life had gone completely off track.

GETTING THE PLACE WIRED

STEVENS: I remember two things about the first day. First, Richard Feinsilber ran the mailroom; Richard didn't like me, I didn't like him. The second was Beth Swofford.

SWOFFORD: Well, I was the only woman in the mailroom. Nick stood out, too. His personality was so . . . big.

TOLMACH: Feinsilber sat at the desk right in front of the mailroom and presided over all things. He'd say, "You—across the street." "You—for Stein." He was exactly like Danny DeVito in *Taxi*.

STEVENS: Matt Tolmach came in a little after me. I showed him around.

TOLMACH: What he means is that within the first hour Nick walked up, literally grabbed me, took me into the hallway, and said, "Look, I've been here a week. I've got this whole place wired. Watch me. Follow me. You'll get it."

I thought, Who the fuck is this guy? But I said okay. There were little cliques; everybody looked for an angle. There were the good students, and the kids who smoked weed in the back of the room and got by. We were *those* guys. Operators. Nick and I thought we were cool. We became best friends. Nick was controversial. He had long hair. We went to see punk bands at Club Lingerie three, four, five nights a week. Nick had an Alfa Romeo sports car with license plates that said COWPUNK, and then I bought one. We were a terrible twosome. We weren't terribly deferential, he much less than I, who was sort of in his shadow. We weren't disrespectful either, just determined to do it on our terms.

COHEN: Me, David Lonner, Jordan Baer, Howard Sanders. We were a very tight group. We used to go to Hernando's Hideaway, in the Beverly Wilshire, for happy hour on Fridays. You could eat dinner from what they put out. We'd sit around and bitch and complain. We'd say,

"Anybody got any dates this weekend?" What, are you kidding? Nobody dates in the mailroom. "Anybody know any good parties?" No. It's the best year of your life, but at the same time it's the worst year.

JAFFA: I wanted to wear my dress shoes the first day, but I couldn't find them anywhere. My only others were sneakers and cowboy boots. My cousin had given me a handmade-to-order pair for graduating from business school. So I wore the boots and immediately got a hard time about it. But it set me apart, so I wore those boots every day and became the alternative kid.

WOODS: I never used the word *mailroom.* To my parents, the idea that their son, who had gone to law school, was in a mailroom might not have been good for their health. I always said that I was in the "training program." My own ignorance was probably also a good thing. If someone had shown me the videotape of what would be the next year and a half of my life, I'm not sure that I would have dived in the way I did. You didn't get a two- or three-page explanation of what the hell you were supposed to do. Everything was done orally, by finding people who had done it and asking a lot of questions. Just like the early years of agenting, when you have to aggressively seek out clients and sign them, in the mailroom you have to make everything happen yourself.

ADELSTEIN: I didn't really believe that the job was delivering mail. Wrong. Steve Rabineau showed me around. He took me to Smart and Final for shopping, to Nate 'n Al's to pick up deli for meetings. He explained how to set up the food, how to take extra food home, how to doctor the invoices. If you usually bought three quarts of tuna fish, you'd just change it to five and take two home. That's how you ate on $180 a week.

COVER ME

TOLMACH: Richard Feinsilber would say, "Who wants to read a script?" Hands would go up. Beth Swofford covered more scripts than anybody.

STEVENS: She was the ultimate teacher's pet mailroom kid—and it paid off. She did lots of coverage and is a fine literary agent now.

SWOFFORD: I was very determined. We spent a lot of time trying to get to know the agents because so much of getting promoted was about

standing out and showing you were assertive. I sometimes covered eight to ten scripts a week. But I was told to be careful how I wrote comments because you never knew if years later they might come back to haunt you. What if you end up representing that writer?

TOLMACH: Nick and I were of the School of Cover Nothing. We analyzed the psychology of the whole mailroom thing and determined that no amount of coverage, no amount of doing things the right way, would get you to the goal of being an agent. We convinced ourselves that what the powers that be wanted to see was an *angle,* that we could come up with a different way.

CREAM CHEESE FOR THE TRAINEES' SOUL

RABINEAU: After three months I felt terribly down. I'd given up a potential law career and I was basically a piece-of-shit grunt. While setting up the conference room for breakfast I knocked the cream cheese container onto the very plush carpet, facedown. I got on my hands and knees, began scraping the muck out of the carpet—and started crying. I was so dejected. Then I heard the door open and Sy Sussman walked in. He was our projectionist. He asked what was wrong. I said, "Look at me. I'm cleaning cream cheese out of the carpet. My parents are furious that I'm here. I don't know if there's a future for me. What am I doing?"

Sy said, "Listen. A few years ago, I had the same conversation with a guy who was doing exactly what you're doing. I'll tell you what I told him."

"What?"

"Stay with it."

"That's it?"

"That's it."

"Who was the guy?"

"His name was Mike Ovitz. If he could hang in there, so can you."

"Mike Ovitz was doing *this* crappy job?"

"Abso-fucking-lutely he was. Sure. It's going to be okay. This is as bad as it gets."

That was a turning point for me. I thought if Ovitz could endure the indignity, then I should suck it up, too. I've never forgotten Sy for that.

For all I know, maybe he made up the story. If he did, I like him even more, though I suspect he was telling the truth because Ovitz wasn't *Ovitz* yet, just another guy who had made it through the mailroom.

AND A SIDE OF PENCILS, PLEASE

KAUFMAN: My job was to set up the food for the television and movie meetings. The instructions were on three coffee-and-junk-encrusted three-by-five cards that had been passed down through the mailroom for at least ten years. They listed what I had to get and for whom. Everything came from Nate 'n Al's. I also had to get milk, half-and-half, bagels, cream cheese, and Danish—but no prune Danish.

When I went to Nate 'n Al's, I always had to bring a box of number-two pencils because the guy behind the counter liked the William Morris logo on the pencil he always kept behind his ear. It was a tradition and almost a veiled threat: Bring the pencils or something bad might happen to your order. Every week I had to make a deal with the supplies guy to give me pencils. Fortunately, he was always interested in an extra pastry.

One morning I forgot the pencils. After I set up the meeting room a call came into the mailroom for me. A guy handed me the phone, shaking. Sam Weisbord was on the line. "We *told* you not to give us the prune Danish." I went upstairs and they literally threw them at me. It was *all* prune Danish.

I was so upset that I let the coffee brew all night in the big percolator. As far as I was concerned, these guys could drink sludge in the morning. I didn't even think about getting fired. The next morning another call came into the mailroom. Jerry Katzman was on the line. "We just want to let you know you've redeemed yourself. This is the best coffee anyone's ever made."

EAST SIDE, WEST SIDE, INSIDE, OUTSIDE

KAUFMAN: The only good thing about Dispatch was that you met everybody, from studio presidents to actors and musicians. Dick Van Dyke

was a big client. One time he invited me in and tried to convince me there was no Jerry Van Dyke, that he was Jerry *and* Dick.

Another time I delivered a script to Lindsay Wagner. I leaned the teleplay up against her door and the door opened. So I decided to put it on her kitchen table. The next thing I knew, she called Walt Zifkin, wanting to know why I had broken into her house. Zifkin called me in, closed his electric door, and said, "We're taping this conversation." I got yelled at for half an hour.

ANONYMOUS: I saw a naked star once. Donna Dixon. It was pretty powerful, especially that many years ago. I guess I knocked at the right time. She opened the door, stood modestly behind it, but there was a mirror behind her. I tried to be as polite as possible.

KAUFMAN: There was a guy, a lawyer and nephew of a producer, who started in the mailroom thinking he should move ahead very quickly. A nice guy, but never wanted to work that hard. We were on the Hollywood run on a Friday night. It was eight o'clock and raining. We delivered some packages to Merv Griffin's place and were on our way to *Dance Fever* with their entire payroll. This guy seemed upset, which wasn't unusual, given the run was cutting into our weekend. He asked me to pull over for a second, and I did. He got out, grabbed the box with the deliveries, turned it over, and poured the contents into the storm drain. Then he walked away. I said, "Where are you going?"

He said, "That's it. I'm done."

I went back to Griffin's company, used their lobby pay phone, and called Mark Drucker, who ran Dispatch. "I've got some bad news. The guy I was making the run with just left."

"Where'd he go?"

"I don't know, but he took the entire box of checks and poured them into the sewer. Now he's walking on Hollywood Boulevard."

Without hesitation Drucker said, "What about the checks? Can you fish them out?"

I said, "They're a hundred feet underground in fast-moving water."

"You'd better try to get the checks."

"There *are* no checks."

"You guys are in big trouble."

"The guy who did it is gone. He's not coming back."

"Then *you're* in trouble."

ADELSTEIN: Mark Drucker called me Nightmare. I did not take to the

work well—it was too menial—so I found ways to get around it. I got very good at simply mailing what I thought were nonessential deliveries. Sometimes I ran it through our postage meter; sometimes I paid for it myself. One afternoon the Dodgers were playing. It was a big game, and I really wanted to go. I mailed everything and went to the game, and I didn't call in for about three and a half hours. I heard that Drucker threw chairs at the wall because he couldn't find me.

Sometimes when we had to deliver to Universal Studios we'd take our cars on the tour route and get the *Jaws* shark to pop up at us. These old guys, retired policemen, would chase us all around the lot. Sometimes I had accidents.

After about my seventh crash, I got called in by the leisure-suit-wearing CFO of the company. He said, "We're going to have to let you go."

I said, "I don't understand why."

He said, "You've crashed seven of our cars, and we can't have that."

I said, "The funny thing is, you hired me to be an agent, not to be a driver. I admit I'm a lousy driver."

They punished me by demoting me back to the mailroom. After two months one of the agents told me there was a job opening at Showtime. I told Kathy Krugel I was going to work for Peter Chernin. She said, "That's probably good, because you're not agent material."

"We'll see," I said.

THE LIFERS, THE LIFE

RABINEAU: William Morris was all history and lore, and some of it was still alive and kicking. Abe Lastfogel still walked around with his hand in his shirt, like Napoleon. Sammy Weisbord was still alive. Morris Stoller, Nat Lefkowitz, and Lou Weiss had already been with the company fifty some-odd years. Norman Brokaw was very active. It all added up to a certain mystique.

On the other hand, other lifers were pretty sad characters. One guy had a stroke. He kept an office in the back and he used to wander down to the mailroom. If he found out which guys set out the food, he'd look at you and go, "Hunnnnh," and you'd give him the two Danish you'd

set aside. He'd wrap up the Danish, take them up to his office. Apparently this guy had been the Morris office "fixer": If one of the stars got into trouble with the Beverly Hills Police Department or got busted, he'd be the person Abe would send to work it out. Now he was just a shadow. I'd look at these old guys and go, What the fuck is he still doing here? I couldn't see myself in that life.

LOURD: I didn't wear the proverbial thirty-six-short suit, but I still looked around at the lifers and imagined staying at the Morris office forever. The company made so much of being a family that I believed them. I eventually learned that, at least politically, it was more the Manson family; they were really competitive killers. The collegial atmosphere they claimed to have didn't exist.

• • •

Many times I felt I just didn't fit in, which is not an uncommon experience among those who leave small towns. I *was* different culturally. But I was also a closeted gay guy who didn't know he was a closeted gay guy. Believe me, I didn't want to be gay, but had I realized it, I still wouldn't have come out, not even for God if He'd asked. It's not like I noticed a lot of people running around saying, "Boy, isn't this great! You can be whatever you want to be here."

It was a very conservative company, and the only flamboyant, open gay was Ed Bondy. Even Ed Limato wasn't really open. Stan Kamen was closeted beyond belief. No one talked about it. Certainly no one talked to me about it. It was still early.

But the truth is, once you made it to agent, had a client list, and were more secure professionally, it was okay. Well, it was *more* okay. It was safer.

STEVENS: Norm Brokaw came by the mailroom one day and asked for a volunteer to come in on a Saturday and move his office. It's the sort of thing Beth Swofford should have volunteered for, but she probably knew she was going to CAA anyway [*laughs*]. I had no interest in helping but ended up being selected for the job.

That Saturday, on my way over, wearing my Meat Puppets T-shirt and my shorts, smoking a big fat one, I decided I wasn't giving Norm my whole weekend. So I got right to work. I moved the Cosby books while Norman emptied the desk that he'd probably used for thirty years. Then he stopped and called me over. He put his arm around me. He was like, "Son, check this out," as he showed me letters from Abe

Lastfogel, written while Abe was in the hospital and unable to speak, giving Norman the company, passing the mantle. Then Norman began to weep. I didn't know him at all, and yet there he was, sharing a very intimate moment with me.

Typically, all I could think was, Get off me. Get me outta here. I thought he was just sentimental, in another world. Living in the old days. Okay, I was blasted, but everything he said made me feel like, Jesus Christ, I cannot stand this guy. What a clown. To him it was an interesting bit of Hollywood history, but at the time I couldn't give a shit.

Of course, in hindsight I respect the man, the moment, the intent, and the history of William Morris much more. Like Norman, being an agent is the *only* job I've ever had, and even though it's been just fifteen years, I can also tell the difference between now and then.

WOODS: I was at Hillcrest County Club, making a drop-off. I saw Abe Lastfogel, the guy who built William Morris as we know it, with an agent I knew. I went over and said hello, and he said, "Sit down!" Mr. Lastfogel started telling his story, about how when he was a kid he could have worked for a tailor or for the William Morris talent agency booking vaudeville. He chose William Morris *because it was a couple stops closer on the subway from his house.* He didn't say that he loved show business, just that William Morris was a few stops closer on the train. If he'd gone to work for the tailor, would he have become Levi Strauss? I wonder how often anyone thinks of that.

THE CANDY MAN CAN

JAFFA: Emile Schelette was Mr. Lastfogel's driver. One day Emile was sick. He called in and said, "I need someone to replace me. I want Jaffa. He'll know how to handle Mr. Lastfogel."

I sat at the desk and got my instructions. "He'll walk in about this time. The phone will ring about ten minutes after he arrives and it will be Colonel Parker. Put him through. Present Mr. Lastfogel with the list of movies playing in Westwood and he'll tell you which he wants to see. Drive him there and back. And most important, do not let him eat any candy."

I said, "Great. Fine. I'm there." I was a little nervous.

Mr. Lastfogel marched in. He had a certain gait. He held his lapel, and his other hand moved like a toy soldier's. It was incredibly endearing. I gave him the trades and set up everything for the morning. Ten minutes later the phone rang. I answered. "Mr. Lastfogel's office."

A gravelly, brusque voice said, "It's Colonel Parker."

Mr. Lastfogel picked up the phone. They talked for about ten seconds.

Then I showed him a list of the movies that day. A couple had WMA clients, but he picked *Christina F,* a German movie about a girl who gets hooked on heroin at a rock concert. I was horrified. I said, "But Mr. Lastfogel, these other two have our clients."

He said, "No, no, no."

I got the car—a big black Cadillac—and pulled it around the front. A couple of older secretaries walked him out, concerned about this kid taking care of the boss. He decided to sit in the front seat with me, and they were floored.

As we drove he started talking. "How long have you been at the agency?"

"About seven weeks."

"I've been here a little bit longer. About seventy years."

I said, "That's a long time."

He said, "Where you from?"

"Texas."

"You know what? I knew a guy from Fort Worth, Texas. What was his name?"

I thought, Who would he know from Fort Worth? The only older, famous person I could think of was the guy after whom the TCU [Texas Christian University] football stadium is named, so I said, "Amon Carter?"

"That's it!" he said. And he meant it, because he told me an Amon Carter story.

I dropped him off in front of the gigantic Village Theater in Westwood and asked, "Do I need to pay for you?" He turned around and didn't say anything. I watched him stroll right past the ticket booth, right past the usherette, right past the ticket taker. I guess they all recognized him.

I parked the car and walked into the lobby. It was 11:15 A.M., and deserted. I heard this "Psst! Psst!" I looked around and there was Mr. Lastfogel, standing at the concession counter.

He said, "Go find us some seats and I'll get us some . . . candy."

I said, "You know what, Mr. Lastfogel? I don't think I'm allowed to—"

He looked me right in the eyes and said, "*Go get the seats.*"

The theater was a cavern. Empty. The sound was too loud. Mr. Lastfogel walked in with a Nestle's Crunch bar the size of a Chihuahua, a big Coke, and a double popcorn. What could I do? I didn't know what was worse: to piss him off or for him to die in my care.

Early in the movie, Mr. Lastfogel leaned over to me and said, "Strange picture." In the rock concert scene, sure enough, the girl started to shoot up. As soon as she put the needle in her arm he said, "Okay, I've seen enough."

It was a very sunny day. We walked to the parking lot and I went to the kiosk to pay. While dealing with that, I could see Mr. Lastfogel by the car, hunched over, scratching at his crotch. Scratch, scratch. I didn't know what had happened, and I feared the worst. I paid and walked over. I could see that he had Crunch bar all over his pants.

I said, "Did you get some chocolate—"

As soon as I said that he straightened up and grabbed his lapel like nothing happened. He was a complete stone face. I opened the door for him. This time he wanted to sit in the back, and he wouldn't talk to me. He started telling me stuff like, "Two hands on the wheel . . . Turn on your blinker." As I drove, we played this game: Whenever I looked in the rearview mirror, I could see him staring back at me; whenever I looked forward, I could see him out of the corner of my eye, scratching at the chocolate. When I looked in the mirror, he bolted up again.

Back at the agency I wasn't sure what to do. I asked, "Can I get you anything?"

"No," he said. "I want you to go home."

"But I have to go back to work and—"

"I want you to go home."

I went to the mailroom and said, "Mr. Lastfogel has dismissed me for the rest of the day." I guess he just wanted to get me out of the way, in case I might tell someone. Or maybe he wanted to protect me because

he knew he wasn't supposed to have any candy and I'd get in trouble. I never found out.

YOU HAD TO BE THERE

JAFFA: I was running up the stairs when I saw Clyde Ravenscroft, who helped run the mailroom, behind me. I turned around and sucker-punched him, like I was going to hit him in the stomach—but didn't. He reacted by grabbing his chest instead. When I looked up I realized it wasn't Clyde at all, but Rock Hudson after his heart surgery. I said, "Mr. Hudson, I'm so sorry, so sorry." He grimaced and said, "It's okay."

RABINEAU: I made a classic mistake my first week. Standing in front of the building with a box of some shit, I saw Lenny Hirshan also standing there, playing with a little kid. Lenny was probably in his fifties. I walked up and said, "Mr. Hirshan, your granddaughter is really cute." He said, "That's not my granddaughter, that's my *daughter*." He hated me the rest of the time I was there.

ADELSTEIN: My car broke down on Sunset, in front of the Bank of America, in West Hollywood. A black girl walked up to me and said, "Hey, you want a blow job?"

I said, "Nah, I'm working."

She said, "Wait. Are you Marty . . . Adelstein?"

What? I said, "Yeah? . . ."

She said, "You don't remember me. I was in your health class at Venice High School. What are you doing?"

I said I was in the William Morris training program. She said, "I used to have a drug problem, and now I'm trying to get it together."

COHEN: Jordan Baer was a very gregarious, energetic guy. One day he said, "Let's go to Vegas—right now!" We jumped into my car, a little two-door, sporty Audi, in our ties, and got toothbrushes there. My aunt and uncle owned a cheap motel in Vegas, and we scored rooms for free. After the third or fourth trip, David Lonner, who had also come along, finally admitted that he hated Las Vegas but that he went for the car rides. They were classic. We made lists of the top ten movies, the top ten *Twilight Zones,* the top ten women we'd like to sleep with. People

started hearing about our trips and, next thing we knew, there were sixteen of us, then sixty. We had to rent a bus.

RABINEAU: Marvin Pancoast ran the copy machine downstairs. He wasn't in the training program, just the Czar of Copy, a tall, skinny, effeminate guy who was friendly but could be pretty officious. Once, my car broke down and he drove me to pick it up. Little did I know our Marvin would wind up killing Vicki Bloomingdale. So bizarre. Now he's dead. Died in jail, of AIDS.

UNDER THE VOLCANO

JAFFA: Stan Kamen's new assistant was chosen by his outgoing assistant, never by Stan. Jim Crabbe worked for Stan, and Edson Howard was on the morning desk, campaigning hard to be the new assistant. I wanted it, too, and became Johnny-on-the-spot for Mike Simpson, who had worked for Stan before Crabbe. I also ingratiated myself with Crabbe. I got the job. We had all sorts of expressions for working in that office. Cary Woods, who followed me, used to call it "under the volcano."

WOODS: Stan's desk was the only desk at William Morris where you were pretty much guaranteed a promotion. I began to understand it all when a producer told me that working for Stan was like clerking for a Supreme Court justice: Knowing that, I focused on nothing else.

JAFFA: I had to choose between Cary Woods and Bryan Lourd. Bryan and I had a weird connection because his mother had gone to a school in Texas that I'd played football against. But Cary worked harder. And Cary actually came out and asked me for the desk. He took me to dinner and said, "Listen. I've busted my ass. I know Bryan is great, but I really want it." So I told Bryan that Cary was going to get the job. Bryan got offered another desk, went into TV, and obviously did fantastically well.

WOODS: Rick also knew that if he didn't bring in the right guy, Stan would have no problem with Rick suddenly becoming an assistant again. I reassured Rick: "There's nothing Stan can do to me that would make me leave the desk. I'm going to be here no matter what he does, and that means you're going to stay in your office and be an agent unless he fires me."

• • •

Six weeks after I started working for Stan he still hadn't said one thing to me of a personal nature, but eventually the ice broke between us because Stan got very sick. He worked out of his house in Malibu. I drove there twice a day, to bring his mail and his phone sheet. I'd stick around and make some calls for him. He didn't want people to see him—he was losing weight and all—but I was one of the few allowed close. That created a bond that I'm not sure would have happened if it had been a more typical working situation.

Stan's illness felt like a tremendous amount of responsibility. He was universally respected in the community. Clients kept calling; they knew he was sick. I did as much as I could to navigate some to other agents who could help, but I had to be careful because there were certain clients Stan wanted to talk to up to the end.

I worked for Stan a little over two years. He told me about a year and a half in that I should start thinking about finding somebody new because he wanted to promote me. At that point I had so much to do that the idea of bringing in a green kid from the mailroom and giving him to Stan felt like abandoning ship. I told the William Morris board I was going to prolong the search until Stan "was better." That's the way that I phrased it, and they knew that I meant better . . . or not. They were appreciative and told me so. I just hung in there.

I didn't realize Stan was going to die until the end. Nobody knew. AIDS was a recent phenomenon, and I didn't know any more about it than anyone else. Not that anyone around Stan ever used the word *AIDS*. He had "lymphoma." The question is whether he knew what he had. I can speculate, but he never said the word *AIDS* to or in front of me. Stan was not out of the closet.

I was Stan's last assistant and, as such, subject to the speculation that I'd be "the next Stan Kamen." I downplayed it as much as I could. It would be like playing center field and saying you're the next Mickey Mantle. You don't want to go anywhere near it. You just want to do the best that you can, and hope that you've learned a lot, and do a good job. Bobby Murcer followed Mantle, and although I think historically he was thought of as a disappointment, he had a pretty good career.

JUST MAKE ME LOOK GOOD

TOLMACH: I got my desk after I did coverage for Bob Crestani on a script called *Devil Jocks from Hell High*—a B-movie about Satan's football team. Crestani's client loved the coverage. "That makes me look good," he said. "That's what this is about. You did a good job."

Crestani was promoting his assistant and said, "If you want this job, I'll pull you right out of the mailroom. I'll have to break a company rule. This isn't supposed to happen, and a lot of people are going to be upset, but I'm betting on you. Don't fucking disappoint me."

I said, "I have no plans to disappoint you."

LOURD: Larry Auerbach's secretary, Heidi, asked me to cover Larry's morning desk, a tradition that had been all but wiped out because it was too competitive. Then, out of nowhere, she said she was moving to New York in four days. I'd been in the mailroom for six months and I begged Larry for the job. He pulled lots of strings, and I got to skip Dispatch. One of my proudest accomplishments is never having driven a car for William Morris, and as a result, I don't know how to get home now.

I was Larry's secretary when he put *The Cosby Show* together. Just the idea that Larry could call up Bill Cosby and say, "I have this idea, whaddaya think?" amazed me. He introduced Cosby to the producers, Carsey and Werner, two days later, and made a show happen that not only affected business but became part of the national conversation. Norman Brokaw takes credit for it, but Norman was the second call. I don't want to start a war between them, but that's what I saw happen.

Larry also taught me about lox and bagels. I was the classic, non-Jew kid from Louisiana who didn't know what *putz* or *schmuck* or *bagel* or anything was, and he was the quintessential William Morris years-at-the-company Jewish kid from New York. We were certainly the odd couple. One morning, Marcy Carsey, Tom Werner, and Cosby came in for an early breakfast. Larry said I had to get food for everybody. I went to Winchell's and bought all the doughnuts I could, then laid them out really pretty in his office.

"What's this?" Larry barked.

"Breakfast."

"No one eats this."

"What do you mean?"

"Where are the bagels and lox?"

"I don't know what you're talking about." He screamed, and I found out not only about lox, but what *putz* and *schmuck* meant, too.

RABINEAU: I was on Ron Mardigian's desk, a guy I thought the world of. One of the real gentlemen. He had this elaborate buzzer system in his office. A circuit went from his desk to my desk, and there was a code: one, two, and three buzzes. One meant "licorice." Two meant "Sanka." Three meant "butter toffee peanuts." I'd be sitting at my desk talking with someone, and I'd hear *annnnnnnhhh—annh annh—annh annh annh* and have to jump up. Whomever I was talking with would say, "What the fuck are you doing?" It was all pretty humiliating. A subtext of daily belittlement. And yet it could have been worse. My friends worked for people who screamed, threw shit at them. They were physically and emotionally battered. I got off relatively easy.

SWOFFORD: I worked for Judy Scott-Fox, who'd never had a trainee before. But we just hit it off; she was like another mother to me. Judy told me stories about the old days, about working for Peter Cook and Dudley Moore when they first came out of school, about dating Sean Connery. She was a class act, principled, worked hard—and included me.

Three months after I started with Judy, she discovered she had cancer. She worked from home, did chemotherapy, and fought for her life. Because of her illness, I stepped into semiagent mode pretty quickly. I knew everything going on with everyone and I spent a lot of time with her, so I became a clearinghouse. I made sure business was handled. We were scared because we were all worried about Judy—and she didn't want any balls to be dropped. It didn't work then at William Morris the way it works now at CAA, where everyone works in teams. Judy was always one-on-one with all her clients. The only one.

I really changed because of Judy's cancer. I learned that life is short. She went into remission, came back to the office, but got sick again quickly. I think the job stress brought it on. I learned to value my time, to spend it on people who rewarded me back.

CAME AND GONE

LONNER: Alan Berger, a hot television packaging agent, was a really nice guy. I wanted to work for him. A bunch of us campaigned for the desk. I asked Tanya Lopez, a young agent very close to Alan, for her advice. She said Alan ate breakfast alone every morning at the Beverly Wilshire Hotel. I thought, Do I want to barge in on breakfast? Was it too aggressive? I did it anyway. He was at breakfast, reading the trades. I said, "Alan, can I talk to you?"

He said, "Have a seat."

He called me about five o'clock that evening. He said, "You want to work for me?" That was a great moment.

HARBERT: I bonded with David Lonner and made a point of being his guy in the mailroom to help him with Alan Berger. Then Berger left for ICM, along with Lonner and Tanya Lopez. It was a big thing, security guards in the lobby. Slowly but surely, I got the message: "Alan's gone. You don't really have a foothold here anymore." Because I was Alan's guy, people thought, "Maybe he *knew* Alan was leaving." Of course, I had no clue.

I managed to hold on until I got another big surprise.

During the summer someone in Personnel called all the trainees' colleges to make sure they graduated. Boston University told them I didn't graduate, that I was a credit shy. David Goldman brought me into his office and accused me of lying.

I thought I *had* graduated, and I was stunned. "What are you talking about? I didn't go to graduation, I didn't get drunk with my friends, I didn't go backpacking around Europe—all because I wanted to come and push your mail cart around."

I called the school and found out that Goldman was technically, legally, correct. I'd received an incomplete I hadn't known about. I had no problem with that. But I *did* have a problem with the way he'd dealt with it. I thought, You guys don't get it. You're old, you're soft, you're babies. *You* don't work hard. What I actually said . . . I don't remember. I probably was respectful and polite, because that's the way I was raised.

Goldman gave me a week to resolve the issue. I flew to Boston, wrote a paper, and took a test. I came back with a letter, signed by the regis-

trar's office, with the official BU stamp. But I told David Goldman I didn't think I wanted to be at the agency any longer, that I was sorry things hadn't worked out. He said, "Okay, fine."

I called Alan Berger at ICM and he said, "Come in tomorrow."

STEVENS: I lived in the Music Department, where they were thinking of putting me anyway. It was easy. The music guys were loose. Deadbeats. It was the path of least resistance. I got Kevin Scott's desk. He was booking one-nighters, getting a run of dates for Yngwie Malmsteen. He had his own tiny plane and was on the road a lot. I could sit in his office and listen to records. I became a little mogul within my circuit. To the Meat Puppets I was a guy on the inside. I tried to convince William Morris to consider the Meat Puppets and Hüsker Dü, but they were, like, "Fuck you."

Then William Morris made a big deal with Triad and brought over their Music Department, headed by John Marks, a guy with a vest. He was supposed to be the savior and Kevin Scott was going to report to him. I went to Marks and said, "I saw this band called Guns n' Roses last night at the Whiskey. They're playing one more night. They have no record deal. I think they're awesome."

He said, "I'm not going. We already represent all these hard acts." Then the Meat Puppets made a major deal, but William Morris said no to booking them; Hüsker Dü made a major deal with Warner, but William Morris said no. I thought, Okay, I'm outta here. They didn't even want me to do what they wanted me to do—use my assets to get them to the next level.

I went to see Walt Zifkin. I said, "Walt, I want to learn the actor business."

He said, "We don't do that at William Morris."

I said, "What do you mean—that I selected a major and I can't change it?"

"Right."

I left.

TOLMACH: Bob Crestani had said to me, "I'm going out on a limb for you. If you quit, you make me look bad." Unfortunately, I'd realized I wasn't agent material, so one day I showed up at Crestani's door and said, "Bob, could we have a moment?"

"Yeah, come on in."

I closed the door. I hemmed and hawed: "You've been nothing but

kind. . . ." My voice was shaking. "You've been so good to me and took the shot, and I just don't feel that I can—"

He said, "You're leaving. And you're leaving before bonus time. Not a smart move." Again I thought, I'm not cut out for this.

Crestani was kind. He said, "I want you to stay in touch because maybe I'll represent you someday." And he did.

RABINEAU: I was completely ambitious and driven, yet still clueless about the internecine workings of William Morris and how to behave with certain people. It took until my boss fired me to really get the game and realize the whole thing was a fucking sham.

I was about eighteen months to two years in when an agent in our department left to work at a studio. My assumption was that I'd be the next guy promoted. I campaigned very hard for it, and Ron Mardigian said, "Come in tomorrow at seven-thirty, we'll talk."

The next morning he said, "I'm going to let you go."

"Huh?"

He repeated himself, then added, "I don't think you've really got what it takes. I don't know that you have the constitution that you need to be an agent here. I'm going to give you two weeks to get your shit together. I'll help you find a job."

I didn't understand. I had worked for this guy for a long time, trusted and admired him. He was my first and only desk. I read a script a night and had come in on Saturdays. We got along great. It came as a complete shock, and it hurt because Ron Mardigian was my rabbi at the Morris office.

In retrospect, I've gotten philosophical about it and thanked Ron. If I was ever in any danger of becoming a lifer there, he saved me by throwing me out of the nest. And it got me really fired up. I was determined to prove him wrong. I got a job at another agency and built up a pretty good little business. Then I went to ICM for twelve years and was head of the Literary Department. During that time Mardigian called me and said, "Won't you come back and work for me?"

I said, "How about this—why don't you come work for me?" We both laughed. It's our ugly little secret. Nowadays we have lunch once a year, but then it was a terrible blow. I felt completely betrayed. My first kick in the nuts as an adult.

ADELSTEIN: At William Morris I was the wayward kid. I wasn't mature enough to get the bigger picture. I had to do it on my own and learn it

on my own. Now I see that most of the people in the mailroom are afraid of me. It's ironic. Now *I've* become the adult. Sometimes it's hard for me to accept that position. I still feel like I'm one of them.

WOODS: I used to compare William Morris to the Yankees. It was an old company, and people would always put it down because it was so ancient and out of step, especially after Stan Kamen died. The fact is, if you're this old, you should be one of the most esteemed things in the world. When I was there, I said they should hire some documentarians to produce the last hundred years of entertainment as seen through the eyes of the William Morris Agency. I wanted to get the Burns brothers to do it. Who's not going to see that movie? You'd get permission from everybody. There are five thousand and some-odd members of the Academy of Motion Picture Arts and Sciences. Every single one of them has, at some point in his or her career, been represented by the William Morris Agency. That's when it hit me. I was producing a concept for a movie. I figured I should get the fuck out of there and go produce movies if that's what I wanted. And it was.

LOURD: Each mailroom generation has its own particular ambience and ethos. I feel like my class missed the drugging of the seventies, and the clubs and the scamming, and consequently the communal bonding. My friends were friends from school. I worked all hours of the day and night. I was afraid if I didn't, I wasn't going to make it.

The training program made me more confident. I appreciate now the tradition and the sharing of stories. I've heard Diller and Geffen and guys like that, whom I admire so much, talk about their experiences. They have lots else to talk about, but that those old days always come up is significant. Usually all it takes is more than three agents or former agents in a room. Diller told me the story about gluing someone's shoes to the floor. He was laughing the whole time.

• • •

BRUCE KAUFMAN heads the motion picture department at the Broder, Kurland, Webb, Uffner Agency in Los Angeles.

RICK JAFFA is a screenwriter/producer.

CARY WOODS is an independent film producer.

BRYAN LOURD is a partner at CAA.

MARTY ADELSTEIN is a manager, producer, and partner at Original.

STEVE RABINEAU is a partner at Endeavor representing directors, writers, and actors.

DAVID LONNER is a partner at Endeavor.

ANDREW COHEN is a talent agent at ICM.

NICK STEVENS is a managing partner at UTA.

MATT TOLMACH is executive vice president of production, Columbia Pictures.

BETH SWOFFORD is a motion picture agent and partner at CAA.

CHRIS HARBERT is partner and cohead of the Television Department at UTA.

BROTHERS IN ARMS

Creative Artists Agency, International Creative Management, InterTalent, Los Angeles, 1986–1990

BRIAN MEDAVOY • KEVIN MISHER

Wherever you come from, your mailroom experience is your hometown in Hollywood.
—Barry Mendel

KEVIN MISHER: I always had the show business bug, but in the eighties a well-intentioned student went to business school. I got into Wharton, but I also took a small filmmaking class and subscribed to the *Hollywood Reporter*.

Every good graduate of Wharton went to Wall Street, and I did the normal interview process. But I also sent letters to the CEOs of big entertainment companies, asking for a break. The text was earnest and breathless, like "I've got to have this or I'm going to die." I wrote PERSONAL AND CONFIDENTIAL on the envelopes. I sent one to Michael Fuchs, who then ran HBO. I later learned that he got the letter only because he had a temp the day it arrived. He responded by sending it to Jeff Bewkes, then their CFO. I met with Bewkes and got a job working on their annual budget.

I was still restless. Bob Conti, a writer who still works at HBO, hired me as a reader after I gave a good recommendation to a script called *Rain Man*. I did finance during the day and read at night. When I asked him how I could pursue the creative side, he said, "Get to California."

In one week I got rid of my apartment, broke up with my girlfriend, and moved. My grandmother said, "We're never going to see you again!" My mother started crying: "Oh, my God, you're going to be a waiter!" My father came with me for a week. We set up my apartment,

got a car. I had a little money saved, but my parents also threw me some shekels.

I sent letters again, and just to give a sense of how green I was, I looked for offices where I could literally ring doorbells, meet people, and drop off some résumés. In the yellow pages, Paramount Pictures was at 5555 Melrose. I'm such a New Yorker, I drove around looking for the largest skyscraper I'd ever seen. I literally drove by the studio five times.

I met Marty Caan, a cousin of Jimmy Caan, at Kings Road Entertainment. He came from Queens. He'd gone to my high school. Marty said, "Let me see if I can help a kid from the neighborhood. You should be an agent." He said it was the time-honored way to get into the business—and it had worked for him.

Marty called four agencies. ICM moved really quickly. I talked to Steve Rabineau. He walked me over to Jeremy Zimmer. The interview with Zimmer was completely bizarre. All the shades were half flipped, and his face was like Kurtz's in *Apocalypse Now*. He was on the phone, wandering around and spinning its unbelievably long cord. His desk was dark marble, more opulent than anything I'd seen in an office. Zimmer's assistant, Barry Mendel, stayed in the room. I sat there in my one suit, a gray button-down banker's uniform. I was petrified. But it must have gone well because they offered me a job.

Within five years it became de rigueur to graduate from an Ivy League school, pass on Wall Street, and get into the media business. As for me, as the director Mike Newell has said: "I never knew my itinerant life choice would become a good career move."

BRIAN MEDAVOY: It was difficult growing up as the son of a Hollywood executive. It would have been a lot easier to be like Kevin Misher, the son of a dentist, who came from Bayside and was completely under the radar.

I had a dysfunctional upbringing. My father was at the pinnacle, building Orion and United Artists Pictures, making movies like *Rocky* and *Annie Hall,* but he was not around much. I've been through eight family marriages, four by my mother and four by my father. I've been in seven different schools.

At first I didn't understand why, but my father also never gave me a penny. Unlike a lot of the other executives' kids, I didn't drive around in a Porsche. My dad got me a Scirocco, and I had to pay him back. I

drove that car for thirteen years. For a while I was really bitter about it, until I understood it was just the hand I was dealt.

Since my father didn't give me money, I had to work every summer. I took jobs on an experimental basis, to see what I liked. My first was delivering pizza through Bel Air. I was a bag boy at Drager's. I worked as a waiter. One summer I worked as a PA on a movie that my father did called *Under Fire*. I didn't like it. The next summer I worked for Rogers and Cowan, in PR. Didn't like that either. All the jobs were my idea. My father never forced Hollywood on me. He didn't believe in nepotism. He said, "Make it on your own." But the truth is that from the tenth grade on I wanted to be an agent. I never told my dad, though. I'd just be in class thinking, What the fuck am I doing in this class when I'm going to be an agent?

I wanted it for many reasons. One, it was in my blood. Two, life is competitive, and, nepotism or not, I had an in I'd have been a fool not to use. Three, today we're in the information age. Back then, the agency world *was* the information age. You were in the middle, between the buyers and the sellers. You had access to an incredible amount of knowledge, and I thought that was important because I understood Hollywood just through osmosis. Being around my father's group—Michael Ovitz, Michael Eisner, Peter Guber, Jeffrey Katzenberg—I learned what made them successful. I could tell who was real and who wasn't. My father also brought together an eclectic group of people at the house, everyone from Jerry Brown to Pat Benatar to Connie Chung.

In 1984, when I was at UCLA, I was a summer camper at CAA, a temporary job that connected kids got. I worked from three to eight, after school. I distributed, I copied, I floated on desks. But I was not well accepted by my peers in the mailroom. If you're a son-of, you're always under the microscope, and people often feel things have just been handed to you. The show business world breeds insecurity and fear. The attitude of those who didn't get to know me was "Of course they're going to give Brian Medavoy a job here. *We* had to go to Wharton. This punk comes in, this rich kid . . ."

I certainly wasn't perfect. I took it a little easier. I showed up late. I goofed off. I could be arrogant and cocky and flamboyant. I wasn't going to try to win everybody over; I just wanted to figure out who I wanted to be.

However, most of the *agents* at CAA took me in. I spent most of my

time sitting in Rick Kurtzman's office, where I watched everything, read everything, schmoozed. I made the most of it.

I also got to watch a brilliant man—Mike Ovitz—build his business. I remember seeing Ovitz's list of client hobbies, and I learned why he didn't just buy clients champagne and flowers. He gifted them in a way that made each of them feel that they were the only client he represented.

• • •

After college I applied for a job at ICM. I didn't go back to CAA because I hated Dispatch. After a Friday night run out to Sam Elliott's house in Zuma, I was drained.

I went through six or seven training panel interviews at ICM, starting with Anna Adler and ending with Jeremy Zimmer. Jeremy was really tough on me. He asked strange questions. I came out dripping sweat, but I don't think there was any way they could not have hired me unless I'd fucked up pretty badly. I probably had the job even before the interview process began. And I probably could have worked on a desk very easily—hey, my father was a major buyer—but it would have created more resentment. I decided to start in the mailroom in hopes of creating a level playing field. I wanted to do all I could to lessen the threat of my family name.

It didn't work. On my first day I was pushing the mail cart down the hallway, and Zimmer stepped out of his office and said, "Oh, look, it's Medavoy's kid handing me my mail." Loudly.

MISHER: Brian and I started on the same day. I had no other friends in Los Angeles, certainly no guy friends. Being the same age, we bonded from the beginning.

MEDAVOY: Kevin didn't know a soul. I introduced him to his first celebrity: Justine Bateman.

MISHER: At first it was like rushing during pledge week, plus ICM was unstructured and it was hard to pin down clues on how to act. Yet I had the sense that whatever there was to "get," Brian got it. I just wanted to lean on somebody, and his was the shoulder I picked. Brian was unbelievable at the game because he had grown up in it. We'd get into parties with the right people, or be at assistant parties in the backyard with a keg and a hundred people standing around on the lawn. Suddenly I began to have a network of people who were in my "class." I always thought it was amazing that the way people treated you was based on whom you worked for. Now that I have some perspective I re-

alize that everyone has an agenda and is schmoozing, and everybody is trying to work everybody else. It's like a tennis game: Everybody's trying to play with a better player.

MEDAVOY: What I loved about Kevin is that he looked at me as just Brian, not "Medavoy's kid."

MISHER: I unknowingly passed a test of sorts. Hey, we were both miserable in the mailroom, not because of our origins or because it was stressful or work-intensive. We just weren't using our brains. My friends from the East would call up and say, "So, what is being in the mailroom a euphemism for? What do you do all day?"

"Nothing," I said. "I deliver mail, I sort mail, I Xerox."

MEDAVOY: It was brutal. Kevin made it bearable because we spent a lot of time in the freight elevator trying to figure out how to get out of the mailroom.

MISHER: It felt like we were plotting to overthrow Hollywood. What we were really saying was, "This sucks. How do we get to the next step?" The good news and the bad news were that there was no real order in the ICM mailroom. You could be in it for a month or a year. The ICM program was like the wild, wild West. Fortunately, Brian was interested in the Lit Department and I was interested in Talent, so there wasn't any turmoil between us. We were able to support each other.

MEDAVOY: I was more ambitious than I had ever been, and I worked as hard as I could. When I was ready to take it to the next level, I wanted to work for Ed Limato because he was the man. Whenever Ed Limato turned around, I was always in his face, asking if he needed coverage or if I could do anything for him. I knew everything was timing. Then I heard a rumor that he wouldn't hire me because I was Medavoy's kid. I walked into his office and asked him, and he said it was true.

I said, "Well, I want to work for you. I'll work my ass off."

He was still reluctant because Michelle Pfeiffer and Richard Gere had deals at my dad's studio, Orion. It was the height of Limato and my dad's relationship, and if I worked for him, I'd have to listen in on the phone calls, and he was very concerned about confidentiality. I can understand that in some regard, but I was relentless. I kept going back. One day I just walked in—I always used to just walk in; people were threatened by that, too, but I have no fear—and said, "I will not repeat a thing. I understand your concerns, but I can't take a no. This desk is opening, and I want this job."

He said, "Okay."

MISHER: The tenth-anniversary Hard Rock Cafe television special was being shot on the Universal back lot. John Cougar Mellencamp played, Dan Aykroyd hosted. The invitations had come to the mailroom addressed to the agents and some clients. A few of those agents and clients were no longer with the company; we were supposed to mark those invites RETURN TO SENDER. Of course, one of the rules you learned as an agent wanna-be was to do whatever you could, short of criminal activity, to meet people. I wanted to go to this party. I grabbed an invite and RSVP'd. Now I had two tickets. I called a friend and asked her out.

We were standing in a clump of people trying to get a drink; Jim Wiatt, cochairman of ICM, was behind me. I turned around and said, "Can I get you a drink?" I had met Wiatt at the William Morris–ICM softball game. As guys playing sports do, Wiatt and I became friendly, even though he was a humongous authority figure.

The next day I heard that Wiatt was on the warpath because he couldn't understand how all these trainees got to the Hard Rock party. He was calling assistants and trainees into his office to find out. Eventually the phone rang for me: "Can you come up in a moment? Jim would like to speak with you." Instantly I knew I was completely busted. On the walk up I contemplated saying that Brian took me, because Brian got invited to everything.

Wiatt said, "We're going to have a short, unpleasant conversation. How did you get to that party last night?"

I told him the story. He shook his head and said, "The integrity of the mailroom has to be preserved. You're either fired or you're going to resign."

I didn't know what to do. I crossed my legs, twice. I thought I would start crying or pee in my pants. In the back of my mind I remembered someone saying that if you resign, you don't get unemployment, and if you get fired, you do. I'm certain that's what made me have a little bit of gumption. I said, "I'm not going to resign over something like this, so you're going to have to fire me. But I just want to tell you, I think this is insane. If you ask around, you'll see that I'm doing real well here and that people would speak up on my behalf."

Wiatt said, "I've heard only great things about you, but it's not the issue. This isn't about you and me. You can't do that in the mailroom. You're either fired or resign."

I started to say something more, but the phone rang and he said, "Excuse me for a second," and took the call. I broke into tears and walked to Anna Adler's office, certain I'd been drummed out of the business forever. I said, "Jim Wiatt fired me." She couldn't believe it, but I had to leave the building immediately. I've always wanted to add a security guard escort to the story, but it didn't happen [*laughs*]. I went home and lay on my bed. I probably cried the rest of the day.

Wiatt has since told me, "I made a mistake. It would have been good to have you working at the company." That took a while to happen, and now we're great friends. He asked, over a lunch, "Do you still harbor resentment?"

I said, "No, I understand what you were trying to do. I was just a kid. A slap on the wrist would have been a little easier, but . . ."

MEDAVOY: I was Ed Limato's second guy, in the outer office. Chris Andrews was inner office. I answered the phones, Chris listened in on the calls. I sent out letters, got Ed's coffee and his lunch, walked Ed to his car, set up booking slips. I hated it. I sucked at it. I didn't respond well when he yelled at me. I made a lot of mistakes. I dropped calls. I was nervous. I had to file; I hated filing. Sometimes I'd throw files underneath the desk. Chris was a robot. I hated the hours, I hated being the son-of. The pressure built. So I quit.

Jim Wiatt said, "If you leave, I'll never speak to you again."

It was tough because even though I was a fuckup, I was actually starting to get liked. I had helped do a report for Jeff Berg—the other ICM cochairman at the time. He'd assembled teams of four people each to do reports: on distribution, production, development. We had a month. Our team was Kevin, Chris Harbert, and Steve Friedman. We won a thousand-dollar check.

But in the end that didn't matter.

I handled my talk with Wiatt poorly and left.

MISHER: Jeremy Zimmer and Steve Rabineau tried to get me rehired, but it didn't happen. On Rosh Hashanah, Rabineau spoke to Bill Block at InterTalent and said, "We just lost a good kid. You should meet him if you need anybody for your mailroom."

Getting fired by Jim Wiatt was the best thing I could have had on my résumé for Bill Block. Block, who'd been at ICM, had helped form InterTalent six months earlier. They were just promoting their first person out of the mailroom and had only one kid, David Greenblatt's

brother-in-law, left in there. Tom Strickler, who'd come over from CAA, didn't have an assistant, so he got Greenblatt's brother-in-law. That left room for me. I met with Tom on Yom Kippur. Tom walked me in to meet Bill, and then I met David Greenblatt and Judy Hofflund. They hired me on the spot. I started the next day.

If ICM was the wild West, the InterTalent experience was like charging the castle. We were Robin Hood and his gang. We were the rebel force trying to take it to Hollywood and do something different.

I was in the InterTalent mailroom for a day. Then Greenblatt's assistant quit and Block's assistant quit. I went to work for David and stayed with him a year.

I was probably a horrible assistant. I developed a stress rash that covered part of my face. I never knew what kind of skin condition it was. Some of my friends said that when they met me for the first time they thought I had horrible birthmarks. It only lasted six months, but it was hairy.

After David I moved to Bill Block's desk as my finishing school. I worked there for six months—then decided I didn't want to be an agent after all. I wanted to be more involved with the creative process. I had not moved to Los Angeles to make deals and set meetings for other people to be in rooms talking about the creative storytelling and movies and television.

Brian, who had also come to InterTalent, introduced me to his dad, who hired me at TriStar as an executive assistant—though he allowed me to tell the community I was a creative executive. Mike actually said, "You don't want a creative executive job. You executives go nowhere. What you want to do is be an agent and then jump over."

I said, "I really don't want to be an agent anymore. If you give me a desk, a phone, and an expense account, I'll take care of everything else."

MEDAVOY: I interviewed with Judy Hofflund. Judy was very tough to work for. I was at the office from 7 A.M. until 9 or 10 P.M., and I wasn't used to it. I was a party guy and I couldn't believe how much time I was spending trying to become an agent. And I was still a terrible assistant. I couldn't fucking type. She asked me to do coverage every night. I went home, called my friends at the various agencies, got their coverage of the same material, and retyped it. Judy found out about it. She yelled at me, but Bill Block said, "That's pretty resourceful." In Judy's mind it was "He doesn't want to do the work." In Bill's mind it was "Good for

him." But Judy's clients loved me, so she kept me. Also, I think she liked me as a person.

One day I heard the company was going to bring in David Schiff from CAA, and there was no physical space for me if they did. By then, not counting summers at CAA, I had been in the mailroom for a year and a half, on Ed Limato's desk for a year, and working for Judy for eight months. I needed to keep moving ahead.

I called my father and said, "Dad, they're going to bring an agent over from CAA, and there isn't space for me here if they do that."

He said, "Who are they bringing over?"

I said, "It doesn't matter."

He said, "Give me the initials."

I said, "Come on, Dad, I work here, remember? Don't play me for a fool."

But, my dad being my dad, I ended up telling him that it was David Schiff. The next day my father got on the phone with David Schiff; they were talking about a deal for Cheech Marin. My father said to David, "I hear you're thinking about leaving Ovitz and going to Inter-Talent."

Schiff called Bill Block and said, "How does Mike Medavoy know I'm thinking about coming there?"

Bill Block walked into my office and said, "Did you tell your father?"

I said, "Yes."

He said, "You're fired." He searched my stuff and walked me to my car.

I got in my car. I cried. I drove to my father's office at TriStar. I walked in—he was in a meeting with a director—and I said, "Excuse me, I need to speak to my father." I slammed my hand on his desk and said, "You just got me fired from a job. Do you realize how difficult it is being your son? You have screwed me. Screwed me." He felt terrible.

My father called up Ovitz's office and said, "Will you hire Brian?"

Mike said, "Have him call." I called Ray Kurtzman, and he said, "You can work for Marty Baum." As much as I loved Marty Baum, I knew I just wasn't going to learn from him. Besides, they were asking me to become an assistant again, and I said no. Afterward nobody would hire me. I did not have a job. I freaked out.

• • •

The only person who gave me a shot was Dolores Robinson, who had a small management firm. I worked for her for four months, then quit.

But in the elevator there I met Erwin More. We talked, and he hired me at Larry Thompson's company as a manager. It was tough, but I did well.

A year later Norman Brokaw asked if I wanted to be an agent at William Morris. I turned it down out of loyalty to Erwin. But a month later I changed my mind. I told Erwin, "I'm leaving to become an agent." Then I found out that William Morris had nixed me. So there I was, quitting a job thinking I had *another* job, and William Morris wouldn't hire me. Why? I heard that Alan Iezman, who ran the Talent Department, vetoed it because I had gone after one of his clients while I was at InterTalent—which is not true.

Erwin said, "Brian, why don't we start our own company!" I told my father and grandparents, and nobody thought I should do it; they said I couldn't stick with anything. But Erwin recognized things in me that maybe I didn't see myself. I figured, What do I have to lose?

Since my father had gotten me fired from my job, I asked him to loan me the $150,000 we needed. He said no. Flat-out no, before I even had a chance to finish.

Erwin owned a condo on Wilshire and Spalding worth $275,000. The bank took it as collateral and loaned us $75,000. We had two clients. Within six months, we created a television series, *Sweet Justice*, with clients Cicely Tyson and Melissa Gilbert. Erwin and I were together twelve years and he was a brother, a best friend, a partner. We were extremely successful, and I could never ever have it without him.

● ● ●

BRIAN MEDAVOY has moved on and is now a partner and president of talent management at Immortal Entertainment.

KEVIN MISHER was copresident of production at Universal Pictures. In July 2001 he opened Misher Films, a production company with a deal at Universal. Their first movie was *The Scorpion King*, a spin-off of 1999's *The Mummy*.

AS THE MAILROOM TURNS

International Creative Management, Los Angeles,
1989–1993

DEAN LOPATA, 1989 • BEN PRESS, 1991 • PAULA BESIKOF, 1992 • JODI GUBER, 1993

Here's the thing about ICM: Every rule they made
was made to be broken.
—Ben Press

DEAN LOPATA: My college roommate at the University of Miami wanted to be an agent and got into the ICM training program. I wanted to write and be in production, and was a PA on a movie of the week. But I hated it because I was just driving all over Los Angeles, dropping off stuff. One day he told me that the dispatcher in the ICM mailroom just quit. He said it was a regular gig, nine-thirty to six-thirty, you don't work overtime, you get to read the trades every day for free, you have a computer, and if you make friends with the copy room, you can probably get your scripts copied for free—and you get paid. I'd moved to Los Angeles with seven hundred dollars and had been doing standup comedy and improv. The job sounded great, especially considering the access and the learning potential. What more could I ask for?

BEN PRESS: My parents are in the clothing business: J. Press. Clothing is so boring. Fortunately, it was very laissez-faire around the house: You do what you do, whatever you love. For instance, my father had gone to the American Academy of Dramatic Arts. As a hobby, he produced Broadway plays. I grew up in the wings watching rehearsals.

I went to Middlebury College, in central Vermont, and steered toward politics. It was my dream to one day run for office—there's a lot of theatrics in that, too. I worked summers for Vice President George Bush. My mentor was Lee Atwater. After graduation I went to the Republican National Committee, where Lee was chairman. I was

his assistant and then, tragically, at age thirty-eight, he developed a brain tumor and within nine months of diagnosis passed away.

My whole life went into a tailspin.

My best friend from high school was Bobby Jaffe. His dad, Stanley Jaffe, has been president of Paramount and is now a very well known producer. Bobby and I went to boarding school together. After college he went to work for TriStar and then Columbia, as a creative executive under Dawn Steel. Stanley was producing *Fatal Attraction*. I was at loose ends. They both said, "You should be an agent."

I said, "Are you crazy? You mean a fat guy with a cigar who sits in a back room?"

"No, no, it's not like that. That's a stereotype. It's executive, it's corporate, it's very sleek." They were referring to Ovitz and how he had legitimized the agency business. I figured I could use my political training, and I did have a rudimentary background with theater and actors.

I flew to Los Angeles and stayed at Bobby's place. Stanley set up a couple of appointments. Both had prepped me: The mailroom was an anteroom to a larger world—but you had to walk through that room first. It was how you learned who's where, who's important, who's not, who you want to be, who you don't. Some people call it Dante's eighth ring of hell.

PAULA BESIKOF: I was at USC planning on law school. But after studying in Spain my junior year I started thinking that law school didn't really sound all that great. I'd be going into it solely to follow after my dad, also a lawyer.

I asked a friend interning at *Entertainment Tonight* if I could get a meeting there. To my surprise, the guy hiring was someone who'd hated me in college. But he gave me the job and we ended up great friends.

After that I interned at NBC in their talent department.

My senior year I grabbed a friend and said, "Let's go to the movies." I had enrolled in a producing and directing class, and as we waited for the next show I was telling my girlfriend how to produce. That's when the gentleman sitting next to me leaned over and said, "I'm sorry, but that's not correct."

His name was Robert Littman. He was an old-timer who had pretty much lost his career, but we talked for almost two hours and he said, "Why don't you come work for me?" I thought, Okay, another job for free, but who cares?

Littman had a schlocky office where I did literally everything and nothing. But I was aggressive and learned quickly, so he said, "You'd be a great agent." At first I was offended because when you think of agents you think "asshole." But I started to read up on the agencies and thought ICM sounded like a great place. I went in for my first of six or eight meetings during the Los Angeles riots. Then they put me on hold for four months. I thought, Oh, God, I'm not gonna get this, and re-signed myself to taking a class to study for the LSAT. Then ICM merged with InterTalent and brought in Bill Block, and I was called back.

Block was the last person to interview me. I used a family connection, Arnold Schwarzenegger, as my reference, to slam-dunk it. My father was also a Mr. California. When Arnold first came to this country, he didn't know anyone and didn't have much money. My dad helped him out legally, and they became friends.

I was the first person hired under the new regime. It was November 1992. It was a weird time to begin. The holiday season was starting, tons of people had been fired, and the halls were bleak.

PRESS: I went to CAA first. Walking in, I immediately thought of Space Mountain at Disneyland. Space Mountain is designed to make your heart race and make you scream. The CAA building, a monument to itself, was designed to do the same. It was all about power.

I was shuffled from one office to the next for a series of fifteen-minute meetings. The first was with a young guy who was getting his shoes shined while we talked. I thought, How could he be concentrating on me with some guy literally under his desk? That would never happen in D.C., where you couldn't even have the hint of any kind of subservience. Nonetheless, that first meeting got my adrenaline up. I thought, Okay, we're dealing with something different here. Washington is so frigging conservative and frumpy, even in a Democratic administration. Here it was Armani suits and Hugo Boss, and slick and very hip. I hadn't been in a hip environment in a long time.

ICM was the funniest experience of all. The old building, on Beverly Boulevard, was a seventies-looking thing. Really tacky. I thought, Oh, shit. If CAA was Hertz, ICM is Avis, the "We try harder" agency. I met with Alan Berger, who was very normal, not Hollywood. We hit it off. Instead of having to take twenty more meetings, I just met with Bill Robinson, head of the training program and one of the great old-time

agents. He never even asked me why I wanted to be an agent, only who I was, where I came from. Then he said, "So, can you start tomorrow?"

JODI GUBER: I was the firstborn, so I was like the son. My dad, a producer who ran Columbia Pictures and now has his own business again, always said, "One day you're going to run my company."

When I was at UCLA, Ray Stark, the famous producer and a family friend, told me, "You really should be an agent." I moved to New York and worked as a model instead. When I came back he said it again: "You really should be an agent." I went to work on *Last Action Hero* at Columbia instead. But this time I thought about what he'd said. Based on what I knew of my personality, I decided I'd be suited for the job. I'm very social. People like me. [*Pauses.*] I want to say this in the right way: I have a manner about me that makes people want to help me. I called Ray and said, "You were right."

I knew a lot of people in the business. I called Bill Block at ICM, John Burnham at William Morris, Jay Moloney and some other guys at CAA. After the interviews, I didn't want to be at CAA—I can't remember why. I didn't like the William Morris offices—too dark. I wanted sunlight. I decided on ICM.

I met with Jim Wiatt, Bill Robinson, and Jeff Berg. Jeff was concerned about hiring me because of my father. Brian Medavoy—with whom I'd grown up; our families are best friends—had been there a few years earlier and had gotten fired. I think Jeff Berg was afraid I was just a little rich girl. Also, he had a very good relationship with my father and didn't want to jeopardize it. I knew that meant I had to fight harder. I had to get the job not because I was Peter Guber's daughter but *despite* it. I found out afterward that the perception *was* "Here comes the little princess rich girl," but that they were very surprised because that's not what I am at all. Still, I was watched. I had more eyes looking over my shoulder than anybody else.

BESIKOF: ICM liked names. They loved a connection. Besides Jodi Guber, Scott Gertz was in the mailroom. Sweetest kid in the world, but not the brightest star. He clearly got in because his actress sister, Jami, was Toni Howard's client. Unfortunately, they abused him horribly. It was a climate of fear. You'd watch these trainee happy faces come in, and after three months—always three months—we'd say, "You have the ICM cancer." Three months and people were miserable. I couldn't name a person who was jolly most of the way through.

PRESS: From day one I had a philosophy: I was going to work my ass off during the day and then party my brains out at night. If I was a little hungover or a little tired the next day, I didn't give a shit. I was just delivering mail. I knew that *after* the mailroom it was only going to get harder and increasingly more difficult to get free time—so I wanted to have fun.

THE AGENT TRACK

PRESS: My colleagues on the agent track were Jim Rosen, a thirty-one-year-old lawyer who left his very secure, well-paying job in San Francisco; Daniel Saunders; and a woman named Pam, who accused us all of sexual harassment, ran out screaming, and never came back. I didn't do anything, but I know for a fact that one of the mailroom guys used to throw condoms on the floor and read *Swank* magazine to try and get a rise out of her. That achieved what at least one of the people in the mailroom wanted, which is less competition.

We also had Cecil Cox. He was unbelievable-looking. He could have been a runway model. He was better-looking than Denzel Washington, whose company he eventually ran. He did not have family money. He made it on his own. He worked with youth leagues on the weekend. People kept telling Cecil he should act, not try to be an agent.

Jason Spitz, now an agent at Endeavor, was also in the mailroom. His father was head of distribution at Sony.

The last guy, Dean Lopata, didn't want to be an agent. He became one of my best friends.

I netted $180 a week, if that. To be honest, I didn't depend on that money to make my rent. I had help and will be forever grateful. That kind of pay tends to breed a community of rich kids, and the mailroom becomes a class system that's perpetuated generation after generation. Nothing wrong with that, but that's what it is. You're not talking about your Better Chance program. It's not Scholarship on Parade. You're dealing with well-monied kids who, if they're pulling themselves up by their own bootstraps, are pulling Tony Lamas. When some mailroom kid tells you he couldn't make ends meet, it usually means he was still driving the Mercedes his parents gave him for his twenty-first birthday.

BESIKOF: Not all of us had money, but even in the mailroom you had to wear amazing clothes. My suits were seven hundred dollars apiece. All the big agencies expect a certain look. When the clients come walking in, they don't want you to be seen pushing that mail cart in an outfit from Sears; they want Armani.

THE BOYS' CLUB

BESIKOF: My first day, Mark Conroy, who ran the mailroom, said, "Go bind scripts." So I put scripts together, thinking, This job stinks. Meanwhile, every male in the agency except Jim Wiatt and Jeff Berg came down to see who the new girl was. They were looking for fresh female blood. It was like a revolving door. The first person to check me out was Warren Zide. He was notorious for hitting on all the girls at ICM. Another one was Ben Press, who was Ed Limato's assistant. I found out later that Ben had asked Dean about me and that Dean told him, "She's got a boyfriend, but I think they're on the outs. I'll monitor it."

At the end of the first day, Mark Conroy said, "Do you know who Howard Stern is?"

"Yeah."

"Your homework tonight is to watch a tape of his *Butt Bongo Fiesta* and report back to me."

They wanted to see if I could hang with the guys or whether I would say, "How dare you!" I'm the former, and I knew I had to take control of the situation. I watched the tape and the next day made some pretty rude cracks about it. After that, we all kind of made friends.

MR. BERG IS GONE FOR THE DAY

LOPATA: I had a reputation for practical jokes. The best thing I ever did to Ben was before I really knew him well. Jeff Berg went out of the country on a Friday afternoon, and he let his assistants go home early. All he needed was somebody to cover the phones and say, "Mr. Berg is

out of the country and unreachable until Monday." Ben volunteered right away.

Everyone was waiting for me in the mailroom. Jim Rosen said, "Ben's all alone in Berg's office. *We have to do something*."

I said, "Okay. Put him on the speakerphone and hit mute. I'm going into another office. Don't say a word." I dialed Berg's office from an outside line so my extension wouldn't show up on the phone display.

Ben answered, "Jeff Berg's office." He was all pumped to go.

In a voice not my own, I said, "Yeah, it's Brandon. Lemme talk to Jeff." Brandon Tartikoff. Ben said perkily, "Oh, I'm sorry. Mr. Berg's out of the office right now. He's out of the country and won't be back until Monday."

I said, "Fine. Lemme talk to Nancy Josephson"—ICM exec VP of TV, and daughter of company founder Marvin Josephson.

Ben said, "I'm sorry, Nancy's gone for the day also."

"All right. Let me talk to Carol."

"I'm sorry, Carol's also gone."

I said, "Who the fuck is running that place? Do you have any idea what's going on? If I don't have this fucking thing signed today, this whole thing is gonna fall apart."

Ben began stuttering.

I said, "Who are you? This is gonna fall apart because of you!"

He was, "I—I—"

"You gotta be kidding me," I screamed. "Jeff Berg left you in charge of his office? Who are you? What are you, a trainee or something?"

"Well, yeah, I, uh . . . I—I—I—I—"

"If this thing falls apart, I promise that you will never work in this city again." I could see through the window into the mailroom, and everyone was crying with laughter. This went on for about five minutes, until my accent broke.

Ben went, "Excuse me. Excuse me. I, um, I could be throwing my career in the toilet here, and God help me . . . is this Dean?"

I started laughing. A few minutes later he came down to the mailroom, his face red. He'd been in a panic, but he got the joke. It sealed our friendship.

JODI'S COMING! JODI'S COMING!

BESIKOF: Jodi Guber came in about a month after me. I kept hearing "Jodi Guber is coming!" I was afraid she'd pass me in the race to get out of the mailroom. Who was I compared to her? Then I met her. Jodi was funny and quirky. Hilarious. On the phone all the time, ordering from J. Crew catalogs. Her first day, I got a call that Ed Limato needed his dirty dishes cleaned. I looked at Jodi, smiled, and said, "Jodi, come with me. I'm gonna show you around."

> **GUBER:** I was, like, Oh, my God, this is gonna be a treat. Little did I know.

BESIKOF: The dishes were disgusting; they must have been crusted with days-old oatmeal. Jodi said, "Is this what it's going to be like every day?" I said, "Close." We both laughed. That was the beginning of our friendship in the Hollywood equivalent of boot camp.

> **GUBER:** I expected to set up coffee, deliver mail, do errands. I didn't know that I was also going to be a maid, but that was fine. I wanted to prove that I wasn't the liability they were afraid I might be. I did what I had to do.

BESIKOF: Really. When we moved to the new ICM building on Wilshire Boulevard, Jodi and I were the only two trainees in the mailroom. No men. We had to do all the work. We were there until midnight. It was awful. There was a huge sign that needed moving. Next thing I know I saw Jodi walking past me with this big thing on her back.

BOB, BABY!

PRESS: In the early nineties, Bob Evans was known for having great parties. Even Heidi Fleiss was sometimes there. Before one party Bob wanted some scripts delivered to his house. I figured that was my chance. I would deliver the scripts. I'd also dress to the nines and stay. I didn't know him, but I had met him in passing because he used to work with Stanley Jaffe, so there was a little bit of a recognition factor.

Walking into Evans's house is like walking into Dracula's castle. It is

otherworldly. As I strolled in with the scripts I heard, "Hey, how are you?"

I said, "Bob! Ben Press."

"Hey, Ben, how are you? Why don't you stay?"

Thank God. Immediately all these people started showing up. It was a classic Hollywood party: Jack Nicholson, Warren Beatty, and Heidi's girls. I was a young guy—this was before I met my wife—thinking this would make for great stories.

Later that night Bob said, "Hey, Ben, come on over here."

"What is it, Bob?"

He took me into his library room. He pressed a button and a whole wall moved away, revealing a bubbling hot tub. He said, "Cindy, come over here," to one of the girls. He sat her down next to me, and I was in heaven. It was a fun night. Oh, yeah.

SICK AS A DOG

LOPATA: Let me sum up a trainee's mentality: An agent would call the mailroom, very angry about something. The trainees would jump up and volunteer to take care of it, even if it was as simple as cleaning up a ring from a cup left on a glass table. That's okay, but they'd *also* go into a panic about *who* should do it. "I should because I want to be in Lit!" It was all blown out of proportion. "If I don't get that package up to the desk as soon as it comes in, I'm going be fired." The pressure was self-imposed. Then at lunch people would pound on the table and say, "I'm not going to take it anymore. This is not why I went to college."

Of course, the agent's assistant should have done these little jobs, but shit rolls downhill, and the mailroom is the bottom of the hill. There's a legendary story that illustrates the point perfectly.

One day after lunch I got back to my office to find my voice mailbox was full. The first message was, "Dean, it's Richard Saperstein, give me a call right away." Richard was on Rabineau's desk and was about to be promoted. Next message: "Dean, it's Richard. Call me *right* away." I was listening to the third message from Richard when my phone line lit up. Richard. "Dean. How come you haven't called me back yet?"

"I just heard your messages. What's wrong?"

"Does someone have a dog in the building?"

"Um, yeah, I think Bill Robinson has a golden retriever. Why?"

Richard said, "Someone's dog got really sick in front of my door."

"What do you mean, sick?"

"I mean really *sick*. Like it's diarrhea or throw-up or both. I don't know what it is, but somebody's gotta clean it up."

I said, "*I'm* not coming to clean it up. Call the mailroom."

He said, "Can you call?"

"Okay, okay. I'll get somebody up there as soon as I can."

PRESS: Not only was there a trail of shit all through the eighth floor, but the dog went into Jeff Berg's office while he was out to lunch and shit all over his brand-new carpet. Dean also got a call from Berg's assistant: "You'd better get a crew up here now. There's shit all over Berg's office, and if he comes back and sees this, *he's going to shit.*"

LOPATA: I called the mailroom. Ben answered: "Office services."

PRESS: We were too proud to answer, "Mailroom." Dean said, "Ben, listen to me very carefully. Hang up the phone and leave the mailroom now."

I said, "Dean, what—?"

He said, "Ben, hang up the phone and leave the mailroom now. Do what I'm telling you." Okay. I had a feeling something bad was about to happen, so I left, pretending I was on a mail run.

LOPATA: I hit redial. "Office services." It was Jim Rosen. "Jim, it's Dean. Hang up the phone and get out of the mailroom as fast as you can."

Jim said, "Dean, I know I was upset at lunch. I was really blowing off steam—"

I interrupted him. "Jim. *Hang up the phone.* Get out of the mailroom. Trust me. Just go."

"Dean, I appreciate the sentiment. But whatever it is, I'm going to have to do it. Just tell me."

"Jim, this is your last chance. Hang up the phone, get out of the mailroom."

"Dean, *just tell me what it is.*"

"Okay . . . Bill Robinson's dog took a shit in front of Richard Saperstein's office and in Jeff Berg's office. You've got to clean it up. Bring a lot of paper towels."

Later, I heard that my brother, who was interning on Rabineau's desk, and Cecil Cox, Rabineau's assistant, had come back from lunch going, "What's that smell?" They saw it, and my brother said, "I wonder who's going to have to clean that up?"

On cue, Jim walked by with his head down and a roll of paper towels under his arm.

THE CAMPAIGN

PRESS: The hardest thing about being in the mailroom was getting a lot of crap from the young, lesser agents. When one of these little pishers would yell at me, I'd get so pissed off. The idea that I'd gone to college and all my friends were on career tracks while I delivered mail and got yelled at by assholes had started to take its toll. They always wanted to prove their mettle. If the client didn't get a job, a script didn't get delivered, they'd kick the guy in the mailroom—sometimes literally. There was definitely some hitting going on. I looked at it like they were testing you on how good an agent you were going to be.

My rule was, if I was going to get yelled at, I was going to get yelled at by the best. That's why I wanted to work for Ed Limato. I went in with tunnel vision and just worked and worked until I got it. He'd ream me sometimes. Absolutely tear me a new asshole, screaming. But I knew I was getting yelled at by a guy at the top.

I started campaigning for Ed Limato's desk on day one. I knew his assistant, Dan Cracchiolo, wanted out in order to produce. I started working for Dan in the morning and ingratiated myself to the point where, when I knew he was ready to announce his departure, I was the choice to take his place. The clincher came in a most atypical way. When I was alone in the mailroom, one of the assistants came downstairs and dashed into the supply room. I heard a bang, and then I didn't hear anything. I walked back and the girl was on the floor, passed out. She wasn't breathing. My heart beat very fast, but I had taken a CPR class, so I got her breathing again. Then I called 911. By the time my friends came down from the mail runs, the fire engine was there, the paramedics, everything.

Dan Cracchiolo said to Ed, "Ben's perfect for the office. And by the way, he just saved a girl's life."

"Okay," Ed said, "Okay, then. Come on!"

AS THE MAILROOM TURNS: ACT ONE

PRESS: I had just started working for Ed Limato when Dean came to me and said, "Have you seen the hot new chick in the mailroom? You've gotta check out this girl." I made an excuse to go down, and through the slats I saw this gorgeous woman, Paula.

LOPATA: Actually, Ben called *me* on her first day and said, "Who's the new girl?" She was totally not his type, or mine. I'd grown up on Long Island, and she was exactly the Jewish American princess type I was getting away from. I said, "Oh, that's Paula."

He said, "Make it happen."

I said, "I'll see what I can do." The truth is that I was working so hard, I didn't even try to be friends with Paula right away.

BESIKOF: Dean's a very to-himself guy and I'm very "Hi, I'm Paula." When we first met I acted like I knew Dean: "So, tell me about yourself." By the end of the conversation he said I was the little sister he never wanted. He couldn't shake me off.

LOPATA: I told Ben that Paula had a boyfriend. He said, "That never matters." In fact, things weren't perfect with the boyfriend. Paula would tell me all her problems. She'd complain about the guy. I'd say, "I know someone who would treat you like gold and would appreciate you."

BESIKOF: Every time I'd tell a joke, Dean would say, "You know, you have the same sense of humor as Ben Press." Or "Did you ever talk to Ben Press about that?" It was always Ben Press, Ben Press. I sort of thought Ben was cute, but I wasn't really *that* into him. Plus I knew that although a lot of people ended up getting together in the agencies, when you start to date it's different. Then one day I took an attractive female temp around with me and introduced her to everybody. I noticed the way Ben looked her up and down and I thought, Now I really don't like this guy.

PRESS: Because he was in administration, Dean worked it so that Paula got assigned the mail routes on Limato's floor.

BESIKOF: I was doing a last-minute delivery to Ed Limato's office. Ben came out and, very Ben, said, "Stay a minute!" I didn't have to stay. I always had a lot of attitude. But I knew that he kind of had a thing for me—and, finally, I was curious.

LOPATA: Little by little, Paula jockeyed for Ben's floor. Then she and the mail cart starting coming back late. I wouldn't bust them, but everybody would say, "Where the hell's Paula? We've got to get the packages out." I'd call Ben: "Hey, Ben, is Paula up there with you? Can you get her back down here, she's got some mail to take care of." It just started happening.

PRESS: Sure enough, one thing led to another, and we started dating. We kept it very quiet. That sort of thing was frowned upon. It was considered a distraction from work. That meant not even going to parties and premieres together because the company wanted us to focus on the talent, not each other.

LOPATA: The next thing I knew I got a phone call from the two of them. It was so sappy, saccharine, and disgusting that I wish I'd taped the call. It was like, "Well, it's all your fault. We're on our way to Santa Barbara for the weekend." They were giggling and laughing. "We've got twenty scripts in the back, but we don't care. We're getting a room at the Biltmore." That was it. And then tragedy struck. . . .

<div align="center">

[CONTINUED . . .]

WE'RE NOT IN KANSAS ANYMORE

</div>

PRESS: I was still brand-new, and Ed Limato was having dinner with David Geffen at a club called Numbers. Limato called me on his way over there and said, "Kid, I forgot my cigarettes. I need them."

I didn't want to do it, but I got the cigarettes and the directions and drove to Numbers. I thought it was like Spago, but Numbers was a little off the beaten path. West Hollywoodish. Drove up and told the valet guy, "Leave the car here, I'll be very quick." I walked in and down a spiral staircase. I entered a room with nothing but men. I thought, Oops, we're not in Kansas anymore. All eyes turned, and I saw Limato in the corner with Mr. Geffen. I walked up and said quickly, "Ed, here's your cigarettes, I gotta go." I ran up the stairs. The car peeled out.

That was when I knew this job would be *very* different from Washington, D.C.

● ● ●

Working for Limato was like life in a time warp. He's truly the last of the great—and he'll kill me for saying this—old-time agents. He treats his clients like his own children. He's got pictures of them at home on his piano: Richard Gere, Mel Gibson, Michelle Pfeiffer, Denzel Washington. Even people who have left him, like Nic Cage and Anthony Hopkins—he still has their pictures up. As good as Bill Clinton is as a politician, Ed Limato is better as an agent. It's natural. It's not cerebral. It's literally in his blood.

Limato became my mentor. He took great pains to explain to me why something was happening and he was always open to questions. I always called it a professor-student relationship. To this day, it's still professor-student. He calls me "kid," and even though I'm not working at the same agency with him, I still have this very endearing feeling. I'm lucky because most people did not have this experience. They worked with people who trained them and then turned them out to the next desk.

I'd get into the office at six-thirty in the morning and leave at eleven-thirty at night, and I worked on Saturdays. I was exhausted and hated those days when he'd say the office wasn't working as well as it could. Sometimes I was moved to tears because it was my life, and my life was completely Ed's.

Those were the times I was glad I'd partied in the mailroom.

AS THE MAILROOM TURNS: ACT TWO

LOPATA: Ben, Paula, and I became good friends. We'd go out together, along with my girlfriend at the time. And then the worst thing happened: Ben and Paula broke up. I would spend lunches with her crying to me, "I don't know what I did. I don't know what happened." And then I would spend drinks or dinners with him, after work: "I don't know what happened."

My attitude was, "Get back together or shut up already, but you two are driving me crazy."

Then Paula went from despair to anger and the two of them hated each other.

BESIKOF: We broke up because his family had a problem with me. They are conservative Jews from New York, and here Ben brings home an outspoken Jewish girl from the entertainment business, which, at the time, they were still waiting for Ben to leave. And I'm from California. In their mind that combination was just unheard of. Also, I might not have been deferential enough. I'm not certain that's what they thought, but it's how I felt.

My friend Elizabeth Fowler, who also worked for Ed Limato, heard the call come in from Ben's parents. Basically what they said was—and I knew this because Elizabeth and another girl, Amber, eavesdropped— "We don't think Paula's the girl for you." They could tell we were serious. They said, "You should rethink this. You're making a horrible mistake."

Ben had always listened to his parents, and he panicked, not knowing what to do. He called me up and took me out to Dominick's, where we went a lot. We sat across from each other and he said, "We need to break up." What? Literally out of the blue. Fifteen minutes earlier we'd been holding hands, and now I'm thinking, This guy's breaking up with *me*, and I wasn't even sure if I was gonna date him in the first place? Forget it.

But I was devastated and shocked. I really liked Ben. I asked why he wanted to break up, and Ben wouldn't tell me. He wouldn't admit he got a call from his parents. Little did Ben know that Elizabeth and Amber had told me everything.

The worst part was that Jim Wiatt's office—where I was floating— and Ed Limato's office were close to each other, so Ben and I had to stare at each other all day long. And we still had to talk to each other on the phone for business three million times a day. Meanwhile, if Ben gained five pounds, some woman in the office would call me up and say, "Don't you think Ben looks fat today?" We had a whole circle against Ben, and everybody knew everything.

For the first month I cried. Then I was furious and I hated him. I was ego-bruised. A family that doesn't like *moi?* Then suddenly I thought, I'm crying over that? By the second month, I was happy. I was, like, Thank God, I could have made a big error. I would never date a guy who listens to his family.

[CONTINUED . . .]

THE INFORMATION ECONOMY

PRESS: You never know what to expect when you're listening in on the phone—for business. When Richard Gere was being harassed by the press for that rumor about the gerbil, I heard him say to Limato, "I wish they would leave me alone. It's not true. It's just such shit." He was really impassioned and emotional. I went home that night and called everyone I knew who ever uttered that rumor, and said it was bullshit. I was on a mission.

Usually my reaction to what I heard on the phone was less "Wow, this blows me away" than "Nobody knows this." When Steven Spielberg cast *Schindler's List* he was very interested in Mel Gibson. He met with Mel but ultimately chose Liam Neeson—not because Mel wasn't right, but because he thought it would turn into a Mel Gibson picture, not a movie about the Holocaust. Nobody knew about that.

I also knew who was going to get fired in the building before anyone else, because the call would come to Limato. I'd walk through the hallway and know whose job was over. It was the power of information. It was horrific.

BESIKOF: There was also information withheld. ICM was structured to make everyone hate each other so they'd be competitive. In staff meetings they'd ask what projects they needed to focus on. But Elaine Goldsmith, before she left ICM, wasn't going to say what project they needed to focus on, because she was trying to get it for Julia Roberts; and Joe Funicello was trying to get it for Jodie Foster. No one told anyone anything except for what was public knowledge. They'd say the agenda was to get Mel Gibson a project. Everyone would say okay, then run to their offices and dial for their own clients. If you heard an agent calling for a project for their client, you'd be dialing for the same project at the same time.

REVENGE

PRESS: Sometimes when Limato gave me a tough time and I wanted to get back at him I'd fill his Jaguar convertible with the lowest-grade gaso-

line. He loved that car, and it would ping and knock. Limato also lived for coffee and would have God only knows how many cups a day. When I was pissed I'd give him decaf. All these little fuck-you things just because I couldn't deal with him being a pain in the ass.

Of course he busted me on this stuff. One day he came back from a morning staff meeting that went too late. He blamed me for it. It wasn't my fault, but he yelled and screamed. I finally pushed my chair back, got up, and said, "I'll see you." I walked out, and I didn't come back. Everyone thought I'd quit. I knew I wasn't going to quit, but I needed to go home. I went home and cried. I was a mess. The other assistant, Ed's outside secretary, called and said, "Ben, you have to come back."

I said, "I'm going to let him wait it out a bit."

I finally walked back in at six o'clock that evening, sat down as if nothing happened, put on the headset, and started doing my thing. He looked at me, smiled, and said, "I hope you were out getting drunk."

I loved him like Bear Bryant's players loved their coach.

EATEN ALIVE

BESIKOF: Walking through the building with my mail cart, interacting with the assistants, I learned to spot weakness very quickly. I saw it all day long. Any weak specimens were eaten by their bosses—and I mean eaten alive. It was the kind of yelling and badgering that you couldn't even imagine. If you told someone not at an agency the story of what you'd seen, or what was done to you, they'd say that anywhere else your boss would be in jail.

I saw people who broke down and cried every day. One of my best friends, a beautiful girl who was my partner for a while after we left ICM, worked for an agent named Chris Andrews. Chris is a great guy, but he needs things to work well. The first month or two it's very hectic being Chris's new assistant. She ran out of the building, crying. This is a girl who graduated from law school with honors.

The lesson is that it didn't matter how smart you were. It only mattered that you matched yourself correctly with a boss, and then you had to work it right. The weird thing is that if you're good at taking abuse, you'll probably work for somebody who's abusive.

I became aware of the political game almost immediately, and once you spot it there's no looking away. You realize how to maneuver: Go here, don't mess with this one, avoid that path if you can, befriend this person, remember that people are careful what they say because they're going for the same desks.

You're not supposed to have to figure all this out by yourself, though. There was an official mentor program; I had a mentor, Amy Ferris, and we were friends. But in the end, at least then, no one told you anything. It's trial and error. No one leads you down any golden path. And you can never show a moment of weakness, not even to your mentor.

• • •

Within a month or two of being in the mailroom I began floating in Jim Wiatt's office. I was brought in to replace one of his assistants. The assistant didn't know that, and I was sworn to secrecy. But suddenly I was eliminated and maneuvered out. Not by anyone in Jim's office, but by Jeff Berg's assistant, who ended up marrying Jim Wiatt. I guess she thought I was her competition. That was the farthest thing from my mind. But it was a real soap opera, politically and otherwise. Being cast out of Jim Wiatt's office was my moment of doubt and pain. I'd been on the fast track. Then *boom*. I could have been an agent, but I knew that my path was blocked. In fact, I thought my career at ICM was over. Fortunately, everything died down because I had a few cards to play myself. Still, I had to find another desk. Unfortunately, there were a lot of sexual harassment suits going on at ICM, so only certain desks would take women.

It was frustrating, as a female, to watch people who came in after me—young males—be able to get desks that I couldn't, and then be promoted before me for the same reason. I went to Alan Berger and said, "This is a nightmare. You have to take over the training program. Look at this company phone directory. In the last ten years, twenty-five guys and two women have been promoted."

It was all male then, for a reason. The only desks you could almost count on getting promoted off were Ed Limato's and Jim Wiatt's. There weren't tons of people coming off Toni Howard's desk, though that changed. Even Alan Berger's desk was a bit iffy: You could make it to departmental coordinator, but you didn't always make it to agent. Jeff Berg didn't take trainees most of the time. Bill Block, who originally hired me, wouldn't hire women when I was ready to take my next desk.

Besides Ben, Ed Limato had Elizabeth Fowler working for him, but she wasn't a trainee, only a very bright girl who should have been an agent—but they did not promote her because she was a woman. A strong woman. They didn't want strong women who could challenge them.

Not even Jodi Guber got promoted. She ran Jim Wiatt's office, but she did not get along with Jim's future wife, either. I believe that Jodi went to Jim at one point and said, "Just so you know, I don't like your girlfriend." Jodi could do that because she was Jodi Guber. For her the rules were different, and she could get away with it, but she still suffered. Later, she and Toni Howard didn't get along, and in the end her name couldn't do enough for her.

GUBER: I never actually said that to Jim, but I did feel Elizabeth didn't like me. One day she asked me out for drinks. Jim said I should go, and I said, "I have nothing to say." I called her back and said, "I don't have a problem with you and I don't need to go to drinks." Toward the end, my relationship with Jim, which was really great, got somewhat tainted because of her relationship with him. That made me sad. And there was a time when I was very angry with her—but no longer. We all have our journeys and our paths. And there are things I also could have done differently.

AS THE MAILROOM TURNS: ACT THREE

BESIKOF: Ben finally realized he'd made a tragic mistake breaking up with me. He put himself into therapy. Then he spent months trying to get me back—not that I was even interested. Of course, he won out, because Ben agented me like no other. Ben is a great agent, and it worked.

When the word got out to everyone that we were seeing each other, the big joke line—but not really—was, "Oh, you and Ben Press. What—are you sleeping your way down?" Usually if you were going to sleep with someone, it would be one of the bosses, or at least someone who could promote you. I'd say, "No, but it's my investment."

We ended up getting married, and everybody was fine with it. In fact, our relationship turned out the opposite of what they thought it

would be. Ben and I went out every night to premieres, to parties. It was brilliant, really, and it showed where the agencies have it wrong. They want you to sleep with everybody *outside* of the building because they think you can bring in personal information that way, and they like that. The truth is, if you're with somebody in the building, you go out with clients more. We went out easily five or six nights a week for three or four years. We were more focused.

PRESS: We got married August 12, 1995. It's great. She knows everyone I know. She went through the system. I'm very lucky to be married to a woman who gets what I go through at work. I'm very lucky, period.

[END]

DANCE WITH THE GOD THAT BRUNG YA

PRESS: I would have paid money to know how long my tenure would last with Ed Limato because it was a double-edged sword: I did a great job, he loved me, he didn't want to get rid of me. I needed to move on. I finally raised the subject.

I got promoted, but I'd invested myself so much in Limato's business that it backfired for me down the line. The day I was promoted, I was told by Toni Howard, the head of the department, "I don't think you're ready to be in this department yet." That created a problem. I'd given my all and was loyal to Limato, but now I also had to serve Toni as well. It was like having to worship two gods. Clearly I was inclined toward Limato, and that created the schism. You can't serve two gods.

The weird thing is that Limato brought Toni over to ICM. Theirs is a very weird relationship. It's twisted and bizarre—the way all the relationships are there. It's every man for himself. It's like countries: You can be allies, but nobody is friends.

BESIKOF: Toni didn't really take to people who worked for Limato because she felt that in situations they would go to him first. She has been quoted as saying "I like people far up my ass," and that is the truth. If you're up Limato's ass, then you're not up hers.

To work well with Toni you had to befriend her. If you didn't, you'd go nowhere in motion picture talent. She knew every nuance of everything and everyone. If you had a new pimple, she'd know it. It was

horrible to work under her because if you made a mistake, she found out. People were petrified. And worst, if she knew she could get to you, she'd eat you alive. People would sometimes walk a different way if they saw her coming.

Although Ben and Toni did not work out well, Toni and I were surprisingly fine. I wasn't afraid. If I was mad at Toni, I'd just yell at her. Of course, she'd say something like, "You know, Paula, your earlobes turn red when you yell," and totally disarm me, but we got along perfectly because she knew she couldn't push me. Toni gets along with people she can't push.

ALL OR NOTHING AT ALL

GUBER: Joe Rosenberg wanted me to work for him in Motion Picture Lit. Joe was a great boss. Not a screamer. I worked really hard. But my biggest fear was the coverage. Writing was not my strong point. I didn't know how to read a script and critique it. It was important to me that I knew what I was doing, so I found someone who did coverage really well and paid them to tutor me.

After two years and the time I worked in Jim Wiatt's office, ICM asked me to sign a contract. The word was everybody had to sign one. The gist of it was that if they were to fire me, I wouldn't be able to do anything about it. I thought, Are you out of your mind? Are you kidding? I went to Wiatt and said, "There is no way I'm going to sign this."

Turns out they didn't ask everyone else. I was the *only* one. I ran out of his office, and Jim came after me, saying, "Don't ever run out on me." It was a poor judgment call. I'm not stupid. They thought if they fired me, I would sue them because of who I was. I had better things to do. And that's when I knew I had to get out of there. I knew there was no future for me at ICM.

Even so, I knew that it was important to become an agent to get to the next level. My dad kept saying to me, "Do not quit. You've gone this far, stick it out. You're almost there." I stuck it out, and for several months I was miserable. I went down to Paula's office every day, in hysterical tears. Sat in Alan Berger's office, eating all his candy, miserable. I

didn't know what to do. I wanted to be promoted so I could use it to do something else, but I wasn't sure how much more I could handle.

In desperation, I decided to throw myself a birthday party. I invited everyone I knew, all the relationships I'd networked myself into, and had a really cool time. Agenting is all about relationships, and my motive was to somehow use the party to show how far I could cast my net. Brian Gersh at William Morris took the bait. He called me up and said, "I heard you had this great party. Sean Penn, my client, was there." He said William Morris was interested in hiring me as an agent. It was a relief. I didn't care that I once thought their offices too dark. At that point they looked bright and shiny. Brian sold me on William Morris and on him.

It was great at first, and I became friendly with a lot of the agents, but I quickly figured out it wasn't for me. Promises were broken. I didn't get brought in on meetings. Brian was hard on me and not only in front of me. I knew I would stay at William Morris only until I figured out what I wanted to do.

BESIKOF: I ended up working for Steve Small, who's now at UTA, and it was the time of my life. Great guy. He literally let me do everything. Then Toni Howard became my mentor. After Steve's desk she wanted to put me on the promotion track, so I worked for Alan Berger, out of whose mouth an abusive word never came.

One day Toni said they would promote me to departmental coordinator—a junior agent—and then I could become an agent. I said, "No. You're promoting me to agent or forget it."

She said, "Paula, everybody takes this step."

But everybody doesn't. The women take the step, the men don't. I told her I was turning it down and that I would leave. She said, "Take two weeks. Don't say no. You've spent all this time here." I took two weeks to think about it, and I decided there wasn't one person at ICM whose life I wanted mine to be like. Even Ben's life was horrific. I decided to leave.

I wrote Toni a letter and said I appreciated everything, but I had to find my own path. Until then, my whole life had been wrapped up in the building. I didn't have a free second. For three years of my life, all I knew was ICM.

SURVIVAL OF THE FITTEST

LOPATA: I had floated from job to job and almost accidentally become an assistant in Jeff Berg's office. But I really wanted to work for a production company, on a film. At a lunch with Ben and Mike Pitt—who'd been AD-ing a lot—Ben said, "Oh, you know who's looking for an assistant, Mike? Mel Gibson." My eyes nearly bugged out of my head. I knew Mel was leaning more toward directing—exactly where I wanted to be. I kicked Ben under the table and, luckily for me, Mike said, "Yeah, I don't know if I really want to go be the assistant right now."

As soon we got back in the car, Ben said, "Why'd you kick me?"

I said, "You know I've been trying to get into a production company, and you know I've been trying to work with either a director or a producer on set."

He said, "I'll call them today and tell them you want it."

I faxed over my résumé. Went through five weeks of interviewing. On the first interview I didn't say anything to Jeff Berg's office, where I'd been assisting temporarily, because what's the point? But they called back and asked me to meet with Mel's partner next, so I had to tell. I went to Elizabeth and said, "Listen, I really wasn't looking for a job, but this thing has come up and I really would like to do it. I figured I'd better let you know."

She said, "That's great. Let me know how it goes and if you need us to do anything."

I said, "If I make it past this next interview, then I think it would be time to tell Jeff."

Sure enough, I made it to the final three and a face-to-face with Mel. He was in the middle of post on *Man Without a Face* and learning his stuff for *Maverick*. Meanwhile, Elizabeth told Jeff, "Dean's been interviewing to be Mel Gibson's assistant."

Jeff said, "Is this a good thing? Do we want this to happen?"

She said, "Yeah, I think he really wants it, and I think this is a good thing for everyone."

Jeff was great about it. My meeting with Mel lasted over an hour, and it went really well. We joked and laughed. Afterward I called Elizabeth from the car, and Jeff also picked up the phone. I said they'd let me know in a couple of days. Jeff hung up and called Mel directly and said,

"If you like this guy, don't feel like you're taking somebody out of my office. We'd be happy, considering we represent you, to provide you with somebody that you're happy with."

• • •

Things worked out pretty well for me. But they don't work out for everybody—like the guy who had been my roommate for a while. His name was John Sepler. He was at ICM in those days too. *Inside Hollywood* followed him around the mailroom for a segment.

John had become a TV agent. He was always upbeat, smiling, happy. The assistants liked him. I was out of town a lot with Mel. Probably the last time I saw him was at Ben and Paula's engagement party.

One day I got a call from Ben's assistant. I was in New York, working on *Ransom,* and I could tell by her voice that something was up. My fear was that something had happened to Paula. Ben got on the phone and said, "You'll hear today at some point, and I figured you'd better hear it from me."

A few minutes later Mel got called onto the stage. I walked into the dressing room and told him, "Hey, they're ready for you."

He said, "Oh," then looked at my face and asked, "What's wrong?"

The words caught in my throat. "My old roommate . . . killed himself last night."

• • •

DEAN LOPATA is a writer/director.

BEN PRESS is cohead of the Motion Picture Talent Department at the Paradigm Agency.

PAULA BESIKOF PRESS is an independent producer and co–executive producer of the HBO original comedy series *Baseball Wives.*

JODI GUBER eventually started the public relations company Beyond PR with a partner. She then segued into her current vocation as a personal life counselor and yoga instructor.

IN YOUR FACE! . . . WITH LOVE

JEREMY'S KIDS

United Talent Agency, Los Angeles, 1991–1994

SUE NAEGLE, 1991 • MARTY BOWEN, 1991 • BRANDT JOEL, 1991 • MICHAEL CONWAY, 1991 (ADMINISTRATOR) • SEAN FAY, 1992 • ROB KIM, 1992 • JASON HEYMAN, 1992 • SHARON SHEINWOLD, 1992 • TONI WELLS-ROTH, 1992 • DAVID KRAMER, 1992 • JIMMY DARMODY, 1993 • KEVIN STOLPER, 1993 • GLEB KLIONER, 1993 • SHERWIN DAS, 1993 • BASIL IWANYK, 1993 • PETER SAFRAN, 1993 • CHARLES FERRARO, 1994

There's nobody more intuitive than Jeremy Zimmer. He's like Hannibal Lecter in the sense that he looks at you and he instantly knows all the demons and the stories. He gets deep fast. His whole thing is the meek shall inherit the earth, because when he was in high school and college he was a total slacker. He dropped out and had no idea what he wanted to do. The agency business changed him. He very much believes that people change, and he believes that he can change people. As long as you have something on the inside that he likes, he feels he can change everything on the outside.
—*Gleb Klioner*

SHERWIN DAS: Indian immigrants' children are usually doctors or engineers. I've always been the family wild card. I was born in Bombay and came to America when I was six. I went to Catholic schools, then Berkeley, studied economics and history. I got a job as a media planner, then applied to film school.

My parents knew nothing about Hollywood, but I had read voraciously about Michael Ovitz and the articles about how he and Geffen and others had started in the mailroom. Through friends, I managed to talk to a couple of assistants at William Morris. They filled in the details. But without any real connections, I knew I had to do something special to get in.

With the help of an art director, I took a *Hollywood Reporter* cover, scanned it into Photoshop, and fictionalized an article about myself. I sent it cold to people at CAA, UTA, ICM, and William Morris. What they got was a letter and mock *Reporter* cover story about me and the person I'd sent it to. For instance, I'd read in *Entertainment Weekly*

about Gavin Polone, then a twenty-eight-year-old hotshot agent at UTA. I headlined my article/letter to him "Polone Works with Das: UTA Hires Hot Young New Dude." It was either brilliant or cheesy. It would either make somebody go, "This guy is an idiot" or "This guy is brilliant."

MARTY BOWEN: I was into investment banking, like all my roommates at Harvard. But when it came time to meet the company recruiters, something felt wrong, and I had to force myself to feel interested. Fortunately, I was fascinated by the entertainment business. I decided to go to Los Angeles and check it out, or regret it for the rest of my life. I bought *Premiere* magazine. I learned about Mike Ovitz and how Hollywood was going to be the next Wall Street. I knew there was money to be made. I took general meetings with four or five people and learned about talent agencies. It could take four years to make agent at William Morris and CAA; at ICM, maybe three years. But at a new company, United Talent, a real hustler might squeak through a little faster.

BRANDT JOEL: I'm one of those guys who always wanted to be an agent. I loved movies, music, television, and theater. At Duke University, where I went on a naval scholarship, I dealt with agents and planned all the concerts. Then I went into the navy and was aboard the USS *Frederick* as a navigator. We were in the Gulf War. Afterward I was stationed in San Diego. A guy I'd known at Duke had gone into the agency training program. On a day off I drove up to Los Angeles and saw him for lunch. He told me what it was like: no money, long hours, hard work.

BASIL IWANYK: I played basketball in high school and was supposed to go to West Point like my uncle. But they wouldn't let you wear contact lenses, so I failed the physical. After studying philosophy and political science I went to USC film school and convinced two of my best friends to move to Los Angeles with me.

I did the usual fucking around as a PA, and, like the Don Henley line from "Heart of the Matter"—"The more I know, the less I understand"—it was miserable. On a Whitesnake video shoot downtown, I had to go down an alleyway in a hard hat and lock the set; that meant guard the perimeter. The hard hat didn't fit and I was humiliated, so I didn't wear it. I stood around for four hours and suddenly somebody in a tenement apartment window above dumped a bucket of shit and piss all over my head. The line producer told me to go home and get

showered. He also said he wasn't going to pay me for the hour I was gone. I knew I had to quit. Welcome to showbiz.

A week later I got a PA job at a company that shot direct-to-video horror and slasher movies in Romania. The overseas production coordinator told me he'd once been an assistant at UTA. "You'd be perfect there," he said. "Let me call Jeremy Zimmer."

JIMMY DARMODY: My best friend, Basil Iwanyk, was in Los Angeles working at UTA. I was going to Rutgers. I came to visit, spent a couple days, and thought, Screw it; I'm gonna move out. The move to California was less about being in show business than it was about getting out of New Jersey.

I arrived in January 1994, two weeks after the big earthquake. The entire town was in disarray. Basil, Charlie Ferraro, and three other guys lived in a house that, while it hadn't been condemned, was still a shambles. There were cracks up the wall, the floors were warped. I walked in, dropped my bags, and thought, What have I done?

JASON HEYMAN: At the University of Pennsylvania I helped put together something called the Penn Film Foundation, and got equipment and funding from people in Hollywood like Marc Platt and Kevin Misher. I came to Los Angeles to work on a movie in the summer of 1987, but there was a writers' strike and I ended up as a temp at the *Los Angeles Times*. I did my junior year at the USC film school before graduating from Penn. Then I packed my Honda Accord and moved to Los Angeles. I didn't want to be a writer or actor or director; I wanted to be on the deal-making side of the business.

My great-aunt had once told me she'd helped a guy get started out in Hollywood. His name was Tom Sherak. He was fantastic! Gave me the VIP treatment, said he would call some people. One, Roger Birnbaum, the head of production at Fox, told me about the agency route. He also said his friend Jeremy Zimmer had started a new company called United Talent Agency. I dropped off a résumé and literally, the next day, Zimmer called me.

ROB KIM: I was born in Korea, moved to the States when I was one, and ended up in northern California. I wanted to get into politics, but I met Bill Cosby during my first month at UCLA. He'd been jogging. We had a very brief conversation—"Hello, I'm a big fan"—and it was so cool.

Through the Bruin Democrats we got celebrities to man voting

stations in Westwood. I had to walk Bruce Willis from a trailer to the table where he would sit and register people for a couple of hours. I sat with him. I had no idea what to say, so I told him how much I loved *Die Hard*.

My last quarter at UCLA, I went to work for Mark Gordon, who had a deal at Disney, and started to make connections. The last day of my internship, Mark called me into the office and said, "You should check out agencies—they're more your style and speed. If you'd like me to, I'm happy to make some calls."

I'd already been accepted at USC law school, but what I read about show business fascinated me. I decided to defer law school for a year. I got the agency and managers directory and called all the personnel people. I bought two books on cover letters. They said things like "Be aggressive" and "Be confident," so I wrote this really obnoxious, way overly self-confident letter that included a P.S. I copied out of one of those books: "Your time will not be wasted!"

GLEB KLIONER: My parents immigrated to Miami from St. Petersburg, Russia, in 1979, when I was seven. I majored in business at Carnegie Mellon and was very much into standup comedy when it was really exploding. I got involved with the activities board in college and was responsible for bringing comedians to campus. That gave me an opportunity to talk to personal-appearance agents in Los Angeles and New York.

A friend wrote a script, and I raised seven grand to do it as a student film. Our senior year we shot the film. Another friend knew a producer in Los Angeles, so for spring break I came out to try to get it sold as a feature. I met with one producer who gave us a thousand dollars for the year and said he was going to make it, yadda yadda.

After graduation I moved to Los Angeles to be close to the project. I asked everybody in town the best way to become a producer, and they all said to start in an agency mailroom.

DAVID KRAMER: Between my junior and senior years in journalism school at the University of Georgia, I worked on an internship for the Georgia Film Commission. One movie came in, produced by Mark and David Wolper, called *Murder in Mississippi*, the prequel to *Mississippi Burning*. The head of the commission said, "It's really slow and you're bored. Why don't we make you a PA and we'll pay your salary," which was $750 for the summer. I worked in the office, I ran errands, I

took the film to the airport every day, I drove the director to get a massage. Once they tried to send me out to buy liquor. I said, "I've got a fake ID, but . . ."

When I decided on film school I applied to the Peter Stark Producing Program at USC. The guest speakers I found most interesting were those who told stories about how they'd started in mailrooms; some admitted to having faked their résumés to get the job. I decided there was something sick and glamorous about being able one day to say, "I started in the mailroom."

SUE NAEGLE: I grew up in New Jersey loving TV. After college I hoped to get some sort of production job in New York but realized I couldn't afford to live in the city. Then a friend said, "My sister lives in Los Angeles. She's an actress. She said we could crash on her floor. The rents are nothing and we can for sure find jobs as production assistants, making three-fifty a week." I worked all summer as a waitress, saving money, and then moved to California in October 1991. We found the cheapest apartment ever. Tons of traffic outside. Very loud. We sent our résumés everywhere, called everybody, got nowhere. I started making brownies and cookies to sell to craft service people and ended up taking over the craft service on a nonunion show, *Down the Shore,* until it got canceled.

Through a friend of my mom's I met a guy who said I should work at a talent agency. My new pack of Los Angeles friends freaked. "You're out of your mind. That is the last place you should work. They're awful people, the worst part of the industry. No one likes them. How can you take a job where people think you're evil?" All I knew is that I wanted a *job*. No matter what anyone said, I was ready to go.

SEAN FAY: I graduated from the University of Connecticut in 1991 with a degree in communications. I substitute-taught for a while at my old high school in Glastonbury, Connecticut. When I came across a 1992 *GQ* magazine article about the mailroom training program, entertainment sounded exciting. Different. The story mentioned Brandt Joel, the assistant to Nick Stevens at UTA, and said he'd been in the Persian Gulf. I thought that was kind of cool. I got Brandt on the phone, told him I wanted to be an agent, and asked if he could help.

He said, "When you actually move out here, call me and we'll have lunch."

I packed my Volkswagen Jetta in September 1992 and moved to

Huntington Beach. I called Brandt and he set up a lunch. He gave me an overview of the program: put in a lot of hours, read a lot of scripts, work hard. About a week later I had an interview with Jeremy Zimmer.

PETER SAFRAN: I graduated from Princeton and from NYU law school, then became an attorney in New York, working for a big Wall Street law firm, Sullivan and Cromwell. One night I was at the printer with a partner at the firm and a twenty-five-year-old Goldman Sachs analyst. We were waiting for a prospectus to come off the press. The analyst said, "Okay, guys, so, you'll take care of this?" and took off. It was about three o'clock in the morning. I looked at my associate, the partner, and thought, This is what I have to look forward to?

A music video producer friend asked me to help him with some of the business and legal affairs and production on a Los Lobos shoot. I spent three days casting, building sets, doing contracts for the actors. Everyone worked their asses off, but they were having a good time and making a living. There wasn't a trade-off between art and commerce. Very shortly afterward I decided to leave Sullivan and come to Los Angeles.

Ben Press's family and my family are friends from New York. I met Ben for lunch when I came out. We hooked up on a Saturday at Ed Limato's office at ICM. Ben was about to be promoted. He showed me Ed's client list. It was staggering: Denzel, Michelle Pfeiffer, Richard Gere.

Ben and I went across the street for lunch, and he said, "Listen, the agency thing is great, but it's really hard work. I don't know if I'd recommend it, because if I'd known then what I know now, I don't know if I'd have spent all this time doing it."

"But you're getting promoted," I said.

"Yeah," he said, "and I'm going to get paid properly, not, like, as an assistant."

"What did they bump you up to?" I was expecting him to say eighty-five, ninety grand.

"Thirty-two thousand."

My jaw dropped. You get *promoted* to get $32,000 a year? It blew my mind that somebody could work so hard and make so little money. But once I decided to go ahead anyway, the relief was greater than the fear. By quitting my job, I had removed the safety net. I'd thrown my hat over the wall, and there was no way I could go back.

SHARON SHEINWOLD: My mom is an attorney, and my dad is a retired high school principal who's now a member of the Israeli army. He builds tanks there. He's just totally gung-ho to save the country. My mom and I would like him home.

I went to NYU film school, then to the American Film Institute. I loved movies, but I quickly realized that, surrounded by incredibly talented people, I didn't feel I had anything meaningful to contribute—except that I could *identify* talent and put people together.

One of my teachers was the producer Rob Cohen—a UTA client at the time. He's now a big director. Each week he'd come in and talk about film development and conversations with his agents. I was seduced. I knew mailroom programs were the best way to get an overview of the industry. It could be a continuing part of my education, like postgraduate work. After a year at AFI my parents cut me loose. I needed health insurance, so Rob got me a job in the UTA mailroom.

KEVIN STOLPER: I'm from Denver, Colorado, which could not be any more removed from the entertainment industry. I went to school at USC, joined a fraternity. I was intent on Wall Street, the hot place at the time, but one day I was farting around at Sigma Alpha Mu, and a buddy said, "Hey, why don't you come check out this little talent agency I'm working for? We need interns. It's really fun and you get to be in the movie star business."

It was a disaster. I drove all over town. The big client was the guy who played Harry in *Harry and the Hendersons,* the TV show. Quite literally, the guy in the gorilla suit. It wasn't the right job, but I liked the industry. Besides, my friend Jason Heyman had gotten a job at UTA, and now he went to movie premieres, dated women in a league that he hadn't dated before, and talked to Mike Myers every day. Through Jason and socializing I started making inroads at UTA.

TONI WELLS-ROTH: I was one of the top ten junior tennis players in the East and earned a full college scholarship based on that. In school I took a film criticism class and fell in love with the movies. After graduation I wanted into the business. I asked everybody I knew, and through a connection my father had in the shipping industry, I wound up meeting the Pettis brothers, who produced the Coen brothers' first films, in Washington, D.C. They said that if I wanted to be in the movie business, I had to be in Los Angeles.

I moved to a two-bedroom apartment in Brentwood with a

roommate, for eight hundred dollars a month. It was the shittiest building on the block. I drove a little white Nissan. A friend, Will Davies, who cowrote *Twins* and had coauthored a book with John McEnroe, was represented at UTA. Through Will, I got a meeting with Jeremy Zimmer.

JEREMY'S KIDS

BOWEN: Jeremy immediately made me feel very comfortable. He asked what movie I'd seen last. He asked me if I partied a lot in college. He asked if I got a lot of pussy. He played to my ego, which was smart. He pointed to one of the trainees, pushing a mail cart, and said, "You can't fuck her because she's dating a client." I'm paraphrasing, of course. He was a little more articulate.

Then he said, "If you want the job, the job is yours. But I need to know immediately." When you're twenty-two years old and haven't had any experience in that world, you don't realize that you have time to think about it. He was hot-boxing me. Jeremy gave me until Monday.

I decided to drive to San Diego to see a friend from Texas, talk over the decision, and hang out at the beach. But I got caught up in traffic and pulled off the freeway, found a phone, and called UTA. I said, "Jeremy, I don't need the weekend. I'd love to do it. I'll start as soon as possible."

IWANYK: I lied on my résumé. I made up a literary agency reference— the Watershed Literary Agency, located in Santa Monica—and said I'd read scripts there. I thought there were hundreds of agencies around town and Jeremy wouldn't know.

He studied my résumé and said, "What the fuck is the Watershed Agency?"

"Oh, I used to read scripts for them."

"Who are some of their clients?"

"Oh . . . writers you wouldn't know."

He said, "Are you kidding me? That's such a lie. And not even a *good* lie." I thought it was over, but he said, "Jesus Christ. Do you at least play sports?"

"Yeah, I play basketball."

"Well, good. I can't look at this résumé. If you lied so obviously, I don't believe anything on it. But we need some guys, so go ahead. You're hired."

I was thrilled.

FAY: Jeremy said, "Why did you go to junior college?" I told him I'd had terrible grades in high school. I was a misguided youth and didn't get my shit together until I had to. Then I got a scholarship at UConn. He thought that was interesting. "So, you were a fuckup in high school?"

"Yeah."

A week later his assistant called and asked if I wanted to start working.

KLIONER: The weirder and more different the interview is, the more Jeremy likes it. Mine was about almost everything *but* the business. He was very paternal, and that appealed to me. He gave me an opportunity to talk. I can't say I gave a good interview, but he hired me, probably because I was very different. That's what's interesting about Jeremy: He hires people from different backgrounds on purpose. He knows that talent is diverse. CAA hires a lot of fraternity-type guys, but not every artist is interested in being with a fraternity crowd. I'm a Russian. I was the state chess champion of Florida. He knew some client would have a kid who wanted to learn chess and he could say, "Oh, Gleb was the state champion." Jeremy understands the value of being unique.

Take Kevin Stolper. I can say this because I've known him a long time and he's my friend: You couldn't get that kid arrested. Somebody would ask him to temp on their desk and answer the phones, and he would start to sweat. He was petrified. He was nervous, he couldn't talk, he couldn't express a clear thought. He'd say the dumbest thing. Jeremy knew this was a challenge, and he believed he could really turn this kid into something great. It took time, but he did it. That's Jeremy's thing. He loves to hire the lemons because when he converts them into lemonade, he's reliving his life.

FERRARO: I think it's what side of the bed Jeremy wakes up on. He was in a particularly feisty mood and started attacking me immediately. We got into some heated, in-depth conversation about family and life, and whether I was conservative or liberal. He said, "You strike me as a very conservative person. Is that true?"

I said, "Yes."

"Doesn't that make you a bigot?" he said.

I started laughing at him.

He said, "What are you laughing at?"

"Well, no offense," I said, "but the fact that I categorize myself as a conservative and you automatically called me a bigot—that's the definition of bigotry."

I don't remember the exact response, but obviously it was favorable.

HEYMAN: Zimmer was very cool. He asked me if I knew how to do coverage. I told him I was fantastic at it—I had no idea what coverage was—and had done it a million times. His assistant brought in a script, ripped off the title page, and told me to write up the coverage that night.

I asked a friend from CAA to help. He gave me sample write-ups. That night I read the script and did the work. Then I did another. Several days later they hired me.

But I don't think that's what got me the job. On the way out of the interview I noticed that Jeremy was sucking echinacea from a bottle through a dropper because he had the flu. It is really gross-tasting stuff, so I told him that he should dilute that in warm water, as it dissolves the alcohol and makes the herb more effective. He asked Andrew to get him a glass of warm water. I think this is what really closed the deal.

KIM: Jeremy said, "So, who's your favorite filmmaker?"

Believe it or not, I didn't know what the term *filmmaker* referred to. A writer? A director? Both? I tried to buy some time to figure out my answer: "Well, I've haven't seen a lot of movies lately."

"Okay, let's back it up a second. What have you seen recently that you liked?"

"*A League of Their Own.*"

"Oh. Well, okay. What about TV?"

I thought the cool answer would be, "I don't have time to watch a lot of TV these days."

"You don't?"

"No. I love TV. I grew up watching TV. But I'm pretty busy these days."

He said, "Well, who directed *A League of Their Own*?"

"Penny Marshall."

"Right. And where did Penny Marshall get her start?"

"Television?"

"See what I'm getting at?" Then he said, "I'll give you the job, but your competition is sitting in the lobby, so you've got to go get rid of her."

I jumped up. "Fine," I said. "I'll take care of it! Thank you."

He said, "No, no, no, I'm just kidding. Don't say anything to her. We'll call you and you'll start soon."

WELLS-ROTH: I was twenty-three, very naive, very eager. I walked in thinking I would have a friendly discussion with Jeremy Zimmer. I wore jeans and a blazer, and the first thing out of his mouth was, "Do you always come to interviews in jeans?" I was shocked. I said I thought it was a favor to Will Davies, so I came in very casually. His whole demeanor changed. "Oh, you're a friend of Will Davies. How do you know Will?" Then we started talking about tennis. I told him I could beat his butt. He didn't believe me at first, but then I told him my background. Jeremy said, "Make sure my assistant gets your phone number."

Two weeks later I got a phone call: "Jeremy Zimmer would like you to play tennis with him." I showed up at Mulholland Tennis and kicked his butt. I got the job—and a call to play tennis every weekend for the next six months.

COLD OPENING

JOEL: The turnover was constant. Some people would come in on a Monday and go out on a Wednesday. They weren't used to being humbled, getting the crap beaten out of them, getting yelled at, being talked down to. The graduation rate was less than 10 percent. Unbelievably low.

KRAMER: When you first start, you hear that they get a thousand résumés a week and if you screw up once, you're out! The only thing you can bring to the party is the fact that you will work hard. You feel so expendable.

BOWEN: There's an incredible amount of contradiction in the mailroom. You're asking naturally aggressive people to sublimate the strengths you value, to work as a team. That's really hard. Everybody in the mailroom wants to be the first and the best and the fastest and the

strongest. Then they're told to answer the phones, be someone's "person," and live vicariously through their boss for three years. That conflict was the most difficult thing I've ever had to deal with.

MICHAEL CONWAY: As the guy who ran the mailroom, I've seen a lot of these kids come in with big aspirations, great college degrees, lots of ambition. And it's a big ego deflation to push a mail cart for three hundred a week. Their feet bleed; they work twelve-hour days and come in on weekends. Someone's throwing things. They get yelled at because they dropped a call. Or they're sent out to get Lamb Chop panties for an agent's daughter. Suddenly they realize, I got a degree from Harvard for this? There have been more than a few crying sessions. It's psychological warfare.

JOEL: In the navy I had to be at work at six-thirty every day, did not have a weekend off in four years. At UTA they said I didn't have to be at work until eight o'clock and I had weekends off. I'd been living on a ship; suddenly I worked in beautiful offices, with glass everywhere. It was like Disneyland. People talked on headsets; they used computers. You'd think the military would be very high-tech, but we're the most prehistoric, poorly run organization. We had only one computer on the entire ship. At UTA a guy came up to shine agents' shoes. Everyone was well dressed. I could not get over the fact that some of the assistants had even nicer cars than the agents. It was a world I had not remotely been exposed to, and it was incredibly intimidating.

IWANYK: The first guy I met was Kevin Stolper, who said, "I've been here six weeks, man, and this is a tough gig. This is really tough. I'm gonna train you today, but it's hard, man."

I was, like, Fuck, what's gonna happen? Are people gonna throw shit at us? We went to the first agent, put stuff in the in-box, took stuff from the out-box. He said, "How you doing, nice to meet you." Did it again and again and again. Kevin was so nervous and there was so much tension, it was almost unbearable.

Back in the mailroom, I said, "That's it? That was hard?"

Kevin was, like, "Yeah, man, that was tough." All the other guys were, like, "You got through it all right?"

I'm thinking, *This* is hard? How hard can it be?

STOLPER: There didn't seem to be any structure to the training program that I'd read so much about. It was just a bunch of kids. I realized I'd been sold on a "training program" and duped. I'd believed the magazines, not realizing that they have to glamorize things to sell copies. I'd

envisioned, in a horribly materialistic way, one day driving a Mercedes, talking on a cell phone, and doing business. I couldn't quite get my head around the fact that my first job was in the fourth-floor closet—literally a closet—where they'd stuck a smaller copy machine to handle the overflow. I wasn't alone in this closet. With me was Stacey Boniello, a really attractive, cool woman. I stepped inside and thought, This is the greatest day of my life. I have a new job and I'm locked in a closet with a cute girl, and there is nothing to do but copy paper and hit on her until she is so completely sick of me that she says yes to going out with me.

Of course, I'm sure Stacey was thinking, "Get this geek away from me." She'd already been there for a couple of weeks, and she knew the score.

SAFRAN: Some twenty-two-year-old walked me around, showed me a room with three giant copy machines and a script library. Soon I was in my Brooks Brothers suit, Oxford shoes, shirt, tie, and cuff links, sweat dripping down my forehead, scrambling to collect pages of a script that were stuck in the machine. Meanwhile, assistants called every two seconds: "Where's my script? Where's my script?" yelling at me as if I were the bellhop at a bad hotel. I got home about ten-thirty, absolutely exhausted. I thought, What am I doing? I took a pay cut of *$1,900 a week* to do this?

NAEGLE: The first day I made two mistakes: I parked in the wrong lot and walked over, and I wore heels. But we all bonded quickly. It didn't matter how much money you or your family had. We all got paid $275 a week. My first lunch was at Hamburger Hamlet. What's creepy is that I still remember what I ordered: a Morgan sandwich. For fun we went to industry events and ate from the buffet. We snuck into premieres. We had our own parties on a rotating basis. We didn't get much sleep.

SHEINWOLD: I showed up in some retarded burgundy dress. I really tried, but I'm so not a dress girl. Right away I did filing, but I was so uninterested, I didn't even look at the stuff. Then I got to wheel the cart around. A guy in the mailroom gave me a crumpled map, a diagram of where every agent's desk was. He lectured me about how I had to make sure I put the right mail into the right agent's box or some travesty would unfold. And above all, "Don't lose this piece of paper."

JUMP? HOW HIGH?

JOEL: I was temping for someone when his wife called and asked if I would make a dinner reservation for them that night. In the time she took to call me, she could have called the restaurant and made the reservation herself. That's the first thing I wanted to say; of course I didn't. Afterward it struck me if I didn't make it as an agent, I could always be a hotel concierge.

KRAMER: I had to take one agent's family—the kids, the nanny, the wife—to the airport for their vacation in the Hamptons. The son was about eight years old and, on the way, puked all over the backseat of the car. This was what I had to do to make it in the film business: drive a puke-filled car.

KIM: I had to pick up lunches for a meeting with seventeen people. Every order was some fucked-up request like "Turkey sandwich on sourdough, nothing on it, a little bit of onion and lettuce on the side." There was even some kind of sandwich I'd never heard of. I got all the orders and walked to Judy's Deli. Closed for remodeling.

I freaked out. It was a hundred degrees outside. I had half an hour. I started walking. I went into each restaurant and coffee shop and asked if they had the sandwich I'd never heard of. "No, sorry." Finally one guy said, "Roll up your sleeves and get back here. We'll get you out in ten minutes." I did as he said. Order by order, we made the sandwiches together.

HEYMAN: Mike Myers was our biggest client at the time because of *Wayne's World*. He called and said that he was going to London and he wanted two tickets to the Wimbledon semifinals or the finals. That is about as tough a request as you will ever find. I thought about it, saw that it was on NBC, looked up who was the head of NBC Sports. I called Dick Ebersol's office in New York, and told them I represented Mike Myers, who had just gotten married and wanted to go to the finals of Wimbledon. Could Mr. Ebersol accommodate the request? Amazingly he got two box seats, center court, free, no questions asked, compliments of NBC. Mike was very happy.

STOLPER: I gassed Peter Benedek's car. Picked up Jeremy Zimmer's tie from the cleaners. Got Marty Bauer's laxative medicine. Fed somebody's

cats. Delivered a package to Charles Grodin, and he opened his door in his underwear. Illuminating: boxers.

One partner had a birthday party for her three- or four-year-old kid, and a few of us mailroomers worked the occasion. We were paid; it was perfectly reasonable. But I remember literally jockeying for position to play with the kids of the more significant partners, so that they would see me being nice to their offspring. I recall some pushing and shoving.

KIM: Sometimes it could be fun. When I put gas in Jeremy Zimmer's Jaguar, a woman at the station checked out his wheels—and me. I thought, It must be nice to have a Jaguar. I came back and told Jeremy the story. He said, "Rob, if you ever have an opportunity to get laid, do it—and when you come back late, tell me, and I'll be fine with it." I thought, I love this place! Where else are you going to hear that kind of encouragement?

KLIONER: As an agent, there isn't one thing a client can ask you to do to which you can say no. They say, "I need you to baby-sit my kid and change his diaper." You say, "Sure. What time do you want me there?" That said, someone's also got to service the agents. There are a lot of people in the mailroom who don't understand that. You never say to your boss, "I can't take this shirt to the dry cleaner because Tom Cruise needs a ride." They don't care—even if they represent Cruise. They want their shit at the dry cleaner. Find somebody else to pick up Tom Cruise.

The mailroom wasn't a test. You just had to strip yourself of any dignity, especially when you were driving to the Laundromat with a week's worth of a partner's smelly clothes, or when you went to Toys R Us to pick up Play-Doh for a partner's daughter. And God forbid you screw up. One kid in the mailroom house-sat for Jeremy. He went to work and left the back door open, and the dog went outside and got sprayed by a skunk. He had to go home during lunch and buy eight gallons of tomato juice to wash the dog and get the smell out.

GOOD THING THESE GUYS AREN'T WORKING IN MISSILE SILOS

KIM: We didn't yet have e-mail, just little Amtel terminals. If you typed in Shift + + and hit Send, your message would go to the entire company, on every Amtel.

I was in the copy room; Mike Patterson worked on Jeremy's desk. We were sending Amtels back and forth, just kind of joking around. I realized I hadn't heard from him for a while, so I typed, "What up, little bitch?" I hit Send, and suddenly I heard all the Amtels going. I had sent it to the entire office instead of just to him.

The blood rushed out of my head. I stood there, turning white, and stared at the thing. I tried to convince myself that no one would notice, and went back to copying scripts.

Then the Amtel started going crazy with people responding: "Are you insane?"

From Jeremy Zimmer: "Who sent this?"

I ignored it. Jeremy sent another: "Who sent this?"

I didn't respond.

Ten minutes later, Jeremy appeared at the door, smiling. I said, "I'm sorry. It was supposed to go to one person. I don't know how that happened." He kept looking at me with that crazy Jeremy stare and just let me grovel, then he walked away.

KRAMER: One girl in the mailroom had huge breasts. Her name was Evie. Jeremy Zimmer's daughter, who was only two years old at the time, is also named Evie. One day some guy filled in for Evie, and his friend in the mailroom sent a message to him saying, "Hey, Evie: nice tits!" Accidentally he hit the wrong button and sent the message out to the entire agency. This just happened to be a day that the two-year-old Evie was running around the office. Jeremy Zimmer got the message—and man, was it uncomfortable.

BLOWING OFF STEAM

KLIONER: A new kid was on her first desk, working for Jim Berkus. I called her and said, "Hi, I have Orson Welles calling for Jim." She said, "Hold on," then went running down the foyer: "Jim, Orson Welles for you on line two!" In front of everybody. It was unbelievable. Welles was *dead*. We were under our desks. Of course, that could have happened to any of us. One out of a hundred knows anything about film history before they come into the mailroom—*and they don't learn there*. Within a few years we can be at the highest level of the business, representing significant talent, talking to studio heads, and still not have seen *Citizen Kane*. And worse, it doesn't matter, because in the movie business knowing about the movies has nothing to do with anything.

IWANYK: If you wanted to send a fan letter to one of our clients, it would be in care of UTA. There were mountains of letters, and when we got bored we answered them. People would ask for a head shot. We'd send a head shot and say, "Dear Sue: Get a life. Love," whoever. It was total stupidity, but when you were in the mailroom you just got punchy.

SHEINWOLD: I was the proverbial shit stirrer. I've always tried to push people and maximize their aberrant behavior. One girl got sent home for dressing not overtly sexual, but inappropriately. She wore a blouse that amazed us all: a white button-down Oxford shirt with a big open square across her considerable chest. I'm sure I said, "Oh, what a pretty shirt. Why don't you go drop this off at Jeremy's office." Just for fun.

THERE'S ONE OR MORE IN EVERY MADDING CROWD

CONWAY: We had a guy who was so dumb that people called him Beavis. He walked like a big hulking thing and talked southern. I resented the fact that the only reason he was at UTA was because he was related to one of the agents.

I'd say, "Beavis, you're a walking turnip."

He'd say, "Conwaaay, you gotta lot to lurn."

One day a manager called. He'd signed a new client that we corepresented. He said, "I'm going out with him to the top ten casting directors in Los Angeles. I need ten demo reels. They've got to be done quick and letter perfect, okay?"

Beavis was working the video-duping booth that day. I explained the task, and Beavis said, "Okay, I'll do it." He made ten tapes, labeled them, and sent them to the mailroom, which sent them to the manager, and the manager sent them out.

About two hours later, the manager called up the agent, screaming, "What are you trying to do? What did I ever do to you? Are you trying to fuck me over? I just sent out ten tapes of people fucking in a hot tub! Someone just called to ask which one in the hot tub was my client!"

The agent and the assistant couldn't stop laughing. There's a little switch on the machine that lets you watch one tape while you're duping something else, and clearly Beavis had flipped it the wrong way. The manager screamed, "Go ahead and laugh! Everybody else in town is, too!"

The moral of the story is (a) don't have Beavis do your tapes, and (b) check your tapes before you send them out.

STOLPER: One guy in the mailroom with me told me that he'd been talking to River Phoenix the night before he OD'd, and it was a real bummer because he'd known River very well and he'd felt 100 percent sure that, given a week or two, he would have been able to bring him into the agency as a client. A few of us were pretty certain that we caught that same guy trying to sexually molest the copy machine.

THE PINK DRESS

KRAMER: When I started they assigned a girl from the mailroom to show me how the system worked. She was a very odd bird who wore a pink dress that I soon discovered she wore almost every day. The dress was always very dirty. It was hard to talk to her, and you never knew how she'd respond. She was incredibly emotional. I thought that if everyone in the place was like that, I'd be in big trouble.

I went to lunch with a friend who had started two days before me. I

told him that I had been trained all morning by the girl in the pink dress. I tried to be politic about it, but he started laughing hysterically. Apparently everyone felt that way.

She actually gave us a lot of joy because every day there was a crazy story about her. Once she heard that we had ordered pizza. When she saw there was no pizza for her, she threw a hissy fit and started crying. As time went on, she got darker and darker. Then her clothes and hair got different. I think the head of the mailroom finally said something to her.

CONWAY: Oh, God. She was sweet and she meant well, but she was a lost cause, bless her soul. She was not going to make it. She wore her pink flannel dress with the flowers on it day after day. She was dirty. Her glasses were always gunked up with crap. "Grimy" was her nickname. She talked about her . . . diseases. She was kind of gross, but I think it was her way of trying to fit in with the guys. She wanted to be part of the group, and she tried desperately.

KIM: No one knows what happened to her. She was on *Love Connection* at one point, and then we never heard from her again. She lasted pretty long, considering.

THE WHITE GLOVES

DARMODY: One girl wore white gloves because she didn't want to get paper cuts. We would always goof on her: "What's with the gloves?" She'd always say: "My hands are very soft." You could tell she was insanely wealthy. She drove a brand-new Beemer and was hot-looking. It was good for the place to have her out on the runs instead of delivering mail, making temperatures rise in the office.

CONWAY: I thought the gloves were the most princess thing that I had ever seen. She was amazingly beautiful, from New York, a debutante type who had seen it all and done it all. Nothing impressed her. I liked her immediately. She was a straight shooter, and there was something really engaging about that.

All the partners thought this girl was amazing, too—particularly Marty Bauer. When Sharon Sheinwold worked for Marty, he wanted this girl on his desk while Sharon was on vacation. Marty was so

ferklempt when she showed up—and he wanted to wow her so badly—that he went to his partners asking if they could maneuver to have Jeffrey Katzenberg or some big executive call his office so this new girl would be impressed.

SHEINWOLD: Marty's office was next to Jim Berkus's. Bauer would get his nails manicured each week. When she floated on Berkus's desk he said, "Would *you* like to have a manicure?" It was always so funny to watch these tough guys felled, particularly by a five-foot-tall girl in white gloves.

THE GOLDDIGGER

CONWAY: We had one trainee who clearly wanted a rich husband. Why she was hired, I have no idea. One day she wore these maroon spandex pants with a matching bodysuit top, cut low. I said, "You know, that's really not appropriate. You need to put on a jacket or something—at least." Then I'd get calls. She was loitering in an agent's doorway—I think it was David Schiff—with her breasts jutting out seductively, saying, "Hi, David, how are you?"

One day she showed up in a see-through Victoria's Secret kind of blouse thing. She wanted to run the cart that day so she could schmooze, but I was on to that. I said, "No, today's not your day—especially not with this blouse." The next day she said, "It's my day to run. Can I deliver the mail?" She was wearing a jacket, so I said yes. She took off, and suddenly my Amtel's going *ding-ding-ding-ding-ding!* They're all saying, "Have you seen what she's wearing today?!"

She had taken off the jacket.

As if the provocative clothes weren't enough of a problem, she stalked Rob Kim, Marty Bowen, and some other guys. She'd find out where they were having dinner—they were all assistants and went out together—and she'd show up unexpectedly, "Oh, hi! How are you?" and join their group. She was always out late at night, partying, and always late to work, and tired—except when it came time to push the mail cart.

One day Mark Conroy, who ran the mailroom for me, called and said she was complaining of fatigue. I said, "Tell her to lie down if she's not feeling well. And when she's asleep, call me."

He called: "She's asleep, and she's snoring."

"Great. I'll be there in just a second."

She lay on an old piece of furniture behind the shelves in the back, hidden from everybody. I kicked the sofa and screamed, *"What are you doing? Get up!"*

I terminated her.

She decided to go back to Baltimore and become a model. I don't know if that worked out. A couple of years ago someone saw her at the Sundance Film Festival, hitting the trail.

KLIONER: The girls who flirted with the agents always got out of the mailroom first. I don't want to harp on that because it's true of every business. It's one of the early advantages that women have. However, later in the business, men have the advantage. It's almost karmic.

Girls like that self-destructed in the long run, because any agent is smart enough to know she's not going to be a great colleague if she's not also doing the work. My buddies and I would take bets on which girl would self-destruct first. But sometimes we'd be forced to go, "I can't believe this shit is working on people. There's no way people aren't seeing through that bullshit rap, but let's go another six months." Those were long-running wagers.

Some of those women slept with the agents, but they deny it and the agent denies it. Everybody denies, and yet everybody kind of knows. In Hollywood, it's like almost all rumor and innuendo: It's usually true.

HOW DO YOU SPELL RELIEF?

ANONYMOUS: I had sex with two people when I was in the mailroom—though not at the same time. I was sleeping with the receptionist when Marty Bauer, who was going through a divorce, asked her out. He came to my office, put a hundred-dollar bill down, and said, "I know you're telling people that you're sleeping with Kathy [not her real name]. I think you're fucking lying. I bet you a hundred bucks that you didn't sleep with Kathy." I knew at that point I had to separate myself from her.

I had sex in every one of the fourth-floor offices before they were finished building them, but the video room was my favorite place. It was so dark and it was fun to do by the red lights of the video machines.

Then there's my favorite sex-as-an-assistant experience of all time.

We were selling *Afterlife,* a spec script by Joss Whedon. This was back when spec sales were the big swinging-dick thing to do. A lot of egos and big numbers were involved. Everybody was on a different phone, cell phones and regular phones. I couldn't stand the tension any longer. I looked over at a girl in the office that I fooled around with, we walked outside onto the balcony, she gave me head, and I came back in to help close the deal. It was the most exciting thing ever. But you have to understand: I had no money. I'd just gotten out of college. I spent twelve, fourteen hours a day in the office. Who else are you going to fool around with?

CONWAY: Yeah, there's a lot of that. I found out an assistant was having sex *on my desk*. It was, like, God, I had to get Windex and clean it [*laughs*]. He was just a dog, and still is.

HEY, BABY, WANNA GO TO A POLKA PARTY?

IWANYK: I lived with all these guys and we'd often go out en masse. At a bar called Mom's, in Brentwood, I talked to a beautiful girl for about three hours. I was hitting on all cylinders. I was so charming. She laughed at all my jokes. Her friends were talking to my friends. Right out of a movie.

At a quarter to two I said, "Hey, we all live in the same house. Let's go back and hang out. We have a pool." She and her friends were, like, "Sure! Yeah!"

The door to the bar opened and Weird Al Yankovic walked in. I went to settle my tab and I saw Weird Al go over and talk to my girl. I thought, Oh, God, poor guy; she's with me. Three minutes later she walked out with Weird Al. The other girls came back to our place. I'm, like, "Did she know Weird Al Yankovic?" They're, like, "No, but he was so nice . . ." Never saw her again.

I totally got the movie business in that one evening.

WITH FRIENDS LIKE THESE . . .

WELLS-ROTH: I thought I could make some friends but that didn't happen. My peers in the mailroom decided they were going to show me exactly how things worked. About eight-thirty one night, after all the agents and most of the assistants had gone, they asked me to come into one of the offices. We all sat down and they said, "You either learn to play the game our way or you'll never get out of the mailroom." I didn't know what they meant, why they were doing this, or what to do. I had never talked much to any of these people. I just ran around smiling, delivering mail. I learned that if you don't act social, they think you're a know-it-all. They also didn't like that I played tennis with the partners as a way to get ahead. Now I know it was exactly the right thing to do, but they wanted to make my life miserable because of it.

I went home crying. Like most women, I thought it was my fault. Instead of focusing on the job I became a basket case. I stopped talking to my classmates almost altogether. I didn't go to the parties. Every day somebody said something cruel. I got to do the stupid jobs. They wouldn't let me in on information—who people were meeting with, what scripts and talent were hot.

There was no one I could trust, no mentor. The only person who befriended me was an assistant who supposedly slept with people at the agency. I don't know if that's true, but in an elevator I witnessed some of the agents saying things to her that I thought were inappropriate. She was very tall, very pretty.

Before I left UTA only one person apologized: Sue Naegle. She said, "I'm really sorry for what we did. It was wrong." It meant a lot to me.

THE RACE

KIM: Sharon Sheinwold was bizarre. We called her Beetlejuice because she had jet black hair, pale skin, and dark makeup, and she wore these weird, drapey black clothes every day. I don't even know what the style is—mod, Goth, something. We were all freaked out by her.

SHEINWOLD: If anything, I fostered my weird reputation just because I

knew people would ask me to do less work if I was kind of unapproachable. I didn't think that my job required me to stop hanging out with all my friends, so I would work crazy hours and then go out crazy hours. I worked at these weird underground nightclubs and was slightly notorious as the palest, most tired assistant in the company. You just can't have a job and party all night, I guess. I wore weird motorcycle boots. I dyed my hair black. People here probably thought I'd gone Goth. But even though I had a little rougher exterior than most of my colleagues, I took my job very seriously and they couldn't get rid of me.

KIM: David Kanter was a feature lit agent. His assistant, Jenny Mintz, called me and said, "Hey, you seem really cool. People seem to like you. If you want David's desk, it's opening up because I'm leaving. I'll get it for you."

I'm, like, This is the greatest! Everyone's nice to me, and now I'm going to get a desk! I said, "Okay, I'll do whatever you say."

Jenny said, "Why don't you have lunch with me today?"

We popped in her car and she told me about David: "He's never had a male assistant. He likes hiring women because he wants tips on how to get his hair cut. His wife used to be his assistant. But this could work. I'll set up the interview. When you walk into his office, if he's on the phone, pick up the other phone and listen. He'll be impressed."

At the interview he *was* on the phone. I started listening, like I knew what he was talking about. He hung up and I hung up. I followed everything he did, kissing his ass like you would not believe. I said things like, "I know I have the tools, I just need someone to help me put it all together." Just cheesy, cheesy stuff. But he seemed to buy it.

SHEINWOLD: Jenny told *me* David's desk was available. I remember thinking, I have to get out of this fucking mailroom, so I'm gonna get that desk. Rob also interviewed. I don't know what either of us had to offer, except we could pick up a phone. Turned out David and I were born in the same hospital on Long Island. It was a weird coincidence that we both clung to as a sign that it was all going to be okay.

To get the desk I utilized a skill I didn't even realize I had, but it's something every agent needs: to be able to switch from idle mode to being the person who can sell anything or get the answer you want.

KIM: The next week Jenny came to me right before lunch and said, "David's going to make his decision today. He's at lunch right now. Go

over to his office as soon as he gets back and make the one final play, and I'm pretty sure you'll get it."

I went to lunch, came back early, and wandered around. At two-thirty I guessed David had gotten back. Someone must have also called Sharon, who was inside the copy room, and told her David had returned.

I walked past the Dutch door to the copy room on my way to David's office, and I heard, "Rob! Rob! Come in here!" It was Sharon, calling me.

I stopped, turned around, opened the bottom of the Dutch door, walked through—and saw Sharon literally run out the other door. She ran over to David's office and got the job.

SHEINWOLD: I don't remember it exactly as Rob told it, but I'm sure I did it. It sounds like me exactly. I've done similar things since.

KIM: It was such a devious thing to do. But she probably wanted it more than me. Afterward I didn't speak to Sharon for the longest time. Now we've gotten to know each other a little and it's fine.

SAMURAI AGENT

WELLS-ROTH: I substituted on Gavin Polone's desk, and one day he walked up and yelled at me: "Aren't you afraid?" I looked up at him and said, "Of what?" Maybe I should have been. He walked around his office with a bullwhip, cracking it in the air. He did karate kicks. He tried to scare and bully people because he thought it was funny.

KIM: I'd been in the mailroom three days when Gavin Polone walked right up to me and said, "Are you a fag?"

"What?"

He said, "Are you a fag?"

"Uh, no."

"Then here," he said, and he gave me two tickets to a boxing match at the Forum that night. I thought, Wow, that's really cool, he's giving me tickets to something.

He said, "You've taken them. Now you have to go."

I looked at the tickets and they were for seven o'clock—and it was seven o'clock.

He saw my face and said, "You have to go. If I give you the tickets, you have to go," and he walked away.

I didn't go. I was nervous about it, but I couldn't leave.

• • •

For some reason, Gavin thought that Asian people worked harder. The stereotype, I guess. He asked his assistant, Michael Brown, about me, and Michael said nice things. A few days later Michael said he was going out of town and Gavin wanted me on his desk. I was intimidated as hell.

There's a Fruit of the Month Club in which they send you a box of fruit each month. The day before I was supposed to start with Gavin, a box of fruit came for him. I took the fruit, walked it up to his office, and said, "You once asked me if I'm a fag." Then I handed him the box that read FRUIT OF THE MONTH with his name on it.

He laughed. Okay, I got one in. He didn't kill me.

I went psycho working for Gavin. I got in at seven-thirty and didn't leave until eleven o'clock at night. I could not have been more focused. At the end of the week, Gavin said, "You did all right, but you have no personality."

I said, "I didn't have time to have a personality. I was scared shitless all week. I just wanted to get the job done."

Michael Brown later told me, "He thought you were great. He wants to hire you when I get promoted."

FAY: A lot of people were afraid of Gavin. I thought he was a trip. Gavin did martial arts and always walked around in his socks and a quasi ponytail. He threw spinning back kicks in the hallway, which I thought was hysterical. He actually called me "Sean," which is a big deal. Even though he'd pose for photos with brass knuckles on, I knew he was a great agent. He certainly paid for himself and then some at the company. He became a partner at twenty-eight or twenty-nine. He was the guy. I looked to him as sort of a role model.

NAEGLE: For all the horrible stories about him, Gavin was actually very approachable, very smart. He was incredibly helpful and taught me a ton about how to interact with clients, about how he found material.

GINA GERSHON ON LINE THREE

KLIONER: After two months in the mailroom, my first desk was as second assistant to Jeremy Zimmer and Gavin Polone. Marty Bowen, who worked for Jeremy, was on one side and Rob Kim, who worked for Gavin, was on the other. They drove me nuts. They were killing me. But Gavin always created that friction between people who worked for him, because that's how he stayed in control of the situation. If people were worried about each other, they weren't worried about him. But he's also a great guy. Everybody who worked for him, he protected vigorously. He was just an asshole to everybody else.

KIM: Gleb was the rag doll that Marty and I beat on every day.

KLIONER: One day the phone rang and it was the actress Gina Gershon, Gavin's then-girlfriend. I had no idea they had a thing, didn't even know she was an actress.

Rob listened in on the call, and he said, "Tell her you saw *Love Matters* and you really liked her in it."

She was very sweet to me, and I thought, Okay, I'm a big shot and I'm going to be nice, too. "Hey, I saw you in *Love Matters*. Thought you were great."

I didn't know that she was *totally naked* in that movie, that it was a piece of crap and she hated it.

Gavin was home sick with the flu that day. That afternoon I brought over some chicken noodle, his trades, and the mail. He invited me in. He was like, "Hey, Gleb, come on in," all nice. I sat down on the couch and he said, "Gleb, why would you tell Gina Gershon that you saw her in *Love Matters*?" This was the first I knew I had said something wrong. "She's totally naked in the movie and it's a piece of shit, and she was totally freaked out that you mentioned it. She called me and asked why my guys were watching naked movies of her."

I said, "Gavin, I had *no* idea. Rob told me to say it. I didn't even know what I was saying."

Suddenly Gavin said, "Rob, do you hear that?"

I didn't realize that Gavin had Rob on the speakerphone. Rob had already testified that he hadn't said anything, so Gavin had set me up to rat out Rob. I got back to the office, and Rob looked at me like I'd just sold him down the river.

KIM: It was just a joke. Gleb, of course, didn't get it. After he left for Gavin's, Gavin called me and screamed, "What the fuck is wrong with you? You think you're fucking funny?" He was crazy.

I said, "Gavin, Gleb fucked up. I'm not taking the heat for this. I said it to Gleb as a joke. I didn't know he was going to tell Gina and say I thought she was great."

Right then Gleb rang the doorbell. Gavin left me on the phone and said, "Gleb, did Rob tell you to tell Gina that he saw the Showtime movie and thought she was great?"

Of course Gleb goes, "Yeah, he did." I could hear it all happening.

Gavin was livid. He went into a whole thing where he said, "This is how you prioritize my life. Number one, matters of my dick. Number two, matters of my clients. Number three, me."

PICKING THE RIGHT HORSE

SAFRAN: I'd been in the mailroom four days when Adam Isaacs's assistant moved to Judy Hofflund's desk. Adam had a lot of European clients—Juliette Binoche, Isabelle Huppert, Catherine Deneuve, Christopher Lambert—and he likes to have an assistant who speaks French. I put myself up for the job. I said, "I know I haven't been here a long time, but it's a meritocracy and this is the one instance in which I truly add value right from the start."

Adam's office was right next door to Nick Stevens's. Nick's big client was Jason Priestley. His other client, Jim Carrey, was shooting *Ace Ventura* and hadn't hit yet; he was just the white guy on *In Living Color*. Nick was notorious as the hardest agent to work for. It was high volume, he was incredibly demanding, and he could be a screamer. Sometimes I'd look pityingly at Abram Nalibotsky, Nick's assistant, because Nick would be throwing something at the glass between them, to get Abram's attention.

One night, Adam left the office and I was still working at seven-thirty. Nick's phone rang and, as a courtesy to Abram, I picked up.

A voice said, "Who's this?"

"Peter."

"It's me, Nick. You know, I'm thinking that Abram, I've gotta get rid

of him. It's not working out. I don't think he's the right guy. He's fuck-
ing up." Nick's version of fucking up is probably that Abram dropped
one phone call. He said, "You know what you should do, if you're
smart? You should come work for me."

I said, "Why? It's good over here with Adam."

He said, "Tell you why. If you do the job I think you're going to do, I
will become your internal advocate. I'm a very vocal person and I've got
everybody's ear here, and I will make sure you're the next person pro-
moted to an agent."

I believed him. He was close to Bauer and Berkus and Zimmer. And
it seemed like an opportunity. I don't think Zimmer was thrilled with
my moving, but Nick did his number, and I started working for him. It
was a whole different world.

Adam's desk was very civilized. Nick's desk was a shit storm. It was
television, features, people crossing over, character actors who do three
or four movies a year. It was Jim Carrey, poised to explode. I started
working for Nick in October, and *Ace Ventura* came out in January.
Eleven million dollars its first week. *The Mask* was due out in the sum-
mer. Jim was now an entity. As a result, Nick suddenly had to raise the
level of his own game. In doing so, he felt comfortable allowing me to
raise the level of my game, and I took over with some of the younger
clients. Occasionally Nick would still throw things against the glass, but
because I had everything under control, he treated me in a much more
civilized manner.

Nick is as good as they come in terms of being a hard-core, hard-
pressure salesman and negotiator. It was great to listen to him on sign-
ing calls. He knew what to talk about that was important to them. He
listened. Very, very persuasive. Great closer.

But it was more the personal side of things, the way clients would
sometimes unload on their agents, that was interesting. You realize
you're in much more than a business relationship. I think Nick actually
cared about the personal stuff 90 percent of the time. At least he didn't
just sit there listening on the phone, making jerk-off motions with his
hand.

Nick taught me an important lesson. His son was about two years
old at the time, and all he ever wanted to do at the end of work was go
home to his wife and kid. He said, "You don't need to go to premieres.
You don't need to go to business dinners. What you need to do is do

your job well. If you do your job well, clients will come. Clients will stay with you. You'll get a good reputation. You don't have to schmooze."

WELLS-ROTH: I finally got out of the mailroom after four months. I wanted Cynthia Shelton's desk, but Jeremy Zimmer called me into his office and said Jill Hollwager, who was a TV lit agent, wanted me on her desk. Jill was a nightmare at the time. Nobody wanted her desk. She screamed and yelled—and I cried. Nothing I could do was good enough for any of these people. My desk was next to Nick Stevens's office; his assistant, Brandt Joel, saw how miserable I was. He told me Connie Tavel, a big manager, was looking for an assistant.

The day I left, I met with Jeremy Zimmer. He said, "At least you won't wake up when you're thirty-five or my age and be miserable."

Suddenly I got it. I said, "Are *you* really that miserable?"

It was an unkind thing to say in a sad state. I think he's a very different guy today.

NAEGLE: The big lesson was to get the big picture. The big picture was: You had to jibe personalitywise with the person you were working for.

My first desk was Nancy Jones. People said we sounded like each other and had the same mannerisms. She took care of me, would bring me clothes, buy me lunch. That helped because it was really hard to pay for my car and insurance and rent on zero money.

After Nancy I wanted to work for Gavin Polone. I thought Gavin was really cool.

My interview with Gavin was memorable. He said, "If you make one mistake, I'll fire you. Can you handle that kind of pressure? If you're not here when I call, if you miss one call off the phone sheet, I'll fire you. Do you understand that? Does that scare you? Are you going to act like a little girl? Are you going to cry when I yell at you? Are you going to complain to your mom? Are you going to be able to do this?"

I said, "Yes. Yes, absolutely."

I'm not going to lie: I almost peed in my pants. I was thinking, Of course I'm going to make one mistake. It took a while before I realized he was just trying to scare me. But Gavin hired Wendy Casaleth instead of me. Wendy was very glamorous, and I was tortured every day that I wasn't chosen. I went to work for Gary Cosay instead, who was great.

Wendy got married and left after about eight months. Then she sued Gavin for sexual harassment.

When I finally got promoted Gavin delivered the good news. He said, "We've all been talking and we think you're going to work out. But in case you don't, we'll fire you—and you shouldn't take it personally."

HEYMAN: When we merged with InterTalent we no longer had a list of B-actors, but real talents. Sixty performers. I knew we'd be expanding even more, so I cornered Judy Hofflund in the elevator and told her that she had to hire me. She said, "Great," and I worked for her for two years.

Judy was very cool, very hyperefficient. She learned her style from Ron Meyer, who had learned his style from Phil Weltman, who learned his style from whoever—maybe Abe Lastfogel. I learned techniques that I'm sure had been passed from generation to generation. This is why no one should be bothered to hear "Oh, my God, you're an assistant! You're a secretary, making three hundred dollars a week, working twenty hours a day. How can you do it?"

You say, "Well, Barry Diller did it, Mike Ovitz did it, every single person who has reached any height has gone through some version of that process."

BOWEN: It took me five months to get out of the mailroom. It's taken me years to admit that it took me that long. I couldn't come to terms with it.

Peter Benedek was my first desk. In a sea of sharks, Peter is the dolphin. He said I'd be promoted in a year. Two years later I was still waiting. I had moved from his desk, a partner's desk, a step down to work for Risa Gertner. Risa didn't give a shit about my future. She just wanted me to watch her back.

Then I moved to Jeremy Zimmer's desk. I loved listening in on Jeremy's phone calls. He was hysterical. Jeremy liked to have an audience. The bigger the audience he had, like a good comedian, the funnier he could be. Negotiating a deal, he could twist people up like a pretzel. Getting a date, he could be a maestro.

Jeremy was also going through a divorce and an early midlife crisis. My job was to help him negotiate his own life. That was how I finally learned to be vicarious, to truly think, live, eat, and sleep whatever my boss did. Otherwise, how else are you going to stand three years of

answering phones with an Ivy League degree under your belt? When everybody else is making six figures, how else are you going to survive if you don't take the job personally?

KIM: I wanted Gavin Polone's desk, and he had promised it to me. But when his desk opened, Wendy Casaleth, who had worked for Jay Sures, complained, "I've been working in the Television Department for eight months. It's not fair if I don't get a chance."

Gavin called me and said Wendy was having a big fit. He didn't want to hire her, he wanted to hire me—but he felt he *had* to give Wendy the opportunity. He offered me Jay Sures's desk. I said fine. He walked me into Jay's little office in the corner and said, "Jay, this is your new assistant," and walked out.

While I was on Jay's desk I had to make a decision about law school. I'd gotten letters about declaring for the next year and I had ignored them because I didn't know what to do. I asked the USC law school dean of admissions if I could defer another year, and she said no. So, on the spot, I said, "Well, I guess I'm not going."

I hung up, and reality sank in. For the first time, working at UTA really became serious for me. I felt like now I *had* to succeed. I come from a very traditional Korean family—you're either a doctor or a lawyer, and everything else is a joke.

After a few months on Jay's desk the whole Wendy sexual harassment thing went down; she left the company. Gavin walked over and said, "Do you want to be my assistant now?"

I said, "Yeah."

He walked into Jay's office and said, "Hire a new assistant," and walked out.

• • •

Gavin was a partner, he made over a million dollars a year, he had a Ferrari. But he went to every TV taping, he went to every meeting, he signed people, he serviced people. He believed what he believed, whether you agreed or not. He lived by a code of ethics he created for himself and followed without exception. He never expected anyone to do anything he didn't do. And because he did it all, there were no excuses. It left you no room to slack off.

I got promoted in February 1994. I was twenty-three and the youngest agent at UTA at the time. In the press release, Gavin's quote was, "I believe Rob Kim will be the greatest agent who was ever born in Seoul, Korea."

He belittled me to the very end. [*laughs*]

SHEINWOLD: After David Kanter I worked for Marty Bauer. I pursued that, embarrassingly so. Elyse Scherz, an agent here now, was his assistant at the time. I say this with love in my heart, because she's a really good friend, but she did everything in her power to give the desk to someone else. So I did the most embarrassing thing: I made this little book of pictures of me. I came into the office one weekend with a friend of mine from film school and he took a picture of me in a sleeping bag at Marty's assistant's desk, the idea being "I'll work long hours." Then me fixing a car, and me in a karate outfit. My friend played a dead body in that one while I did a kick. It was dumb, but I got the job. I gave it to him as a gift and he said, "Anyone who would do this is obviously interested in the job." And retarded [*laughs*]. I recently found the book. First I lamented how thin I was, but then I was, like, What was I thinking?

Working for Marty was amazing. We didn't do a lot of *work,* but that's where I learned some of the most valuable lessons ever. For instance, how to get him a room in Vegas, no matter what, because he had said, "I never want to hear the words 'No, I can't do that' from you."

I went to Jeremy Zimmer next. He was the fount of all learning. I worship Jeremy. He is brilliant. He always knew how to say something funny that was still a knife in your heart. He taught me how to be an agent. He's a genius at it.

This is bad, but [*sighs*] I think that primarily the reason he hired me was that I worked for Bauer. Jeremy was going through his divorce at the time, and I had a lot of really cute friends. I think he thought if he hired me, I could set him up on dates. In fact, I probably intimated that I could, just to get the job. Whatever it takes, right?

BODY SHOT

KIM: My first year at UTA the Christmas party was at Typhoon, at the Santa Monica Airport. It was employees only. No spouses or anything. The last party I'd been at was a fraternity kegger. This was an open bar, with food and everything. People got really, really drunk.

I sat with David Kramer, who was having a drink with Gail Fanaro, who had just become an agent. He was confessing his love for her—but like I said, we were all drunk. Behind us were Judy Hofflund, David Schiff, and Marty Bauer.

I heard Judy Hofflund ask her table, "What's a body shot?"

I turned around. "Body shot?"

"Yeah. What is a body shot?"

I explained that you put salt on a woman's neck and she holds a slice of lime in her teeth. You lick the salt off her neck, do a shot of tequila, then bite the lime that she's holding in her teeth.

Judy said, "Oh, let's try one."

I said, "Nuh-uh, Judy. I can't do a body shot with *you*."

She said, "No, no, it's fine. I want to try it. It sounds cool."

I said, "Judy, if you promise me I'm not going to get fired, I'll do one." All the partners sat there, looking at me. She laughed. "I promise you're not going to get fired."

I ordered a shot of tequila. I dipped my finger in the tequila and wiped it on her neck. I poured salt on her neck. I licked the salt off her neck, did the shot, bit the lime out of her mouth. I looked over her shoulder and saw people's mouths on the floor. Even Gavin's. Judy loved it. The rest of the night I was flying on cloud nine. I was the center of attention.

The next day I got a call from Judy's husband, Tom. "So, I heard something about you and my wife last night at the Christmas party." We joked about it a little bit and I hung up relieved. The second year I got a call from Tom the day of the Christmas party. He said, "You know, it's around this time of the year that I begin to hear your name around my house. I just want you to keep in mind: Judy's a mother and my wife." Just kind of giving me shit.

That night, sure enough, we did body shots.

The third year Jeremy did a whole body shot thing where he'd call people out—two women and everything—and everyone did them.

The last year, before Judy left to start her own management company, she was very pregnant. We were about to do the body shot and she said, "Do you want to do it off my stomach?"

I said, "No fucking way, Judy. That's where I'm drawing the line. There's no way I'm licking your pregnant stomach."

BOB SUGAR OR JERRY MAGUIRE?

JOEL: What you discover in the training program is that there are many personalities out there, and you have to learn how to handle *all* of them. Everyone I represent is different. When you're pushing the mail cart, each assistant you meet is someone new. If you're an automaton, you don't make it.

You also learn that a lot of the Hollywood myths *are* myths. The power lunches are bullshit. You're a reflection of your clients, and that's how you get hot. It's as simple as that. You also see what to do and what not to do. A lot of *Jerry Maguire* was true. There are two ways to go: There's the Bob Sugar way, to sleaze out, or there's the Jerry Maguire way. You can watch assistants and tell if they're going to become Bob Sugars or Jerry Maguires.

Even though the myths created in Hollywood are just bullshit, lots of people believe what they read in *People* magazine. Last year I went to Duke University and spoke to about three hundred kids. I said, "You want the reality or you want the bullshit?" The reality is, it's $285 a week, it sucks, you have no free time, but it's a means to an end. If you don't want to see the movies, don't want to watch the TV shows, don't want to go to the comedy clubs, don't even apply, because there are thousands of people who want to.

But if you want to, here's the payback: I was driving along Santa Monica Boulevard not long ago and there were two billboards, on opposite ends of the street, for TV shows about to premiere—and my clients were the leads in both of them.

WITHOUT A NET

DAS: I was a motion picture lit agent for a little under three years. I made deals for writers and directors. Sometimes I thought, God, I can't believe I'm getting paid for this! Here I am, at a screening, on a Friday afternoon, watching a great movie. Or I'm at Sundance, and it's *my job*.

But I gave it up. The partners in my company began to look old. It's a hard world. You have very little social life. Everything revolves around

your work. You're in your office and on the phone 75 percent of the time. It gets pretty repetitive.

If you're really into the whole glamour of the movie industry, maybe you won't mind. You're at the top of the mountain, looking down. It's very exclusive. And the rewards are okay. You're a salaried guy, you get a nice bonus, and you have a four-year contract. Nice car, nice house, a decent life. The other side is that you're stuck in Los Angeles with a very expensive house, expensive cars, and two kids to put through private schools. Plus you're always *servicing* people: your clients, others' clients, covering studios. I wasn't convinced this was the way for an entrepreneur to go. It's ironic, because people have the impression that agents *are* entrepreneurs. They're not, really. Agents are secure. They have something to sell that has a built-in sell. Agents are not really risk takers. If you don't sell one client, you have another client to sell. You're a company guy and you're working for the man, and that's it. You're not going to be a millionaire unless you slug it out for the long haul and become an Ed Limato or Jack Rapke.

Agents figure that out pretty quickly. I know a lot of unhappy agents.

I had begun to do fairly well. I sold *The Sixth Sense* to Disney with Peter Benedek for $2.5 million. No one had any idea that the movie would be as successful as it was. M. Night Shyamalan was the client I loved working with the most. But deep down it had become meaningless to me. Making money was never my motivation; working with filmmakers was. I was no longer psyched up enough to go to work every morning.

• • •

I put my stuff in storage, bought three plane tickets, and went to South America, Africa, and the Mediterranean. I hiked the Inca Trail to Machu Picchu. I trekked in Patagonia. I climbed the highest mountain in Morocco. I asked myself: Is the rat race for me? Is Hollywood? I was thirty-one and had had two careers. I was pretty confident that I had enough contacts at my level in the industry that I could take six months off and come back—be an agent at another agency if I wanted. I was also 99 percent sure I wouldn't want that.

I didn't even come home for the premiere of *The Sixth Sense*. Night was cool with it. Finally, after a year and a trip around the world, I was almost ready to return, but my girlfriend suggested that maybe I should go to Kosovo. I had wanted to do some volunteer work. Give something back to society. I was in Italy, not too far away.

I went to Kosovo cold. I ended up transferring my skills as an agent to the relief effort. I went to this war-torn country—flattened, nothing, no prison, no bank, no mail, no legal system, no nothing—with the biggest UN mission ever. I knocked on doors and I met a guy who ran the United Nations Development Programme. With luck, timing, and salesmanship I managed to get hired to run this $2 million, $3 million program. I had a local staff of three and a Land Rover, and I ran the office in the most important city in Kosovo, identifying, implementing, and monitoring rehabilitation programs.

My plan was to do that for a month. They offered me a contract to do it for nine months. I took it. The job was great. It involved me doing something, the results of which I could see immediately: creating jobs, reforestation, repairing roads, cleaning rivers, making parks. I personally made a difference.

After nine months they offered me another year, but by then I was ready to come home. And here I am. I don't know what I'm going to do next, but that's okay with me.

AND IN THE END, THE LOVE YOU TAKE
IS EQUAL TO THE LOVE YOU MAKE

KLIONER: Jeremy Zimmer sent me out to get some tulips for his office. I didn't know the first thing about flowers, but I found a shop and I bought tulips. By the time I got them back to the office, they were drooping. Jeremy said, "I'm not having anybody work for me who pays twenty dollars for wilted tulips and gets ripped off. It's embarrassing." I expected that, even to get yelled at, but not what he did next. We got in his car and drove to the flower shop. He took the flowers in and right in front of me told the salesman, "These are not acceptable." He was almost like a father standing up for his son, showing him how to do it right.

• • •

SUE NAEGLE is partner and cohead of the Television Department at UTA.

MARTY BOWEN is "humbly" an agent at UTA.

BRANDT JOEL is an agent at CAA.

MICHAEL CONWAY is executive administrator at UTA, currently overseeing the management of UTA's daily administrative operations, including recruitment and hiring for the agent training program/mailroom.

SEAN FAY is a personal manager who worked his way up from assistant to partner at Imperato-Fay Management.

ROB KIM is an agent in the Television Literary and Television Packaging departments at UTA.

JASON HEYMAN is a motion picture talent agent at UTA.

SHARON SHEINWOLD is a talent agent at UTA.

TONI WELLS-ROTH is available for "a great job or a great adventure, preferably both."

DAVID KRAMER is a motion picture literary agent at UTA.

JIMMY DARMODY is an agent at CAA.

KEVIN STOLPER is a talent agent working in both feature film and television at UTA.

GLEB KLIONER became a talent agent at UTA in 1997. He is now a business entrepreneur and a manager at Schacter Entertainment.

SHERWIN DAS was last seen back in Kosovo as a civil affairs officer with the United Nations.

BASIL IWAYNK is president of production at InterMedia Films.

PETER SAFRAN is a manager at Brillstein/Grey Entertainment.

CHARLES FERRARO is an agent at UTA.

IN YOUR FACE! . . . WITH LOVE

Endeavor, Los Angeles, 1995

ADRIANA ALBERGHETTI

My aunt is Anna Maria Alberghetti. My father is an entertainment attorney in business affairs at the studios. But that's not what brought me to the business. I've just always been obsessed with the movies.

After graduating from Berkeley in 1992, I wanted to come home and pursue my dream of somehow working in film, but I had also fallen in love with San Francisco and didn't want to forfeit a couple of years there by jumping right into Hollywood. I was only twenty-one. I thought it would be a good idea to have some kind of life experience outside of show business because I knew once I was in it, I'd never leave. At first I thought I could compromise by working at Coppola's company in northern California, but they told me, "Listen, we don't really *do* anything. We're not *in* the business. Don't be an idiot. Go down to Los Angeles."

Instead I found a job at Smith Barney, in the marketing department. I lived in San Francisco and had lots of friends. I enjoyed the idea of dressing up in a suit, wearing pearls and stockings, and working downtown. I had my Coach briefcase with, of course, nothing in it, but at least I had it.

After three and a half years I was the youngest cohead of a department, with thirty-five people. But I couldn't shake the old feeling that I wasn't in the right business.

I decided to talk to the CEO, who only came in once a week. I put a

piece of Bazooka gum in my mouth and read the fortune on the comic: "So, what are you waiting for?"

I thought, This is it, and I walked in and quit. I still have that gum wrapper.

I came to L.A. on July 3 and moved in with my parents. I interviewed at ICM and found out I had to meet with ten agents in a month. It seemed to me that they did that just to see how many outfits you could get together.

I also went to see Rick Rosen at Endeavor. The agency was brand-new. Rosen and my father had worked together at Columbia in the early 1980s. He said, "We don't have anybody in our mailroom. Do you want to do it? I think you'd be great."

I told him about the ICM routine and asked, "Who else do I have to sit down with here?"

"Nobody," he said. "I'll hire you. You have twenty-four hours to decide."

A day? "You can't leverage me," I said. "I've known you since I was seven."

He said, "I can and I will."

"What about my exposure? It's going to be so much greater at ICM or CAA, with so many different departments and people." I was attracted to the idea of a place with hundreds of employees, where I would have the camaraderie of twenty people in the mailroom alone. Instead Rick offered me a job, by myself, in a back room in rinky-dink offices on top of Islands, a restaurant in Beverly Hills, where you could always smell the hamburgers cooking. Computers sat on cardboard boxes. Nothing was in its place. It was horrifying. Plus the company was all guys except for the temp who answered phones.

Rick must have read it in my eyes. "We're all taking a risk," he said, "but I guarantee your exposure will actually be much greater here, in less time, because we all need each other. There will be no layers. The mailroom won't be separate from what we're doing. We're all in this together, I promise you."

The pay was minimum: $21,000 a year, a huge comedown from Smith Barney.

• • •

Endeavor at the beginning was the four partners—Rick Rosen, David Greenblatt, Tom Strickler, and Ari Emanuel—their four assistants, and Phil Raskind. All the partners had to remortgage their houses. The furniture was brought from home. Rick Rosen used Strickler's kitchen table; Strickler had his architectural drafting table. The mailroom was a third the size of my current office, with one copy machine. Michael Johnson, a guy Strickler knew from Harvard, copied and collated scripts, but he was moving to Ari Emanuel's desk, which left the mailroom to me.

I brought in my ghetto blaster, put up my van Gogh poster, and tried to make it a homey little place in which I could spend twelve hours a day. It was exhausting. There was too much work and too few people. I managed to find time for a bit of a social life, but not of the boyfriend variety.

My stay in the mailroom was shorter than expected. After two weeks, Michael Johnson quit Ari's desk because Ari was too intense.

They chose me to take his place.

I was supposed to start on Ari's desk on Monday morning. The Friday afternoon before, I trained with Michael. I also walked into Ari's office and said, "Listen, here's the thing: As long as you and I can keep an open line of communication, I think we're going to be just fine." I came at it like, "We're starting this partnership. We can make it work." He stopped what he was writing, looked at me, and said, "*Get the fuck out of my office.*" That was his take on the open line of communication. There was no partnership.

An hour later he walked up and said, "We have an over/under bet on how long you're going to stay. Three months is the time limit. I want you to know, I bet against you. Let's see how quickly I can make you cry today."

I said, "You want me to run your operation in an effective manner, right? How does it help you if you bet against me? You're trying to sabotage me, but if you do, *your* life becomes worse. I don't understand the logic." I had come from a very logical place run by very clear-cut rules and regulations that all seemed to make sense. But here . . . I had no idea what I was in store for. None, none, none.

I was lost on Ari's desk. I had hardly used a computer mouse. I'd

never worn a phone headset, and I dropped waiting calls at least six times. I knew Ari would verbally pummel me, and I resigned myself to it, waiting for the hurricane to hit land. It didn't start out as a screaming match, but it quickly became one. Michael leaned over and said, "Why don't you just take five minutes? Whatever you do, don't let him break you. Don't let him see you cry."

I excused myself, went into the mailroom, my safe haven, and stood there talking to myself in the mirror: "Whatever you do, don't get upset, don't cry. Don't cry." But as I kept repeating the words, I worked myself into a frenzy. I was angry and frustrated because I didn't know how to do anything. Then I heard Ari yell from down the hall: "Where the hell is she?"

He burst into the mailroom, grabbed me by the arm, walked me back to his office, and said, "It's not that fucking hard!" He sat me in his chair. He sat in my chair, looking like a complete buffoon because he's three times as big as the desk. He put on my headset and played assistant, rolling calls, the whole time saying, "It's not *that* difficult!"

Suddenly I couldn't control the tears. They poured down my face. "Listen, it's not that tough," he said quietly. "I'm sure you'll be fine."

That night I picked up my girlfriends from San Francisco at the airport. They were all excited because they'd heard I'd just been promoted to a desk. When I showed up they said, "Is it great? We're so excited!" I just looked at them and burst into tears. I told them what had happened, and they were, like, "This is an outrage! This is criminal!"

I spent the rest of the weekend wondering whether or not to show up on Monday. There was no point in putting up with the craziness if I wasn't determined to succeed. The more I thought about it the more I knew not only that I'd show up but that he'd never break me again.

Are some of the things done to teach you? Absolutely. Are some of them done just to fuck with you? Sure. Yes, absolutely. They want to get a sense of what you're made of. If they don't think you'll survive, they'd rather weed you out immediately. They don't want to waste their time, or your time, frankly. The added pressure at Endeavor was that the company was new, the partners were young, and they had everything on the line: everything to lose and, they hoped, everything to gain. They wanted people they could bring up and mentor and make their

own. It was very important who they'd let into an upstart, highly precarious operation that everybody else in the agenting business wanted to fail.

Monday morning I was at my desk at 8:00. I'd been told that if I got there at 8:01 there would already be three messages because Ari would call and hang up, or leave a bad message: "Why the fuck aren't you there?" *Click.* If I got there at 8:02, there'd be six messages. When Ari came in, he said, "So, are you going to cry today?" I looked at him and said, "I want you to know something: You will never beat me again. Ever. I'm better than you and I know it. You don't scare me. You will never break me. I'm glad you had your fun. But that was it. Since I hadn't officially started last Friday, I'm not even going to let it count, as far as you and me."

"Right," he said. "We'll see."

Of course I kept dropping calls. And I didn't know who anyone was in town. He'd say, "Get Bernie Brillstein." I'd say, "Who's Bernie Brillstein?" All of a sudden, there was a huge book on my desk, a history of the business over the last ten years, so I'd know who all the people were.

The first two hours that Monday I let him yell at me. Not after. From then on, if Ari yelled at me, I yelled right back. When Ari said, "Fuck you," I'd say, "You know what? Fuck *you*." If he said something smart to me, I'd say something smarter. If he said, "God, your hair looks bad," I'd say, "Yeah? You're balding." It immediately became a tit-for-tat. One day he threw a highlighter pen at my head in the middle of a call. I ducked. I took a stapler and chucked it back at him. I was far enough away that he saw it at the last second, flying in his direction. He had to dive off his chair onto the floor. He popped back up and looked at me like I was insane; I did a little dance and laughed.

Ari and I kicked the shit out of each other, and boy, was it fun. More than fun, it was *complete love*. Not *that* kind of love, but the kind where he knew he had an equal he could fight with who would fight back. Once I even dreamed that we put a wrestling mat, instead of carpet, in the agency, and that he and I would have it out. In retrospect, that's really sick, but hey . . . that was the frame of mind.

Ari taught me a lot. How to never let them see you break, or reveal your real emotional state or the cards you're holding, because then you

lose all leverage. It doesn't mean that you can't be human. Ari is the most loving, softy, sensitive man ever, and that's the interesting thing about him. I just had to get to that place with him, and the people who know him well know what I mean. Ari continued to kick the shit out of me as his assistant, and I was on pins and needles the entire time, but the difference was that I knew he loved me. I got Ari—and he knew it. He was a big Bazooka freak, too.

Ari cares less about the details and more about the big picture. He is always outside the box, always going beyond. Whatever level he thought he should be at, he always went ten steps forward. He also taught me that there was nobody I couldn't talk to, couldn't call, couldn't ask out to lunch. He said I had just as much right, just as much to say, and just as interesting a point of view as somebody who had been in the business for ten years. Ari read sixteen magazines every weekend and would tear out different articles, tack them with Post-its: "Put this CEO on my phone sheet, figure out how to get his number." If Ari talked to the CEO of a major company, even someone completely unrelated to the entertainment industry, and if I was busy doing something else on his desk, he would snap his fingers and point at me, like, "Listen on the call. Pay attention."

He might say, "I read about you over the weekend. I just started a new talent agency, and I think there are some things we could do. I'd love to take you to lunch." It would be a two-minute conversation, and pretty easy for someone to say okay to. Even if lunch wasn't for six months, Ari wouldn't care. Once Ari got in the door, he'd be able to charm the pants off pretty much anybody. Ari has no fear, and that is so invaluable.

I worked five really tough months for Ari, and look back with the fondest of memories. Then it was time to move on. I *wanted* to go. Also, we had decided that every six months, *all* the assistants would change desks, in order to learn different sides of the business. Each of the partners had something valuable to teach.

I had always wanted to be in features, so I went to Tom Strickler's desk.

Ari and Strickler are best friends. In some ways they're exactly alike,

and in some ways they're completely different. They were both part of the Young Turks at ICM: good-looking, aggressive, powerful agents that everybody had their eyes on. Same age. Grew up together in the business. Disciplined. The differences: One is a Democrat, one's a Republican. One is very people-oriented, one is very book-oriented. One is very book-smart, one isn't.

Ari loved me, but that didn't matter to Tom. Tom hated me, and he was very open about it. He didn't know me, and he didn't like that I was some random, Rick Rosen "I knew her from childhood" hire. He told me—and tells me still—"I didn't like you and I wanted to get you fired. I used to tell Ari that I was going to make sure you got fired."

He took me on, though.

> STRICKLER: *I did it with a sense of humor. I probably said, "It's my job to make sure you bomb out of here, because I don't believe in you and I'm going to prove it quickly." She would smile and say, "Okay, go for it." Mind you, she loves telling that whole story.*

Tom is one of the best teachers in the business. Where Ari was all big picture, Tom is meticulous with detail, incredibly anal. Ari can have shit all over his office—piled magazines, everything. Tom is completely immaculate. There are no loose papers on his desk. In fact, having a paperless office was his big thing. He doesn't want anything in his in-box.

At that time all assistants' desks were right outside the agents' offices, and the agents' offices were all glass, so you could see inside. The week before Tom's assistant quit, he did something that pissed Tom off, so Tom moved the assistant's desk inside his office. It's the last thing an assistant wants, to be completely under a microscope. Outside, you can get away with the shit that falls through the cracks, the stuff you hope your boss will never remember. When I started I said, "So, now we'll be moving the desk out?" I articulated every word clearly. Just as clearly he said, "No, I think I'm going to keep the desk in here, so you and I can be next to each other every day. I'll be watching everything you do."

"That isn't fair," I said. "I think it'll be better because I'll be able to communicate . . . ," or whatever bullshit excuse I came up with.

"No. Every day it'll be you and me, and I expect to see you at eight o'clock."

Our chairs actually touched, on an angle. It was like an L. He had an architectural drawing table, with a really tall seat, and I was lower, so he could look down on everything I did.

Tom worked really, really hard. He said—and it's something I hear myself saying now to my assistants—that he worked his ass off and he'd never ask me to work harder than him. By putting it that way, he made sure I could never feel like I was the one being put through the wringer. Who was I to complain?

Despite his declaration of hate, Tom and I immediately got into a very jokey, friendly relationship. Very quickly we started to go one-on-one with each other. It was all about who could be louder, who could be more obnoxious, who was going to strangle whom. At times it was a very physical, visceral kind of thing.

Tom would pull my hair if I was on a call. He'd kick my chair and whisper, "Who is that?" I could only give him the "Shut up, I'm trying to do work" look. He was so involved with my every move that it became suffocating. "Any paperwork? What is this? Why haven't we got money on this?" He'd always try to unsettle me, on purpose, to see how I would handle it.

Tom is an intellectual. He tries to get into your head and manipulate you. When Ari tried it, I could see it coming; with Tom, there was much more stealth, in the sense that he would plant seeds and haunt you. He wouldn't yell unless he got really pissed, and when he did it was really scary. A twenty-minute speech about why I'd disappointed him would leave me crushed.

All I did was work. Except for making friends with the other assistants, I didn't date for two years. I lived at home because I couldn't afford an apartment. After being out of the house for years, it was a major step backward. It was even impossible to exercise because I had to be at my desk at eight o'clock, period, and stay there until eight o'clock at night. At home, I read scripts and wrote coverage. Anyone would be spent.

Sometimes when I could muster the energy I'd go to assistant functions, usually on a Wednesday or Thursday night, at a local bar. There I'd befriend people from the other agencies, the studios, and producing houses. There's a network of assistants who end up having more information than anybody, because they're on their bosses' every call. Assis-

tants are powerful people. They hold the keys to their boss. They can drop you from the phone sheet. They can push forward something you need, or not.

My life was Tom and Ari's life. They were dependent on me professionally and personally. I knew more about what was going on in their lives than they did. I used to wonder how they were able to live and not know what they were doing that night or that weekend. I used to think my life was so hard because I didn't *have* a life, because I'd given up my life to make sure I could figure out how they could manage their lives. Then I realized that, as the agent, you give up your life for thirty clients' lives. I had it easy. It only gets worse.

When I had been Tom's assistant for about five months, he decided that he was going to put me through the wringer unlike anybody else.

Every weekend he would read scripts, and so would I. It wasn't unusual to take home from eight to twelve scripts and to write about some of them, too. Then I'd have to pitch them to him in under two to three minutes each. That is the toughest thing to learn. It's difficult enough to be concise about character and story, but Tom would call the office every morning at 8 A.M., giving me no time to go over stuff at lunch, and have me go through the whole list. If I started to ramble on, he'd say, "No, no, no. Give it to me in under two minutes. Start again. Go." That would make me even more nervous, and of course I couldn't go on. The scripts I couldn't nail he'd save until Friday, about six-thirty at night, and say, "Okay, let's talk about that one. Now pitch it to me."

One day he said, "Listen, the thing about you is, you want to be a literary agent and you don't even read."

I said, "What are you talking about? I've been at the company for ten months. I read every weekend. I read all of your crap. Are you nuts?"

He said, "No. You are basically illiterate. You're just a dummy."

I laughed at him. He grabbed a big purple marker from his desk, went to a wall in his office, and drew a line as high as his hand could reach—and he's over six feet tall. "Starting today," he said, "you're going to have to read clients' scripts. Not projects that are out there, not specs that come in from random people who want to be represented. People who are on the client list."

The challenge was that he wouldn't consider me for a promotion until I had read enough scripts to hit the line on the wall. In other words, I had to read every single person on the client list and know all of their material.

I said, "Wait a minute. I've already read at least fifty clients. Can we count those?"

He said, "No, it starts today. I know what you've read since you've been on my desk, and I'll talk to Ari and find out what you read for him. If you try to bullshit me and if I find that you're lying to me, you'll be fired." Another part of the deal was that he could pull out a script at any place in the pile and I'd have to pitch it to him in under three minutes. If I couldn't do it, it would go off the pile. And I had to get it all done by October—five months.

I complained. No other assistant ever had to do anything like that.

"There's a bet going on in the office," he added. "Don't embarrass me."

The pile slowly grew. I'd fluff up the pages now and then so the stack had more height, but he'd slam them down. He'd knock the pile over if it was crooked, because it swayed as it grew. Sometimes he'd keep me in the office late on a Friday night, having me pitch random scripts. It was painful.

Finally, about September 15, I came in to find that he'd taped up an envelope above the pile that read THE PRIZE. He said, "Don't you dare touch this envelope. Once you touch the line, if you can get to it by October first, you'll get the prize." I still had a good twenty scripts to go. He said, "Don't disappoint me. I am the only one who bet you were going to make it. If you embarrass me, I'll be very disappointed." Of course, there was no way I was going to disappoint Tom.

On Monday morning, October 2, I put my last couple of scripts on the pile. I'd finally made it to the top. When Tom walked in he said, "All right, you did it." Then he grabbed the prize envelope off the wall and went to the morning staff meeting. About ten minutes later he came out and called the entire office into the staff meeting.

I didn't know what was in the envelope. I knew I wasn't going to get promoted yet, because it was too early and there was no space for a new agent. I figured it wasn't money because it's not like Tom to do that. That's too easy and not thoughtful enough. For my Christmas present

he'd bought me a black-label Armani suit. It cost $2,200. It remains to this day the most expensive thing I own.

When we had all gathered, Tom spoke. He had tears in his eyes, and right away I had tears in mine. "As you all know, I put Adriana up to this horrible task. I'm really proud to say that she made it. She's read every single client that we have, and she's probably more well-read than anybody in the office, including myself. We'll probably be calling her the Librarian from now on." He turned to me and continued. "Adriana, I'm really proud, and I want you to have this as a token of my appreciation to you."

He gave me the envelope; in it was an airplane ticket. A few of the partners were flying to New York at the end of the month for the New York Film Festival. My prize was to go with the partners, stay at their hotel, go to the film festival, then take a drive out to Tom's country home in Massachusetts for the rest of the weekend.

It was really sweet. I'd been beaten up for eleven months, but I'd made it, and I understood the point to it all. It was a great, if painful, lesson in what I needed to do. And, to tell the truth, it's very intoxicating for an agent to take an interest in what you have to say. No matter how I complained, I loved hearing "I want you to read this and give me your opinion." There was nothing more exciting for me than giving Tom my input and then hearing him call someone and talk about the script based on my opinion, as if he had read it himself. Sometimes I'd panic when I realized he trusted me that much. When I'd ask why, he'd say, "You're here precisely because I believe in your opinions."

I don't do anything like this to my assistants, though. God forbid, if I drew on these walls, Tom would have my ass.

STRICKLER: Assistants love challenges. Anyone could walk into my office and see the stack of scripts. It became a matter of pride for her to get to the top. When she was within eight to twelve inches of the top, I started to play a trick on her. It was as if she were Sisyphus. She'd go to the bathroom, and I'd pull out a script and hide it in my desk so she'd keep reading, but she wouldn't get any closer to the line. Eventually she figured that out, and we added those scripts back in. Adriana is a very, very goal-oriented person. If you told her to run a four-minute mile, she'd train until she could do it.

Assistants love challenges. My theory is that we're a service business

and we deal with irrational people, and it is sometimes good to be a little bit irrational because that's the world the assistants face when they get promoted. When you go back to your assistant days, the things you remember most are the wild, crazy, insane things that you had to do. They're your pedigree and the stories you can share later. It's my job to provide those memories.

Once, someone had sent us a pair of handcuffs and I handcuffed one assistant to his chair for about three minutes. I said, "You're not working hard enough here!" I think I also gave him the key. He also had a watch I thought was particularly unattractive. It was bright yellow. I said, "That's an ugly watch, don't wear it anymore." About a month later he came back with the watch, so I said, "Come in here." We went into the men's room. I said, "Take off your watch." He took off the watch and I flushed it down the toilet. I said, "When I tell you to do something, you always do it."

I'm sure I bought him a new one. I hope I did.

I hoped to get promoted that Christmas of 1996, but I'd only been with the company for a year and five months, including the mailroom, and that's not a long time. Tom gave me my bonus and my review and said, "Just know you *will* get promoted. There is a space for you here. But David Lonner and Adam Venit just joined us, and there are a lot of changes going on. It looks like it will happen after April fifteenth. You'll be fine. It's only four months away. Don't fret."

I masked my disappointment completely—as I'd been taught.

We had our first Christmas party at Ari's house. Tom got up and talked about how the company had changed and how unbelievable the changes had been. And then he said, "Tonight's a special night for another reason. Tonight we're going to promote the first agent from our training program." My heart sank.

Tom said a few words more about how proud he was of this person, going on and on. We all looked around the room at each other. Then he called me up. He handed me a package. It was a metal plaque with my name and the names of all the agents I'd worked for. To this day that moment still makes me cry.

For the next seventy-two hours, my feet didn't touch the ground. That night we all went out dancing, including Tom and Ari. We must have been out until three o'clock in the morning. I held that plaque all

night long, and so tightly that I cut my hand and there was dried blood all over it. Whenever I think of that night now, the image of all the sweat and blood I had to put into becoming an agent is still perfect.

Tom still gives his assistants a hard time. But these days trainees who want his desk seem to make a point of coming to me to say, "I want to go to Tom's desk. Tell me what it was like."

So I tell. All of it.

• • •

ADRIANA ALBERGHETTI is a motion picture lit agent at Endeavor, handling writers and directors. She is the first trainee to make it out of the Endeavor mailroom, and she still chews Bazooka gum: original, not sugarless.

STAIRWAY TO HEAVEN

Creative Artists Agency, Los Angeles, 1994–1996

**ALLEN FISCHER, 1994 • COURTNEY KIVOWITZ, 1994 • JIM TOTH, 1995 •
MARK O'CONNOR, 1996 • BLAIR DICKERSON, 1996 • DEAN STYNE, 1996**

*When you're in the mailroom, you're positive that there is a
movie to be made about your life. Why? You cannot believe
what your life is like, and you're sure no one else could
believe it either—so it has to be a movie."*
—Courtney Kivowitz

ALLEN FISCHER: I grew up in Beverly Hills and went to school with tons
of kids whose parents were in the entertainment business. My best
friend's father managed Kenny Loggins, so we'd go to shows, but most
of all I loved to watch the guy in the suit, running around taking care of
things in the background.

During my junior summer at the Wharton School I got an intern-
ship at CAA. It seemed like every week Ovitz was on the cover of *Time*
or *Newsweek*. Ovitz used to say that he wanted to hear a deal a minute
being made, and that's what it felt like in the offices.

The next summer I worked for the late Jay Moloney when one of his
assistants was on vacation. It was amazing. Every day I came in excited
and scared shitless because I didn't know what was going to happen. I
talked to everybody I'd grown up loving. Sometimes Marty Scorsese,
Steven Spielberg, and Bill Murray were on all my phone lines simulta-
neously. Moloney was energetic and incredibly charismatic and smart,
and I was the cocky kid playing Hollywood Guy.

To get into the training program, I went through five interviews in
one day. I answered all the questions right. My two summers had paid
off. And unlike many others, I knew what I was getting into.

COURTNEY KIVOWITZ: I grew up in Dallas and went to the movies to
beat the heat during Texas summers. Of course, I ended up wanting
to be in the movie business. I went to film school at UT Austin and

majored in critical studies. I did an entire thesis on how you could track Rob Reiner's movies. After an internship in London with an agent who worked out of his living room, and another in Los Angeles, I interviewed at all the agencies. I even had a speech prepared, a monologue, as if I was doing an act: "The truth is, I think a lot of people come into this room and don't have an idea what an agent is or what an agent does. I've had these two very different experiences in London and Los Angeles and I'm totally willing to stop my life, go down to the mailroom, and work my way through. I know it's not easy and I know it's not as glamorous as people think it is. . . ."

The process at William Morris moved very slowly. At UTA Jeremy Zimmer kept me waiting for about forty-five minutes. When I finally went in, he said, "So, why do you want to be an agent? No, you know what? Don't even answer that. I know: You want to be an agent because . . ." and he went into this twenty-minute conversation so he could listen to himself talk about why *he* was doing what he was doing. He never looked me in the eye, and then he said, "You're never going to make it here. You won't be able to compete. All of our trainees went to Ivy League schools, and I don't think it's ever going to happen for you here."

I said, "I don't think it takes going to an Ivy League school to get this job done," and walked out. I had ten interviews at CAA. It was clearly the best agency and my top choice, anyway.

JIM TOTH: When I graduated from Loyola Marymount, I had a roommate who worked for *Buzz* magazine. He was my only conduit to show business. It was 1992 and the height of Mike Ovitz as "the most powerful man in Hollywood." I asked my roommate questions and read articles and decided I wanted to be Ovitz. My friend totally discouraged me. He said everybody in the training program was a Harvard MBA or had a law degree. So I blew it off and became a stockbroker. Then I lived with a girl who, after college, wanted to get into Hollywood. She put out feelers everywhere and ended up working for CAA. After one day she called me and said, "You have to come and work here." That was it.

MARK O'CONNOR: Starting in junior high, I had an affinity for both television and the business. I subscribed to *Variety* and paid attention to the Nielsen ratings every Wednesday. I idolized Brandon Tartikoff. When I was in the eighth grade I sent him a letter giving him advice on

his scheduling. Like, "Maybe if you moved *Night Court* to Wednesday, it would provide a stronger lead-in. . . ." I got a letter from him, saying "Thank you for your comments. They're very astute for someone your age. Enclosed please find an NBC Peacock towel."

During spring break in the tenth grade I met a classmate's father, Hugh Wilson—*WKRP in Cincinnati*—at a party in Vail. We talked about the television business. He said, "You've got to come to Los Angeles and visit."

Perhaps to humor me, my parents took me there in 1987. We stayed at the Beverly Hills Hotel. We saw the very first *Cheers* with Kirstie Alley. We saw *The Tonight Show* with Carson. We visited Hugh on the set of *Frank's Place*. Hugh set up meetings with Warren Littlefield at NBC and Kim LeMasters at CBS. Brandon was in Israel. I told Littlefield what I thought of the fall schedule.

I went to USC and tried to get a job as an assistant in network programming after graduation but got nowhere. Disappointed, I sent my résumé to CAA, William Morris, and ICM. Only CAA called me. I met with Arlene Newman and told her that I wasn't interested in the formal training program. I just wanted to work for a television agent. (I wasn't even sure I wanted to be an agent; I'd always thought of them as used-car salesmen.) I interviewed with Tony Etz, and we hit it off. Six months later I changed my mind. I told Tony I wanted to go into the training program. He was completely receptive, and he didn't have to be. It's an unwritten rule that you have to work as a nontrainee assistant for at least a year before they let you in. He said, "You know that means going backward—into the mailroom."

BLAIR DICKERSON: My sister is a business affairs executive at CAA and proof that nepotism works. She got me the interview. At the time I was doing advertising sales for a television station in Monterey but wanted something more creative. Monterey is a beautiful town, but not for a single young guy. I was bored out of my mind

Little did I know I'd be going from making eighty grand a year to making minimum wage, working twenty hours a day, delivering packages and carrying mail bins. I had the tendency to believe, being in sales and a generally socially advanced person, that I could get through it in like three months, get on a desk, and after six more months be an agent. I didn't realize I'd be in the mailroom for almost two years.

DEAN STYNE: My brother, David Styne, is an agent at CAA. My dad

was an agent, and my uncle's an agent at ICM. I always knew what an agent did. I got offers from both ICM and CAA, where I went through five interviews all at once, in about two and a half hours. A couple days later I came back and they offered me the job. My brother had worked for Ovitz for two years, and I had heard all the horror stories. So I knew. And I still wanted to be an agent.

THAT'S WHY THEY WEAR
WOODEN SHOES ONLY IN HOLLAND

FISCHER: The mailroom is a big ladder and you're counting on each person on the rungs above to progress and let you get to the next level. You don't want to step on people because the only way the system functions is if you work together. Very competitive people don't succeed because you learn quickly that if you rat out your friends, you're not going to have any friends—and that's all you have to survive. You can't slack, either, for the same reason. Those who did were asked to leave by the company or they were driven out. If you get the silent treatment sixteen hours a day, you're in a very lonely place.

KIVOWITZ: When you're on the bottom you get the shittiest jobs, the shittiest life, the longest day. You think it's going to get easier when you move up, but it gets harder with each step.

TOTH: The first Friday, on the way home, I bought one of those Dr. Scholl's foot massagers. My feet were killing me. I wondered if the knee surgery I'd had because of high school football might prevent me from becoming an agent. I admit it—it actually crossed my mind.

STYNE: For some reason I wore wooden-soled shoes the first day and came home feeling like Fred Flintstone.

O'CONNOR: After the first week I was so tired I took a bath. It was the first bath I'd taken since I was eight years old.

FISCHER: I had to learn to do the shopping starting at five-thirty in the morning. I had to pick out fruit. I knew that if there was a bruise on someone's apple or pear, I would get reamed. To this day I can't buy fruit, because I'm still emotionally scarred.

O'CONNOR: Eventually CAA hired a service to deliver the food, so no

one had to shop anymore. The next task was collecting the morning mail at the Beverly Hills post office. Bin upon bin. My car would be packed to the gills.

When I had two people beneath me, I went on what was called "bottom conference," which is setting up glasses, pitchers, orange juice, and fruit plates for the morning meetings. That was the worst. We have seven or eight conference rooms, and we did every meeting that was before 10:30 A.M. I was stuck on bottom conference for fourteen weeks because they didn't hire anybody new.

"Top conference" is actually *making* fruit plates. It's very peaceful. You're in the kitchen instead of in the mailroom. However, there's nothing inherent in making fruit plates that, as far as I can tell, has anything to do with show business.

FISCHER: We did any stupid thing to get through, like contests about who could do the most creative napkin folding. Sometimes we alternated what side the fork was on. We got artistic about designing the fruit plates, using two kiwis with a banana coming out of them—that is, until an agent said, "What the fuck is this? Cuba Gooding came in and said the banana looked like a dick."

THE LOCKER ROOM

STYNE: One day all the mailroom trainees and permanent employees were called into our boss's office to talk about farting. We all looked down at the floor. He said, "This farting, passing gas, whatever you want to call it, it has to stop." I looked up and realized I was the *only one* looking up.

O'CONNOR: This was after one really bad day when there was more than one gunman, and it literally cleared the room. Since it was mostly male, the mailroom was like a locker room. It got more interesting when we had a couple of females, and we had to rein it in a bit, but not that much. We had to respect any girl who could last there for more than a week.

STYNE: I started seeing a girl, let's call her Tiffany, when we were in the mailroom. She continually fucked up. She would go out to her car at lunchtime and pass out because she was on Xanax and whatever else

she could get her hands on. One time we had to knock on her BMW window at four-thirty in the afternoon. No one knew where she'd been for three hours.

When Tiffany was up for a desk, she came to my house the night before and we celebrated—and overslept. She had to rush home and got to work ten minutes late. Josh Berman, who ran the mailroom, went to Arlene Newman in Human Resources and narked on her. She didn't get the desk. Last I heard she was a waitress.

DICKERSON: Another girl said she was from Tulane and had been on the golf team. She'd told stories about thinking of going pro, but the rigor of the tour and working through the qualifiers was too much. I played golf growing up, so I said, "Oh, I'd love to play golf with you sometimes." She avoided it. Finally I pinned her down.

O'CONNOR: I'm a shitty golfer, but even I kicked her ass.

DICKERSON: On the first tee she shanked the ball. She hit about a twelve on the first hole. I said, "You didn't play golf for Tulane."

She said, "Uh, no, I didn't. But I *went* to Tulane."

O'CONNOR: She also said she was in the CIA training program before she was in the CAA training program.

DICKERSON: And that she went out with Leo DiCaprio.

STYNE: I was seeing her. It was tough. We got in fights. It was totally secret.

DICKERSON: Not that secret. I knew. But Dean would never have gone out with her if he'd had a normal job and met normal people. When you're in the mailroom twenty hours a day, anything that comes in that's halfway decent, you're like "All right!" Why? Otherwise you'd get no action whatsoever. You work too much, and when you go out on weekends, what are you going to say to a girl? "I'm in the mailroom"? You have no game.

PULL OVER!

FISCHER: I was racing to get home from a late delivery to Malibu, and I got pulled over by the cops for speeding. It was eleven-thirty; my eyes were bloodshot, and I was the picture of pure exhaustion. I was driving my piece-of-shit Chevy Blazer that had gotten stolen in Philadelphia, so

when the cop looked for the vehicle identification number he couldn't find it because they'd had to replace the windshield. I had some old paperwork that you couldn't even read anymore. He threw me in the back of his police car, handcuffed and everything. The only thing I could think of to say was, "Can I call my office and let them know that my packages will be delayed or that I can't deliver them tonight?"

"No. Shut up and sit tight."

A half hour later he found the VIN on the engine. He said, "I'm sorry, I know this was a pain in the ass. I'm not going to give you a ticket, but why are your eyes so bloodshot?"

"I've been up for eighteen hours delivering packages," I said. "It's not fun, but it's my life."

KIVOWITZ: I wrecked five cars; I totaled one. I had four other solid accidents, just from being on the road so much. I'd be driving, the pager would go off, it made me crazy. One time it went off and I hit the car in front of me, just because I couldn't deal with the idea of going back to Fox after I'd already been there.

DUDE!

O'CONNOR: Remember Dave, one of the permanent mailroom employees who delivered things during the day? A good-looking guy, like a surfer dude?

STYNE: Yeah. He was delivering something in Westwood when a woman pulled up in the car next to him. A blonde, about twenty-five, in a brand-new silver convertible BMW. He came back to the office forty-five minutes, an hour late. Everyone was like, "Dave, where were you?" He was honest about it.

"I'm sorry. I met this chick and I just couldn't pass it up. She blew me." Everyone was, like, "Yeah, but dude, you can't do that. Someone's waiting for that package."

He said, "But her body was *slammin'*."

I got lucky, too. I delivered something to Uma Thurman and saw her butt-naked. She lived up Cherokee, off Coldwater. I walked up her brick stairs, by the bedroom, to the front door. The long, thin shutters

were open, and I saw her. I wanted to backtrack, just to catch another glimpse, but I figured maybe someone was watching *me*. The front door was open and her mean chows were growling. I left the package and walked back, but she was gone. Whew!

KIVOWITZ: I didn't get any actors answering the door in towels, but I did get Brad Pitt with his shirt off, and that was a major highlight. Thank God I had sunglasses, because my eyes were popping out of my head.

BUBBLES

STYNE: I had a delivery for a Melissa Sears. I thought, Who the hell is Melissa Sears? I went to the door and this young, kind of heavyset woman answered. I looked past her and saw Gabriel Byrne and Ellen Barkin. Ellen came to the front door and said, "So, are you part of that mailroom thing?"

I said, "Yeah. I am."

"Were you the one who said I was a crazy bitch?"

"I, uh, I have no idea what you're talking about."

"All I know is my agent, Kevin Huvane, told me that I was a crazy bitch. And now I'm supposed to invite you in for a fucking drink or something."

I looked at her and said, "Miss Barkin, here's your package. Have a great night. Bye-bye." I left feeling hugely paranoid. I had walked away not only from a client but from one of Kevin Huvane and Bryan Lourd's best friends.

The next day, as I passed Huvane's office, his assistant said, "Dean, come in. Kevin wants to hear the story."

I hadn't even met Kevin yet. He was on the phone and motioned me to sit down. "What happened?" he said.

"Well, Mr. Huvane—"

"Kevin."

"Kevin. I didn't know what I was supposed to do."

He said, "Hold on a second." He got Ellen on the phone and goes, "Bubbles?"

I could only imagine what she was saying.

He said, "You know my boy who delivered the package last night? Well, what the hell did you do to him?"

She said, "What do you mean?"

He said, "Well, first, he quit. Second, he has a nervous twitch in his neck. And third, he's now the houseboy for Warren and Annette. The reason I'm calling you is, Warren and Annette are having a barbecue for the mailroom staff, and the mailroom wants to know if you'll be their date."

I walked out of there not knowing what the hell was going on.

A week later I'd just gotten back from my night run. I walked into the main elevators, and there were Ellen Barkin and Kevin Huvane.

A second went by, and then Kevin said, "Ellen, you remember my mailroom employee, Dean."

"Dean? *Sure*. Hi, Dean! How are you?"

I couldn't have answered if I tried.

HEEERREE'S JOHNNY!

KIVOWITZ: Even though I have nothing in common with half the people I work with, most of them also went through the mailroom. Having that shared experience makes us part of each other. And hearing their stories makes you laugh because you get it.

Mike Menchel tells a story about when he worked for Bill Haber, who was trying desperately to sign Johnny Carson. Haber was on the phone with Carson, saying, "Johnny, is there anything you need? *Anything at all.*"

Carson was on a boat trip down the Nile. He said, "Yeah. If you could get me some ice. We could really use some ice out here, it's *super*hot."

Haber told Menchel to find a way.

Menchel had a friend who worked at some kind of shipping place. She said, "If you can get a real address, we'll get some dry ice and ship it there." Menchel worked it out.

A couple of days later Carson called Haber and said, "I cannot believe that you got me ice on the Nile. I believe you can do anything."

Haber hung up the phone and patted Menchel on the back.

About two weeks later Menchel went through Haber's mail and saw the bill for the delivery. It was twenty-five thousand dollars. Menchel tried to slip it in so Haber wouldn't really see it, but he did. Haber went crazy: "It's over! You're fired! Get out!" But Ovitz said it was fine.

THIS PARTY LIFE

STYNE: We all wanted to get noticed. One way was working parties like Brad Pitt and Gwyneth Paltrow's engagement bash. This convertible BMW drove up, one of the first guests, and when I looked, it was Gwyneth Paltrow! I was psyched. Brad Pitt was way down in the passenger seat. I said, "Hey, welcome! Congratulations! I'm happy for you guys." She was, like, "Thanks, that's really sweet of you." Brad leaned over, very cool, and said, "Thanks, bro."

O'CONNOR: Somehow a photographer from the *National Enquirer* got into that party, so for the New Year's party Brad Pitt threw with Kevin Huvane, at Kevin's house, they wanted to be really tight with security. Three of us were asked to work. One checked the list at the front door and the two checked the list at the neighborhood entrance. It had a gate, so we sat there with the remote control.

Courteney Cox and David Arquette came through. Ellen Barkin came through. Cuba Gooding. Bernie Brillstein came. He rolled down his window and I said, "Hello, Mr. and Mrs. Brillstein." He said, "How did you recognize us?" I said, "I read the trades." They laughed. I think they were a little frightened that I knew who they were.

We were told to be on the lookout because Leonardo might show up—and to watch out for any crashers. This kind of old-looking, huge seventies sedan pulled up. The window rolled down, and this British guy said, "Hello there." I thought he was a total crasher. I said, "Yeah, I'm gonna need your last name, please." Then I hear from the passenger seat, "Ma*don*na."

THERE'S SOMETHING ABOUT FRED

STYNE: I worked for Fred Specktor for two years. Fred always said, "When I was in the mailroom, Dean, it was at MCA in 1956, and I worked for Lew Wasserman. I remember driving Lew around, and Ted Williams hit a home run." Fred's actually cool. Fred still has the edge.

DICKERSON: If you drove his Porsche or even his Mercedes, you'd want to be the pimp daddy. You'd lean the seat back a little, try to be the man for at least ten minutes. But you had to be careful. Josh Berman had a Specktor car one night, a convertible Mercedes SL. Josh decided that he was going to pimp out and put the top down. He got the car home, parked it in the driveway, got a guy to pick him up and take him back to the office. That night it poured. The entire interior was ruined—the leather, the stereo, everything.

STYNE: When Fred's wife met him at the office, it took two mailroom guys to handle the logistics. One had to drive her car back to the house, and the other had to meet him and bring him back to the office. I was chosen to drive her car home. It was a white Range Rover. I got to Brentwood and parked the car in the driveway, waiting for Blair to pick me up. Everything was good. Went home, went to sleep, went back to the mailroom in the morning.

Seven forty-five: *Rring.* "Dean, telephone. It's Jamie"—Fred's assistant. "Dean. Did you lock Pamela's car?"

"Yeah."

"Well, her two-thousand-dollar Prada purse was stolen, with her wallet and everything."

"I—I—I—I—" I turned white. "Oh, my God. Am I gonna get fired?"

"Let me just see what Fred's demeanor is when he gets into the office. If he's in a good mood, we'll just slide it by."

I said, "Uh-uh. You call me when he gets into the office."

Jamie called and I came right up. Fred got off the phone and said, "Yes?"

I said, "Hello, Mr. Specktor. I'm Dean Styne. I drove your wife's car home last night and I could swear I locked the door. Jamie told me her purse was stolen."

He went, "How could you fucking do that?"

"I'm—I'm—I'm so sorry. . . . I could have sworn. . . ." I was spitting out anything. "What can I do to make up for this?"

He said, "It's not about that. Just learn, damn it. Double-check everything you do."

"Okay, Mr. Specktor," I said, and I left with my tail between my legs.

• • •

Because I was a man about it, Fred kept his eye on me after the stolen Prada purse incident. The day he hired me for his desk he said, "I want you to know, I may yell at you. I may yell at you *every* day. It's water off my back. But if you *continually* fuck up the same thing, then I'll really be pissed at you."

I said, "Okay, Mr. Specktor."

"Call me Fred."

"Okay, Fred."

Three days later I was doing fine, thinking everything is cool. Fred, too. Then he stopped by my desk, stared at me, and said, "Don't think I've forgotten about Pamela's purse."

STAIRWAY TO HEAVEN

TOTH: I was in the mailroom nine months. Kevin Huvane told me that Bryan Lourd's desk was opening up and asked if I wanted to work for him. Are you kidding me? I couldn't believe the people Bryan knew. Everybody called and sought his counsel. It was amazing the kind of influence he had, not only on what an A-list movie star did as their next project but in terms of who pulled the strings around town. If I was lured in by the power that these guys had, I certainly found myself in the generator room.

Although I got Bryan's desk quickly, it still takes time to get promoted. I waited four and a half years. I also worked for Rick Nicita for eighteen months. Heather was his assistant, and she was willing to let me do as much as I wanted to do. It was great.

There's a big difference between Rick and Bryan. I don't know if I pissed Bryan off, but sometimes I felt like I did because I'd ask him a

ton of questions. I figured if I was going to make no money, at least I could ask questions. But Bryan operates in his own head, so a lot of the process was just learning by listening.

Rick would answer any question. He took me out to dinner my first night, to the Palm, and we sat at a table with his picture on the wall above us. He was really engaging. He knew that I was into learning, so he played to that.

Eventually I became the departmental assistant in Talent, until Dan Adler came back to the agency after working with Ovitz at Disney. I was tired of waiting for a promotion. Kevin said it wasn't the quality of my work, and just to hang in there. When Dan came back, I started talking to him. His coming back to CAA was a big thing. Dan's awesome and totally unlike any other agent I've ever met. His mandate was to create a New Media Department, so I volunteered to be involved.

FISCHER: I was a couple of weeks off Dispatch and the fifth kid from the top. One of the assistants was being promoted. They interviewed the four people ahead of me, but none of them meshed with the agent. I did. We're both workaholics. An hour after the interview a memo was issued: "Allen Fischer has been promoted to Rand Holston's desk."

Rand was a great boss. Unassuming. The most low-profile guy for his level of success, given who he represents. He was like a time clock. If it was Monday, you knew he would be there at eight-fifteen; if it was Tuesday, he'd be there at nine; on Wednesday he was there at seven-thirty, as well as Thursday and Friday. He left the office every night at seven o'clock to go be with his kids. I had worked for Jay Moloney and thought Hollywood was this big schmoozing place where everybody went out all night and partied and then was intense and crazy over the phone. With Rand the big eye-opener was, yes, you can be wrapped up in the business and still have a successful family life. Does it happen often? Rarely. But Rand made it work. He was the antithesis of Hollywood. He didn't go to the Hollywood premieres, which was great for me because I got his tickets.

I worked for Rand for about a year, then Kevin Huvane. Day one was the scariest. Kevin's desk and my desk were very close and there was no escape. Every move I made, he watched. My job was to do all the phones. Sometimes line one was Tom Cruise, two was Demi, three was Cuba, and four was Sydney Pollack. It was star central. I talked to Julia Ormond, Ralph Fiennes. It was amazing.

I also got the late calls from the clients when they ·
very prominent actress arrived in Los Angeles on a Mor
in bed at midnight, reading a script, and she called: ·
town. Grab Kevin and let's go out." I called Kevin: "Dude
to go out. Do I have to?"

Kevin said, "I'm in bed and going to sleep. You don't ha ·· go if
you don't want to."

It was late but I thought, How can I pass up this opportunity? One
of the most prolific actresses in Hollywood is calling me, saying let's go
out. I called back and said, "I'm in!"

The actress, her assistant, two other people, and I went to a very pri-
vate strip club. It was amazing. She gave us dollar bills and we stuck
them up there. She danced. We hung out until the wee hours, and I
showed up in the office the next morning all bleary-eyed. I said, "Kevin,
I'm going to take a role in the back office today and let the other assis-
tant come up here." He had no problem with that. Now he calls this ac-
tress my girlfriend. We were at a premiere a few months ago and he
said, "Did you see your girlfriend here?"

There is also another side to being close to the clients. Kevin was in a
meeting and I got a call at lunch from a lady at a record store, asking if
we represented so-and-so. We did. She said he was in the alley, passed
out drunk. I'm, like, Okay. I didn't know what to believe, but you see so
much in Hollywood, you believe anything. I said, "Thank you very
much, I'll take care of it."

I called the client's manager. The manager said, "It's probably bull-
shit. Forget it."

I couldn't. I interrupted Kevin's meeting. There were twenty people
in the room. I told him and he said, "Go check it out."

I drove my little piece-of-shit Blazer to the record store and pulled
into the alley and went, Holy shit, it's *him*. Two seconds later the cops
came up behind me. I told the client, "Get the fuck in my car, right
now." He looked up, like, "Wha?" stumbled into my car, and we drove
away.

I drove the client to his house. A couple of hours later I got a call
from another person: "We have photographs." Holy shit. I called our
private security force and explained the situation. They said, "No prob-
lem. We'll take care of it." The next day it was planted in the press that
our client was doing research for a role as a homeless guy. Killed the

The photos went away. For a month and a half after that I got phone calls: "How's it going with his movie? Is there a script yet? Who's financing it? Can we get in on it?"

O'CONNOR: I interviewed for a desk with Doc O'Connor. We're not related, but I thought I'd never get the job because we have the same last name. I worried that everyone would think it presumptuous. But working for Doc would be working for a partner, and to not pursue that would be stupid. I didn't know Doc at all, so interviewing with him was like meeting him for the first time. He was a supernice guy. I stressed our last names being the same right off the bat, saying if it was going to cause any problems or assumptions of nepotism, I'd change my last name. He laughed. Everything seemed to go well.

I sent Doc a thank-you note for the interview, and on my stationery, I crossed out "O'Connor" and wrote "Smith." I heard later that it helped put me over the hump.

Doc was open to any question. He also had the greatest stories. Just hearing the story about Ovitz's car keys was priceless. Even better, it was good to work for someone who had been through the mailroom as well, because we had that bond.

His best advice was "Always have your own life."

THE PAYOFF

DICKERSON: After a frustrating year and a half in the mailroom, I got passed up by Mark and Dean and a couple of other people. Even though I was at the top of the heap running things, I was desperate to get out. One idea kept me sane: A CAA agent, you're told over and over again, is a team player. What you do is for the good of everyone. You have to keep it in the back of your mind that all that sacrifice is meaningful and that the people after you will also sacrifice for the good of the company. That common bond of sacrifice kept me going. If others worked twenty-hour days, delivering mail for a year or two years, for a chance to become an agent, then there must be a payoff.

There was. I spent two years on Michael Wimer's desk. During that time the whole Internet heated up. A couple of Michael's college room-mates had helped venture capital eBay. His connections were pretty

deep. People came to him from Silicon Valley and Menlo Park, asking how they could incorporate Hollywood in the new, new thing. I was privy to a lot of those conversations and negotiations. Eventually, with Michael's endorsement, I pitched myself to the head of the New Media Department. It wasn't what I'd expected, but it worked out fine for a while.

TURN, TURN, TURN

FISCHER: One day Bryan Lourd's assistant and I were driving Bryan and Kevin Huvane to the airport. In our eyes, it was the current moguls in the backseat and the wanna-bes of tomorrow in the front. Kevin said, "You guys want to be back *here* one day, don't you?" and we all joked about it. But it was true. I thought back to the old days of Abe Lastfogel, Norman Brokaw, and Stan Kamen; then about Diller, Geffen, Meyer, and Ovitz; and then the new group, Lovett, O'Connor, Huvane, and Lourd. We all want that position of power one day. Bryan seemed to read my mind. "Careers come and go," he said. "Power changes hands. But everybody will get their turn in this seat—if they're persistent enough."

• • •

ALLEN FISCHER is a literary manager at Santos-Fischer Management.

COURTNEY KIVOWITZ quit CAA to run the talent division at Benderspink Management and Production.

JIM TOTH is a motion picture talent agent at CAA.

MARK O'CONNOR was a motion picture lit agent at CAA. He recently left to pursue his muse and write screenplays—though he's not ruling out a return to the executive suite.

BLAIR DICKERSON was an agent at CAA for eighteen months. He is now a music manager at Spivak Entertainment in Los Angeles.

DEAN STYNE became a talent manager at Nine Yards Entertainment and is "really happy."

THE SECOND HUNDRED YEARS

KIDS AT WORK

William Morris Agency, Los Angeles, 1997–1999

ALEX CHAICE, 1997 • **KELLY ANNEMAN, 1998** • **ESTHER CHANG, 1999**

ALEX CHAICE: My father is a lawyer, and Bill Cosby's attorney for twenty years. Bill has a relationship with Norman Brokaw at William Morris.

I went to school in Boulder and got a master's degree in philosophy—I loved logic—but I also took film classes. In 1996 I went to work for a small Internet firm, and we were bought by Hewlett-Packard. All of a sudden I had a choice to make. I lived in Fort Collins, had dyed my hair blond. People in pickups catcalled at me. I could have been financially set, but I realized I didn't want to spend the rest of my life there. On February 4, 1997, my twenty-eighth birthday, I woke up and decided to be an agent at William Morris.

My father called Norman Brokaw.

I went to Men's Wearhouse and bought three crappy suits. Also, three shirts—but I didn't have money to wash them regularly. Because it was summer and kind of hot, I'd drive to work without my shirt on, put it on once I got there, take it off after work, and hang it up to wear again three days later. I probably wore the shirt three to five times before I actually laundered it. I know, a stunning admission.

The first time I walked in the mailroom it seemed like a handicapped stall in the bathroom. I had visions of standing in there for a year with seven other trainees and no personal space. I began to sweat, then realized I couldn't because I'd need a clean shirt.

Nothing can prepare you for being on your feet that long. I had

never done a service job before. I didn't know to buy a couple of pairs of shoes to make them last longer. The sweat would be trapped inside and there was no time to dry them out overnight, so I got the worst athlete's foot.

I didn't ask my parents for money, either. I'd made some in Colorado, but not enough. The William Morris salary was $300 a week and I lived off that. Spent three months on a friend's futon, then moved into a shitty apartment in Hollywood. My mattress was on the floor, and every night the fleas would bite my legs where they'd stick out from under the blanket.

Every time somebody big came into the building a buzz went around. When Ashley Judd showed up, the first thing I did was pick up the nearest mail bin and start walking around to see if I could find her. I finally caught a glimpse in the stairwell. She was walking up, and I followed. She wore very tight, practically see-through pants, and a tight cutoff sweater. She looked incredible. Suddenly she looked down—and I tripped and fell flat on my face. The mail went everywhere. She stopped, smiled, and without missing a beat said, "I'll take that as a compliment."

After I got out of the mailroom, I worked for Sam Haskell for a year and a half. He would tell me what it took for him to get to the top, the battles he had to fight, how quickly he made it, and how proud he was. It's a great accomplishment. But maybe twenty years ago you could learn the business in only nineteen months. There's a lot more to learn today. Or maybe I'm being defensive because it took me longer.

Very few in the training programs today have a sense of the history of Hollywood or realize that many, many people have been there before them. We're not doing anything new, but some people lose sight and think they're inventing the wheel. On the other hand, you have to make and learn from your own mistakes. William Morris, which started in 1897 and is already into its second hundred years, has a huge tradition and wealth of knowledge. I have used it and still do.

I don't know what my end goal is, but I'm in it for the process, not the money or the power—though those are nice, too. But if you don't enjoy the process, what's the point? Suppose I get lucky and I'm the next Mike Ovitz or Sam Haskell—and let's face it, a lot of it is about luck and timing—and twenty years down the line I go, What am I do-

ing here? This isn't what I want. Could happen. If it does, at least I'll have enjoyed the process.

But I can't imagine enjoying the process and not the reward.

KELLY ANNEMAN: It's ironic to me that I'm talking about this right now because I am very uncertain of my future. I'm not sure if I will stay in the agency business or even show business. I've been here four years; I'm assistant to the head of the Talent Department, and I want to be a talent agent representing writers and directors. But our group is so solid that there may not be room to promote me. I guess it's all about timing and luck.

My father is in the business; he runs his own firm. I always had an idea of what was going on. I was never completely blindsided by "It's all about show, not business." This town is a business, and the longer I work in it the more I realize it.

From as early as I can remember, I've loved movies. I took critical film classes in high school. I studied film in college. But the most important thing I learned about show business at school was that there's very little to learn when you're not actually *in the business*.

After school, my father watched me sit on my butt for a month. One day he announced that I had an interview with Norman Brokaw at William Morris. "You have to be there in forty-five minutes," he said.

My meeting lasted an hour and mostly consisted of me listening to Mr. Brokaw tell me his story. But whatever I said was apparently enough for him to call Human Resources. They asked me to come in for an interview. That led to *eight* interviews with different agents. Each one was a test. Why does she want it? How bad? What does she want? Who is she? What's she about?

My first interview was with a woman agent who had just started at the company. The first twenty minutes I watched her make and return calls. Her speed, the aggressiveness, and the selling fascinated me. I told her I wanted to do what she did.

Actually I had no idea what I wanted to do. I just gave good interview. By the second, third, fourth, fifth interviews, I had it down pat.

I'd thought of every question anyone could possibly ask. I sold myself like you can't imagine. I did it because I *was* tired of sitting on my butt and I wanted to get in the door, get on the path, and matriculate. I figured out quickly that it was all about being accepted.

Six weeks later they offered me a spot in the mailroom.

The agency sold the whole trainee thing to me as three years, *boom*, you're an agent. They really pushed that. I never knew, until I started working, that not everybody who's in the program becomes an agent just because they want to be one. It's unbelievable to me that I didn't know it, or even guess. I just know I never heard those words.

I decided not to let it matter. I was confident that if I decided to go for it, I'd make it all the way because I am who I am. I have drive and motivation, and I am totally capable. I thought, What better position could I be in than to be guided and mentored and part of a program that has so much history and success?

When I started, the pay was $375 a week. After four weeks in the actual mailroom, which was the most fun because you got to wander the halls and meet people, you move to other parts of the company, like Dispatch. But there were no more cars. Too expensive. They'd hired a professional delivery service. We just walked through Beverly Hills.

I did two weeks in Dispatch and two weeks pulling pictures in the Commercial Department, which is a colossal waste of time. You work in a room with no windows, just shelves and shelves of pictures of the commercial actors we represent. All I did was put pictures and résumés in a packet and send them out. I had no contact with anybody *living*. The whole process just threw into sharper relief what is in part the point of the training program: providing the company with underpaid labor in whatever department they need it.

After the mailroom I was a floating assistant for seven and a half months, meeting different agents, hoping to get promoted. It takes time because you can't just go on *any* desk. It has to be a trainee-approved desk, meaning that the agent is supposed to have *some* interest in your future, in helping you learn, and in guiding your career.

I went to my first trainee seminar when I'd only been with the company three weeks. Two agents spoke about their history and about how they became agents. The new trainees, this other girl and I, had to introduce

ourselves. One of the agents asked me, "What do you think of your first three weeks here?"

I was still smarting from no one saying thank you when I ran around the building delivering packages. I said, "Honestly? I think everybody is so rude." The trainees chuckled under their breath. I could tell they were all thinking, Boy, she's gonna get it. I figured, Oh, that's it, I'm out; they're gonna fire me. But the agent, who was not known as a nice guy, loved it.

Of the people in my mailroom "class" I'm the only one who got an assistant's desk. One guy was fired—something about a pushing incident—and two left voluntarily.

I don't know how it is at other agencies, but I know the future won't just be given to me. I get that it takes a certain amount of passion about anything in life to become a success at it. Even after four years I still believe I have that passion.

ESTHER CHANG: My parents are from Korea. My dad owns shoe stores and my mom's a nurse. They emigrated here and built their whole lives around the kids and our education. It was hard for them, but they struggled and did it. I grew up in Palos Verdes, California, and wasn't at all interested in entertainment. I was very involved in high school: cheerleading squad, president of my class, most likely to succeed. I was always more focused on the more stable things in life, like going to law school, being a doctor.

At Columbia University in New York my eyes opened to other aspects of life. I got involved in politics, working for Governor Pataki, then came home for the summer and worked for the Democratic National Committee. I also interned for Fox Searchlight Pictures and worked at *Variety* in New York for two summers. I hung out with reporters and learned how people live and breathe over whether a spec script is bought, or who is cast in a picture, or who is making how much per film. It was shocking—shocking that it all seemed so important to these people when, to me, there was another entire world out there that didn't care about that stuff at all.

And yet it appealed to me because ultimately entertainment is for

everybody, the great equalizer that people like to talk about when there is nothing else to say. I was exposed to how people could work so hard and get their emotions and lives all wrapped up in something that, in the end, just meant people can go out, buy some popcorn, and watch a movie.

My parents wanted me to go to law school, but I didn't want to. Instead, I looked into entertainment. My boyfriend at the time had a good friend at William Morris and suggested I try an agency—do it for a year to learn, then see where I wanted to go. It turned out to be the start of a domino effect. I got hired, worked as a floater in the mailroom for a month, then got hired as an assistant.

It's just my personal opinion, but the caliber of trainee hired these days seems different. They seem to feel *entitled* as opposed to wanting to *work* for something. In the past, they worked hard and developed relationships. These days, because of connections, some people inherit the relationships without having to do anything for them. Being hired here and getting a desk is only a third of the battle. The rest is making your way through the ranks, and yet I get the impression from some of the new trainees, when they want to become assistants or work at other companies, that their attitude is "I'm a trainee. Why *wouldn't* you want me?"

Maybe the difference between my generation and earlier ones is that we haven't had that much hardship. We don't know what it's like to really work. In the nineties we saw a lot of wealth come fast, especially to young people. It was easy for us. We had freaky ideas for the Internet and then sold them to these old venture-capitalist guys for millions of dollars. Or a very young director makes a movie that rivals Spielberg at the box office, but not in quality.

There's a lot of surface but not much yet beneath the surface. It comes too fast.

I wanted to keep moving up. After a lot of hard work, being tested by agents like I was on trial, and, to be honest, the process of elimination, I became the departmental coordinator in Talent. I wanted to step up to that not only because I like a challenge but because I could finally see down the road to what kind of person I'd be. I'm not sure they really wanted to give me the job at first, but I did the work, a lot of people

vouched for me, and I got it. I think some others were really shocked because when you meet me you think I'm this docile little person. I just look that way.

I came to William Morris just to check things out. When I realized I could be really successful I was seduced. All my life I'd been good at just about everything—and lucky—but I always wondered what I'd be *really great* at. What did God or fate have in store for me?

I'm in my mid-twenties. I recently got promoted to agent. Now I'm very invested in this company. Maybe because I'm young I feel the familial bond more than others, but this is all I know. Some people see it as a stepping-stone, but not me. I'm very committed.

I'm like the kids who started in the mailroom long ago: I can't imagine working anywhere else.

• • •

ALEX CHAICE is a TV talent agent at William Morris.

KELLY ANNEMAN was an assistant in the William Morris Talent Department until she left the agency to pursue a career in interior design. She is "incredibly happy for the first time in a long time."

ESTHER CHANG was promoted to talent agent in the Motion Picture Department in August 2001. "I'm extremely fulfilled in my new position and very proud to be a part of this company," she says. "I've discovered the sweet satisfaction of reaching a goal and seeing the challenge of the many goals ahead."

I looked down to the clear nearby ocean bottom and saw the sea urchins encased in their rocky prisons. When small they had found an opening in the rock and gone into its wider comfort for protection. Now adult and fat, they were trapped inside and could only wait for the slow passing currents to bring them food. Here they would pass their placid lives, prisoners in the rock, fed by driftings tidal-wet.

—*from* The Flesh Peddlers: A Novel About a Talent Agency, *Stephen Longstreet, 1962*

Acknowledgments

Writing a book is like starting in the mailroom—and much else in life: you do it from the bottom up. The blank page fills with words, uncertainty gives way to confidence, questions become answers. But contrary to the conventional wisdom, a book is never a solitary endeavor. An oral history, which is more like a film—drama, comedy, mystery, and documentary all squeezed between hard covers—takes a team. I couldn't have done *The Mailroom* without the collaboration, generosity, wisdom, patience, trust, and just plain help of so many.

I'm especially grateful to Cynthia Price, who was with me from beginning to end on what often seemed like a Möbius strip. Without her considerable talents this book would not have been finished before the *next* millennium. She listened, read, critiqued, and improved. Her value cannot be overstated; just try making sense of more than two hundred interviews on your own. Now she can get back to her garden and her life. May they bloom. Thanks also to her husband, District Attorney Joshua Marquis, for understanding her absences—and for having truth, justice, and the American Way to keep him occupied.

I'm equally appreciative of Brian DeFiore. His excellent representation, unwavering inspiration, uncanny intuition, great laugh, and willingness to take all my phone calls made all the difference. He sparked this project when, while I was developing another book, I sent him an e-mail hoping, at a low point, to elicit a gratuitous pat on the back.

"Did I ever tell you about my idea for a book on the mailroom?" I wrote. "It would be an oral history of that mythical place many of the show business greats and most of the people who run Hollywood got started." Brian responded, "No. You never told me about the 'mailroom' idea and if I were you I'd drop everything and pursue that!" And so I did. Serves me right. I also owe Laurie Abkemeier for her steadfast friendship and for sending me Brian's way. It's been very good.

I am deeply indebted to every mailroom graduate and former trainee—there are many—who had the courage to tell me everything and contribute unselfishly their time and recollections to this endeavor. Regrettably, not all appear. To those whose presence and influence are felt throughout these pages but are nonetheless missing in action: It has everything to do with space limitations. No more, no less. The same applies to those who are now asking themselves, "Why didn't he call me?" *The Mailroom* could easily have been more than twice as long—and at one point it was—but the idea was always to be able to pick up the book with only one hand. I know you understand.

For moral support, thoughtful encouragement, always being in my corner, or just because: thanks to Bernie Brillstein; Bill Zehme, the Cadence King; Lisa Kusel, a mirror and a miracle; Carrie Brillstein; Mark S. Roy; Dennis Klein; Joe Rensin and family; the Peterson family; Apryl Prose and Wylie; Mauro DiPreta; Jennifer Gates; Christina Berger; Catherine Crier; Chris Calhoun; Peter Kaufman; Linda Thompson; Eric Zohn; Luisa Mercado; Larry King; Louis and Cynthia Zamperini and family; John Davies; Team Yanni for their patience; Nancy Steen and Mike McManus; Carole and Tony Miller, Victor Prussack and the brand-new Loy; Diana Price; John Rezek and Steve Randall, the best teachers; Arthur Kretchmer; Judd Klinger; Jane Ayer; Neal Preston; Cameron Crowe; Hilary DeVries; Amy Alkon; Cathy Seipp; Loni Specter; Greg McClave; Kathy Anderson; Holly Edmonds; Special Agent Jennifer A. Laurie; Gravtee; and—always—Mom. I miss you, Pop.

For opening doors, helping make the sale, sharing crucial insights, and showing the way: thanks to Bernie Brillstein, George Shapiro, Howard West, Irwin Winkler, Rob Carlson, Sandy Wernick, Hilly Elkins, Kelly Anneman, Bob Crestani, Judy Hofflund, Gerry Harrington, Ron Meyer, Norman Brokaw, Jim Wiatt, Don DeMesquita, Sam Haskell, John Hartmann, Jack Rapke, Michael Peretzian, Brian Medavoy, Tom Strickler, Leigh Brillstein, Jay Sures, Marc Gurvitz,

David Lonner, Arthur Axelman, Don Faber, Jaimie Roberts, Mike Rosenfeld Sr., Mike Rosenfeld Jr., Donna Chavous, Reuben Cannon, Jeremy Zimmer, Gary Cosay, Dan Adler, Andrea Galvin, Peter Safran, Mark O'Connor, Robert Offer, Elliot Roberts, Rick Nicita, Lee Kernis, Tim Sarkes, the late Mr. Arthur Trefe, Lou Weiss, Cynthia Shelton-Droke, Bob Shapiro, Toni Howard, Ron West, Andrew Cohen, Alan Berger, Jeff Wald, Sandy Gallin, Ben and Paula Press, Rob Kim, Sue Naegle, Marty Bowen, Matt Tolmach, David Manpearl, Joel Gallen, Steven and David Konow, Kassie Evashevski, Peter Bart, Tom King, and Frank Rose. For advice and consensus: Kim Masters, Bernard Weinraub, Paul Brownfield, Rick Marin, and James R. Petersen. Gina Centrello, Peter Borland, Tracy Bernstein, Tracy Brown, Victoria Robinson, Deirdre Lanning, and the entire Ballantine team outdid themselves getting this book to the finish line. Thanks to Courtney Kemp, Kristin Lootens, and Krista Smith for the info in the nick of time. Laura Sapp, Michael Davison, and Peter Reynolds at USA Networks were patient and encouraging. Thanks to Barry Diller for coming through, to the always charming Priscila Giraldo in David Geffen's office, and to David Geffen for trust early in the game.

To all the assistants who answered the phones, listened patiently, took the messages, and kept me on the call sheet: This book is for you. It's also for everyone who hired you, trained you, terrorized, tolerated, and nurtured you.

A vente percent thanks to Starbucks at Santa Monica Boulevard and Wilshire Boulevard in Beverly Hills for caffeine and a comfortable chair.

As always, nothing I do is possible without the love, patience, grace, loyalty, and joy in life so freely given by my wife, Suzie Peterson, and son, Emmett Rensin. People may tell me everything, but you both mean everything to me.

About the Author

DAVID RENSIN is the coauthor of show business legend Bernie Brill-stein's widely lauded memoir, *Where Did I Go Right?*, as well as Olympian Louis Zamperini's World War II survival saga, *Devil at My Heels,* and composer/performer Yanni's memoir, *Yanni in Words.* Rensin also cowrote Tim Allen's #1 bestseller *Don't Stand Too Close to a Naked Man* and his follow-up bestseller, *I'm Not Really Here.* Rensin has cowritten bestsellers with Chris Rock, Jeff Foxworthy, and Garry Shandling, and he coauthored a groundbreaking humorous sociology of men named Bob called *The Bob Book.* He lives in Los Angeles with his wife and son.

David Rensin would like to hear from you about this book and/or your own experience of starting at the bottom—anywhere—while dreaming of the top. Write him at themailroom@tellmeeverything.com and check out the Web site, www.tellmeeverything.com, as well.